TRACES OF VERMEER

Jane Jelley is a painter of still life and landscape, who became intrigued by the unusual qualities of Vermeer's pictures and the lively arguments about whether he used a camera obscura. Familiar with traditional materials, Jane decided to find out for herself whether there was a simple, practical way to transfer an image from a lens to a canvas, and she published a paper about her experiments in 2013. Jane lives and works in Oxford.

Praise for *Traces of Vermeer*

'This is not another speculative Vermeer biography, a fill-in-the-gaps, guesswork life. This is Vermeer the painter, by a painter...Jelley's meticulous approach yields fascinating insights.'

Laura Freeman, *Literary Review*

'A fascinating approach that throws up a plethora of intriguing details that add to the texture of Vermeer's life and technique...Jelley's ingenious experiment offer[s] a plausible suggestion as to how he set about his magical paintings.'

Michael Prodger, *Sunday Times*

'Well-researched...vivid...fascinating.'

Lynn Roberts, *Tablet*

'Featuring wonderful illustrations, engaging prose, and a deep knowledge of the craft, this is a study in art history and methodology to delight an audience beyond just visual artists.'

Kirkus, **Starred Review**

'The exquisitely luminous paintings of Johannes Vermeer have long stirred debate over whether the seventeenth-century Dutch master used optical aids. Artist Jane Jelley probed the issue pragmatically.'

Barbara Kiser, *Nature*

'Jane Jelley adds a unique perspective on Vermeer's techniques and style.'

Professor Johan Wagemans, University of Leuven

'Fascinating. Jelley brings a vast knowledge, and, more importantly, practice, of traditional painting techniques...she proposes a novel suggestion as to how exactly Vermeer could have used a camera obscura...A boon to both scholars and casual art appreciators.'

Politics and Prose, Washington DC

'Jelley infuses her descriptions of Vermeer's world with a vivid immediacy, taking readers into the hustle and bustle of market day in Delft...It quickly becomes an immersive reading experience, like an excellent historical novel.'

Simon Donoghue, *Christian Science Monitor*

'Magnificent.'

Anna Maria Polidori, *Al Femminile*

'A work of art in itself.'

Roger Abrams, *New York Journal of Books*

'A satisfying addition to any technical art history library...discoveries made by the author in this book are something of a revelation and give us valuable insights that will influence the way we view and interpret Vermeer's paintings and mysterious working practices.'

Laura Hinde, *The Picture Restorer*

How to reprefent to thofe which are in a
Chamer that which is without, or
all that which paffeth by.

THis is one of the fineſt experiments in the *Optiquer*, and it is done thus, chufe a Chamber or place which is towards the ſtreet, frequented with people, or which is againſt ſome fair flouriſhing object, that ſo it may be more delightfull and pleaſant to the beholders, then make the Room dark, by ſhutting out the light, except a ſmall hole of ſix pence broad, this done all the *Images* and pecies of the objects which are without, will be ſeen within, and you ſhall have pleaſure to ſee it, not only upon the wall, but eſpecially upon a ſheet of white paper, or

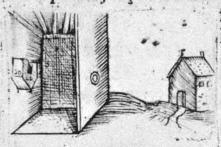

ſome white cloth hung neer the hole: & if unto the hole you place a round glaſſe, that is, a glaſſe wᶜʰ is thicker in the middle than at the edge: ſuch as is the common Burning Glaſſes, or ſuch which old people uſe, for then the Images which before did ſeeme dead, and of a darkiſh colour, will appear and be ſeen upon the paper, or white cloth, according

Figure F.1 Room camera obscura illustrated in *Mathematicall Recreations.* Leurechon, *c.*1624.

TRACES *of* VERMEER

JANE JELLEY

OXFORD
UNIVERSITY PRESS

OXFORD
UNIVERSITY PRESS

Great Clarendon Street, Oxford, OX2 6DP,
United Kingdom

Oxford University Press is a department of the University of Oxford.
It furthers the University's objective of excellence in research, scholarship,
and education by publishing worldwide. Oxford is a registered trade mark of
Oxford University Press in the UK and in certain other countries

First published 2017
First published in paperback 2018

Published in the United States of America by Oxford University Press
198 Madison Avenue, New York, NY 10016, United States of America

British Library Cataloguing in Publication Data
Data available

Library of Congress Cataloging in Publication Data
Data available

ISBN 978-0-19-878972-7 (Hbk.)
ISBN 978-0-19-878973-4 (Pbk.)

Printed and bound by CPI Group (UK) Ltd,
Croydon, CR0 4YY

To Nick, John, and Tessa;
and to my grandfather, Harry Morris.

Writing is not describing, painting is not depicting.
Verisimilitude is merely an illusion.

GEORGES BRAQUE (1882–1963)

CONTENTS

ACKNOWLEDGEMENTS

For some reason, painters are not expected to write about painting. It is fine for poets to write about poetry, and architects to write about architecture; but painters are different. It seems that they are not expected to venture into an area served by other more academic disciplines: that they are better kept roped-off, away from the hush of the gallery.

Yet painters are the ones who know what it is to contemplate a blank canvas, hold the brush, and apply the paint. They know how difficult it is to make an image: how hard it is to construct and choose, to eliminate and exaggerate; to create volume out of flatness, to use colour to create depth. They know the power in the movement of line; and in space left unfilled. They are used to looking.

If you want to know how a picture was made, then practical experience can be useful, because the manner in which an artist uses his materials, inevitably affects his thinking, his method, and ultimately his style. The power of pictures comes not only from the artist's treatment of his subject matter and any meaning he might like to convey; but also from the choices he makes about structure and placement, colour and tone; and the way he applies his paint.

Painters can give insights into pictures of the past not evident by scrutiny, or in any description of a process. How thick does paint have to be to store in a pig's bladder? How do you make a glaze that does not run? How easy is it to string a canvas? When you look at a painting, you tend not to imagine the tools, the equipment, or the materials the artist may have had at his disposal, and how they may have affected what he could do.

Johannes Vermeer (1632–1675) left us no clues about how he went about making his masterpieces, and his pictures present some unusual technical puzzles. One of the enduring questions is whether he painted intuitively, in a way only he knew; or whether, in addition, he might have used a new technology of his age: a lens.

Out of curiosity, I made some experiments in my own painting studio, using authentic materials. I wanted to see how a camera obscura could have

been used in practice, and how an image could be transferred from a projection to a canvas. The results led to some possible explanations for the strangeness we see in Vermeer's pictures.

In subsequently writing this book to explain how these discoveries might help our understanding of Vermeer's techniques, I have many people to thank. First must be my dear heart Nick, who has been by my side with constant encouragement and unfailing support. His scientist's logic has been invaluable in understanding and untangling arguments. He has travelled every step of the way with me, as we made discoveries; and he has tolerated strange concoctions in the kitchen, and searches for unlikely ingredients. Many of the best photographs in this book are his. Thanks too, for help from John and Tessa: for their enthusiasm, their suggestions, and their constructive criticism.

There are many others to whom I am very grateful. Very many thanks to Barry Cunliffe and to Bert Smith for their advice and encouragement; and to Martin Kemp, without whose kind help and support I could never have published a paper on the subject of Vermeer and the camera obscura, nor ventured any further with my experiments, or this book.

Thanks are due also to Liesbeth Mol, who first thought that my ideas were worth publishing; and to Luciana O'Flaherty, Kizzy Taylor-Richelieu, Matthew Cotton, Matthew Humphrys, Jonathan Bargus, Libby Holcroft, and Sandra Assersohn, who have brought my work to fruition. I am most appreciative of the help of Huib Zuidervaart, who gave me much information about the lenses of the time; and also of the many people who have been happy to talk to me about the challenges facing the seventeenth-century painter, including Philip Steadman, Bas van der Wulp, Quentin Buvelot, Ariane van Suchtelen, Leslie Carlyle, Quentin Williams, Colin Blakemore, Frans Grijzenhout, Desmond Shawe-Taylor, Christopher Brown, Henry Woudhuysen, Jonathan Janson, Louis Velsaquez, and Lara Broecke.

Thank you to Mitzi Feller, for finding pigs' bladders for storage experiments; to Mariette Fiennes, who kindly harvested freshwater mussel shells for me from the moat at Broughton Castle; and to Michel Haak, who took the time to tell me how he made his replica Leeuwenhoek microscope.

Clare Hills-Nova, Jane Bruder, and all the staff at the Sackler and Weston libraries of the Bodleian were unfailingly helpful, as were Eveline Kaiser and Annika Hendriksen in the Delft Archive. Thanks to Léon-Paul van Geenen and his father, who generously gave their time to explain points of history, and who showed us round Vermeer's birthplace; and to Anne and Marinus Brinkman who provided warm hospitality on our trips to Delft. Peter van

Dolen helped me with translations from Old Dutch, Piernicola Ruggiero helped with Old Italian; and David Margulies gave much time to discuss the extraction of ultramarine from lapis lazuli. I have been fortunate also to have had conversations with Herman Weyers, Bastiaan Blok, and Robert Vlugt. Finally, I must thank my friends who have patiently tolerated my writing obsession and offered help, most especially Jane O'Regan, Clare Astor, Cheryl Trafford, Pam Nixon, Elinor Williams, Christine Stone, and Felicity Wood.

The layout of Delft is much the same today as it was in Vermeer's time; and I have followed Anthony Bailey's book in using Dutch names for the churches, and streets in Delft. Although I have tried hard to be accurate, I am sure there will be mistakes, and I apologize for any I have made. I have included notes and a comprehensive bibliography; and, for those who want to find out more, there is a related website to this book:
<www.tracesofvermeer.com>.

On a very damp evening in February 2007, I climbed the steep stairs up to the Museum of the History of Science, to hear Professor Philip Steadman speak. As the lecture unfolded, every one of the audience, huddled together in the dusty basement, became entranced by his exploration of the camera obscura. I was so interested that I contacted him the very next day to explain that I had had an idea about how Vermeer could have dealt with the orientation of the image produced by a lens.

My subsequent research has led me into some unexpected areas, and as a result, this book is unlike others on Vermeer. You will have to look elsewhere to find explanations about the layers of meaning in his pictures. My focus has been on the layers of paint. I have tried to see Vermeer as an artist in his studio, with practical problems to solve.

Many would like to point out the exceptional qualities of Vermeer's painting, however, few provide explanations as to how he might have worked. I make no claim that the results of my experiments prove anything irrefutably; but I think they show that there is a simple way Vermeer could have used a camera obscura, in conjunction with other traditional techniques, without compromising his genius. Just maybe, these observations will resolve some of the current differences in opinion about why his pictures look unlike those of other Dutch painters of his day.

JANE JELLEY
OXFORD, 2019

LIST OF ILLUSTRATIONS

CHAPTER 6. THROUGH THE LENS

CHAPTER 7. A GLIMPSE OF VERMEER

CHAPTER 8. THE BRIGHTNESS OF DAY

CHAPTER 9. INTO THE DARK

CHAPTER 10. PRINTED LIGHT

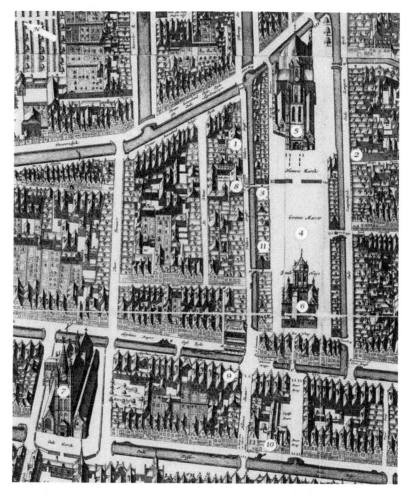

Figure F.2 Dirck van Bleyswijck *Central Delft c.1675 Kaart Figuratief (Staat I)* (detail), Archief Delft, B&G inv.nr.108599.

1 Vermeer's birthplace, the *Flying Fox*

2 Vermeer's family home on the Oude Langendijk

3 The inn *Mechelen*, Vermeer's mother's house

4 Markt

5 Nieuwe Kerk

6 Stadhuis (Town Hall)

7 Oude Kerk, site of Vermeer's grave

8 The Guild of St Luke

9 *The Golden Head*, home of Anthony van Leeuwenhoek

10 *The Golden Eagle*, home of Pieter Claesz. van Ruijven

11 *The Golden ABC*, home of the Dissius family

CHRONOLOGY OF PAINTINGS

BY JOHANNES VERMEER

(1632–1675)

Those paintings by Vermeer which can be found in this book are indicated by the figure and page number.

Vermeer's pictures have been given different titles and different dates by scholars. Here, except where indicated, dates, order, and dimensions (height x width) are taken from Liedtke (2008)[1] and titles listed below are from Wheelock (1988) and (1995).

*c.*1653–1654	*Diana and her Companions* Oil on canvas, 97.8 x 104.6 cm. Mauritshuis, The Hague.		
*c.*1654–1655	*Christ in the House of Martha and* *Mary* Oil on canvas, 160 x 142 cm. National Gallery of Scotland.		
1655[2]	*Saint Praxedis* ** Oil on canvas, 101.6 x 82.6 cm. Private collection.		
1656	*The Procuress* Oil on canvas, 143 x 130 cm. Gemäldegalerie, Dresden.		
*c.*1656–1657	*A Girl Asleep* Oil on canvas, 87.6 x 76.5 cm. The Metropolitan Museum of Art, New York.	Fig. 10.5	page 214
*c.*1657	*Girl Reading a Letter at an Open* *Window* Oil on canvas, 83 x 64.5 cm. Gemäldegalerie, Dresden.	Fig. 1.3	page 21
*c.*1657	*Officer and Laughing Girl* Oil on canvas, 50.5 x 46 cm. The Frick Collection, New York.	Fig. 8.4	page 163

c.1663–1664 *Woman with a Pearl Necklace* Fig. 5.9 page 108
 Oil on Canvas, 51.2 x 45.1 cm.
 Gemäldegalerie, Staatliche Museen zu
 Berlin.

c.1663–1664 *A Woman Holding a Balance* Fig. 5.5 page 102
 Oil on Canvas, 40.3 x 35.6 cm. Fig. 5.6 page 103
 National Gallery of Art, Washington. (detail)

c.1665–1667 *A Lady Writing* Fig. 8.6 page 171
 Oil on Canvas, 45 x 39.9 cm. (detail)
 National Gallery of Art, Washington.

c.1666–1667 *Mistress and Maid* Fig. 4.7 page 85
 Oil on Canvas, 90.2 x 78.7 cm.
 The Frick Collection, New York.

c.1665–1667 *Girl with a Pearl Earring* Fig. 5.1 page 92
 Oil on Canvas, 44.5 x 39 cm.
 Mauritshuis, The Hague.

c.1665–1667 *Portrait of a Young Woman*
 Oil on Canvas, 44.5 x 40 cm.
 The Metropolitan Museum of Art,
 New York.

c.1665–1667 *The Girl with a Red Hat* [3] ** Fig. 4.8 page 87
 Oil on Panel, 23.2 x 18.1 cm.
 National Gallery of Art, Washington.

c.1665–1670 *Young Girl with a Flute* [4] **
 Oil on Panel, 20 x 17.8 cm.
 National Gallery of Art, Washington.

c.1666–1668 *The Art of Painting* Fig. 1.4 page 23
 Oil on Canvas, 120 x 100 cm.
 Kunsthistorisches Museum, Vienna.

1668 *The Astronomer* Fig. 6.5 page 126
 Oil on Canvas, 51.5 x 45.5 cm.
 Musée du Louvre, Paris.

1669 *The Geographer* Fig. 6.6 page 127
 Oil on Canvas, 51.6 x 45.4 cm.
 Städelsches Kunstinstitut, Frankfurt.

c.1669–1670 *The Lacemaker* Fig 8.7 page 172
 Oil on Canvas laid on Panel, (detail)
 23.9 x 20.5 cm.
 Musée du Louvre, Paris.

c.1669–1670 *The Love Letter*
Oil on Canvas, 44 x 38 cm.
Rijksmuseum, Amsterdam.

c.1670–1671 *Lady Writing a Letter with her Maid* Fig. 2.2 page 32
Oil on Canvas, 72.2 x 59.7 cm.
National Gallery of Ireland, Dublin.

c.1670–1672 *Allegory of the Faith*
Oil on Canvas, 114 x 88.9 cm.
The Metropolitan Museum of Art,
 New York.

c.1670–1672 *A Lady Standing at the Virginals*
Oil on Canvas, 51.8 x 45.2 cm.
National Gallery, London.

c.1670–1672 *A Lady Seated at the Virginals* Fig 8.3 page 160
Oil on Canvas, 51.5 x 45.6 cm.
National Gallery, London.

c.1670–1672 *The Guitar Player*
Oil on Canvas, 51.4 x 45 cm.
Kenwood House, London.

c.1670–1672 *Young Woman Seated at a Virginal*[5] **
Oil on Canvas, 25.5 x 20.1 cm.
Private Collection.

** indicates disputed attribution to Vermeer.
[1] Liedtke (2008), pp.56–176.
[2] Date and dimensions from Wheelock (1998), p.50.
[3] See Arasse (1994), Appendix 2, pp. 99–100; also Liedtke (2008), pp.136–139.
[4] Liedtke (2008), pp.141–142 and Wheelock (1998), pp.126–127 both discuss the attribution
of this painting.
[5] See Liedtke (2008), pp.175–177; Wheelock (1988) p.43. This date and title is taken from
their jointly written entry at <http://www.theleidencollection.com>.

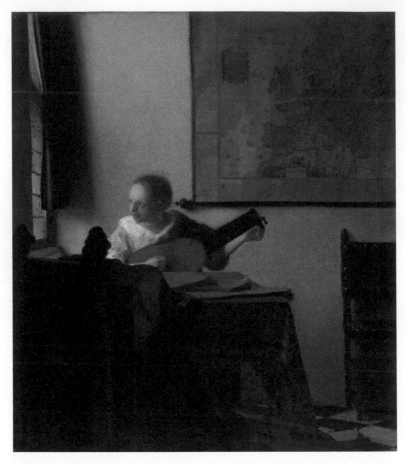

Figure 0.1 Johannes Vermeer (1632–1675), *Woman with a Lute*, c.1662–1663. Oil on canvas, 51.4 × 45.7 cm. The Metropolitan Museum of Art, New York.

Prelude

The crowd in the gallery ebbs and flows; but the rows of visitors standing in front of the pictures of Johannes Vermeer (1632–1675) are always two or three deep. People crane their necks, edging forward to see the familiar and the unexpected. They grow silent, as they gradually absorb the scenes playing inside the ebony frames.

We are invited into quiet sunlit spaces, where women pause to listen and dream. We wait for them to turn and speak to us; for the clouds outside to move the shadows on the wall. As we move closer, we seem to see less distinctly. We wonder if we can reach to touch the frosted window. We wonder if we can breathe the painted air.

Some of Vermeer's paintings possess an immediacy that belies the use of a brush. It is not only the truth of the textural illusions: the glimmer of satin, silver, and linen, and the softness of a hand on a lute string or letter; it is the unfocused impression of a moment of time, where a note of song still vibrates in the room.

How did Vermeer create these balanced, luminous masterpieces, which are admired by so many? We want to know, but he is far from reach: he lived in a world very different from our own, more than three centuries ago. He left behind no more than thirty-six paintings: a small, precious body of work; but there is so little record of his life, that we know next to nothing about him as a person, nor anything about his way of working. There are no famous quotes, no anecdotes, no reminiscences; there are no diaries and no letters; not even any drawings by him remaining. We have only a few words about him in a poem; some throwaway comments recorded by passing travellers; and some dry notes in official ledgers.

It seems that the greatness of Vermeer's stature is almost equal to the dearth of knowledge about him. We would expect more evidence of him than just a few of his signatures on documents and on paintings. The space he should occupy in the history of his time is strangely empty, and as yet, no one has been able to explain why.

In the late 1980s, the American economist, John Michael Montias, made a painstaking study of the archives, looking for anything to do with Vermeer. He learned to read Old Dutch, and combed through volume after volume of contemporary depositions, transactions, wills, and petitions.[1] Despite his huge efforts, his search yielded only threads of second-hand information from which to build up an understanding of Vermeer and his life in the small city of Delft in Holland, where he lived with his large family; where he traded pictures; and where he painted.

If you travel there yourself, to find your own answers, you may be charmed by the seventeenth-century architecture that has survived, and the pretty streets and tree-lined canals. You can visit the two immense churches that dominate the skyline, and cross the vast cobbled space of the market square that Vermeer must have known well. You can stand where Vermeer must have stood, and see the vault of sky, the reflections in glass and water; and the curve and lean of bridges and houses; just as he saw (Fig. 0.2).

The intimate scale of the city makes us imagine that by treading on the same stone, we can somehow revive the footfalls of Vermeer's life; but we cannot. His was a harder, more unforgiving world, which we would do better not to romanticize. We would like to think we can share some of his mind set: his worries about money, business, and family. We might think that we can understand some of the political and economic pressures of the time. We can try to imagine the daily practicalities and privations of his life; but all this is severely limited by our inability to establish any physical, personal connection with him at all. Apart from his birthplace, there is simply nothing left: none of the buildings he once occupied still stands; nothing he held or owned can be identified.

Vermeer's childhood home was right at the heart of Delft, in an inn called the Mechelen. This once stood on the Markt, but was removed in 1887, when two larger entrances were made on each side of the square, for safety purposes. It seems perverse that this particular building should have been taken away, when so many others of less importance to us remain; but the empty space is marked today by a plaque in the passageway, high on the wall, between a café and a hairdresser. The back windows of the inn would have given onto a view

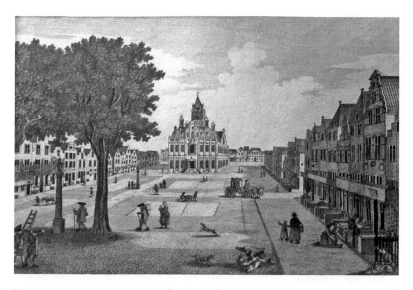

Figure 0.2 Isaac van Haastert (1753–1834), *View of the Market Square in Delft,*[2] Engraving, *c.*1755–1785 (reversed as for viewing).

of a building that Vermeer was to frequent often, to meet friends, fellow paint-ers, and craftsmen, but the headquarters of the painters' Guild of St Luke was completely demolished in 1879.[3] It is only small compensation that a replica has been rebuilt at the same spot, to house a new tourist attraction called the 'Vermeer Centrum'. The man himself would no doubt be astonished at the memorabilia they offer for sale: the *View of Delft* umbrellas and the *Girl with a Pearl Earring* soap. He might also be surprised that not one of his original paintings remains in Delft today. Only facsimilies are on display.

There are hardly any images of the Mechelen, and the one normally used as an illustration is very generalized. No one seems to have noticed another print, made in the mid 1700s (Fig. 0.2). Its significance has been overlooked, probably because it was made to be viewed in reverse, using a device called a zograscope, which incorporated a mirror.[4] The artist stood by the side of the Nieuwe Kerk to make this view of the square and the solid Stadhuis; and if we see this print the correct way round,[5] then the horse and carriage is head-ing very slowly straight for the Mechelen, on the far side of the gap between the houses. This was a large dwelling, with no less than six fireplaces,[6] and Vermeer's father Reynier Jansz. Vos[7] took out a hefty mortgage for it, which was never paid off either in his, or his son's lifetime.[8]

Vermeer's own family home, where he lived with his wife, mother-in-law, and numerous children, was in the Oude Langendijk, a little street right behind the Markt on the other side of the square, just about level with the man leading his reluctant nag across the cobbles. Today, you go past tourists queuing up for the cash machine to reach this street, hoping against hope still to find something of his house, in what was the Catholic neighbourhood of the city. But opposite the little canal, where once there must have been windows and a front door, is only the dark faceless brick of a nineteenth-century church.

Most of the rest of the architecture around the square appears unchanged from Vermeer's time; but the stone divisions between the stoops of houses have mostly gone;[9] replaced by a clutter of bollards, café umbrellas, and blackboards advertising pizza. There is the syncopated rhythm of bells, and a buzz of conversation;[10] but now a quieter soundscape: no confusion of dogs, horses, or scuffles on the pavement.

The appearance of historical coherence in Delft makes the lack of any trace of Vermeer particularly frustrating. There seems almost to have been a determined effort to destroy anything that ever had a connection with him.

Maybe we will find something in the church? The foundations of the Oude Kerk are a bit too close to the canal; and its tower leans alarmingly.[11] Inside, gone is the scene that greeted Vermeer: gone are the children playing games and scratching graffiti; the stray dogs urinating on the pillars;[12] and the whiff of corruption, as the gravediggers exhume new space for the corpses of the 'stinking rich'.[13] Today, small crowds still gather in this handsome space; but many come in the hope of finding a painter's memorial. Two stone monuments to Vermeer are set into the floor; but it is extremely unlikely he rests under either.[14] Records were lost, and graves were cleared; and no one is sure where he lies.[15]

In a further effort to follow in his tracks, we might imagine that Vermeer's painting of a view of a house in Delft might tell us something useful; but there is no agreement about whether *The Little Street* (Fig. 0.3) was a real scene, or whether it was imaginary.[16] In the Spring of 2016, posters all round the city loudly proclaimed that Vermeer was 'coming home', after an absence of 320 years. The exhibition in the Prinsenhof, where this picture was proudly displayed, on loan from the Rijksmuseum in Amsterdam, laid out ten different addresses for the exact location of the house.[17] But not even the latest research, using information from an old tax ledger,[18] provides a definitive answer.

The architecture of the house in the painting suggests that it was built in the sixteenth century;[19] and the cracks in the wall, held together with

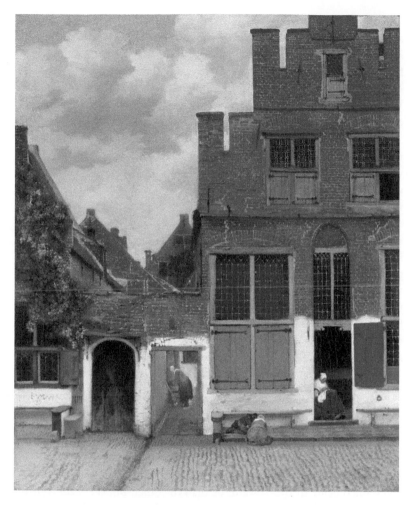

Figure 0.3 Johannes Vermeer (1632–1675), *The Little Street*, c.1659–1661. Oil on canvas, 53.5 × 43.5 cm. Rijksmuseum, Amsterdam.

clamps, may be a sign that it escaped the worst of *The Thunderclap*, the huge munitions explosion, which destroyed a good part of Delft in 1654.[20] There is debate about whether its design indicates that it was old enough also to have survived a fire, which struck the city in 1536. Whether or not this particular building is one shown still standing on a map, made to document this calamity, cannot be confirmed for sure.[21]

Nothing quells the enthusiasm of those with theories. Is *The Little Street* a view of the Old Men's house from the back of the Mechelen? Or does it show two houses, whose foundations, revealed during re-development, confirmed the presence of twin alleyways side-by-side in a street beyond the Nieuwe Kerk? Alternatively, could it be a depiction of a house on the Vlamingstraat, in the poorer Eastern side of Delft, which belonged to a tripe-seller, who just happened to be Vermeer's aunt?[22]

Interestingly enough, all these suggestions assume that Vermeer was recording something he actually saw. But, if he did paint a real house, he would be much more likely to make studies in a place where he could be left undisturbed for a while. It would be easier to work *from* a home belonging to a member of his family, than to depict it.

The only really certain thing is that it can't be much fun living in the newest candidate for *The Little Street* (Fig. 0.3), because even though the building shown in the painting has long been replaced, nothing stops the tourists gawping from across the canal.

There are those who think Vermeer made this scene up. They think that the architecture is unlikely, because the outside supporting wall is too thin for the structure; and they point out that if the green shutters were to be opened, then they would block both the passageway and the doorway; and that the red shutter on the right is unreasonably less wide than the others. They argue that the pattern of colours, windows, and arches, has been constructed for purely visual reasons.[23]

We can see that Vermeer has enjoyed the beat of composition: we hear the yawn of windows, and the bang and clap of wood, inside and out, as he plays the puzzle. He has balanced his horizontal and long divisions, divided his rectangles and squares; shown us windows shut and shuttered; and left other black openings to suck in the air. He gives us further depth by pushing one framed figure further towards us than the other. But the razor edge of the diagonal roofs, forming a triangular sky; and the very flat frontage; suggest that all this structure might be as insubstantial as a Buster Keaton film set: a house of cards, just waiting to fall.[24] We wonder at this illusion and its contrivance; but we know, from the look of surfaces; familiar as if they were under our own hand; that there must have been purposeful observation in this composition all the same.

Once our eye has roved over the house, we are free to look elsewhere, and to move closer in. We remember being near to the ground, just as these children are: playing somewhere we identified as our own, which adults did not

recognize as a precious space. Here we observe the spiders; and smell damp wood and earth. We watch the marbles run along the checkerboard cracks; we scratch the gritty chalk on the unevenness of tile. We barely notice the sloshing of water in the passageway; as the tired maid scours out the barrel, sending a sparkling trickle of water down the gutter. But we know that this moment will end soon; that our mother, who has brought her linen to mend out in the daylight, will shortly stand up, and call us in. There is no sun today, only the freshness of approaching rain.

As beguiling as *The Little Street* (Fig. 0.3) is, we cannot open any window to find Vermeer himself. Just as we despair of ever making any connection with him, we discover there is somewhere left to look.

The antique shop behind the market square does not yield up its riches all at once. The newspaper article pasted on its glass door claims that this is Vermeer's birthplace, and was once an inn called the *Flying Fox*.[25] But we are used to disappointments: every other place of significance seems to have been smudged out through neglect, or has been demolished. What can we find here?

Léon-Paul is tremendously knowledgeable about the seventeenth-century Delftware and earthenware he sells. If you have the money, you can actually buy the kinds of pots that graced Vermeer's kitchen and dining room.[26] A glazed earthenware crock, with little trivet legs, blackened underneath by use, is similar to the bowl *The Milkmaid* (Fig. 1.2) is using, and would have been put over the embers in the fire for cooking. There is a smaller container for hot coals, to insert inside a little box foot-warmer, just like the one we can see on the floor in the same picture; and a whiteware piece, bearing more than a passing resemblance to the glazed jug on the carpet-covered table in Vermeer's *Music Lesson* (Fig. 8.5).[27]

Further treasures are crammed into this small space, not least the tiny thumb-sized pottery jars artists used for their paint in the seventeenth century, some still with traces of pigment inside them; there are whole sets of old decorated plates and serving dishes; jugs, moneyboxes, beakers, candlesticks, and vases, standing in their gleaming white and blue beauty on narrow shelves.

It feels strange to be able to handle some of the reality that Vermeer would have known. These objects are not imprisoned in the vitrines of museums, but can be taken home to a modern mantelpiece, far from The Netherlands. Some of the stock here was found in past excavations in the city, some traded by families who had no use for their heirlooms. But the real valuables in the shop are not to be found on display or in packing crates; they are in the fabric of the building itself.

You might see the soot-blackened wall from the chimney of a fire, which warmed Digna Baltens and her baby, Johannes Vermeer. And right at the very back of the shop is a toilet, whose walls are decorated with old Delft tiles (Fig 2.1). Amongst them are two tiles which have been in this house since the seventeenth century: two tiles Vermeer must have known in his childhood. Two tiles. All that remain of the material goods that can be directly connected to one of the most famous painters in the world; that is, apart from the masterpieces themselves.

The lack of information about Vermeer means we are able to make very few links between his life, and the extraordinary work he made in his short career: connections which might help us understand his working practice. He died at forty-three, and we have a very small number of works by his hand.[28] There are three large, early paintings,[29] completed probably in his mid-twenties, after which there was a shift in the way he approached his work.[30] Those of his 'mature period', from about 1657 onwards, look very different, and writers on Vermeer 'seldom avoid some expression of bafflement' about their appearance.[31] They cannot explain how he achieved the effects of light, the variable focus, and the strangely blurred quality of his brushstrokes.[32] Looking beneath the surface, using scientific techniques, they have been at a loss to account for the extreme differences of dark and light in his confident first layers of paint; and why, where they would expect a preparatory sketch, there is a puzzling lack of line.[33]

Vermeer's canvases and panels have been scrutinized from every angle to find out more about their construction; they have been subject to spectroscopy and autoradiography; they have been looked at under high magnification and infrared reflectography.[34] But all investigative techniques have limitations. It can be hard to interpret the results;[35] and although they may show what pigments and oils are present, they cannot explain why they are there, or how they were applied.

One explanation for the unusual qualities of Vermeer's painting was put forward as long ago as 1891 by the American artist and printmaker, Joseph Pennell.[36] He thought that Vermeer might have used some kind of optical apparatus in the making of his pictures, because he noticed features of his work that shared some characteristics of photography.[37] There has been much contentious discussion about this ever since, but the million-dollar question is whether Vermeer actually might have traced from a projected image, and used this information in his painting. Some accept that the use of a lens

would explain some of the unusual qualities of his work, and that it would have offered him new possibilities. Others find the suggestion that such a great artist might have used an optical aid unconscionable;[38] maybe because of a fear that Vermeer's reputation as a genius could be diminished as a result.

As the arguments rage back and forth, a sort of acceptance has emerged that it is possible that Vermeer looked through a lens and appreciated the optical effects he saw; but there is no agreement at all as to whether he went further than this and actively used tracings from projections in his paintings. Apart from anything else, would he even have had access to a device with a lens, which could be used in a studio, such as a camera obscura?

It seems that he would. Lenses were the new accessible technology of the seventeenth century. Pedlars went from town to town selling spectacles,[39] and the development of the telescope and the microscope were hot innovations, and cause for much wonder. The pinhole camera obscura had been known since antiquity, and the addition of a lens at the end of the sixteenth century increased its light collection and made its images brighter. This new improved form of camera obscura was recommended as a useful aid for artists;[40] and one of the few scraps of documentation we have, that concerns Vermeer, describes a visit to his studio by an expert in optics.

The question as to how Vermeer might have used projections from a camera obscura in practice, is difficult to answer, because using it is nothing like as straightforward as taking a picture on a mobile device today. The camera obscura can only project an image; there is no light sensitive film or digital technology to capture it. The only way to transfer and fix its picture is by a laborious, painstaking, manual process; which includes the challenge of tracing in reduced light, and the inconvenience of the image being either upside down, back to front, or both. If Vermeer did use a camera obscura, it would not have been easy. The unanswered, nagging question, is how he could have done so.

This book takes a new path in this detective story. It approaches what evidence there is of Vermeer's working methods from the viewpoint of a painter, familiar with paint and brushes, pigments, and canvas; and who can consider the puzzles his work presents in a practical way. It pieces together an understanding of what Vermeer's studio might have been like from historical sources; but it also looks at the way that he could have managed the materials of his day to make use of a camera obscura, by presenting some painting experiments. These are not intended to emulate Vermeer's work, but rather to help reach an understanding of the technical challenges he faced, using the limited resources of his time.

If Vermeer did work out how to transfer images from projections onto his canvas, he might have found that the materials and procedure, necessary to achieve this, influenced his subsequent process of painting, as well as the ultimate appearance of his pictures. It appears that he did follow time-honoured methods that had been recorded in artists' handbooks and passed down in workshops: techniques that had been refined by trial and error over several centuries; but also it is clear that he had plenty of opportunities for innovation, and room for a creative use of his materials and equipment. It would actually not be that surprising if some of Vermeer's studio practice was idiosyncratic: painters were constantly trying out new ways of working, and often kept their techniques a secret.[41]

Some of the sources of information used in this investigation have a direct connection with Vermeer, but some is more circumstantial. We have the inventory made of his house and possessions after his death, which tells us something of his personal circumstances.[42] We know that Vermeer must have trained as a painter, because he registered with the painters' guild in Delft as a master, which means he was grounded in the traditional methods of his day.[43] Then there are records of seventeenth-century artists' practices, both written and visual; and we have a treasure trove of recipes in treatises and 'books of secrets', which link alchemy, medicine, and painting. We can hear from travellers of the time, who recorded interesting insights into life in the Dutch Republic; and from men of learning, who were turning their lenses outwards towards the heavens, and inwards to examine the minutiae of natural life. Vermeer could have been connected to this network of scientists who were spreading optical knowledge across Europe. The substantial scholarly literature on Vermeer is another area for study, providing visual analyses of his paintings by many experts; and there are dozens of reports of detailed scientific examination of his pictures, made with the latest technology. Finally there are the materials themselves, which in Vermeer's time were small in number, and in scope. There were only a few ways of synthesizing colours back then: most pigments came from minerals, earths, plants, animals, or insects.

Painters of the seventeenth century needed to be practical people, to have understood the properties of their ingredients: the vitriol, Brazil wood, husks of grapes, quicksilver, and poppy seed; the useful qualities of wine, ash, urine, and saliva. They may have gone to great efforts to find some of the rarer materials required; but once they had bartered, bought, or collected

their raw ingredients, they may have faced some danger. Quantities and boiling points were uncertain, and the artist might have been unprepared for sudden chemical reactions or even explosions. Peril also lurked in exposure to toxic or dusty materials, or those that were impure; and the artist needed patience: he knew some processes were uncertain, or that there might be fugitive results. Painters were used to waiting; they were used to experimentation, compromise, and invention; they were used to economy, and to failure.

Also, they would have been familiar with the conventional wisdom of studio practice, which said that a painting needed to be made in stages. That the canvas *ground* had to be prepared just so; that the *inventing layer* should be followed by two further layers of colour, one dull, called the *dead layer*; and one bright, called the *working up*. Then finally, a *finishing layer* of tinted glazes, and a protective layer of varnish or oil, could be applied.[44] Pigments and oils needed to be used in particular combination; and it was worth following this tested route, otherwise the surface might blister, flake or fade, resulting in a valueless commodity: an unstable, un-saleable painting.

All the traditional materials available to the seventeenth-century painter had their own natural characteristics, and only allowed themselves to be used in particular ways. Working with them directly can explain why certain choices were made by artists in the past, and give insights into Vermeer's own technique, which has so puzzled the experts. The clues have been there all along. They were hidden in plain sight.

* * *

Vermeer's paintings appear to be so perfect that it is hard to believe that once they were incomplete, and that he was standing before them, brush in hand. His room may not have been clean and tidy, but in the slightly disordered state that many painters find comfortable: with oily paint rags on the table, and dusty plates and flagons on the windowsill. From below, there may have been the sudden shout of children's games; the creak of the pump; the bang of metal from the yard; and from the street, the glint of water from the little canal outside.

In the solitude of his studio, Vermeer kept his secrets safe, tight behind his door. Now, after all this time, we may be able to catch a glimpse of him inside, turning his base materials into something more precious than gold.

We can see him at work, painting light.

Figure 1.1 The site of Vermeer's home today on the Oude Langendijk, seen on the left-hand side of the Molenpoort alley. There is an explanatory plaque on the wall, giving possible alternative layouts of the interior.

1

A Painter at Home

The last day of February in the leap year of 1676 was cold and damp in the small Dutch city of Delft. The clerk who came to take the inventory in the painter's home may have wanted to get back to his hearth as soon as he could. The fires were out here; the sad detritus of life, exposed to the scrutiny of strangers, was jumbled about, pulled from chests, and out of the kitchen and attic. There were no sounds of family life; no tread on the stairs to the studio upstairs; only the echo of the visitor's footsteps as he kicked over the remnants of a creative life, and counted it down in his ledger.

We know the contents of the rooms in this tall corner house on the Oude Langendijk that chilly Saturday.[1] We can imagine the pathetic piles of linens, and metal wear: the *twenty-one children's shirts, so good as bad,* bundled up with the aprons, the tablecloth, the *green sit-cushions* and the *pillowcases, large and small.* This was the stuff of a household with eight, possibly eleven children: there was a need for bedpans, back pocket-handkerchiefs, small collars, ear pillows, muffs, and foot warmers. It was also the home of the Painter, the wearer of an *ash grey travel mantle,* the owner of *a great wooden painted coffer* and a *yellow satin mantle with white fur trim*; it was the home of Johannes Vermeer, who died suddenly; leaving nothing behind but money owing, and the small matter of his life's work: pictures which would become some of the world's most precious art.

It might seem extraordinary that a painter who is the subject of so much veneration, and whose works are beyond price today, should have died a bankrupt. Although Vermeer was born in a golden age, when the Dutch amassed huge wealth through trading, and when there was money enough for people to enjoy luxuries and decorate their houses with pictures,[2] there was a terrible market crash in 1672 following the invasion of Holland by foreign troops. There were no buyers for paintings then:[3] neither for those that Vermeer had as his stock-in-trade as a picture dealer, nor for his own works

of art; and it looks as if the stress of his precarious financial position proved fatal. In a document of the proceedings of the High Court, his widow Catherina told how problems with money and lack of business had pushed Vermeer into the 'decay and decadence' that led to his death 'of a frenzy' in less than a day and a half on the 13th or 14th December 1675.[4]

Because Vermeer died without means, the inventory was of no small importance to his creditors, though some assets were obviously of more value than others. There were paintings and mirrors, bedsteads and embroidered cushions; but some items seem hardly worth listing. Possibly someone might buy *a bad mirror*, a *tin butterpot*, an *old lantern*, or a *pewter salad colander*; but the proceeds might not have relieved the debts, that were now Catherina's responsibility, to any significant degree. If it had not been for the support of her mother, Maria Thins, in whose house the family was living, it is likely she would have been left destitute.

The probate inventory itself tells something of this struggle, because it is not one document but two. Two thin folios, made of four folded sheets each, enclose the complete details of the contents of the house. It is a touching experience to see these papers in the Delft Archive today; one listing the goods belonging outright to Catherina, which would have been put up for sale; and the other detailing those jointly owned by Catherina and her mother, which they were entitled to keep, and continue to use for everyday living. They are written in a confident clear hand in brownish ink with good space between lines and margins, giving room for further notes if necessary. These documents give us some emotional connection with Vermeer's situation, making real the privations of his family life. However, there is a pang of disappointment at the realization that they must be transcriptions from the original notes made in the house.[5] Papers such as these were often copies made back in the office, bound in book form to be preserved for the future. We know that these particular inventories did come in such a form, from the establishment of the notary J. van Veen, who signed it himself: the holes for the binding threads are still visible in the centre creases of the paper.[6]

John Michael Montias, the American economist who made a detailed study of these documents, thinks that the list is shorter than it should be. He suggests that Catherina may have salted away some valuable items, and perhaps rearranged her possessions to make the house look fuller than it was. For example, there is no evidence of the gilded jug we see in Vermeer's painting *Young Woman with a Water Jug* (Fig. 9.1), nor any jewellery: both recorded earlier, as bequests from her mother.[7] We can see that some other

items present in Vermeer's pictures are not listed either: there are no rugs, no chandelier, musical instruments, maps, or globes; but then these might have been borrowed for artistic purposes. Other items that historians would expect to be in the house are curiously absent. Where is the armchair for the master of the house; or more mundane articles, such as shoes, outer clothing, hats, toys, or even a washbasin? Maybe these do not appear because they were still being used; or had been pawned, or sold.[8]

Catherina's most valuable assets were Vermeer's paintings themselves, and she used two of these to settle a huge debt for bread, although she negotiated terms with the baker Hendrick van Buyten, to allow her to buy them back, if she ever had the money to do so in future.[9] These pictures were most likely *The Guitar Player*,[10] and *Mistress and Maid* (Fig. 4.7) which one expert suggests had come straight from the studio in an unfinished state.[11] Catherina also made shifts to preserve Vermeer's masterpiece, *The Art of Painting* (Fig. 1.4), which had probably been kept in the house as a presentation piece. She said that this belonged to her mother and so should be exempt from probate. Maria Thins persisted in this claim, even when the painting had passed out of her hands; but it appears she was unsuccessful in this attempt. There seems to have been no little wrangling over the details of Vermeer's estate, and the authorities interviewed Maria Thins twice, and asked for written confirmation that she had not conspired to conceal any assets and defraud Vermeer's creditors.[12]

It is sad that the most important documentary evidence we have of Vermeer comes from the aftermath of his death. However, we should be grateful for the scrupulousness of the probate clerk, since his list gives us the only glimpse we have of Vermeer's house and his family life, and along the way, it also tells us something of his studio room.

Vermeer's choice to live with his mother-in-law was an astute one, and could have been directly related to the need he had for a good space in which he could work. When Vermeer started his married life with Catherina in 1653 he was already a master painter, and they were most probably living in his mother's house, the Mechelen inn on the Markt in Delft. But some time before 1660, the couple took the decision to move about a hundred metres to the Oude Langendijk, just across the square.[13] Maria Thins' protection and situation could offer a number of advantages. She was comfortably off, with income from rents, inheritance, and her divorce settlement;[14] and it was likely that it was her money which sustained Vermeer for much of his career. Her house was one of the larger dwellings in Delft, and gave him space to

bring up his ever increasing family, and the opportunity to use a good-sized, well-lit room as a studio, warmed by the heat coming up from beneath. In contrast, the living quarters in the Mechelen inn may have been cramped and noisy, with much space taken up by Vermeer's father's picture-dealing activities, and by the public rooms for drinking downstairs.

The *Map of Delft* by Dirck van Bleyswijck (Fig. 7.2), made from a survey in the year of Vermeer's death, shows the town ringed by walls and water, with a schematic drawing of dwellings along the many canals. The big space of the Markt in the centre is plain to see (Fig. F.2) and Maria Thins' house was just nearby. However, just how large a plot this would have occupied; what the house actually looked like; and how the rooms were arranged, are still subjects of debate.[15]

This house was in the Catholic area of town known as the 'Papists' Corner'[16] and there is a theory that, although it appears to have been bought by Maria Thins' cousin, Jan Geensz. in 1641, the money may have been provided by the Jesuits, who were keen to keep a foothold in Delft, in the face of the advance of Protestantism. Maybe it is relevant that this plot has remained true to its faith. When the house was demolished around 1733, a church was put in its place, which has since been rebuilt as the monumental Maria van Jessekerk.

Today, in the small candlelit chapel entered halfway down the Molenpoort, you can stand in a spot that was once inside Vermeer's house. Sadly, there is not a flicker of recognition left of the numerous lives lived just here. It cannot have been such a peaceful place in Vermeer's time. It was home to some fifteen people and there must have been many visitors: Catherina's troublesome brother Willem,[17] people coming to see Maria Thins, or those wanting to buy pictures from Vermeer's stock, or make commissions for painting. We know that the household employed at least one servant,[18] but there may have been others to help look after the children, clean the house, and cook the meals.

Much has been made of the number of Vermeer's children and the burden they put on his resources: he and Catherina baptized fifteen babies, of whom eleven appear to have survived beyond infanthood.[19] What would life have been like for them? The inventory gives us clues as to the effort and activity needed to look after so many. There are plates, beer mugs and flasks to fill, and much kitchen equipment: kettles and iron pots for cooking over the open fire; pans to warm milk, to make pancakes and porridge. There is a peat chest for fuel, and a quantity of linen, all of which had to be laundered

by hand: sheets, pillowcases, nightshirts, ruffs, napkins, caps, aprons, bonnets, collars, and cuffs. There were nappies to wash too, and a special basket was used to dry them, with a space for hot coals underneath. Buckets would have to be hauled up from the pump in the yard, and many bedpans emptied. Water from the canal or well was dangerous to drink, so the tankards were filled with home brew or beer bought from one of the many breweries in town. Food was brought back from the market in baskets and pails for immediate use, or to be preserved for the winter; and time had to be spent in the filling of barrels with brined or salted meat and fish. Amongst all the equipment in the house, is some we would not recognize, such as the large wicker basket called a 'bakermath' in which a mother could sit and feed her baby, while shielded from the cold.

Visitors to Holland at the time said that the Dutch were frugal with their heating, and Delft must have been uncomfortable in winter. Along with the rest of Northern Europe, The Netherlands was experiencing the effects of a Little Ice Age, and the weather was particularly harsh in the 1650s.[20] The wind blew uninterrupted across the flatlands; and the mists and damp would have chilled the bone. There was a fire in the kitchen for cooking and for light; and, if the Vermeers could afford it, another in the hall; but otherwise it was just perishing cold.[21] No wonder people wore hats and caps, and layers of wool, even indoors.[22]

On fine days the doors and windows could be opened to let the fresh air in again, people would sit on their steps or on the benches outside their houses while the children played in the street. Meanwhile, the housewives of Delft raged a battle against grime and muddy water, and aired the damp bedding. Visitors remarked on the cleanliness of the town, and we can see the scrubbing brooms and mops in pictures of the time.[23] But we would notice the smells: not only of the unwashed populace, itching from fleas and lice; but also from the latrines in the back yards, the stink from the fishy rubbish, the robust fermentation of the breweries, and the smoke from the kilns in the many little potteries supplying Delftware.

We forget how life must have been before advances in medicine and the advent of public health: before sanitation, refrigeration, penicillin, analgesics, contraception, immunization, anaesthetics, and dentistry. In seventeenth-century Holland, life was tough, and mostly much shorter than our own. Untreated infections could kill, as could a plethora of other illnesses. Vermeer buried four of his children in infancy, and although Catherina survived her confinements, many women did not, succumbing to botched

births or puerperal fever. Vermeer's pictures of moments of tranquillity pre-served seem all the more miraculous against the background of family anxieties; illness and loss; financial worries; and the sheer hard work of car-ing for so many.

Until you consider the size of Vermeer's establishment, Maria Thins' house sounds large. The clerk listed twelve rooms: on the ground floor, the *front* and *great hall* with an adjacent *small room*, and four rooms described as *kitchens*. One of these was for cooking; and another for washing; but there was also an *interior kitchen* and a *little back kitchen*. Downstairs was a *basement room*, which must have been damp, but which contained a bed; and then upstairs there were a further four rooms: a *'hanging' room* (a kind of mezzanine), a *back room* which contained some books; and the *front room* that was proba-bly Vermeer's studio, with *an attic* connected by a ladder. Back downstairs was *the place*, which was a toilet. Interestingly its name corresponds with the slang 'loo' used in English today. This comes from the French *'lieu d'aisance'*, meaning the 'place of ease', shortened to become just *'le lieu'*: *'the place'*.[24] Vermeer's loo contained *a tin waterpot*, which we might assume was just a chamber pot. The privy would have been in the back yard.[25]

We have only a sketchy idea as to how these rooms were arranged inside the house. A number of plans have been suggested,[26] and the size of his stu-dio is still under debate, However, it is plausible that there were two stories on the front of Maria Thins' house facing the street, and that the kitchens ran down one side, one behind the other, backing onto the alleyway. The bare room, with a broken windowpane, in which *the Milkmaid* (Fig. 1.2) prepares her pudding, looks very like a scullery. Maybe it is one of these little kitchens.[27]

We cannot be certain either how any of the rooms in Maria Thins' house was used, but the front hall and great hall are likely to have been spaces in which Vermeer could have conducted his business affairs. Public and private areas were less clearly defined than they are now;[28] and a bedstead, with *green curtains* and a *valance* for privacy, was listed as being in the *great hall*; and there was a *'bad bed'* in a small room adjoining it. There was even a bed in the *cooking kitchen*, maybe for the maid.

In the seventeenth century, many people worked where they lived,[29] and so it seems reasonable to suppose that Vermeer did his painting at home, most probably upstairs in the front room of the house, as this is where some artists' equipment and materials were found. We can identify where this room was because it is thought that the clerk listed the contents while walking

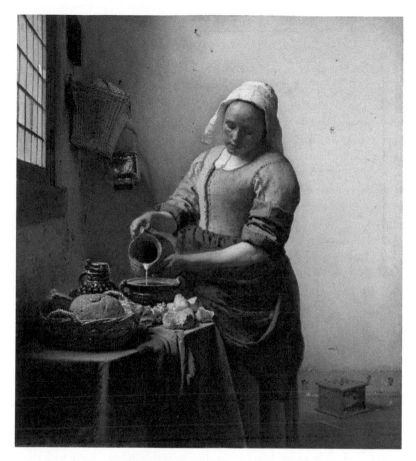

Figure 1.2 Johannes Vermeer (1632–1675), *The Milkmaid*, *c.*1657–1658. Oil on canvas, 45.5 × 41 cm. Rijksmuseum, Amsterdam.

through the house in a logical order, and reached this room second to last. Its height and position would make it the lightest room in the house and a good choice as a studio, as from its windows there would have been a huge expanse of sky with an uninterrupted view over to the far side of the Markt, only partly shadowed by the great bulk of the Nieuwe Kerk.[30] It would have faced North, with some reflected light coming in from the little canal running along the street:[31] ideal conditions for a painter wanting steady light, without dramatic shadow, during the day.

In the late 1670s the Amsterdam painter, Joachim von Sandrart, said that direct sunlight should be avoided in artists' studios if possible, as it made colours 'diminished and confused'.[32] Many seventeenth-century studios had shutters or blinds at the windows, as can be seen in Rembrandt's house in Amsterdam, now restored and refurnished. Vermeer's painting of *The Little Street* (Fig. 0.3) shows a house with shutters on the lower half of the windows outside, and there are interior shutters and curtains in other pictures. Controlling the light in the studio was important, as the subject needed to be well-lit, with just the right amount of shadow, allowing the painter to still see his picture clearly.

As part of his research into Vermeer's possible use of the camera obscura, Professor Philip Steadman calculated the size of Vermeer's studio by looking at his pictures and working out the scale of the objects he painted.[33] His optical reconstruction corresponds very closely with the calculations made by the Delft architectural historian Ab Warffemius, who arrived at a dimension based on three factors: a study of old maps and prints; the size of the plot that the house is likely to have occupied; and the architectural styles of the time.[34] Both Steadman and Warffemius think that Vermeer's room was about 6.6 metres wide and 4 metres deep, which, although far from a standard width for Delft houses, is almost the ideal size for painters' studios, suggested by Sandrart: and is wide enough to have accommodated three windows facing the street.

Vermeer could paint only in daylight hours, and must have hoped for the skies to clear to give a steady light. When the sun did shine, light would have been reflected back from the walls, generally painted with a lime or chalk-based distemper. It may be that painting was not a winter occupation, as Vermeer often shows his subjects standing near to windows, some with their heads uncovered and wearing clothes unsuitable for the cold (Fig. 1.3).

Another question that has occupied the experts is how Vermeer might have reached his studio room from downstairs. Seventeenth-century Dutch town houses appear mostly to have been built on long narrow plots; and staircases in surviving buildings of the period are often extremely steep. There have been suggestions that Maria Thins' house could have had a spiral staircase up to the first floor,[35] but although Vermeer might have assembled his canvases on strainers in his studio, their finished size could have been restricted by the elbow room needed to carry them up and down. The block and tackle situated just under the eaves on the front of old dwellings in Delft indicate that things too big to go up the stairs were pulled up

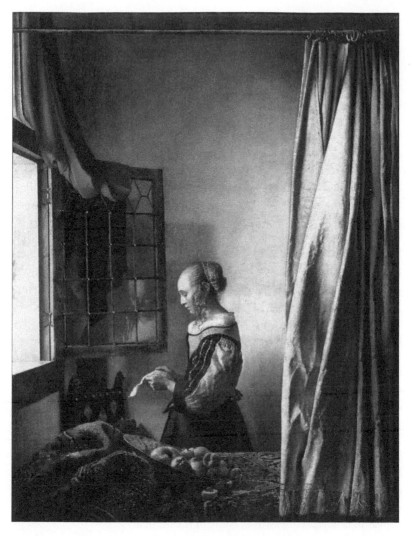

Figure 1.3 Johannes Vermeer (1632–1675), *Girl Reading a Letter at an Open Window*, *c.*1657. Oil on canvas, 83 × 64.5 cm. Gemäldegalerie, Dresden.

outside instead; but would Vermeer have trusted his precious canvases to a hook attached to a rope? When he painted his large *View of Delft* (Fig. 7.3) from another house in the south of the city, he may have had to resort to this stratagem. Large items of furniture are sometimes hauled up through the top windows of houses in Dutch cities today, though by the more modern means of an electric conveyor belt or lift.

If Vermeer did work upstairs in the Oude Langendijk, the complexity of his compositions suggest that he must have needed to leave his equipment, and the motif he had arranged, undisturbed for some period of time; but whether this room was set aside as a place to work away from the noise and bustle of the household, or if it was part of the family living space, doubling as a bedroom, is unclear. There were many people to accommodate, and mattresses might have been put down in any suitable space.

It would be most convenient if Vermeer had told us how his studio looked or how he worked. Unfortunately, we do not have any information from him at all. Not a scrap of paper, not one written comment in his hand; and even though we know he had callers, none recorded anything about Vermeer's working practice.

The accuracy and clarity of objects in Vermeer's paintings seem to suggest direct observation: there are identifiable pictures on the back walls of his scenes which are still in existence, and which were either part of his trading stock, or which belonged to his mother-in-law. A copy of one of the maps shown was found as recently as 1962, and we know that the Rucker's harpsichord in *The Concert* (Fig. 10.3) and *The Music Lesson* (Fig. 8.5), and the Spanish chairs we see in a number of pictures, are faithfully rendered.[36] If we compare objects in his pictures with those in the inventory, we do find that there are some matches. For example, the *mirror in a black frame* could be the one that appears in *The Music Lesson* (Fig. 8.5), and there is an *ebony crucifix* in the *Allegory of the Faith*. Also, the description of some of the clothes: a *satin bodice*, and a *yellow satin mantle with white fur trimmings*, appear to be repeatedly worn by some of the models.

In the absence of documentary or eyewitness evidence to resolve these issues, we might think that Vermeer's *Art of Painting* (Fig. 1.4), preserved to the last by Catherina, will tell us about the arrangement of his working space, and possibly even his studio methods, because it shows an artist painting a picture.

However, all may not be as it looks. Some art historians tell us that this picture is an allegory, which celebrates the idea of art and the importance of

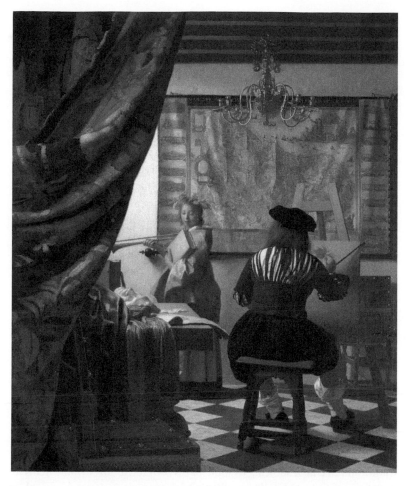

Figure 1.4 Johannes Vermeer (1632–1675), *The Art of Painting*, *c*.1666–1668. Oil on canvas, 120 × 100 cm. Kunsthistorisches Museum, Vienna.

history, and may have nothing real about it at all. They point out that the notary's list reflects the threadbare state of the household, and suggest that Vermeer painted interiors that would appeal to well-to-do buyers, who wanted pictures that mirrored the comfort of their own lives. This school of thought might bring us to the conclusion that this picture is a construction, and was not made from direct observation.

However, this argument is not enough to deny the reality of the space: Vermeer may have built an apparently luxurious scene using expensive objects he could have borrowed, and set them up inside his own studio.

If we look at *The Art of Painting* (Fig. 1.4) ourselves, and try for a moment to ignore whatever meaning might be inferred from the scene, we see past a heavy drape into a room, where a model, dressed in costume, stands in light streaming from a window that is out of sight. The artist, on a low stool, with his back to us, sits in a slashed doublet and bright red stockings, and is in the act of painting.

However, there is little here to tell us how Vermeer decided on his composition, mixed his paint, and applied his ground; or how he worked on the canvas as the painting progressed. There is tremendous argument about whether he is showing us how he painted in this picture, or whether he is keeping information from us, maybe even setting a false trail. Experts have pondered on the significance of the white lines on the painter's picture under his right elbow. Are these showing chalk planning marks, which would have disappeared when further paint was added?[37] Did Vermeer really start his painting process like the painter in the picture, by concentrating on a detail in blue, a colour that was generally applied in the upper layers of paint? Some of the information here does not add up to what we know about Vermeer's painting practice as shown by the scientific examination of his work. Could it be that this is a picture showing how people *imagine* a painter would paint? This luxurious scene may not reflect the real conditions in Vermeer's own studio, but might have been just what prospective clients would have appreciated when they called on the painter, and sat to drink a glass of wine from one of his *three roemers*[38] in the small room adjoining the *great hall*.

It is possible that Vermeer did work on this picture sitting in his upstairs studio, and that he is showing us some of his own furnishings. Some items in the picture correspond with those listed in the inventory, and were found in the first floor room: the *two easels* (one in front of the model, and one used by Vermeer himself, to put this picture on), and *an oak pull-table with a leaf on it*. The *red leather Spanish chairs* could possibly have come from a set found downstairs in the hall, which belonged jointly to Catherina and Maria Thins. *The Art of Painting* (Fig. 1.4) may also show us items that might not have belonged to Vermeer, like the chandelier, and the map, but which may have been just as real: borrowed for a time, and then returned to their owners.

The measurements of the sight lines in this and other pictures confirm that Vermeer mostly sat down to paint,[39] though whether his stool would

have been as ornate as the one we see here is not certain. But where does this splendidly dressed painter mix his paints? And how can he work sitting so close to his model?

Analysis of the first layers of this picture show that Vermeer put the whole composition down in darkish paint, with very little correction;[40] but no one is sure exactly how. Such a secret is not revealed in *The Art of Painting*: there

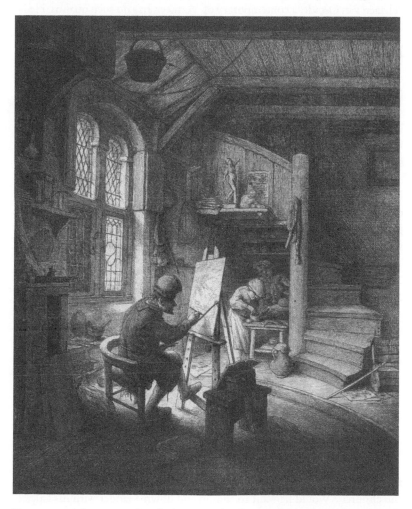

Figure 1.5 Adriaen van Ostade (1610–1685), *The Painter*, c.1667. Etching. Joseph Pulitzer Bequest, 1917. The Metropolitan Museum of Art, New York.

is no evidence of a big plan of the picture in front of the painter, and there are no drawings left behind for us to see either. As with so much to do with Vermeer, this is a puzzle. If only we could turn on our heel to look behind us, where sits Vermeer in the shadows, and ask him some questions.

If Vermeer is showing us part of his upstairs studio in his painting, he seems careful to keep the effort, mess, and untidiness of its making from us. Adriaen van Ostade, a contemporary of Vermeer, has no such qualms. He is keen to show us the general working conditions of painters, although the comical element of his pictures suggest that they are probably not absolutely literal. His print of about 1667 (Fig. 1.5) shows a painter sitting on the edge of a dilapidated three-legged chair, propping up one foot on the easel in front of him. Just like the painter in *The Art of Painting*, he supports his small brush with a mahl stick, which has a soft end to prop against his painting; and although we cannot see a palette in his hand, close inspection reveals a small one hanging on the wall behind him and maybe another on a shelf in the window embrasure to his left.

Various other accoutrements reveal themselves in the shadows: a lute on the wall, an empty frame, plaster figures, boards leaning against an open cupboard, several flasks, and a book propped up on a small stool. It is surprising that the painter is able to concentrate, because in an alcove under the stairs are two small figures furtively busy, mixing something up in a small container.

Ostade's shabby working space is worth a second look, because there could be some parallels with Vermeer's studio, such as the spiral staircase, and the arrangements of shutters in the window: a lower one closed from the outside, and the upper ones ready to be shut from within.

Vermeer's own grinding table and muller were found in the attic above his studio after his death. We might wonder what they were doing up there, since the preparation of paint was often done within easy reach of the painter himself, as illustrated in many pictures of artists of the time working in their studios, including those of Ostade. Had the table always been in the loft when Vermeer was working or was it carried up here later? Would Vermeer have wanted to do all his preparation so far from his easel, or would it have been necessary, in order to store precious materials away from the children? Would he want to run up and down a ladder with his palette when he needed more paint?

A stone table seems to be rather a heavy object to manoeuvre up a ladder, and there would probably have been no male servants to help with any move, since their employment attracted tax, and so they cost more than hiring maids. Some think that Vermeer stopped painting around 1673 because of the lack of demand for his pictures,[41] so he may possibly have decided to store this cumbersome item, and leave the room clearer for the family to use. Why didn't he then tidy away the rest of his equipment, and put it up here too? Maybe he did, and Catherina brought some of it back down afterwards, to make the room appear a bit fuller for the probate clerk.

Perplexingly, the only other items found in the attic were *13 clothes sticks* (possibly clothes hangers or the remnants of a rack) and *a wicker cradle*. Even though the maid would have had to carry baskets of wet linen upstairs, it is more than likely that clothes drying did take place in the attic. One of the most charming sources of information about the households of seventeenth-century Holland come from dolls' houses, made by craftsmen, for wealthy

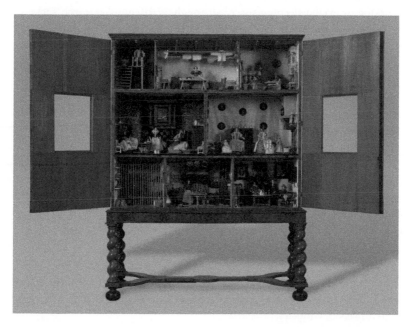

Figure 1.6 The Petronella Dunois dolls' house, *c*.1676 (makers unknown). Rijksmuseum, Amsterdam.

women of the time. Three surviving examples can be seen in the Rijksmuseum in Amsterdam and in the museum of Utrecht. They belonged to three different ladies who all happened to share the first name of Petronella, and also a passion for the miniature. Each of their houses has a linen room on the top floor: a perfect out-of-the-way drying place on rainy days (Fig. 1.6).[42]

Although we can imagine linen in Vermeer's attic, the *cradle* does not seem to fit up here. It would have been a long way away to tend a baby, and difficult to carry an infant up to a room probably reached by ladder, or a steep, open staircase, like the one up to the peat loft on the top left of the dolls' house we see here. A baby is more likely to have been looked after in one of the kitchens downstairs, close to family activity. Montias is of the opinion that, by 1675, Vermeer's youngest child would have been around one year old, and the others too big for this cradle to be needed,[43] and this suggests it was being stored here.

We will never know how this attic was used when the household was active, or even whether it had headroom and was big enough to be a useful working or even a sleeping space, although Warffemius' research suggests that this little room was lit by a small window.

Back in Vermeer's studio, the clerk did not have very much left to note down on his list. There is no mention of curtains or carpets, or much furniture that we have not already considered. However, there was *a desk, three bundles with all sorts of prints, six panels, and ten painter's canvases*, as yet unused. These last two entries pose further unanswerable questions: why were so many empty canvases and panels left behind when Vermeer's output was so very small? It is possible that he hoped to put his brush to canvas more frequently, but never had the opportunity. What could be other reasons? Maybe he prepared a number of painting supports all at once because it was easier to do so, and more economical, or he bought them as a job lot from a supplier. He could have been storing these items for someone else, or for the Guild; but if so, we would imagine that they would be returned before a probate list was made.

The available information is woefully inadequate, as is the notary's final entry for this room. He lists the last tantalizing chattels as *the contents of some rummage not worthy of being itemized separately*. It is hard to forgive him his lack of curiosity.

* * *

As we consider the final sadness of an abandoned studio, what do we make *of a small wooden cupboard*, called a *kas,* which had drawers, but which was empty? Did this once hold materials of value, which Catherina took back to the apothecary to trade in for ready money? There are important items, essential in a working artist's studio, but which are completely absent in the list. There is no mention of brushes, oil, thinners, palette knives, charcoal, canvas, glue, chalk, or paper. Might any of these have been amongst the rummage on the floor?

There is something else of vital importance missing too: extraordinarily, there is not a word of any pigment. There is no colour at all.

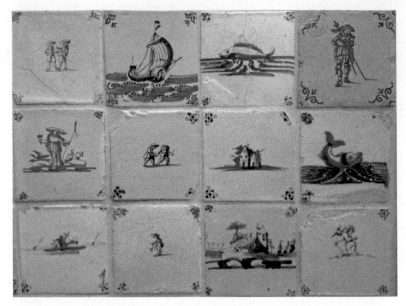

Figure 2.1 Delft tiles in Vermeer's birthplace. Two tiles original to the house, and excavated during renovations, were reset on a wall in the building. These are the ones on the top left and bottom right. Courtesy Léon-Paul van Geenen.

2

Colours of Delft

Seventeenth-century Delft tiles are valued today not only as decorative objects, but also as historical survivals. We see a reflection of a lost world still vibrant in its blue and white glaze. Here are sailing ships at sea, castles, flowers, and windmills; men wearing jerkins, and cocked hats, as they hunt, fish, and skate on the ice. Here are women, spinning and dancing, and carrying their goods to market. Here are all kinds of birds; some singing on their perch; some up away on the wing; and animals too: the leaping fox, the hare, the cow, the dog, the boar, and the leopard. Here are children playing games: we see them on stilts, and swings; skipping, playing hopscotch, and flying kites. There is no end to the invention of the painted life we see here, including religious and domestic subjects; landscapes; and even water scenes with real and mythical beasts.[1]

However beautiful they are, the tiles had a practical purpose in their time: they were a building material that helped protect the walls from damp, and cover up blemishes on plaster. They also stopped wet from seeping into the cracks where floor and wall met, under the assault from scrubbing brushes and mops.[2]

We see Delft tiles in a number of Vermeer's pictures: including *Lady Writing a Letter with her Maid* (Fig. 2.2); *The Geographer* (Fig. 6.6) and *A Lady Seated at the Virginals* (Fig. 8.3); and it may be that he wanted to convey an extra layer of meaning by including their themes, such as the choice of cupids on the tiles in *The Milkmaid* (Fig. 1.2).

Delft Blue is known all over the world. It became famous after the Dutch started imitating the china brought from the Far East in the 1500s, using tin-glazes and local clays instead of porcelain. By the seventeenth century, the city was filled with little factories, making not only tiles, but all manner of pottery: plates, bowls, pots, and jugs; and the tradition still remains. If you go to Delft today, looking for blue and white china for your table, or

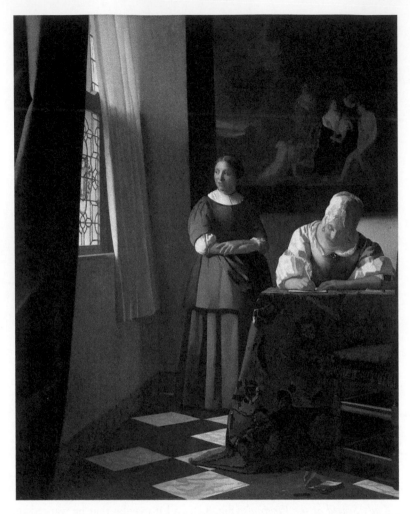

Figure 2.2 Johannes Vermeer (1632–1675), *Lady Writing a Letter with her Maid*, c.1670–1671. Oil on canvas, 72. 2 × 59.7 cm. National Gallery of Ireland, Dublin.

even an antique example for your mantelpiece, it is not hard to find. The shops sell all manner of items, although there is a certain irony in the fact that the local product is now much more expensive than the imports from China also on display.

Delft Blue may be much the same as Vermeer knew it, but other textures and colours have changed since his time. The town is now alive with bicycles, whirring along on all sides, and the edges of the canals are sardined with cars, angled alarmingly close to the water. There are still people on foot; but their heads are uncovered; and they are clothed in colours which clash strangely against the old walls. They wear shell suits of bright carrot, candy pink, and pistachio; and cycle helmets of acid lemon. The sharp stripes on rucksacks are viper's eye green, and the shop awnings are mustard, scarlet, and orange. These colours are not made of the same stuffs as the buildings: the earths, woods, clay, and metals. They are synthesized, and made with modern chemical processes. They dye the nylon, polythene, viscose, and silicone.

In contrast, some of the colours that Vermeer observed in Delft were probably depicted using the very same material on his canvas. The dull pewter-coloured wooden shutters on the left of the house in *The Little Street* (Fig. 0.3) were painted with green earth, an ingredient that was likely to be present in the house paint. Similarly, the red on the other side of the door is a particular hue, seen all round Delft, including on the shutters of the Stadhuis, and is made from ground bricks. This has a parallel in the burnt red sienna on Vermeer's palette. There is ochre earth between the cobbles in the street in the painting, and possibly in reality; and the old metal ring on the wall could have been depicted in rust: iron oxide ground into oil. Not all the pigments in this picture have been analysed, but it is possible that the timber window frames were painted with a colour containing pulverized Brazil wood.

This neat theory falls down quickly in other areas: Vermeer observes a white coating on the lower part of the building, whose walls would have been painted with limewash. This was made with calcium hydroxide and chalk, suitable for water-based painting, but not for oil. Vermeer uses a white made from lead carbonate instead. And, of course, clouds cannot be painted with mist, or faces with flesh and blood. Colours in other paintings, such as the blue in the jacket worn by the *Woman in Blue Reading a Letter* (Fig. 5.4), are made with a combination of paint in layers. Here, although it is likely the silk jacket itself was coloured with an indigo dye, Vermeer

painted it using verdigris,[3] overlaid with pure ultramarine, made from lapis lazuli.

It is difficult for us now to realize that in Vermeer's time there were colours an artist could perceive, but which had no equivalent in paint. There were no bright yellows or strong greens, and only extremely expensive rare violets. Paints could not be easily mixed together, as they sometimes reacted chemically with each other, blistered, or even turned black; so it was better to overlay one layer with another in a transparent glaze. The outer sleeves of Vermeer's *Milkmaid* (Fig. 1.2) were painted this way: on top of a dry, opaque blue base, is a thin yellow layer on the upper part; and a red glaze, possibly cochineal or madder lake, over the upturned cuff at the bottom, to give a violet colour. There were problems with this technique, as some of the shades in glazes, particularly the yellows, were prone to fading. They were made from organic materials such as flowers or berries. We can see an example of their fugitive nature in *The Little Street* (Fig. 0.3), where the trees on the left, once green, now just show their blue underpaint.

In 1888, Vincent van Gogh wrote to his friend Émile Bernard, remarking on the limitations of Vermeer's strange palette of 'blue, lemon yellow, pearl grey, black (and) white'.[4] Whereas Vermeer's pictures include the soft colour of massicot: lead-tin yellow,[5] Van Gogh had the benefit of new industrially produced paints. The brightness of his *Irises* (Fig. 2.3)[6] was due to the thick, pure strokes of chrome and cadmium yellows, invented in the early 1800s, the emerald green (a preparation containing copper and arsenic, invented in 1814), and the cheap synthesized blues.[7]

Van Gogh was able to purchase his colour ready-made in collapsible paint tubes, newly invented in 1841,[8] which kept the paint from exposure to air, and stopped it drying out. Up until that time, although a few oil colours could be stored under water, or covered with a bit of oiled fabric for a few days, most paint had to be prepared as needed.[9] The only really viable container for the storage of oil paint for longer periods was a pig's bladder, which was difficult to reseal, and prone to bursting.

Paint packaged in airtight, portable containers freed artists from their studios, and the necessity to make up their paint before every working session. It allowed them to paint outside, 'en plein air'. Renoir famously remarked to his son that without the paint tube 'there would have been no Cézanne, no Monet, no Pissarro, (and no) Impressionism'.[10] Van Gogh could write to his brother Theo in Paris, and ask him to send artists' paint down to him in Arles, in the South of France.[11] They arrived by train; and

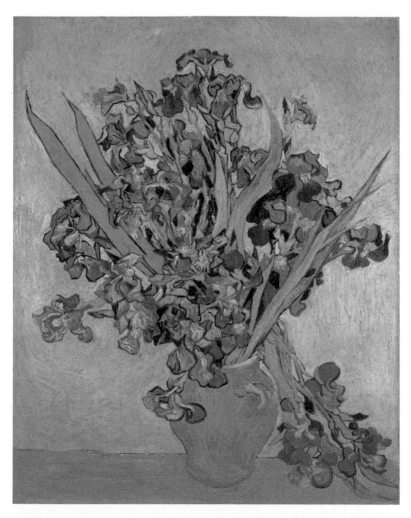

Figure 2.3 Vincent van Gogh (1853–1890), *Irises, Saint-Rémy-de-Provence, May 1890*. Oil on canvas, 92.7 × 73.9 cm. Van Gogh Museum, Amsterdam (Vincent van Gogh Foundation).

although he did complain that some were of poor quality, he could be reasonably sure that the contents would be useable. He could squeeze out his colours as he wanted them, and he could finish a picture in a day.

Van Gogh's method of working would have been inconceivable to Vermeer, for whom there was no question of working outdoors. He was tied to his grinding table and his muller, and he had to prepare paint so there would be as little waste as possible. His way of working meant that he could not make any sudden decisions. If he needed more colour, he had to down tools, to go and grind some up.

These days, it is not hard to find easily affordable art materials. It is not even necessary to have much specialist knowledge to use the variety of products on sale. With a click of a mouse, it is possible to buy ready-made oil paints in a hundred colours, acrylics that dry within an hour, a huge variety of painting supports, and brushes of every size. A novice can walk out of the shop with everything he needs to make a picture, and he can go home and start work immediately. He might want to take advice about how to compose a painting, but he does not need to have completed an apprenticeship: to have ground paints on the slab, to have stretched canvases himself, or to have learned about the properties of pigments, oils, and glues, before he is able to make art. He can be cavalier with his materials: he does not have to think about the order in which he puts down his paint, about which colours are compatible with each other. He has little concern about durability, consistency of supply, or even cost, because he can use cheap chemical colours if he can't afford the more expensive ranges. He can just pick up a brush and be an artist.

We have an idea about how this modern painter might work: we see him with a large palette, with big blobs of colour round its edge. We might imagine him mixing buttery paint together with a knife or a brush, and applying it thickly to his picture. Didn't Vermeer do just the same? Actually not at all. This kind of practice only started in the nineteenth century, by which time painters were less likely to make their paints themselves.

Working practice was very different for the seventeenth-century painter because of the nature of the materials at his disposal. We will see that Vermeer rarely mixed up his colours; that he worked slowly in stages; and used his paint sparingly. He had small palettes, and put on them only the paint he had planned to use for a particular day's session.[12]

And in order to operate as a painter at all, he first had to become a member of the local Guild of St Luke,[13] and have completed an apprenticeship satisfactorily to learn the secrets of his craft. He would have spent long hours doing menial tasks in his master's studio; before being instructed in artistic method, and before being allowed to complete a picture on his own. Once his six years was up, he had to submit a 'masterpiece' for approval, to show his work was up to standard.[14] By regulating the qualification of master in this way, the guild controlled the quality of painters' output; and, because no one could legally sell paintings in the town unless they were a paid-up and accredited member of the guild, the art market was protected too.[15]

The guild had other functions: it organized some rudimentary insurance to provide for artists' families; and was a forum for information, and the latest news in the art world. It may possibly have regulated, or even supplied valuable materials, such as gold or ultramarine, to ensure that no particular painter could corner the market and inflate the prices.[16]

The membership of the guild in Delft was not restricted to painters; other associated trades were represented: printers, pottery makers, bookbinders, glassworkers, art dealers, embroiderers, and sculptors. There must have been many fruitful exchanges of trade secrets, but there seems to have been some differences in status between members. John Michael Montias, publishing his research on the guild in Delft in 1982, explained that artist-painters were at the top of the tree; they were an elite because their apprenticeships cost the most, and their income was likely to be the greatest. Careful thought had to be given by sponsors of apprentices as to whether the fees for the training were affordable, and how safe it was to invest in a young man's future. Life expectancy was short, and there may not have been much return on the outlay. This cost might possibly have been reduced in Vermeer's case, if he had been trained in Delft, since his father was already a member of the guild. Reynier Jansz. Vos may have been offered a discount; or he could have taken on some of his son's tuition himself, or found a friend to help.[17]

There is still much argument about who could have been Vermeer's teacher, and a number of names have been put forward, including that of Carel Fabritius, painter of the famous *Goldfinch* (Fig. 2.4), who had been a student in Rembrandt's workshop, and who died in the huge munitions explosion that flattened a corner of Delft in 1654.[18]

Many of Fabritius' pictures must have been destroyed in *The Thunderclap*, but this tiny picture, made in the year of his death, miraculously survived;

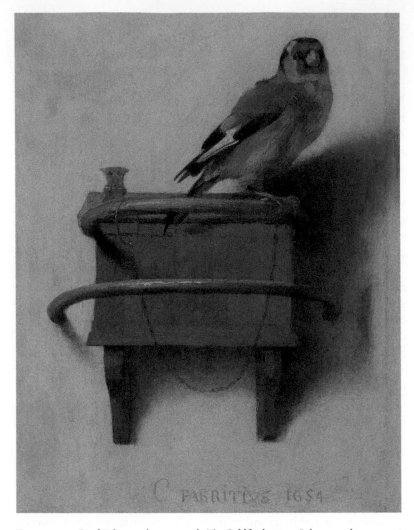

Figure 2.4 Carel Fabritius (1622–1654), *The Goldfinch*, 1654. Oil on panel, 33.5 × 22.8 cm. Mauritshuis, The Hague.

although some small pits are visible in the surface of the paint, possibly made as a result of the blast.[19]

We do recognize some similarities to Vermeer's work here: the bright, uneven plaster wall; the strong shadow; the soft sheen of metal; and the immediacy of the presence of the bird, with its flash of familiar yellow on its wing. The goldfinch's alertness and suppressed energy seem to come from the indistinct brushstrokes, which indicate its feathers. It looks as if it is just about to move.

This picture was made to deceive the viewer: maybe as a cover for a box; as part of a piece of furniture; or to hang high on the wall.[20] Fiction has added to its fame; and its many admiring visitors each want to absorb their own moment of the illusion. If the crowds are too big, then they take a second to catch the bird on their mobile phones, as if it might escape if they do not.[21] But the goldfinch cannot get far, it is chained to its perch.

We know that Vermeer admired Fabritius's work, as he owned three of his pictures, a quarter of the number now left to us.[22] He may have been influenced by the older man: by his interest in optics,[23] and by the effects of light he achieved. However, some art historians would not have Fabritius as Vermeer's teacher after all; they see other stylistic connections. They suggest that Vermeer might have learned his trade from a master outside Delft, possibly in Utrecht; or even that he went to Amsterdam to learn from Rembrandt.[24]

When Vermeer qualified as a master painter, we do not know if he took a pupil himself, as there is no record of this in the surviving papers of the Guild of St Luke in Delft. The contracts between artists and their apprentices suggest that the fees paid for tuition varied from 'a barrel of herring' a year, to payments in gold, paid up-front: differences that depended on the reputation of the painter giving instruction, and whether the pupil lived with his master, or at home. Vermeer probably did not run a big enough concern to justify having help in the studio, and although well respected, maybe could not attract a large fee. He might have done the sums and realized that he was better off without a student. There would not have been much space to spare in Maria Thins' house, or much money to provide extra meals for an apprentice who might eat his head off.[25] Anyhow, judging by the small size of his output, it is possible that Vermeer's main occupation was his picture dealing business; or the management of his mother's inn.[26]

If Vermeer had no one to help, then he would have had to prepare everything in the studio ready for painting himself, and could not make the

economies of scale that would have been possible in a workshop. There is a suggestion that he trained one of his daughters to help him, and that she is responsible for painting some of his pictures.[27] However, there seems to be no evidence at all to support this idea. Apprentices sometimes completed less important parts of a painting, like the draperies, leaving the master to do the more tricky bits: the flesh and the facial expressions. Some, like the painter Rubens, charged his customers on a sliding scale, according to how much painting he had put in himself;[28] but it appears that Vermeer worked on his own: something which is confirmed by his singular style.

About seventy miles from Delft, is Antwerp; a hub for the distribution of artists' materials in Northern Europe since the sixteenth century. Colours came though this city from Iberia, Italy, and France.

By the time Vermeer was painting, most of the pigments he needed were available nearby, all ready to grind on the slab.[29] Artists may have wanted to use some everyday, easy-to-find ingredients for paint, such as charcoal or soot for their black; but in general they probably followed the advice of Gerard ter Brugghen, whose manual of 1616 suggests that painters would do better to buy their pigments ready-made,[30] rather than trying to find the raw materials to process themselves.[31]

Various pigments had been produced on a large scale for some time, such as lead white; indigo (which was imported in bulk);[32] and vermilion[33] (made from sulphur and mercury), which is a synthesized version of the mineral cinnabar, and which was made locally. Painters would not need to follow a do-it-yourself recipe for vermilion, dating back to the twelfth century, which sounds a bit alarming in any case.[34] After weighing sulphur and mercury, you were supposed to combine them in a glass jar and 'bury this in blazing coals', until you heard 'a crashing inside' which indicated the pigment was ready. If you did immediately open the jar as suggested, maybe it was not a good idea to take a deep breath at the same time.

Painters in Vermeer's day needing opaque, orange coloured reds had no problem. They could use vermilion; red lead; or a variety of earth pigments. But in order to make a brighter or a warmer hue, then they would have had to overlay these with something else.

You may have seen a tube of paint labelled 'Crimson Lake' in the art shop, and wondered about its name. Lakes are pigments made from dyes; and they are particularly good for glazing, as they are fine and transparent. Excepting indigo blue, dyes are generally soluble, and so are unsuitable for

grinding into oil as they stand. They have to be fixed to something inert and insoluble, like chalk or ground eggshells.

Lakes are worth the effort to make, because brushed on top of dry opaque paint they can provide richness and depth, or change the colour of the lower layers. You can put yellow on blue to get a green, or put it on top of a red to turn it orange. In England all lake pigments were known as 'pinks', so you could have a brown or a yellow pink, as well as one that was truly the colour of a rose.[35]

If a painter wanted a red lake, then he could use one made from madder root, or from a scale insect. Madder was grown locally just near Amsterdam; but 'lac' insects were imported to Europe from the East, before cochineal was brought by the Spanish from South America.[36] This more recent trade was very lucrative, and jealously guarded. The Spanish exploited the knowledge of Mexican natives, who knew how to cultivate the insects on cactus plants, and harvest them successfully. It took some while for people to realize that cochineal came not from a grain, but from the bodies of the female insect.[37]

It is now known that lake pigments were sometimes synthesized and refined in workrooms at the back of apothecary's shops in Vermeer's time.[38] However, red lake pigments for painting were not generally processed from raw ingredients; instead, clippings of previously dyed red fabric were soaked in alkali 'strong enough to dissolve a feather'. This released the precious colour, which was then reprocessed.[39] It is salutary for us to remember that dyes in clothing were often unfixed, and so going out in the rain could be a sartorial disaster.

Different yellow lakes could be produced using either unripe buckthorn berries collected from the hedgerow; from the flowers of the broom bush; or from the weld plant (confusingly called arzica).[40] You can make such a lake pigment in the kitchen yourself, if you are prepared to enjoy the fizz of chemistry. You have to boil up the plants; and then you need some chalk, some alum;[41] some coffee filters; and a large turkey baster.[42]

Yellow lakes are particularly prone to fading. The Dutch word for them was *schietgeelen*, a word some identified as a shortened form of *verschietgeelen*, meaning 'disappearing yellows'. However, a scholarly article was written to discuss the difficulty of trying to evade the obvious conclusion: that the colour does indeed look just like *schijt*.[43]

Brazil wood was another source of lake pigment for reds and also for browns.[44] This was easy to find, as it was used extensively in the dyeing trade,

despite its eagerness to fade. In most cities in the Dutch Republic, it was available in the local house of correction. Here the enforced labour of the inmates of the 'Rasphuis' grated imported Brazil wood to dust; two men to a log, using a large, long rasp with a handle either end. Many of these unfortunates had committed only minor misdemeanours, such as begging; but were confined until they were seen fit to be released again.[45]

We can imagine Vermeer visiting Dirck le Cocq his local apothecary for pigments, oils, and even gold.[46] If Dirck lacked a colour (and we know he did not keep ultramarine), there were other outlets for painting materials, including the local branch of the Dutch East India Company. Founded in 1602, the Verenigde Oost-Indische Compagnie or 'VOC', as it was known, imported all sorts of commodities from Asia.[47]

There was a good market for pigment in Delft, not only because of the many painters in the art trade, but because the thriving pottery industry needed colour for decoration. No doubt, deals could be made in less formal transactions: sailors bringing materials back from their travels might have had interesting materials to barter; and if one painter had managed to purify a pigment, he might sell it to another. But artists had to watch out for unscrupulous dealers who might bulk up their product with cheap additives, or sell shoddy goods.

There is a written consumers' guide for buyers to beware, in the charming Volpato Manuscript, from the library of Bassano in Italy, written before 1670.[48] In dramatized form, we hear a conversation between two apprentices of painting, one more experienced than the other. While enjoying a glass of wine, the younger apprentice, Silvius, asks the older for advice on the preparation of painting materials; and how he is to distinguish good materials from bad. The answer from 'F' (for we never learn his name) is detailed. Some colours such as the earths should be bought in lumps *because they are natural and there is no other colour mixed with them*; most powdered pigments *must be finely ground and bright in colour*; but smalt, a colour made from blue cobalt glass, needs to be coarser, because over-grinding reduces its luminosity. 'F' stresses that there are some practical tests that need to be done before any money is handed over: ultramarine should be warmed in a spoon over the fire to see if it stays blue;[49] and yellow paint should be exposed to sunlight to check for fading. One can imagine that making a deal with 'F' would have taken some time, since he would be watchful, and would no doubt be prepared to bargain.

Even if some pigments came ready to use, the painter still had to know the characteristics and properties of his materials, and to be able to prepare them ready for painting. Which oil should be ground with which colour? Which paint would dry quickly; and which not? Which could be stored; and which might not last? One suggestion to check for fading was to leave a picture near the privy '... then what can spoil, will be spoiled'; but this advice might leave things a bit too late to be helpful.[50]

It is hoped that the painters of the household were pushed out of the kitchen and into the back yard, if any process required heat; because it is clear that some recommended refining procedures were downright dangerous.

A recipe in the de Mayerne Manuscript of 1620, now in the British Library, starts with the warning 'Protect the face!' In this case, the ingredients for *Chinese Varnish* include lead monoxide, white lead, linseed oil, and colophony rosin.[51] However, the directions do not say where the problem lies. It could be that fumes would be given off, or that the materials in the mixture would react with each other. Painters would have expected that experimentation was necessary in the refinement of their materials: they knew some processes were uncertain or that there might be fugitive results. They were used to the possibility of failure, but they might not have been so concerned about toxicity. It was recommended that artists refrained from licking their brushes, as some colours, such as the arsenic based yellow orpiment, were poisonous.[52] It was known also that workers refining lead white pigment had short lives; but the cumulative effects of breathing dusty powders, or handling toxic materials, may not have been recognized; or regarded as anything other than inevitable.

Theodore Turquet de Mayerne, the collector of the varnish recipe above, was a celebrity doctor whose famous patients included James I and Charles I. He knew Van Dyck and the miniaturist Edward Norgate; and while he was sitting for his portrait by Rubens, he recorded what he could about his painting practice. On his frequent trips round Europe he visited artists and artisans, collecting information on varnishes, priming, pigments, and oils; and wrote down useful everyday recipes in the languages in which they were given. Some of these formulae seem to have come from his patients, and there is a suggestion he may have collected deathbed secrets to add to his portfolio.[53] For a physician to have an interest in collecting artists' recipes is not surprising for the time, because many of the ingredients used in pharmacy

and painting were identical.[54] Chemistry was in its infancy, and the way materials behaved was still explained by the rules of alchemy.[55]

This compendium was never published by de Mayerne; and it has taken until this century for it all to be available in English.[56] If you go to see the original manuscript in the British Museum, you find it is rather like a collection of clippings of favourite recipes you might have in your own kitchen. Made up of miscellaneous bits of paper, it is written in a number of different hands, and de Mayerne has added notes in the margins in red ink, to highlight his own inventions, and some entries of which he is particularly proud. Reading these today gives us a view directly into his world, and the practical problems that needed to be solved. Next to instructions on 'varnishing small pictures' and a description of the properties of pigments, he explains 'how a page of normal handwriting may be written for concealment between a gap in the teeth', while elsewhere he gives instructions for removing a shot arrow in the body. Here he suggests that the efficacious properties of a sliced onion might be helpful.[57]

It is likely that the recipes available to Vermeer would have been those he learned while in training, handed down verbally over many years in painters' workshops, or those exchanged between artists in the guilds; but he may also have had access to books on painting practice, such as the *Schilder-Boeck*, by the Dutch painter Karel van Mander, published in Haarlem in 1604. This was part painters' handbook, part treatise on painting theory; and gave detailed directions on how to use materials most effectively in workshop practice. There has been a suggestion that the books found in the room upstairs, next to the studio, in Vermeer's house might have included some manuals on painting practice and on perspective.[58]

Vermeer may have seen a copy of one of the most famous painting tracts, *Il Libro dell'Arte*, written by the Italian Cennino Cennini around 1380, which has been in print ever since. Although there is continuing research about Cennini's recipes;[59] for the most part his directions are clear and straightforward, and still perfectly useable. He provides incidental information he feels is important for a young painter to know, some of which we might regard as far beyond his remit. For example, he suggests that young painters should lead sober lives, and that they should avoid too much drink and the company of women; in case these might affect their ability to work well in the studio. He is anxious that over indulgence might make a young painter's hands 'tremble and flutter... more than leaves shaken by the wind'.

He also asserts that maidens are better at making ultramarine than men, because 'they stay put in the house all the time, and are more patient'.[60]

We learn other useful facts: that the most sensitive digit of your hand is the ring finger of your non-dominant hand; we learn where to dig the earth on the hillside above Siena to find the best red earth; and we learn how long it will take you to become a good painter. But whatever we might think of Cennini's ideas, which are sometimes politically incorrect, his directions for water gilding have never been bettered, and his recipe for refining ultramarine is still much discussed today.[61]

Scientific evaluation has enabled us now to discover exactly which colours Vermeer used in his paintings, and technical books on painting conservation about his work often show magnified cross-sections of tiny samples of paint, which look a bit like small scoops of cake with nutty insides and brighter icing on top.

These samples have to be taken carefully in order not to compromise the painting: there would be an outcry if scalpels were dug into priceless works of art, unless conservation work was needed already. For this reason, old samples can be re-examined if new technology can uncover further information, and there are now alternative non-invasive methods of examination.

However, the conservators who make these analyses have to be cautious in their interpretation. A paint sample taken from the edge of the *View of Delft* (Fig. 7.3) in 1982, showed the presence of shellac, which turned out to have come from varnish applied to the frame of the painting rather than the picture;[62] and a comprehensive survey of Vermeer's painting materials, carried out by Hermann Kühn in 1968,[63] included a colour called 'Indian Yellow', identified on the curtain at the left hand side of *A Woman Holding a Balance* (Fig. 5.5). It is not likely that Vermeer would have used this pigment, since it was not recorded in European painting before the nineteenth century. Closer examination found this patch of paint to be a later attempt to restore this edge of the canvas with a little overpainting.

Indian Yellow, which found its way into the nineteenth-century paint box from Calcutta, is a dubious colour anyhow. Many reference books on painting stubbornly state that this bright, transparent yellow is derived from the urine of cows fed on mango leaves; and that its production ceased between 1890 and 1908 after an edict from the Indian Government because of cruelty to these animals. However, the circumstantial and documentary evidence of its production is flimsy, and Victoria Finlay, who tried to follow the trail of

this obsolete pigment, concluded that its status should probably be reclassi-fied.[64] There are still lumps of this bright yellow material proudly displayed in the pigment collections of more than one manufacturer of artists' paint. However, whatever was being supplied remains a mystery: was it an extract of elephant or buffalo gallstones, was it vegetable matter, or dried camel urine? The jury is still out.

The pigments we can be more certain that Vermeer used are these: lead white, massicot, minium, weld, ochre, sienna, indigo, green earth, bone and lamp black, umber, vermilion, carmine, madder, azurite, smalt, verdigris, ultra-marine, and chalk. This litany is in itself unremarkable. But these are the colours that made the oyster shell and parchment whites, the deep silvers, the dove grey, the candle wax, thistledown, dust, dun, and lichen hues in Vermeer's paintings; the colours that were transmuted into the starch gloss of the milk; the crushed topaz and honey of the water jug; and the soft pew-ter light folding through the casements.

None of these animal/vegetable/mineral choices of pigment was unusual for Dutch painting of the time, but for the green earth, which Vermeer often used under his flesh tones, and which some think shows knowledge of Italian painting. Was he an expert in this area? Had he ever been to Italy?[65] He may have inherited Italian paintings from his father or his mother-in-law, but also one of the few facts we have of Vermeer is that he went off to The Hague to value some Italian paintings. Vermeer's opinion was possibly partly to blame for the art dealer's bankruptcy shortly afterwards, as he said that he thought they were 'great pieces of rubbish'.[66]

When Vermeer ground his pigment into oil, he knew some would stand stiff in peaks on the stone, and some would be resistant to the muller; and stay stubbornly granular in gritty puddles. Each had their own personality: there were some powerful colours, which would tint well, and others which were much weaker. Some were quick drying, and others very slow. Some were transparent, while others were dense and opaque.[67] The order in which paints were applied to the canvas depended not only on the optical mixtures of colours required, but also on these particular qualities. Another factor was the price of the pigment. Paints made with cheap opaque earth pig-ments were put down first; and then the more expensive ones, including slower drying transparent glazes, were applied on top. There would be no point putting down very valuable materials in underlayers if they could not be seen.[68]

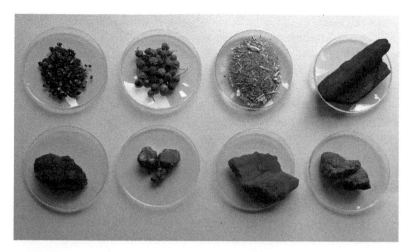

Figure 2.5 Unprocessed materials for pigments. Top row: cochineal insects, buckthorn berries, weld flower pieces, charcoal. Second row: azurite, lapis lazuli,[69] sinopia (red earth), brick.

This last point has a direct relevance to Vermeer. A number of experts on his work have commented on his profligate use of pure ultramarine blue,[70] particularly in the light of his precarious financial situation; because even today this pigment has a value in weight about equal to gold. In Vermeer's time, lapis lazuli was dug in very limited quantities, from a few mines, which are still active today in what is now Afghanistan.[71] The miners worked in winter, partly because they were needed in the fields in summer time, but also because cold helped in the extraction of the stone. When fires were lit under an outcrop of rock, the difference in temperature made it crack, and it could be extracted and crushed.[72]

The lapis lazuli that comes out of the mines varies in quality. The purest is a reddish blue, almost violet colour;[73] but more commonly the stone has a number of impurities, mostly calcite (marble) and 'fool's gold' (iron pyrites). Artists have always wanted the bluest blue, and if they could not buy the very darkest, best lapis lazuli, then they could try purifying poorer samples of mineral, or go and find someone who knew how to do it.

The word 'ultramarine' means 'from across the sea'; and this precious material made its way to Holland along a well-established trade route via

Venice; all to add to the 'bling factor' on a collector's wall.[74] Some was processed into pigment in Venice itself; but the Gesuati in Florence were also said to be experts in its production.[75] Vermeer's patron may possibly have supplied him with ultramarine pigment; or given him the money to go and buy it, if his painting was commissioned.[76] The bond between them might well have specified the particular use and the quality of ultramarine, as is seen in old artists' contracts going back to the 1400s.[77]

Painters using water-based paint needed their lapis lazuli to be refined, because otherwise the impurities would reflect back from the paint, giving a dull and milky effect to the blue. But when it is ground in oil, any calcite present in the lapis becomes transparent, and so impurity has less effect on the clarity of the colour. The quantities needed by either artist were different too. Miniature painters, grinding their pigments into water-soluble glues; or those painting in egg-based tempera; did not need anywhere near as much pigment as those making oil paint. So when we consider the recipes available for extracting pure blue out of lapis lazuli, we have to bear this in mind.

Some have suggested that it would be very much cheaper for artists to extract their ultramarine themselves, because then they could make a saving on the cost of pigment prepared by someone else.[78] But this depends on the quality of the stone they might have found, and how much pure pigment it gives. The problem is that the famous recipe given by Cennini, and the variations of it to be found in other painting treatises, can give unpredictably small yields.[79]

The essential of the method is that you have to break up the lapis stone first, by heating it, and plunging it into cold vinegar. This has a two-fold benefit. First it is a test to see if it is true lapis, because if not, it turns black; but also the change in temperature, and the effect of the acid, cracks the stone; and the tiny fissures make it more brittle, so it can be pounded in a mortar. The crushed stone is then mixed with natural turpentine,[80] mastic, and new beeswax;[81] and this plastic mass then is immersed in a caustic solution of lye. This process keeps the impurities inside the ball of solid material, and allows the blue particles to wash out into the liquid.

In order to release as many of the pigment particles as possible, this blue ball has to be kneaded a number of times in successive basins of lye.[82] It seems odd, but the first washing produces the very best and most intense ultramarine. Because it 'likes' water,[83] the biggest, purest particles fall out into the lye first; and then the pigment becomes progressively less strongly blue, until the last bowl yields 'ultramarine ashes': a dull, flinty grey colour.

The powder is then washed with water, filtered, and dried. The ultramarine produced first in this process is the purest, and is still the most costly.

When you try this method for yourself, you find that the outlay on materials and effort is really quite high. Everything takes time: the preparation of lye from wood ash, the crushing of the stone, and the assembling of the equipment. Although the kneading and mixing is simple, care has to be taken with the surprisingly strong alkali of the lye, and it is difficult to know how warm the liquid should be to make the ball of mixture malleable. At least we now have the additional benefit of industrial strength rubber gloves: the best Cennini could do was to cover his hands with oil before kneading his mastic ball; and to use two long sticks once he had put it in the lye.

Would Vermeer have bothered with all this? He is unlikely to have had an apprentice to help him with the slow, hard, tedious work of crushing the stone, before he could mix it with the other ingredients; and he may have found the inconsistent quantities produced problematic. It appears that Vermeer's ultramarine is mostly of good quality: the pieces of stone in the pigment show up under the microscope as large and splintery, but we cannot say by inspection, how it was processed.[84]

It is possible that Vermeer could have prepared his ultramarine another way; using a technique whose outcome is more reliable. If you buy the very best grade lapis lazuli at the start; you can grind it under water, to get rid of the fewer impurities it contains.[85] Since Vermeer would have to pay top dollar for prepared ultramarine; he could have been tempted to try this to save money, if he could expend the time and effort, and if he could acquire good enough stone himself.

Research on *Woman in Blue Reading a Letter* (Fig. 5.4), indicates that Vermeer may have used 'different qualities or hues of ultramarine' in this one picture, because the blue has degraded in some areas, and not others. However, it is difficult to draw conclusions about the processing method from this observation. It could indicate a method that produces different grades of ultramarine, or it could be a sign that varying qualities of lapis stone or ultramarine were available.[86]

Other blues were available to Vermeer. He did use smalt, but mostly in his early pictures.[87] Rembrandt was keen on this pigment, and it was a much cheaper option than ultramarine; but it is coarser. Made from cobalt blue glass, it is difficult to grind; and if you overdo it, it looks grey, as the glass is broken up and diffuses the light.[88] When used in oil, it can also turn brown or dull over time.[89] Vermeer used azurite, a copper based blue, in some paintings,

which has the additional useful property of improving the drying time of paint. But azurite does not have strong tinting strength,[90] and if not carefully protected by a glaze, can oxidize: and turn strangely green. Vermeer also had indigo, the colour we use to dye jeans, which is a good choice for a cheap dark blue in the underlayers, where a bright pigment is not needed.[91]

But he seems to have known which blue he preferred, and that was real lapis. It is everywhere in some of his paintings. Analysis of Vermeer's *Music Lesson* (Fig. 8.5) shows that it is present in the dress and flesh tones of the girl, the window glass, the upholstered chair, and the tablecloth; but also in duller mixtures such as the plastered walls, and the wooden beams of the ceiling, where it is not really noticeable. It appears all over the place in the *Woman in Blue Reading a Letter* (Fig. 5.4) too. There is argument as to whether Vermeer used this much lapis because he thought that the final effect would be to increase the luminosity of the painting; but it is possible that there is an altogether more prosaic reason, which is to do with his working practice.

Once the precious ultramarine was on Vermeer's palette, then, like every artist, he would have struggled with the thinness of the paint it produces when ground in oil. However, it tints other colours very strongly; and is particularly good combined with white, lending a cool tinge with the slightest smear from the palette knife. It also works well in glazes; but it does not have very much body, and cannot be stored easily.[92]

This expensive paint would never have been made up in great quantity, not even in a workshop, where it could have been handed from painter to painter. Working on his own, Vermeer would surely try and use up this powerful, precious paint anywhere he could, because it would dry if he did not.[93] Maybe this is the answer as to why he used ultramarine everywhere, even in mixtures where he might not have been certain that it would be fully appreciated. He just couldn't bear to waste it.

Even though Cennini described lapis as 'Noble, beautiful and perfect beyond all other colours', ultramarine does not always last. Vermeer would not have anticipated that some of his favourite pigment[94] would ever degrade. Is 'ultramarine sickness' due to air pollution, or an unfortunate interaction with the oil in the paint? No one is quite certain; but it has affected the balance of some of Vermeer's paintings, as we can see in *The Music Lesson* (Fig. 8.5), where parts of the pure blue in the carpet have lightened; and in the *Lady Standing at the Virginals*, where the chair in the foreground has 'a blanched appearance'.[95] Unfortunately, there is no cure so far.[96]

If you try to grind historic colours yourself, you see some of the differences between the pigments immediately. Lamp black pigment is light and fluffy: it takes up a big volume of oil but has little weight. Lead white is the very opposite, it is dense and heavy, and turns from a thick powder, initially resistant to oil, into a lovely strong, silky paint, which covers well and dries quickly. It was very often used as a ground surface for canvas because of its flexibility and opacity.

There was an outcry by artists when their lead white paint was classified as 'dangerous' a few years ago, and was made available only in small tins, out of reach on the top shelf. The cheaper and safer alternative whites made with other metal oxides, titanium and zinc, do not compare with the beauty of lead white. Titanium, while having strong 'hiding power', is cold and bright, and zinc is very transparent. Even when the two are mixed together, to try to combine their best qualities, the result cannot approach the soft colour and ductile properties of lead white paint.

The best 'stack' lead white was made in Vermeer's time by putting coiled lead strips into special earthenware pots, which had a ridge inside to keep them suspended over vinegar. These were then stacked in rows in a hut filled with horse manure, and the door was sealed. The effect of the fumes produced inside caused the lead to corrode, and the large flakes of white carbonate were scraped off the metal by hand. In the Rembrandthuis Museum in Amsterdam you can see fragments of a container for lead white, found in the excavation of the drains;[97] and also a facsimile of a pot used in this pigment's manufacturing process. Its structure is reminiscent of the containers the Romans used to fatten up dormice for dinner.

The workers of the seventeenth century, who made this 'Flake White' pigment suffered terribly from the effects of lead poisoning, as did all women who chose to use it in the make-up on their faces in the distant past. But toxic or not, there was an enormous market for this pigment, which encouraged some traders to cut it with chalk to extend their profit. Whereas *loowit* described a mixture like this; *shell white* or *schulpwit* was a term describing the very best lead white, which was sold still in the pot in which the lead had been put to corrode (Fig. 2.6).[98] If you bought this, you had a better chance that chalk had not been added.[99] It is tempting to think that *schulpwit* was so called because the shape of the pigment, still curled up, looked a bit like the whorl of a mollusc.

Vermeer's pictures may now be some of the most carefully protected in the world, but most do not look as they did when they left his studio. We

Figure 2.6 Coils of lead being processed to make lead white, in a reconstruction of the 'Dutch stack' process. Here, a shed was filled with half a ton of lead, and a three foot high stack of animal manure. The lead was then left to corrode. <www.naturalpigments.com>.

cannot blame him for the deterioration of his canvases, they are ageing; and have withstood some rough treatment from heavy handling, accidents, and theft. *The Love Letter*, stolen in September 1971, was cut from its frame, and was badly damaged;[100] peeling paint on the *Girl with a Pearl Earring* (Fig. 5.1) was stuck back carelessly;[101] and a hole was gashed in the sky of the *View of Delft* (Fig. 7.3) in 1876, when a curtain rail fell off the wall, and tore the canvas.[102]

In some instances, damage can be explained by conservation methods of the past; but degradation is also due to the reaction of the materials in the paintings over time. Recent technical analysis of Vermeer's painting shows the shortcomings of some of his colours: the fading of the lakes; the whitening of the blues; the wrinkling and cracking of the paint surface; and the formation of lead and zinc soaps. 'Saponification' is a slow chemical reaction leading to a lower layer erupting through the upper crust of the paint surface. It used to be thought that Vermeer had deliberately added sand to give textural effects such as is seen on the roofs of the *View of Delft* (Fig. 7.3); but it seems now that chemistry was responsible.[103]

Vermeer's choice of pigments was not unique for his time; and their presence alone cannot confirm that a painting is by his hand.[104] However, they can reveal that a picture is a fake. Han van Meegeren, who tried hard to make some 'rediscovered' paintings by Vermeer, during the Second World War, was exposed as a forger by the blue paint he had used.[105] He had successfully hoodwinked the connoisseurs, but he had not banked on being swindled himself. The natural ultramarine that he had been so careful to find, and had paid so much for, turned out to have been adulterated with cobalt blue. This pigment was not synthesized until 1797, and did not come on the market until around 1807. It was not something Vermeer would ever have had in his studio in Delft.

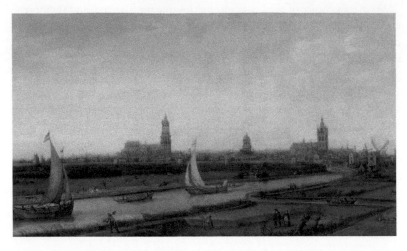

Figure 3.1 Hendrick Cornelisz. Vroom (1566–1640), *View of Delft from the Northwest* (detail), *c.*1615–1634. Oil on canvas, 71 × 162 cm. Stedelijk Museum Het Prinsenhof, Delft.

3

Substance and Supports

It is early autumn: the corn is stacked, the cattle graze on the last of the grass, and the walls and towers of Delft glow in the hazy sunshine. Ships are harboured at anchor in the Kolk, and nearby, a sheaf of sails turns in the breeze. There are six boats gliding along on the river, the largest two, with their canvas full of wind, are making their way in opposite directions: one sports the Delft flag and is going home, the other, a Leiden ketch, makes its way towards The Hague. A single oarsman leans far across the stern of his small barge to doff his cap at the travellers in a painted carriage jingling along the roadway, and a worker off to the fields, spade on shoulder, also turns to look. Others, out for a stroll together, enjoy the air and the opportunity for conversation.[1]

Sir William Temple, an English diplomat, whose *Observations* of Holland was first published in 1668, marvelled at the number of canals that had been dug to drain the flat land, and which led 'not only to every great town, but almost to every village and every farm house'. This comprehensive water network, connected to the rivers and the sea, drew Temple's envy at the advantages this gave the Dutch for trade and efficiency. The cost of transport was a big factor in the price of commodities at the time, and he noted that 'one horse can draw by boat more than fifty can do by cart'. Going by water also allowed the 'industrious man' to multitask: '(He) loses no time from his business for he writes, eats or sleeps while he goes.'[2]

As if in perfect illustration of Temple's remarks, here we can see a heavily laden punt on a side canal, perhaps piled with Delft produce such as pottery, beer, or cloth; and also two towboats, pulled by horse along the river. These were likely to be part of the regular passenger service operating between Delft and The Hague, which departed promptly once a signal bell had sounded.[3] We have to imagine snatches of chorus drifting towards us from the song sheets supplied by the ferry company to entertain travellers on their

journey; and some other sounds that might reach us on the shore: the splash
of oars; the honk of waterfowl; the thud and crunch of running feet on the
towpath; the sudden flap of sails; and the distant bells clanging in the great
steeples of the town.

This idealized *View of Delft* (Fig. 3.1), painted by Hendrick Cornelisz.
Vroom just after Vermeer was born, shows the town before the great explo-
sion of 12th October 1654. At this moment it is calm and complete, sur-
rounded by the water which both confined and shaped it; the townspeople
oblivious to any future threat inside their own protective walls. Many travel-
lers of the time expressed delight with Delft and the Dutch countryside; and
the city's biographer, Dirck Bleyswijck, was to write a description of the
town in 1667 that reads just like a tourist leaflet: 'The field estates around the
city…present the citizens with a pleasant opportunity to occasionally enjoy
themselves with a stroll or a horseback ride.'[4] Samuel Pepys, visiting in 1660
thought Delft was 'a most sweet town with bridges and a river in every street.'[5]

Vroom was famous for his seascapes and pictures of fighting ships, and it
is not known why he departed from his normal subjects to paint this view,
or whether this was a special commission; but this and his other picture of
the town, both in the Prinsenhof Museum, give us some visual idea of Delft,
even though artistic licence has probably intervened here and there. Vroom
was a colourful character, and appears to have thrived on excitement: the
yarns of his swashbuckling exploits across Europe are full of derring-do and
cliff-top rescue. He endured starvation; injury; and freezing to a rock by the
seat of his pants; and returned home after reports of his death had been cir-
culated.[6] He had the good sense to write to his wife to tell her of his narrow
escapes, to lessen the shock of his reappearance. She had not believed the
stories anyway, and must have been pleased to see him come back with the
earnings he had made by painting en route.

Karel van Mander's book on painters, published in 1604, where this
eventful history is recorded, reads like a penny dreadful when it comes to
Vroom's unlikely career. Were these tales the unvarnished truth, or advertisers'
puff? Van Mander seems very keen to explain that it is worth paying serious
money for Vroom's work. He goes on specifically to praise his understand-
ing of the 'construction of ships, their ropes and rigging, (and) the direction
of the winds'; however, despite this fulsome recommendation, in this par-
ticular picture Vroom has shown the two biggest boats going opposite ways,
improbably both with full sails. Vroom may have felt a need to be more
careful with artistic licence when it came to the windmills, because his

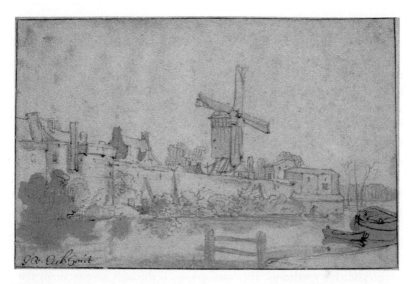

Figure 3.2 Gerbrand van den Eeckhout (1621–1674), *The City Walls of Delft with the Mill called the Rose, c.*1640–1645. Black chalk and grey wash, 12.5 × 17.5 cm. Collection Frits Lugt Institut Néerlandais, Paris.

country's very existence depended on their pumping power, and everyone knew how they looked.

Vroom shows us some of the fifteen windmills on the bulwarks of Delft's town wall, and others in the fields beyond. None of the original mills on the walls survive, but we can see a little illustration of the corn mill, *The Rose*, as it was in about 1645, in a convenient situation to supply flour to the occupants of houses nearby, while easily accessible to the river, for supplies of grain to be delivered (Fig. 3.2).

It is estimated that there were about ten thousand windmills in the Dutch Republic in the seventeenth century, of which a tenth still stand. About a third of the country lies below sea level; and dykes, polders, and pumps, powered at first by the windmills, have been essential to hold back the encroachment of water. Even today there is a rigorous management programme; and a system of ditches and drains and electric pumps takes the water from the land, and funnels it into rivers controlled with sluices and dams, back out to sea.[7] There are ingenious systems in Dutch cities to prevent the buildings presenting impervious surfaces to rain. In Rotterdam there are plants on the roofs of buildings to act as sponges; skateboard

parks that can transform themselves into lakes; and a car park basement, which has a huge emergency tank to cope with excess sewage. This fight with the elements does not lessen; and there is a continual struggle to keep the land free from water and from sea salt. Climate change will probably mean that Northern Europe will see wetter weather in future;[8] but ever since the Great Flood of 1953 which caused almost 2,000 deaths, and flooded 9 per cent of their farmland, the Dutch have taken a long view of the problem, and appear better prepared than other European countries for any excesses of water.

The imperative for water management was uppermost in the minds of all who lived in the Low Countries in Vermeer's day. Not for nothing is Delft named after the verb 'to delve' or dig; and the wonderfully decorated head-quarters of the Water Board dating from 1645 can still be admired on the oldest and deepest canal in the town, the Oude Delft.[9]

For a visitor new to The Netherlands and making a train journey, the countryside is a revelation. The carriages speed through unremittingly flat land, broken into patterns by canals, ditches, and long rectangular fields. Bright slashes of water light up in staccato rhythm, and rows of trees protect buildings, dwarfed by huge clouds that lour in a landscape of their own. The track passes rivers and bridges, dams and dykes; and the occasional old windmill, proud on its polder.

Windmills would have been have been a familiar sight to Vermeer, they were the workhorses of his age, bringing power to pumps, grinding stones, hammers, rams, and saws. When their sails were stilled, they could be used for signalling far across the flat land, and there were semaphore positions for emergencies, and to announce a death, or a celebration.[10] Most mills were worked by the wind: watermills were few and far between in Holland, because the land is too flat to provide a drop to push the buckets round on the wheels. Windmills had a particular importance for an artist. Not only were they generating power to process crops, they sawed the wood for the panels and picture strainers, ground the seeds for oil, pulped rags for paper, and crushed the pigment to powder for paint.

If you go to the Zaanse Schans, an open-air museum just outside Amsterdam, you can see windmills performing just these tasks today. This was the first true industrial site in Europe, and mills once lined the banks of the river Zaan in their hundreds. Boats brought raw materials to the mills for processing, and returned them back up the river to sell them in the city. It is still a working landscape, and the reassembled and restored windmills

stand just across from a modern chocolate factory, whose chimneys give out the irresistible smell of hot cocoa.

Inside the mills, you can get an idea of what the working conditions must have been like in Vermeer's time. Above the relentless grind of the huge running stones comes the clack and clatter of the turning mechanisms, as wood pushes against wood, and from outside, the vibration of the wind in the sails. The mill creaks like a ship tethered at sea. In English we might describe someone as being 'as deaf as a post'; but you were 'as deaf as a miller' in Dutch.[11] When the cogs engage to the hammers, the noise is overwhelming, and conversation is impossible. Milling was a cold, dangerous business: there were many moving parts, heavy machinery, dangling ropes, trapdoors with big drops, and the possible threat of explosion from flour dust.

There are several mills to see at the Zaanse Schans: *De Kat* grinds pigments and chalk, and has a special space for chopping and pounding Brazil wood;[12] *De Zoeker* makes oil from linseed, and presses the spent meal into cakes for cattle feed; and there is also a new sawmill, *Het Jonge Schaap*, rebuilt in traditional materials to the design of the original, which stood on this same spot from 1680–1942. Round the base of the building, whole tree trunks float semi-submerged in bobbing rows, to preserve and season. One by one they are hauled up the slipway, peeled of their bark, and positioned under vertical blades, which slice them into thick planks.[13] Visitors suddenly realize that the whine of the electric saw is missing: instead there is the lapping of water at the open door, the thrum of the sail outside, and a strange irregularity in the rasp of the saws, which pause in a musical phrase as the wind drops.

Wood makes a durable base for painting, but if a large surface is needed, it has to be carefully prepared. Panels in Vermeer's era were commonly made from oak, and much timber was imported from the Baltic, via Antwerp, where the trade was good until 1650, when supplies were interrupted by war. Baltic oak trees produced long straight planks as a result of being planted close together in the forests, and growing tall in their search for light.

To make panels for painting, efforts were made to reduce splitting and warping, by cutting the timber radially; and by removing the sapwood, which was more likely to shrink.[14] Panel makers' guilds monitored and regulated the quality of the output of their members by inspecting the timber and the construction of panels, and branding them to show they met the required standard.[15] Wood was butt-jointed with pegs, bevelled to fit in a

frame, and sometimes constructed with special support cradles on the back to provide strength.

Panels were commonly made up with the grain running horizontally for landscapes; and vertically for portrait panels, where the practice was to have a wide plank in the middle and two smaller ones on each side. If cracks appeared along the joints, then they would not disfigure the features of the face.[16]

Vermeer could have bought panels ready finished, from a joiner or cabinetmaker. He would not have had to look far, since both these professions were represented in his own guild.[17] Alternatively, he could have asked his brother-in-law Antony, who was a frame-maker,[18] to knock up some for him. Several panels were found unused in Vermeer's studio after his death, but we will never know if he intended to use them later, or whether he had changed his allegiance to linen canvas, and these were surplus to requirements. Two small pictures, thought by some to be by Vermeer, are painted on panel.[19] The *Girl with a Red Hat* (Fig. 4.8), is painted over a previous picture of a man,[20] while the support for the *Young Girl with a Flute* was new wood.

By the mid seventeenth century, linen canvas stretched on frames was superseding the traditional wood panel as the most popular base for painting. Canvas is light and easily portable, though its disadvantage is that it is vulnerable to damage; and a primed or painted surface can crack if it is rolled up for transport.

Some of Vermeer's finished paintings on canvas had boxes specially made for them, presumably for protection. The sale of the goods of Jacob Dissius, in early April 1683, listed three pictures by Vermeer as having boxes; one of these could have been *A Woman Holding a Balance* (Fig. 5.5), which was for sale again in Amsterdam on the 16th of May 1696.

There was a thriving linen trade in Holland in the 1600s, which had been established since the Middle Ages. Flax was a local commodity, which grew well in the cool, damp conditions of Northern Europe and was essential to artists: its fibres provided linen, and its seeds made an oil suitable for painting.

The properties of the Flax (or linseed) plant are listed in John Gerard's great *Herball* of plants, first published in England in 1597. This work, part translation from Latin texts, part personal observation, was a huge undertaking. It ran to fifteen hundred pages, and was hugely popular in the seventeenth century, going into several editions, and available in Dutch. It gives

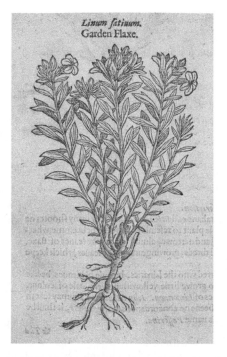

Linum satiuum.
Garden Flaxe.

Figure 3.3 John Gerard (1545–1612), *Linum Sativum* (Garden Flax), *The Herball, or Generall Historie of Plants*, 1597.

comprehensive descriptions of each plant for identification, most with an accompanying picture, and explains where they like to grow and when they flower (Fig. 3.3).

Although we may find the *Herball* the book a thing of beauty, and the spelling and descriptions quaint; it belies the seriousness with which its clinical advice would have been taken by patients desperate for a cure, and ignorant as to the causes of their symptoms. There are thirty-five entries for treatments for 'spitting of blood', and twenty-eight entries for toothache: the chief cure being 'wilde mustard chewed in the mouth' (presumably its fiery nature was some distraction from the pain of a dental abscess). Gerard suggests remedies for curing the 'biting of a mad dog' (the root of a Wild Rose) and even plague (Wolfsbane, Angelica, Gillyflowers, or Marigolds), although it recommends that medicine in these cases be taken 'before the sickness has universally possessed the whole body.' Beside uses for plants

that provide help for trivial complaints such as to 'Take away marks from the skin', or to 'Help olde aches in the Armes', sit other last-ditch cures for smallpox, scurvy, leprosy, and stomach pain. Some treatments must have been arrived at by trial and error; others were suggested because of the plant's apparent similarity in appearance with the part of the body causing the problem. There must have been much unalleviated discomfort and suffering, despite the known uses of palliatives such as poppy seed and hemp.

Francisco de Quevedo, a Spanish satirist writing in the early 1600s, has no respect for the procession of doctors, apothecaries, and tooth-drawers whose remedies 'prove worse than the disease', and whose patients are likely to die as a result of their intervention.[21] His *Visions* of 1627 give us a glimpse of the horrors of medicine in his age, which make a self-help approach seem preferable and possibly more palatable, even if some of the cures were useless.

The uses of herbs for medicine go far back into antiquity, and the *Herball* includes ancient cures, along with more recent remedies Gerard had found. As a result this work is of impressive size, hardly what we would imagine as a handbook. Yet it was meant for practical reference. Each plant was given a 'temperature', which relates to one of the four humours that were believed to keep the body in balance, and which affected how an individual was to be treated in times of illness. Flax is described as 'hot in the first degree, and in a mean between moist and drie', and as having more than twelve *Vertues*, not counting the use of its oil by 'Painters, Picture makers and other Artificers'. If the seed is mixed with saltpetre, fig, honey, and watercress, it 'causes rugged and ill favoured nales (*sic*) to fall off'; while 'it stirs up lust' if 'taken largely' in a cake mixed with 'pepper and honie'. The book describes the plant having 'long, narrow and sharpe pointed' leaves; and such is the intensity of its 'faire blewe flowers', that linseed fields, glimpsed from a distance, can look for a moment deceptively like water.

Although Delft produced some cloth from flax, most fabric production was near Haarlem, less than thirty miles away, where linen was made, finished, and bleached. The names of the processes used to reduce the strong stems to a silky thread, give a clue as to how much effort the process took. Much 'rippling', 'retting', 'scutching', and 'hackling' stripped off the unwanted fibres and combed it to a 'strick', which could then be spun into a hardwearing smooth fabric of different fineness.[22]

A pamphlet published in London in 1695 by 'J. F.', an unnamed but 'plain dealing Linnen-Draper',[23] describes the different kinds of cloth available, from A-Z; and confirms at the very beginning that Holland produced that of the highest standard: 'being made of the best flax in the world and...being spun by the most careful and curious hands; and it is wove by the best of weavers'. Even today, the finest linen you can buy for artists' canvas in Europe comes from the same region as it did then.

In Vermeer's time, the woven linen for garments was bleached by being treated with lye, wetted with buttermilk, then pegged to the ground for several weeks in the fields, to expose the cloth to sunlight.[24] Linen needed to be kept moist to bleach evenly, and apprentices were expected to water it at intervals, though reports suggested that the temptation to lie on the grass, and while away time instead, was sometimes overwhelming.[25] Jacob van

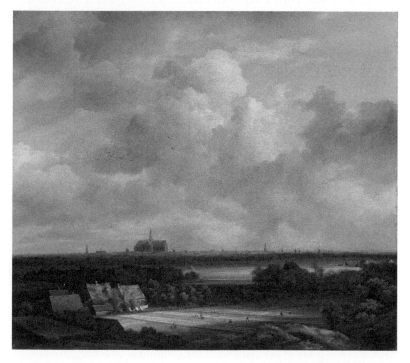

Figure 3.4 Jacob van Ruisdael (1628–1682), *View of Haarlem with Bleaching Grounds, c.1670–1675*. Oil on canvas, 55.5 × 62 cm. Mauritshuis, The Hague.

Ruisdael, a contemporary of Vermeer, made several paintings of vast sky-scapes with the Haarlem linen-bleaching fields beneath (Fig. 3.4).

These scenes may somehow remind us of our own intensively farmed European landscape, with its rows of polytunnels, but it is one that the citizens of Haarlem embraced: they went out in their Sunday best, to admire the sight of their own industry.

The word 'lingerie' originally meant garments that were made from linen, and although it may conjure up an idea of skimpier items of clothing than those of the seventeenth century, this fabric was worn next to the skin. Linen was an essential part of everyday dress: it kept the body from too much contact with outer layers of scratchy woollen clothing, which was rarely cleaned. For men, shirts were long, and functioned as underwear, tucked into breeches in the day; and then worn as nightshirts. And for women there were linen shifts worn under the bodice and skirt, or underneath dresses. Further additions to women's attire could be made with the addition of a blouse, or a small linen shawl, or fichu, to protect the neckline; as we see in the dress of a number of Vermeer's models: *Girl Reading a Letter at an Open Window* (Fig. 1.3); the smiling young woman, also wearing a linen cap, in the *Officer and Laughing Girl* (Fig. 8.4); the women in *The Love Letter*, and the girl in *The Glass of Wine* (Fig. 6.8). Even the *Woman in Blue Reading a Letter* (Fig. 5.4) reveals a flat linen collar under her mid-length jacket, whereas the *Lady Writing a Letter with her Maid* (Fig. 2.2) has a loose-fitting blouse underneath her bodice, in contrast to the more modest linen of her servant.

Detachable collars such as we see in *The Lacemaker*, and goffered ruffs and cuffs were used by both men and women, and could be washed, starched, and ironed separately, and kept for best occasions. Vermeer himself seems to have been well supplied with such linen. The inventory lists *ten men's ruffs and thirteen pairs of fancy cuffs.*[26] Maybe Catherina had a linen chest of which she could be proud (Fig. 3.5).

Washday must have taken a good deal of time and energy with all the soaking, boiling, scrubbing, wringing, and drying in the air and sunlight, when weather permitted, before the linen could be folded away in the chest. People would have hung up their linen in their back yards, open spaces, or on bushes and grass, or alternatively in the communal bleaching grounds for laundry, conveniently situated on each side of town, The 1675 map of Delft (Fig. 7.2) depicts these clearly, where shirts and sheets, shown as big as the houses, are laid out in fields around the edges of the city.

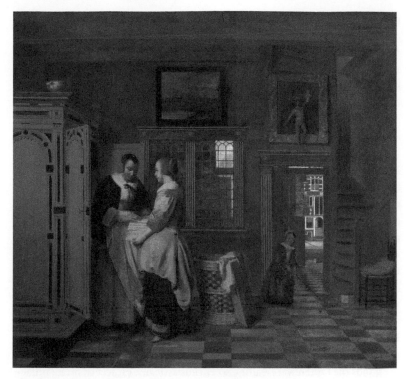

Figure 3.5 Pieter de Hooch (1629–1684), *Interior with Women beside a Linen Chest*, 1663. Oil on canvas, 70 × 75.5 cm. Rijksmuseum, Amsterdam.

It seems odd, that although it was said houses of the time were scrupulously scrubbed, and that linen was laundered,[27] that an English visitor might remark that the Dutch 'kept their houses cleaner than their persons'.[28] Standards of personal hygiene were obviously not high, and contemporary recipes suggested that bodies could be cleaned from within. A herbal written by Robert Lovell, published in Oxford in 1665, lists seventeen plants for curing 'putrefaction'; while Gerard's remedy to alleviate the smell of 'stinking bodies and armholes', was not a good scrub with soap, which we would imagine might do the trick; but to eat some root of the wild artichoke or common thistle. Because these make the urine smell, this was supposed to expel odours from the body. You would have thought that it would be clear quite quickly that this remedy was ineffective; but washing all over seems

only to have been recommended for babies. However, linen does have some cleaning effect of its own, as it is a cool fabric, and absorbs sweat; and maybe the Vermeer household paid more attention to hygiene than these general reports: after all, in a time when many children died in infancy, it was no small feat to have kept a family of eleven living children. In an old auction catalogue, is listed a picture of Vermeer's now lost to us: *In which a gentleman is washing his hands in a see-through room with sculptures, artful and rare.* Such attention to personal cleanliness was not common.[29]

We might now call the fabric on which painters worked 'canvas', but this has become a general term for a cloth on some sort of wooden support used by artists.[30] Linen is the best choice, because it can be woven very smooth, and draws less water from the air than other fabrics, which can reduce the risk of the painting cracking.[31] But it is thought that one of the reasons that only a small proportion of the very many paintings produced during the Dutch Golden Age have survived is because the humidity in Holland meant that many just rotted away.[32] Whether any of Vermeer's lost paintings also suffered this fate, we will never know.

Linen was easily available, because so much was produced in the 1600s in Holland for clothes, mattress covers, quilts, sheets, and, of course, for sail-making.[33] A rougher sort was used as a cushioning packing material for all the goods the Dutch were trading so enthusiastically. However, no manufacturer made any linen exclusively for artists.[34] Vermeer would have had to choose the quality best suited to his needs from what was available, and he and other artists may not always have had an ideal choice.

Van Dyck used mattress ticking as a support for his very large *Equestrian Portrait of Charles I*, painted around 1637.[35] Ticking is a strongly woven cloth, that came wide enough so only one horizontal join was needed for this canvas, which is over 3 metres square.[36] The familiar blue stripes were all covered up with paint on the front, but can still be seen on the reverse.

In the 1670s Charles Beale kept note of the supplies he had to buy for his wife Mary, who was an English portrait painter. Writing in the tiniest handwriting, on the little blank pages of printed almanacs; he detailed all kinds of fabric he bought from his suppliers. One would imagine that onion sacking might not be suitable for painting, but he stretched it on frames for pictures just the same. He purchased fine linen for other pictures, at the same time as buying cloth for 'a paire of sheets, for 3 shirts for my son, for pillowcases, and for capps'; the last of which cost him five shillings.[37]

If you can find a fabric shop today, someone there will know how to hold cloth between hand and chest, to measure out yards or meters. In Vermeer's time, linen cloth was often sold in 'sail widths';[38] and its length was calculated in 'ells'. There is still an echo of using this manual measure in the English language. Half an ell is where our 'el-bow' bends.[39] However, an ell meant different lengths in different places. In England it was about 114 cm.,[40] while in Holland, it was more like 70 cm.,[41] varying slightly from region to region. The width of cloth was dependent on the size of the loom on which it was made.

It appears that the dimensions of a couple of Vermeer's paintings may be directly related to a Dutch ell. One expert notes that the canvas for *The Girl with a Wineglass* is 'probably one ell wide',[42] and *The Glass of Wine* (Fig. 6.8), regarded by some as its pendant piece,[43] is the same size, just turned the other way; with an ell as its vertical. Jørgen Wadum, who was responsible for the restoration of the *View of Delft* (Fig. 7.3) in 1994, notes that this painting is on canvas as wide as the width of cloth could make it, selvedge to selvedge, at 118 cm.[44] Maybe Vermeer made a special trip to find it.

A couple of Vermeer's large early canvases, *The Procuress*, and *Christ in the House of Martha and Mary*, have seams in the linen,[45] so it could be that the local cloth was not made wide enough, and had to be joined for the purpose.

The weave and fineness of the linen Vermeer used, the density of threads, and the slubs in the cloth have been studied closely.[46] It appears that Vermeer mostly took care to find linen that was closely and plainly woven, and had a similar number of threads in the warp and the weft, as this would allow for a more even stretch across the frame. However not all the fabric he used was fine or perfectly balanced in thread count. For example, the *Woman with a Lute* (Fig. 0.1) has a fine, but uneven thread count of 20 × 15 per square cm., whereas *The Lacemaker* is on an evenly balanced, though coarser cloth, at 12 × 12 threads per square cm.

The slotted stretchers with wedges, we can find in art shops today, were not invented until after Vermeer's time,[47] and so for him, canvas had to be either tacked straight onto a fixed wooden frame, called a strainer; or laced onto it with strings, a bit like a trampoline.[48] Laced canvases allowed a painter to prepare a painting surface, without having to make a decision about the final size of the image. He could paint a whole picture, and then crop and fix it onto a strainer; or he might use a trampoline frame only for the preparation of the canvas, and the application of the *ground*; before cutting out primed pieces to cover several strainers. If he did do this, then he had

to be careful not to crack the surface of the canvas when it was pulled tight over the strainer.

When Vermeer's canvases were examined out of their frames, it was possible to see something of the way he worked. Several of the painted surfaces of his pictures extend over the sides of the strainers. But others were clearly prepared on the wooden support itself, because only the front surface has any paint on it.[49]

Unfortunately, we have to scotch the thought that we might learn much about Vermeer's preparatory processes from the record of the *ten painters' canvases* left behind in his studio. We cannot know what size these were, whether they were laced onto frames, or stretched onto strainers. We do not know if they were ready-primed or waiting to be covered with a ground layer. It is likely that they were blank, because the clerk recorded the subjects of scenes painted on any pictures he found elsewhere in the house, such as *a fruit painting, a small seascape, or a landscape.* Ten empty canvases seems a huge number to have waiting and ready, especially if we compare it to the meagre thirty-six paintings left to us. But if Vermeer wanted to start work immediately, it was good to have some in stock.

At what stage did Vermeer decide the format of his pictures, and choose their dimensions?

Experts have tried to answer these questions, but have had a frustrating time. They have looked carefully at each of the canvases, and have used X-ray images to see if the patterns of scalloped stretching marks between old and new tack holes match. They have compared the heights and widths of the canvases with regional standards of measurement; they have considered the trimmed edges; possible changes in size; and any over-painting in old restorations and damaged areas. They have tried to make sense of the resultant pile of data.

The problem is that over time, nearly all of Vermeer's pictures have been moved to new strainers, re-lined with extra linen, and some (though this seems quite dreadful) have been trimmed.[50] This has altered the proportion of his pictures; quite dramatically, in the case of *Diana and her Companions.*[51]

The *Girl Playing a Guitar* may look cropped: she is cut off abruptly, on the left-hand side, as if drawn in by the presence of an unseen friend, who she greets with a smile.[52] But ironically, this is the only one of Vermeer's paintings that is still on its original strainer and has not been relined, re-stretched, or trimmed.[53] Some other of Vermeer's pictures match each other in dimension; but most of the others stubbornly resist categorization.

However, there is a recurring feature, and that is one of proportion. Very many of them have an almost square shape[54] and Vermeer appears to have mostly liked to paint on a 'portrait' rather than a landscape format.[55] Unsurprisingly maybe, the reasons for this are also a source of debate. Some suggest that Vermeer used standard size canvases,[56] but it could possibly be that the modest dimensions, and the format of some of his mature canvases could have been partly determined by the round projections from a lens.[57]

There are a number of professions whose names we have forgotten now. Do we know what a Knoller did, or a Nob Thatcher? What was a Long Song Seller or a Lumper?[58] We don't need their services these days, so their skills, and their identities, have been consigned to history. There was much excitement when Dutch records of the seventeenth century revealed that there were people who would stretch and prepare canvases to sell to painters, called the Primer (*Primueder*)[59] or the Whitener (*Witter*).[60] However, after making an assumption that Rembrandt might have bought his canvases ready-made from one of these suppliers; researchers got a bit of a surprise. A technical analysis of his famous *Night Watch* showed that not only had he taken the preparation of his canvas into his own hands; he had cut corners, presumably to save a bit of money. There was no pigment in the very first ground layer; instead, they found a layer of river clay or fine sand, ground into oil.[61] The discovery of these 'quartz grounds', unique to Rembrandt's workshop, had serious ramifications. It was necessary to look again at the attributions of some paintings, which had been previously dismissed as being neither by his own hand nor by one of his pupils, and re-assign them as the 'real thing'.[62]

Pierre le Brun, writing a painting treatise in 1635, suggests that the preparation of canvas in the studio was 'the work of the boy'.[63] But what if Vermeer had no apprentice to help around the studio?[64] If he hadn't bought his canvases from a *Witter*, he would have to make an effort, and get on with it himself. He may have prepared them in batches for efficiency: lacing or tacking the linen to the frames as evenly as possible, to ensure that the threads of the warp and weft of the fabric ran parallel to the wood.[65] Then, although linen will shrink, and become much tighter when it is wetted; in order to keep it in a taut, stretched state, he would have to fix it with glue.[66] Size made from animal bone or hide, applied warm to the canvas, served this purpose; and also filled the holes in the weave of the fabric, providing a protective coating from the linoleic acid in the oil paint. Unsized linen will rot, destroying the artwork. Some of the old paintings in museums today that have

been relined, might have escaped restoration, if their makers had been care-
ful to treat the edges of their canvas. As the fabric perishes on the supports,
the front of a picture can drop clean away.[67]

Size can be applied to linen by brush, or by dipping it straight into a bath
of glue and then rubbing it smooth once dry. De Mayerne also suggests
putting the cloth on a slab, and pressing the size into it with the muller nor-
mally used for grinding paint.[68]

The glue is made by extracting the collagen from the bones of animals or
non-oily fish.[69] Vermeer must have learned how to make it up during his
apprenticeship: he might have known to soak *old gloves* to extract glue;[70] or
alternatively he could have followed directions from an artists' handbook.
Cennino Cennini explains how goat glue can be made: 'from the clippings
of muzzles, feet, sinews and many clippings of skin'. He says that this should
be made in March or January 'during the great cold or high winds',[71] not only
so the glue can dry outside in cakes; but presumably also to reduce the whiff
of goat near the house.[72]

Animal size can now be found in processed granules, ready to soak; but it
is still difficult to get the right consistency for coating canvases or boards:
beginners tend to make it too strong, and then the glue gets unevenly
absorbed by the threads in the linen canvas, and dries in ridges on the sur-
face. The test is to take a spoonful out, and let it cool; and vary the dilution
with cold water if it is too strong, and does not easily break apart; or put
'more Glewe to it' if it does not hold its shape. Here, less is truly more: when
the size is weak, the canvas stretches evenly, and remains supple and taut:
drying tight enough to vibrate under the fingers, like a drum. The canvas can
then be rubbed down to reduce its rough surface, and any loose threads of
linen can be cut away.[73]

What might Vermeer have been thinking, as he climbed the stairs up to his
studio, carrying the pan of the dusky size he had warmed on the kitchen fire?
Did he think of the work ahead of him, of the necessity to get down on the
floorboards to cut the linen, and tack or lace it to his strainers? Did he mind
the pungent smell; as he poured out a cup of the sticky glue, seeing it spread
and darken on the linen, before pushing it into the fibres? Did he enjoy the
process and rhythm of this practical preparation more than the other busi-
ness that awaited him: the accounts to check for Maria Thins; the meeting
at the Guild; or the appointment with a prospective client, who might have
to be sweet-talked into buying a picture?

As he propped up the wet, blank canvases, he knew that they would be transformed in the morning: that they would dry tight, light as a teasel; that they would respond like a tambourine when he scraped them with a fingernail. Maybe he wondered what gold he might make out of them, when the promise of his ideas came to fruition; and when each held a new, bright image. Or maybe he was only concerned with the next step of the process: the need now to cover the sized fabric with a smooth gleaming ground; to be ready to receive the touch of his brush.

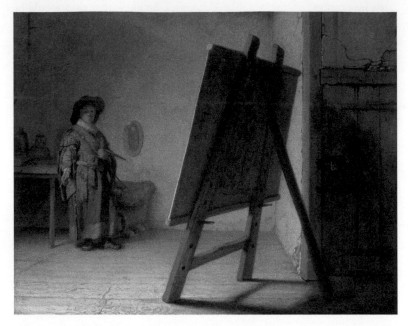

Figure 4.1 Rembrandt van Rijn (1606–1669), *Artist in his Studio*, c.1628. Oil on panel, 24.8 × 31.7 cm. (9¾ × 12½ in.). Museum of Fine Arts, Boston.

4

Working in the Studio

Even in Springtime it is cold in the studio. There are draughts from the windows, and precious little heat coming up through the floorboards from the room beneath. You need warm clothing, so you can forget the chill: a bit like the young man in Rembrandt's picture, all bundled up like a child wearing hand-me-downs, in layers of shapeless clothing. His large dressing gown affair appears a bit odd to us: it is maybe too good to become covered with splashes of paint;[1] but it is a *tabaard*, a practical, warm working gown for a painter, buttoned at the sides, with an open sleeve, to allow his painting arm ample freedom of movement.[2]

Did Vermeer know about the most famous painter of his age up in Amsterdam?[3] It seems possible that he did, as their painting careers overlapped, and as we will see, they both had visitors with common connections.[4] But even though some believe Rembrandt could have taught Vermeer, there is absolutely no evidence to suggest they ever met. We cannot be sure either, whether this is a self-portrait of young Rembrandt, or not. Maybe the model is one of his friends, or even an early pupil?[5] However, what matters more to us, is what this picture can tell us about the conditions and equipment of the painters of the time (Fig. 4.1).

Here, the artist stands some way away from his easel,[6] something we might imagine artists always do; yet we have seen that Vermeer is likely to have painted sitting down, close to his work.[7] There is no convenient stool; but we do see two grooves on the easel where feet appear to have rested.[8] But this artist is surely too young to have had time enough to wear down the crossbar himself. Maybe the easel is an old one, bought second hand?

Ideally a studio would be large enough for a painter to stand back to look at his work; and the 'rough manner' of painting that Rembrandt developed later in his life, meant that his pictures needed distance for them to be appreciated.[9] It is reported that when visitors wanted to get a close view of his

work, he pulled them back by the collar; giving the excuse that the smell of paint would be bothersome.[10] But whether Rembrandt worked standing up is difficult to say, although he must have been on his feet when eventually he had a large workshop to run, putting his own brush on his students' paintings, and offering advice.

What we can say is that this room looks nothing like the picture that Vermeer has shown us of an artist at work. Instead of opulent furnishings, we see a rather work-worn environment. Here, we are behind the scenes, in surroundings that seem more realistic; a place where there is old equipment. There are bottles on the table; palettes on the wall; and a grinding stone, balanced on a wooden log, to bring it up to waist height.

We know that Vermeer's paint-making gear was found in his attic, but we don't know what it looked like. We might feel that as a more meticulous artist than Rembrandt, his grinding stone might have fitted the ideal better than the rather worn version we see here. Was his made from the best materials: the 'white or green marble…cut very even without flawes or holes', as recommended? The advice was that the stone should be of a kind that wears 'very little or nothing, and should last you your lifetime',[11] The one we can see against the wall, with a huge dip in the middle, looks as if it might have outlasted several careers already.

Other items in the room correspond with what we know Vermeer owned himself. He had palettes, and also a table, on which he could have lined up his bottles of oil, if he wanted.

You might think that the oils we use in the kitchen would do for a painter, but they would be useless. Olive and sunflower oil lack the chains of molecules that form strong bonds, which allow them to form a skin.[12] Painters must use 'drying oils', which despite their name, do not actually 'dry' at all: they harden from the outside inwards, reacting chemically with the air to form a solid film, in a process called polymerization.

Just as we see in this picture, painters needed more than one bottle of oil. Linseed oil, from the flax plant, was the most popular option since it dried well; but many artists would also have had poppy or walnut oil at hand, since they yellowed less, and did not discolour white or blue paint so much.[13]

It takes some time for oil paint to become completely cured; although some painters changed the consistency of their oil: accelerating its drying time by heating,[14] or allowing it to stand in the sun.[15] Chemical analysis of the medium in Vermeer's paint showed that he sometimes did this, possibly because using heated oil can also make the paint glossier and more transparent: which is especially good for glazes.[16]

But before ever Vermeer could start to put paint on his palette or even pick up a brush; he had to cover his sized, stretched canvas with a layer or two of *ground*. This would fill in any gaps left in the weave of the canvas. Illusionistic effects were much valued by the Dutch; and if Vermeer had a smooth surface on which to work, then the viewer would be more likely to forget they were seeing cloth and paint, and believe his image to be true.[17]

He could choose what colour this first layer of the canvas should be. Some painters used a mid-toned ground, and then started their picture with one dark paint and one light; while some started with a dark ground and worked upwards towards lightness.[18] But Vermeer seems to have preferred to work on something that was just less than the brightness of pure white.

His grounds all seem to be very slightly different: 'mostly pale in tone, many different shades of gray [*sic*], some warm, some cool, and occasionally a reddish brown in colour…in only a few grounds were chalk and lead white found on their own.'[19] Since there is no standardization here, it suggests that Vermeer could have prepared his paint himself: adding some dregs of paint he found at the bottom of the pot in which he kept his brushes, or some old scrapings from his palette, to slightly colour the chalk and lead white under his grinding stone.[20] However, he may have preferred to start afresh, and not use something that might cause problems if the constituents happened to be incompatible; or that would tint his paint randomly.[21] In which case, he could go slowly, throwing in a pinch of this and that dry earth pigment as he worked, to reduce the glare from a plain white ground.

The light bases in Vermeer's work may contribute to the feeling of heightened illumination we find in his pictures; but possibly, they could also have had a practical purpose, and provided the best contrast to a projection inside a camera obscura.[22]

The majority of his grounds are made just of a single layer of paint, but there are seven which have double layers.[23] Why would Vermeer put two layers down onto his sized canvas? Generally this was a way of saving money: the first layer was made from cheap, quick-drying earth pigments, which would fill the gaps in the weave of the canvas; and then a thinner layer was put over this, in a another colour that suited the painter, but which might have been more expensive. It could be that Vermeer did buy some canvases from a *Witter*, who had not only put a glue size on the canvas, but a priming layer too. Then, maybe finding the surface too rough, or the wrong colour, Vermeer adjusted it to his purpose.

We do not know if Vermeer ground his own paint before each session in his studio, or whether he hired an assistant. Charles Beale, remarked in his

accounts that it was 'moiling work', and employed someone to help him.[24] Could Vermeer have done the same? He would have to choose carefully, as it was a job that required experience. Indeed, where we might expect to see young apprentices in paintings of artists' studios of the time, more often there are 'mature figures', busy working away in the background instead.[25] If there was no help like this available to Vermeer, then maybe making paint up, when it was needed in quantity for a *ground*, was something to do one morning, when the light was bad, or business downstairs was slack. It was good to keep up a supply of canvases ready prepared, because each took at least three months to dry completely.

Vermeer's pigments were brought into his studio in different states. Some arrived as fine powders, like lamp black, but those in lumps, like the earth colours, were put in a pestle and mortar in the studio, and pulverized, and could be further refined by washing and drying, before grinding in oil.[26] When pigments are ground into glue or egg, they appear lighter in tone than when they are ground in oil, because the surface of the paint is rougher and it scatters the light. In oil, the surface of each grain becomes coated all over with something smooth and transparent; and, rather like seeing a pebble under water, the colours are given greater depth. One of the early users of oil paint, the Flemish artist, Jan Van Eyck (1390–1441), appears to have been so skilled with his materials, that he was able to take advantage of the size of the pigment grain too, layering his colours fine over coarse, to increase the brilliance of his pictures.[27]

To make oil paint, the pigment has to be incorporated into the oil against two surfaces, both equally hard; and so the artist needs something to use in his hand against the grinding stone. A muller is not visible in Rembrandt's picture, but in his time it was commonly made of stone, cut in a rough, tapered pyramid with a flat bottom: tall enough to hold with two hands if necessary, to put pressure on the paint when grinding. A spoonful of pigment was put down on the stone, and a small well was made in the centre of the powder to receive a little oil. First, the artist mixed them both together with a palette knife; and then, when all the dry pigment had disappeared, the paste was ground under the muller. As the painter worked, more oil was added a drop at a time; and the grinding continued, round and round, until each pigment particle was coated, and the paint was as smooth as possible, and malleable enough to use (Fig. 4.2).

The paint was taken off the grinding stone with either a knife, or a short piece of wood or horn called a 'voider'; and then everything could be cleaned ready for the next colour to be made. Bran,[28] leather shavings, and bread-

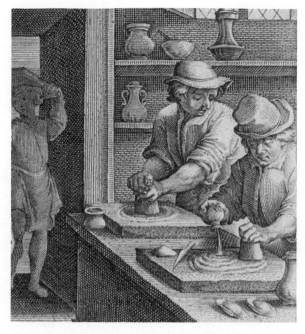

Figure 4.2 Johannes Stradanus (1597), *Color Olivi* (detail). Engraving. Bodleian Library, Oxford.

crumbs[29] were all used for this, as they would absorb the oily remnants of paint; but if harsher cleaning was needed, then the stone could be rubbed with a pumice stone and water;[30] or fine dry ashes or sand[31] could be used to scour the surface.

The paint itself needed to be put into a little container, and many treatises recommended using mussel shells in the studio. We might imagine these would be quite small, like those we see bound up in string bags, on the fish counter. But painters looked also for 'your great muscle shells... commonly called horse muscels' which were 'the best for keeping colours', and which were found 'in July about river sides'[32] (Fig. 4.3).

To put a layer of ground on a canvas the size of the *Girl with a Pearl Earring* (Fig. 5.1), which is 44.5 × 39 cm., Vermeer would have needed a volume of pigment about the size of a tennis ball, with a similar volume of oil. He then needed something to push the paint he had made into the sized canvas, to produce a smooth surface with as few marks as possible. Although a big flat palette knife might leave only a few trails, there is more purchase to

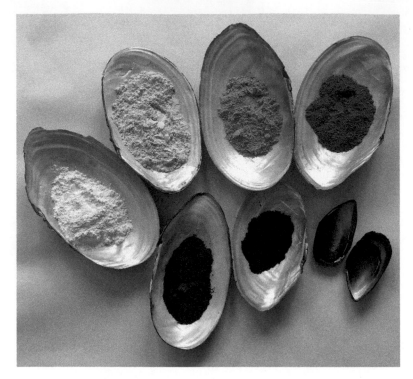

Figure 4.3 Pigments suitable for a *ground*, in great freshwater mussel shells. Top row: lead white, chalk, yellow ochre, red ochre. Second row: burnt umber, bone black. In seawater mussel shells: linseed oil, walnut oil. Freshwater mussel shells courtesy of Lord and Lady Saye and Sele, Broughton Castle, Oxfordshire.

be had from the sharp arc of a cuttlebone,[33] or the edge of a large curved knife; like the one whose terrifying dimensions are illustrated in de Mayerne's manuscript (Fig. 4.4).

The paint for the *ground* was made of a mixture of pigments under the muller (Fig. 4.3). But after that, Vermeer did not combine his colours on the grinding stone; and made few mixtures even on his palette, apart from flesh tones. Mixing tended to dull the colours and he had few enough bright ones as it was.

Like other artists of his time, he worked in a premeditated way. He wanted to keep his expensive colours pure and bright; and the way to do so was not to let them get anywhere near the dull cheap ones; so he would have used a particular palette for particular ranges of colours; and each for a different stage of work.[34] He would have been careful to clean his grinding

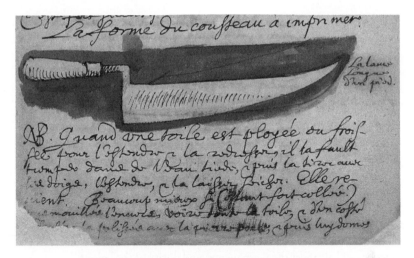

Figure 4.4 The *de Mayerne Manuscript* (B.M. Sloane 2052). 1620–1646. Priming knife, about 30-cm long. British Library, London.

stone, and may have kept his brushes away from each other; there is a contemporary suggestion that those for blue pigments should not be used for anything else.[35]

In the Volpato Manuscript, Sylvio asks 'F' how to prepare the master's palette at the beginning of the day. The answer is that '…it is sufficient for him to tell me what he is going to paint, for I know what colours I ought to put on the palette'.[36]

The apprentices would never have ground every pigment their master would ever use on his picture, before each painting session. The painter's method of working in stages, in the seventeenth century, meant that he only needed a few colours at a time; and would wait for the paint to dry between one layer and the next.

What of the painter's palette? Medieval illustrations of painters show their colours arranged on a piece of wood, shaped much like a breadboard, with a little handle at one end.[37] Someone eventually had the bright idea of adding a thumbhole, and palettes became curvier, and thinner.[38] Those hanging on Rembrandt's studio wall lack the bite out of the side, which became common two centuries later, carved out to allow the artist to hold it closer to the body. They also seem surprisingly small. But this is because they did not need to hold very many colours at once, and because the artists would not have done very much mixing. If we include the one this painter is holding (Fig. 4.1), we see he had three of them: just like Vermeer.[39]

The paints Vermeer made himself were rather different from those commonly available in art shops now. Modern manufacturing processes grind the pigment and oil very evenly and very fine, so it is unlikely to reflect light back in the same way as paint made traditionally by hand.[40] The paints you can buy off the shelf today differ in another way too, because they contain additives; partly to make them homogeneous, and partly for reasons of economy.[41] Paint needs to be the right consistency to squeeze out of the tube properly; and so compromises have been made.

Then, you may not realize it, but if you buy a 'student' colour you will inevitably have a product with proportionally less pigment, and much more filler than the more expensive 'artist's' paint. It is likely also to include a swelling agent, or a metallic soap to make the oil 'gel' better. Sometimes the paint is pre-mixed with two or more pigments; some paints have dye in them to make them more intense; and some are diluted to extend them. These commercial practices will all affect the permanence, and purity of the colour.[42]

The upside of this modern technology is that now you can work with paints that are intermixable, that are mostly the same consistency, and that will probably last. The downside is that however much you try, even if you have a touch of genius, your own painting will never have the depth we see in Vermeer's work. Not only did he enhance his colour intensity by overlaying one with another; the paint he used had a good quantity of pure pigment in it to start with, and not much else, apart from oil.

There is nothing in Rembrandt's picture to tell us how painters stored their paint, but this was a major concern at the time. If a blob of paint was just left on the palette until the next painting session, then it would harden, forming a skin. It might be possible to cut this away, leaving soft useable paint underneath, but it might all have solidified. Rembrandt actually found a use for such dried skins, clearly seen as contributing to the textural effect on the sleeve of the man in his famous *Jewish Bride*. However, leaving paint out for long on the palette was not good practice. It might ruin the wooden surface, and any pigment left in the grain of the wood might stain new paint put on top of it.

If the artist wanted to preserve his spare paint, there were only a few ways to do so, complicated by the fact that some colours were unstable and could fade or blacken. He could put his excess paint in a small pot and cover it with oiled fabric, or he could put certain colours under oil or water,[43] to keep out the air.

In the absence of anything as miraculous as a plastic bag to wrap up excess paint, the only other option for Vermeer was to send someone out to buy a pig's bladder from the butchers; or if none could be found there, then to use one he had stored previously in the barrel in the cellar. Pigs' bladders were

the best airtight container available in the seventeenth century, and you would be pleased to find one.

It is difficult to discover how bladders were used by artists in the past. Not much written information has been left behind, maybe because it was so obvious at the time. However, a certain John Smith of London, who was more of a decorator than artist by trade, gives down-to-earth advice in his book written between 1672 and 1680. He explains that if you intended to grind a lot of paint at once, 'as some do', then, if it was 'tied close' in a bladder it could keep for a long time.[44]

Pigs are slaughtered at a younger age today than they were in Vermeer's time, and so it is likely that the bladders available to him were larger and easier to fill than those found now. The season for killing pigs in Europe was in November and December, when the animals had fattened up through the summer and autumn. The meat was then conserved by pickling or smoking, so it could be used at intervals throughout the year.

An artist in The Hague, called not inappropriately van Beest, seems to have specialized in paintings of pig markets. In one of these pictures, now in the Bredius Museum in The Hague, rather grand ladies are shown viewing the source of their winter meat, as it lies trussed on the ground ready for inspection. The expressions on the fat pigs appear beatific. Little are they aware that they are doomed for the chop.

Once the pig was slaughtered, nothing was wasted, as every part of it could be consumed: the meat, entrails, knuckles, ears, tongue, tail, and blood.[45] Large cuts, such as the hams and shoulders were smoked in the chimney, but smaller, softer parts were pickled in jars with a brine made by adding salt to water so it was 'strong enough to bear an egg';[46] or packed in barrels between layers of salt. The process of conserving pork in this way could be a communal activity for those less wealthy, where the effort and the outcome could be shared.[47]

The bladder was the one part of the pig put aside for more trivial use. Stretched across a crockery pot, it provided timbre for a very basic music instrument called a 'rommel pot'. With the addition of a stick pushed through the centre, this was played by children, and also by beggars. There are several paintings of the time showing these;[48] and also some pictures of children next to a pig's carcass, blowing up a bladder to use as a balloon.[49]

Inflated pigs' bladders have a long history of being used for sport too, providing the 'inner tube' inside footballs up until the middle of the twentieth century. If you want to see one used in yet another playful way today, then find a Morris dance company performing in England in the summer months. The 'Fool' carries a bladder balloon on a stick, ready to whack those dancers whose performance he thinks is not up to scratch.[50]

Working with pigs' bladders sounds very off-putting; and it is true that however much you wash them, they still smell of urine. However, filling them with paint is no worse a task than skinning and gutting a fish; the strange thing is the contrast between the texture of the bladder: slimy, soft, and stretchy; and that of the paint, which is oily and resistant to water.

Once filled, the bladders can be tightly bound, and hung up with string. This shrinks tight as the bladder dries, forming a close seal, which cannot be undone.

When a previously pickled bladder is first filled and hung up, it is wet, and beaded with water. Then the water evaporates, and the bladder appears encrusted with salt from the briny mixture. As the oil slowly migrates from the paint through the skin, it seals everything up; and as it dries out, the bladder transforms itself slowly into a leathery pouch: something not nearly as repellent as when it was fresh.(Figs 4.5a and 4.5b). Tinted by the pigment, the exterior changes colour, and slowly becomes hard; but the paint remains soft inside and can be kept like this for quite some time.[51] However, there is a possibility that the paint may not have quite the same properties as when freshly ground, because it may have retained some of the salt from the brine.

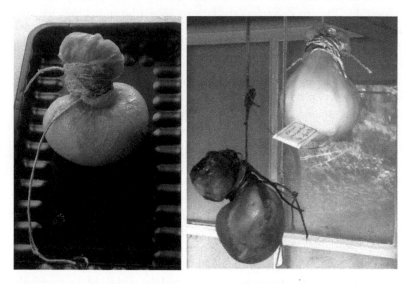

Figure 4.5a & 4.5b Fresh pickled pig's bladder filled with lead white oil paint. The same bladder, on the top right, a month after being filled. The skin has hardened, and has leached salt. The smaller bladder, hanging lower down, was filled with burnt umber, and the skin has turned brown.

Old samples of oil paint have been found to contain salt, which puzzled conservators. Now we have a clue as to where this could have come from.[52]

When large amounts of paint were prepared at once; or when valuable colours, surplus to requirements, needed to be kept; bladders would have been particularly useful for storage. They could be pierced and then resealed with an ivory tack, allowing small amounts to be squeezed out as required; although sometimes the bladders burst, and then all the paint had to be used immediately, or put into a new bladder, in the hope it all might work better next time.

Other kinds of pastes could be stored in bladders too. A painting by David Teniers the Younger (1610–1690) (Fig. 4.6) depicts one of the five senses, in this case, 'Feeling'. A man winces as he removes a dressing from a wound on his hand, while the woman prepares a clean cloth over some glowing coals. Behind the figures, at the back of the room, are some bladders hanging off the shelf. We can only hope that the unguents inside did more good than harm.

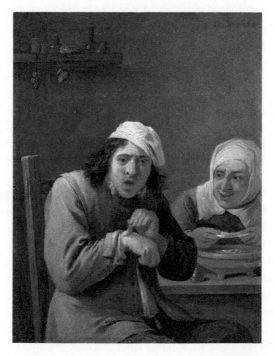

Figure 4.6 David Teniers the Younger (1610–1690), *The Five Senses: Feeling*, c.1640. Oil on copper, 21.8 × 16.5 cm. Harold Samuel Collection, London.

Whether Vermeer split open some bladders of paint he had prepared earl-
ier, or whether he made paint up afresh; he would have recognized the dif-
ference in his canvas, once he had covered it with a *ground*. Its timbre, now
muffled under the heaviness of lead, changed from the lightness of a respon-
sive, scratchy, candyfloss surface, to something altogether much weightier
and more resistant. Once dry, this newly sealed surface gave his brush an
uninterrupted passage along its smoothness, and meant also that marks
could be wiped off it with an oily rag.[53]

Now, the only thing Vermeer needed, were brushes.

The young artist in Rembrandt's painting would have been taught to have
a clean brush at the ready, but painters needed a variety of qualities and
sizes; and it was suggested that they 'should continually have new brushes',
because of the risk of dirty ones ruining work.[54] We don't know if Vermeer
would have managed that expense; or what most of his brushes were made
from. Were they from the tails of squirrel,[55] weasel, badger, otter,[56] or min-
iver? From the ears of oxen or from the hair of bear?[57] Brushes can be resist-
ant and springy, others very pliable; dependent on their length and the kind
of hair that is used. Particular materials were good for one purpose, but not
for another: you would not apply a highlight, and a layer of glaze, with the
same implement. A highlight needs a brush that will transfer a small thick
blob from palette to canvas; while a glaze needs one that can hold a reservoir
of thin paint, which can be spread out evenly.

Some are fixated on the idea that Vermeer painted using only very fine
brushes, because they imagine that he is a painter of detail; but if you look at
his pictures closely, they are much more abstract than you imagine, and have
a great variation in brushwork. His painting *Mistress and Maid* (Fig. 4.7)
shows us this.

Here are rough blobs of paint, dabbed on to give us the impression of
curled ringlets in the mistress's hair. We see these golden dabs as individual
strokes, which must have been made with a different size brush from the one
that created the glittering decoration around her chignon. We see a vari-
ation of movements of Vermeer's hand: here some small dabs on her yellow
silk coat; there, bigger spots of thicker paint, to indicate the pearls at her
throat. Yet Vermeer avoids hardening her features, never quite going close
enough to any edge to call it a line; and paints her hands and arms softly,
without leaving a trace of a brush. He enjoys the variations in texture he can
make with his choice of brushes that hold different densities of paint.

The blue tablecloth looks thin, and the paint here is more transparent,
possibly put on with a wide brush in lower layers. We have the impression
that this is a rougher fabric than the woman's silk and satin: something

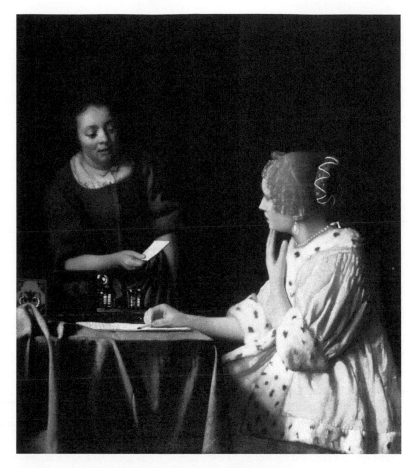

Figure 4.7 Johannes Vermeer (1632–1675), *Mistress and Maid*, c.1666–1667. Oil on canvas, 90.2 × 78.7 cm. The Frick Collection, New York.

almost as coarse as the clothes of the maid who hands the woman her letter. We see the rhythm of the folds of cloth, and see the reflected vertical and horizontal gestures of the two women; but we become fixed on the tension in the empty dark space between their faces, as a message is delivered.

If you browse through books about Vermeer in the library or bookshops, you will see some surprising differences. You might expect a variation in the quality of the colour reproductions of his paintings, but not that their measurements do not always remain the same: there can only be a few good reasons for this.[58] But there is an answer as to why paintings in one book,

hailed as masterpieces, are completely absent in others. This is because the different experts writing the books vary in their views as to which paintings should be attributed to Vermeer.

In the enthusiasm since his rediscovery in the nineteenth century, the number of works identified as being by his hand has fluctuated wildly; not helped by the fact that there were actually two other painters called Jan Vermeer, one living in Haarlem (1630–1695/97) and the other in Utrecht (1628–1691).[59] To add to this confusion, if you read the diary of the Englishman John Ray, who travelled to Delft in 1663, you discover with rising excitement that he visited a man he called 'Jean vander Meer'.[60] We are let down to discover that this man was an apothecary, who showed Ray some of his collection of curiosities.[61] *Van de Meer*, means 'of the lake', and it is no surprise that such a watery name was common in Holland.

The contention over *The Girl with a Red Hat* (Fig. 4.8) is not to do with which of these several Vermeers might have painted it; rather, whether it was even painted in the seventeenth century at all. Some, while acknowledging its attractions, and its popularity, complain about the 'snapshot' quality of the image; the fact that it is painted on board; and believe it to be a painting 'inspired' by Vermeer, but made in the eighteenth century.[62] Others see it as 'exquisite in its compositional and psychological effects' and undoubtedly by Vermeer'.[63] We can decide for ourselves whether it appeals to us; whether it is a masterpiece or not. Would we mind having this little picture hanging above our piano?[64] None was as lucky as Andrew W. Mellon, who had it propped above his, before he bequeathed it to the National Gallery of Art in Washington.

As we peer into the shadows under her flamboyant hat, we are held back by the *Girl's* casual, almost dismissive glance, and then transfixed by a single bright green highlight on her right eye. Vermeer has used his colour in surprising ways, giving us bright ochre highlights on a deep blue coat, maybe to indicate shot silk damask; maybe to show in distinct thick strokes, that this is not fabric, but paint after all. He chose from his handful of brushes; he scumbled in the shadows, with thin glazes; and trailed burnt umber and indigo over the patterned background, using the width of his narrow brush to meander to and fro. He enjoyed the wooden lion's heads on the chair knobs: he let his brush dart around, to show us just how the carvings appear in the crystalline light; he played with the folds of the *Girl's* cravat; scraping back the white paint with a blunt instrument. In some places we see divisions, at others, nothing is certain. Where does her chin end? Where is the back of her neck? Some things are left unsaid: they are unnecessary.

We may only be partly aware of the shorthand of Vermeer's brush, as we take in the scumbles, the shimmering edges, and the dots of paint; but still,

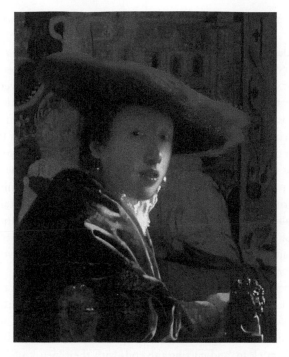

Figure 4.8 Johannes Vermeer (1632–1675), *The Girl with a Red Hat*, c.1665–1667. Oil on panel, 23.2 × 18.1 cm. National Gallery of Art, Washington.

we look beyond them; and believe in the moment he has captured. We believe in the heavy fluidity of the Girl's coat; the depths of her feather hat; the wetness of her lip; and the softness of her young face.

Whatever its size, a good brush should balance in the hand like a violin bow. An experienced painter will feel the weight of the handle; and judge where he should hold it, and how he should move his arm. He can use the force from a turn of a wrist, or the pressure of a finger, to change the direction, depth, and speed of the stroke, as he feels the response of the thicknesses and texture of the paint against the canvas.[65] The brush movement is as much part of the painting as the colour, tone, or composition; and in some cases, especially from the twentieth century onwards, becomes the subject of the picture itself.[66]

Like flies in amber, stray brush-hairs have been caught in the paint in some of Vermeer's paintings. There are hair fragments on the surface of the *View of Delft*, shed from the brush used to paint reflections in the water;

and a few fine, brown hairs on the face of the *Girl with a Pearl Earring* (Fig. 5.1).[67] The National Gallery in London discovered broken and bent hog's bristles in other pictures of his, including *The Music Lesson* (Fig. 8.5), and conservators wondered whether Vermeer had used old or poor quality brushes; or whether these had shed hair because of the way they were made.[68]

We have to be reminded that perfection in painting can be achieved without the most durable materials or implements. Artists can become attached to particular brushes, because they know how they will work for them; and the quality of bristles can actually improve with age or use. One painter suggested that old brushes were better than new, as the hairs of the new ones 'tend to separate into tufts when they touch the colours'.[69] Cennini recommended brushes that had been used for painting walls should be taken apart, and the hair rebound onto small sticks of 'maple, larch or chestnut' to make brushes for pictures.[70] 'Split ends' in our own hair may be something that shampoo adverts claim to be undesirable, but at the tip of a favourite hog hair paintbrush, they lead to an improvement in performance.

There were two traditional methods of making a brush: either the animal hairs were lashed to a stick by binding and gluing, or they were inserted into the quill of a feather first, and then attached to a stick. Quills were commonly used to make dip pens; and people were used to handling them, reaming them clean, and cutting the ends with their 'pen-knife'. For pens, the quills had to be selected for 'handedness': the right-hand wing feathers of a goose curved the correct way for a right-handed person. But for brushes, only a part of the quill was used. These had to be soaked; and once filled with hair, they were tied onto the handles with wire, to shrink tight onto the wood as they dried.[71] The quills used for brushes were generally those of water birds, whose feathers had resistance to wet: such as ducks, swans, or geese; but there are also references to the quills of crows and swallows.[72] For stiffer, bound brushes, the recommendation was to use hog's bristles, which Cennini insisted must be taken from the white pig, rather than the black.[73]

Interestingly enough, although all the brushes made like this would perforce be round in shape; there is a clue that there were larger ones available in the late 1660s, made using manufactured tubes. The hairs were inserted into 'Tinncases... bigger than Quills'.[74] Were these an early version of metal ferrules?[75] It would surely not be long before someone thought of pressing the end, to produce a flat brush with a round handle.[76]

To keep their brushes in perfect condition, painters would have been anxious to keep them away from the destructive power of the moth. The remedy was to pass them quickly through a candle flame;[77] keep them in a ball of

kneaded clay until use;[78] or put them in strong-smelling plant materials, such as hops, 'bitter herbs', or tobacco dust, which the insects did not like.[79]

In a manuscript written in the late 1550s, there are illustrations of hand-bound brushes for decorating pottery, which look identical to some still sold today. However, the modern equivalents are not likely to include some kinds of hairs used then, for finer work, which came from rat or mouse whiskers.[80]

There are records of families in the business of supplying artists with materials in the seventeenth century; and of Delft painters as customers.[81] Many brushes were needed in the pottery factories; and Vermeer could have purchased some for painting, rather than making them himself.[82] He may have chosen them, just as suggested, by their 'fatness in the quills', or by the quality of 'their sharp points'.[83] The advice at the time was that you should wet them in the mouth, try surreptitiously to 'draw a line with it on the back of your hand', and discard those brushes that spread out, or that had 'extravagant hairs (sticking) out of the sides'.[84] So it appears nothing much has changed there.

Every artist now also knows how disastrous it is not to clean up immediately after painting. Brushes can become thick with dry paint; or clogged with the dirty remnants at the bottom of the jar, and bent permanently out of shape. Painters would have been warned about not taking enough care of their brushes, and perhaps would have followed instructions similar to this: 'You must have a Tin-Pan…divided in the middle…and striking (the brushes) several times over the partition… pressing them with your Fingers, till they be clean, (dip) them into Sallad Oyle which best preserves (them) from drying…lay them on a ledge.'[85] Then if the brushes do go hard, you can 'lay them in Soap sometime and with water scour the colours out of them'. Lastly, in order to avoid the hairs 'spreading out like mushrooms', they can be bound with string,[86] to make them dry straight.

If contemporary information about paintbrushes is difficult to find; there is even less written about the painter's stick or mahlstick,[87] which nevertheless, seems to have been standard equipment. These may have been easier to use when sitting, than standing; and provided a support for the brush when a steady hand was needed. There is a recommendation that this be made from wood that 'will not easily bend, about a yard in length'[88] (a little less than a metre); although another source suggests 'bamboo, or some other stick that is light and yielding to the hand', which should be longer, at about 120 cm. One end needed to be covered with a soft ball of some kind, the size of a chestnut, covered with a piece of cloth or leather. Then it could rest on the edge, or the surface of the painting (only where it was dry), without leaving a mark.

We can be reasonably sure that Vermeer used a mahlstick. The probate clerk possibly did not recognize the purpose of the *cane with ivory handle*, found in the upstairs room after his death; and the artist in *The Art of Painting* (Fig. 1.4) leans against a mahlstick as he works. However, Vermeer is not generous with information thereafter. In the painter's hand we can just see a round brush, perhaps tied with string; but his palette and his colours are kept completely out of sight.

In contrast, Aert de Gelder, shows himself working cheerfully on a portrait, surrounded by the various painting accessories that we have come to understand he needs (Fig. 4.9). His canvas appears laced to the frame; he is wearing a painter's smock; he has little pots for paint and oil, and a large handful of brushes. He is even wiping his brush on a metal container, to clean the bristles.

In company with many other artists who painted themselves, he shows a palette fully loaded with a complete set of colours. But this does not reflect the documented painting practice of the time, or the scientific analysis of the structure of paint layers; which suggests he would not have had so many paints on his palette at once. The explanation must be that he wanted the viewer to see the extent of his craft; and so every time he used a colour in the painting, he added it to his painted palette in the picture.[89]

We can see already, that the speed at which painters worked depended on their materials. It took time to stretch and size a canvas, and cover it with a ground; it took even longer for it to dry. If you had pupils, then you could move things along a bit by getting them to grind paint for you, and put it in bladders ready for use. They could also regularly stretch and prime canvases,[90] so there could always be a dry one in the studio, ready and waiting.

Working on his own, Vermeer could not really operate as efficiently as a workshop. He might have prepared several canvases at once; at intervals, he may have filled bladders with lead white paint, to have a good quantity ready when he needed to knife on a ground; but unless he was going to use the complete contents of a bladder all at once, he may not have wanted to store other colours in them, because it would be wasteful if they didn't last. An ivory pin was not nearly as good a seal as the screw tops we have now at the end of our paint tubes: he could never be certain the paint in the bladder was going to be usable.[91]

However, with only about five colours on his palette at a time, we can perhaps imagine Vermeer working for an hour or so, grinding each pigment into oil, before he began his day's painting. He may have preferred to make up small quantities of paint as he needed it; and stretch his canvas only when he knew exactly what size he wanted.

Like other artists of his time, Vermeer painted in stages; so he had to wait for one layer to dry before starting on the next. This meant that unless he

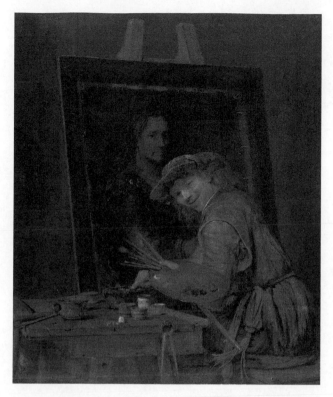

Figure 4.9 Aert de Gelder (1645–1727), *Self-Portrait as Zeuxis, who portrays an ugly old woman* (detail), 1685. Oil on canvas, 141.5 × 167.3 cm. Städel Museum, Frankfurt.

was working on more than one picture at a time, it might be a while before he used some of the same colours again. Once his painting session was finished, he might not have worried too much about cheap pigments, and just put this paint in little pigment jars, hoping that when he removed the cover, that it was still soft.[92] But for valuable colours, Vermeer might have been careful not to prepare too much in the first place, and hope he had enough for the day and no more.

Maybe, sometimes he had to stop work, not when the light went, but when there was nothing left to scrape up from his palette.

Vermeer does not give us many clues about how he made his masterpieces: he is not generous enough even to show us how he laid out his paint. But it is certain that whatever he did, he needed patience. From now on, waiting was part of the painting game. He had to go slowly: stage by stage, and layer by layer.

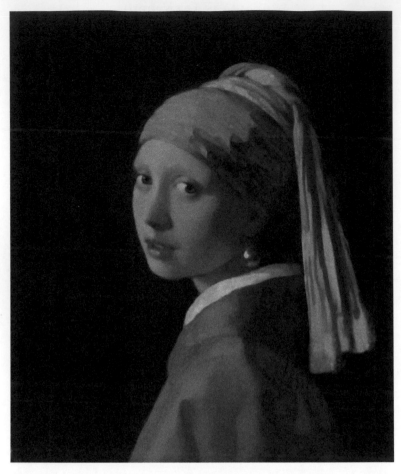

Figure 5.1 Johannes Vermeer (1632–1675), *Girl with a Pearl Earring*, c.1665–1667. Oil on canvas, 44.5 × 39 cm. Mauritshuis, The Hague.

5

Layers and Layers

We do not know the name Vermeer gave to his small picture, now known as the *Girl with a Pearl Earring*. Although we might imagine that its destination was the hall of a rich patron, it could be that it was one of the paintings that the probate clerk found hanging in the interior kitchen of the Oude Langendijk in 1676, and which he listed as a *'tronie........ painted in the Turkish fashion'*. This was a description for a general study of a character, rather than a portrait; but it seems almost certain that Vermeer worked directly from observation.[1] The exotic turban the girl wears, fashionable at the time, means that we can tentatively identify this painting as one that appeared at an auction in May 1696, selling for 36 guilders.[2]

Almost two centuries later, still *'uncommonly artful'*, but now obscured by dirt, and only recognized by professional eyes; it was knocked down for just 2 guilders 30 cents at an auction in The Hague. The buyer, a collector called Arnoldus des Tombe, made an agreement with the only other interested party not to compete, and so his was the sole bid. The unknown seller may not have gained much from the disposal of his asset, but the benefit became public. Once the painting was cleaned and the full import of the purchase was revealed, des Tombe lent his newly authenticated Vermeer to the Mauritshuis, and bequeathed it to the collection after his death. It has been there ever since.[3]

Now beyond price, and recognized beyond boundaries, this image needs no explanation.[4] Critics talk of the girl's beauty, her presence and poise, and the quality of her mesmerizing gaze. They discuss whether the great pearl in her ear is a symbol of purity or vanity.[5] They are lavish in their use of adjectives, talking of freshness, radiance, and sensuality; of poignancy, piercing reproach, and regret, all at once.[6] Is the girl an innocent, or do her parted lips convey immodesty? Is she a portrait after all, possibly one made for a marriage?[7] Could she be one of Vermeer's daughters; or is she just a pretty kitchen maid?[8]

While responses to this picture vary enormously, this image seems to have the power to appeal directly to observers, making their experience of viewing a personal one. The scale of the girl approaches natural size, and so we are forced to stand back to view her.[9] Then we are at a distance that is similar to that when we look in a mirror. Is it possible that we subconsciously overlay our own emotions onto the girl in the picture, and invent feelings for her?

We have to leave such discussions to the art experts, and let them wrangle over the meaning and significance of this masterpiece. We are concerned here with the physicality of this picture, made not, as one admirer fancifully put it, from 'the dust of crushed pearls',[10] but from linen stretched on wood, covered with paint.

However, we might find it an effort to consider it this way. Each time we look, the *Girl* appears to respond, turning towards us expectantly. She seems to be real, and yet she is painted. She is a living, breathing girl; she is a flat image on a canvas, made more than 350 years ago. We can hardly process this duality, to understand the contradiction of how she can be made of dust, oil, earth, and beetle, when she appears before us so vividly; as if about to speak.

It is possible that Vermeer did not want to reveal either the effort or the substance that had a part in the making of his pictures; but his pleasure of paint is still evident. We see it in the broad strokes of the girl's blue turban, applied one over the other while the paint was still wet;[11] in the glint of moistness on her lips and eyes; and in the thick dab of white on the highlight of the pearl. We feel that he must have appreciated his materials in a way that is shared by those who dig and who grow, who know the smell of earth, and the feel of dirt on their fingers. They also have a sensibility for light, colour, and warmth; they share the painter's intimacy with earths and minerals, and the uncertainty about the outcome of their work. It looks as if Vermeer enjoyed the tactile pleasures of the artist; as the pigment and oil were ground against stone; as the paint was scraped together with the knife, and pushed onto a canvas, with the bristles of the brush.

We will never find out exactly how Vermeer made this extraordinary picture. We will never be sure where he found his model, and arranged the pose; why he chose this particular costume; or how in the end, he made the girl so compelling. To some, even trying to come up with any kind of explanation is irrelevant anyway: to them it is only how the painting makes them feel that counts.[12]

However, if we would like any sort of answer at all, it is maybe helpful at the start to think of art like cuisine; and compare Vermeer to a Michelin

starred chef. We know that in our own hands, even with step-by-step instructions, identical ingredients would never allow us to produce the results he achieved. But still, we might like to see the recipe.

We do know that the constituents of this most extraordinary of paintings are commonplace; that the materials: the pigments and the binder, the canvas and the strainer, are unremarkable; and much the same as those used by Vermeer's contemporaries. Moreover, scientific analysis has shown that he conformed to the practice of his day, by applying his paint in stages, as all artists did then; taking his time to allow one layer of paint to dry before applying the next. He could not put on paint in any order, not only because of the incompatibility of some pigments, but also because he had to use his materials in the most economical way possible. Also, he had to think in advance of the optical mixtures he might make, by applying one colour over another. We can maybe imagine silky veils of paint making up the image of the *Girl with a Pearl Earring*; but because she has such a powerful presence, we may not realize how materially micron-thin she is: made from only four layers of paint in all.[13]

She appears on a canvas that has been examined minutely, right down to the very first layers of ground on the linen.[14] But this meticulous analysis of Vermeer's work leads to no universal agreement about the way he would have gone about his painting, or precisely what materials he used.[15] It is as if everyone is concerned with their own tiny part of the puzzle; but as yet, no one has been able to complete the jigsaw.

Let us imagine Vermeer, upstairs in the morning light, free from distractions and ready to work. Before him is his new, dry, perfectly prepared canvas, smelling sweetly of new linen and linseed oil. It springs from his hand, taut and silk-smooth, as it glimmers palely on the easel. He takes up his brush; he loads it with paint; but, at the very moment he is about to start work, the door slams shut. Winded by the gust, we are left abruptly in the dark.

We can have no idea exactly what happened next: we have to feel our way forwards cautiously, and stitch the evidence together piece by piece: relying on technical reports; the eyes of the experts; and our own common sense.

The *Girl with a Pearl Earring* was painted on a small piece of fine linen, tacked with little nails to a wooden frame; made for appreciation at close quarters. The original tacking edges of the canvas are still present on all sides; and the *ground* extends over the top, left, and bottom edges.[16] This suggests that Vermeer may have cut a previously sized and primed cloth

from a larger piece of linen to put on to a strainer size that suited him; and only then did he start working on the picture itself.[17]

Scientific investigation has allowed us to see something of the direction and force of the priming knife, dragged first along the top 'from right to left...and then down along the back edge', spreading the *ground* 'in large arcs' over the canvas, leaving little trails of paint on the surface; but there is still debate about the exact composition of this creamy white paint.[18] It appears to be made mostly of lead white and chalk; with a small quantity of either ochre, umber, or black. It seems it is not possible to be certain of the proportions of these pigments, but the earths and blacks were probably added in small amounts to reduce the glare of the white; and to make colour balances easier. The light colour Vermeer chose for his *ground* exerts an influence in the final appearance of this work, because some areas of paint are applied only thinly on top of it.

Once the *ground* was completely dry, Vermeer could start his *inventing*: the laying out of his picture. This he did in just one colour, using a dark paint to establish the composition. He probably did not need to use a palette for this first stage of painting, as the quantity of paint was so small: he could just poke his brush into a little thumb-pot of paint; or he could take the paint straight off the grinding stone.

So far, we might think that there is nothing out of the ordinary here. However, back in 1950, the art historian Lawrence Gowing examined an X-ray of the *Girl with the Pearl Earring*. What he could see astonished him. Unlike any other Dutch painter of his time, Vermeer had started this picture without using any lines. Instead, there were just sharply contrasting dark and light shapes (Fig. 5.2).

Marvelling at the strangeness of this image, Gowing came to the conclusion that Vermeer had painted his first layers in white onto a dark ground, but we now know it is the opposite. Over a creamy coloured base, Vermeer applied a dark underpaint, which appears to correspond very closely with the final image. In other words, this first layer is not a sketchy outline; but a tonal map of his entire composition, which most unusually, is composed of shapes rather than lines. We can see something of this for ourselves. As the *Girl with a Pearl Earring* turns towards us in the light, we notice with surprise that the side of her nose is completely un-delineated. We are, as Gowing says, 'prepared to take the rest of the shape on trust'. We know from our visual experience where her nose must end, but Vermeer has not made it explicit.

This summary technique has puzzled other experts: one commented that: 'the purpose of the dark underpaint must have been to brush in a

Figure 5.2 X-ray of *Girl with a Pearl Earring*. ©KIK-IRPA, Brussels, Giles de la Mare Publishers.[19]

monochrome image on the smooth, light coloured ground'.[20] This might be the case, but we are no closer to knowing how Vermeer did so without putting down any lines. Some think that the indistinctness of his underpainting is the result of working with a rag,[21] but this does not quite explain the completeness, or the confidence of his images.

Some painters of Vermeer's era made tentative beginnings, putting down a number of lines, making changes here and there, rubbing out areas that were not quite right, or painting on top of them to adjust the composition. Some worked intuitively, feeling towards how they were going to position the objects and figures on their canvas; others more deliberately, planning their pictures out precisely, using numerous studies to make complex images.[22]

But Vermeer's first layers are unexpected. There is no suggestion of drawing, nor any evidence of a careful transcription from a previous sketch or from multiple studies. His dramatic underpaintings appear to have arrived all at once on his canvas, without guide marks, and with little correction. It

is an indication of a very unusual working method. More than this: Vermeer's way of *inventing* is unique, and unprecedented.[23]

Recent examination of this and some of Vermeer's other pictures, using sensitive investigative techniques not available to Gowing, agree with his conclusion that instead of draughtsmanship, Vermeer has substituted tone.[24]

A technique called infrared reflectography, which can penetrate the top layers of a picture, can show something of the beginnings of a painting

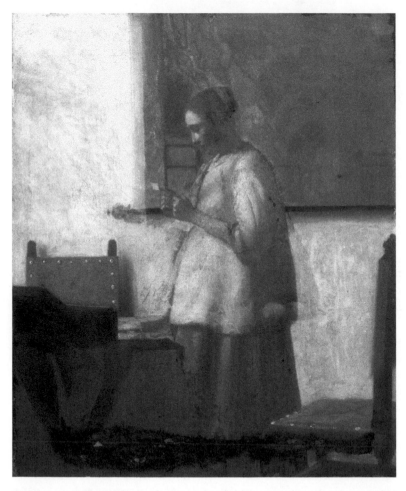

Figure 5.3 Johannes Vermeer (1632–1675), *Woman in Blue Reading a Letter* c.1663–1664. Infrared reflectogram. Rijksmuseum, Amsterdam.

beneath.[25] Although we cannot be absolutely sure how to interpret the images, they appear to reveal some of the *inventing* layer.

On the right is the *Woman in Blue Reading a Letter* (Fig. 5.4), recently restored, and on the left, the infrared reflectogram image (Fig. 5.3). The two images are so similar, that we could almost be fooled into thinking that they are the same; and that one has been reproduced in black and white, and the other in colour. This is not the case. What we can see on the left comes from

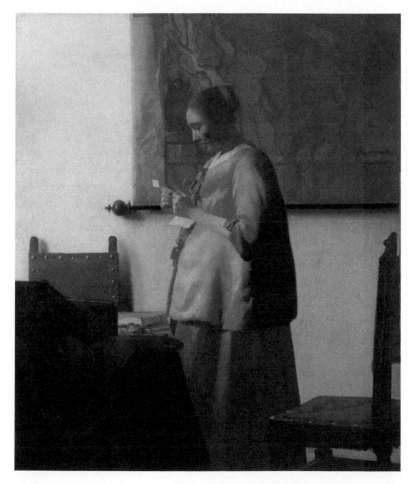

Figure 5.4 Johannes Vermeer (1632–1675), *Woman in Blue Reading a Letter*, *c*.1663–1664. Oil on canvas, 46.6 × 39.1 cm. Rijksmuseum, Amsterdam.

the lower layers: the very first roughed out version. Except it appears not that rough, and not that different. We see almost everything that is in the final painted masterpiece in the underpainting. We see almost everything; except the colour.

We might well wonder at Vermeer's confidence and his ability to make such a perfectly balanced picture from the very beginning. Here is no linear sketch, but an image made of interlocking masses of tone, which define the objects and the figure. The woman is already standing in a luminous space, and we can see shadows and highlights; even details, such as the little tacks on the chairs, where Vermeer has allowed the light ground to show through. And from the start, we see emotion. The woman seems hermetically sealed within her own highly charged atmosphere; she reads her letter, oblivious to everything around her.

The main differences, between the beginning and the final resolution of this picture, are in composition. Vermeer altered the flaring form of her coat, which looks as if it had a fur trim, not unlike those seen on other models in his pictures; and he moved the edge of the map on the wall.[26] These changes, which refine the tensions between shapes, tighten the dynamic of the whole.

How do we account for the unusual way Vermeer has put down these first layers of paint? It is as if Vermeer was able to capture a complete concept of his picture at once, and then edit it as necessary: as if the woman was propelled into the room intact.[27]

Some of Vermeer's dark underpaintings are not only most surprising in appearance, but also they are used in an unusual manner in the build-up of his images. Experts have agreed that his *inventing* can define the whole tonal organization of the finished picture; because the backbone of his composition is not ever entirely covered with further paint, and becomes part of the finished painting.[28]

In the *Girl with a Pearl Earring* (Fig. 5.1), we can see its pivotal role in the final outcome for ourselves. We can see its undercurrents breaking through on the right-hand side of her turban, where Vermeer has drifted a glaze of blue onto the grainy black, swimming in the depths. We can see it in the dark shadow of her nose, and in the shaded side of her face. Here Vermeer has used a semi-opaque white, mixed with earths, and a little bit of an organic red lake[29] on top of his *inventing*, but he still lets his dark first formed shapes speak through a layer, which seems now to be made of flesh. He observes the reflected light off her collar on her chin, and varies the colour

ever so slightly on her lip; but we see pricks of dusky dark on her jawbone, beneath her eye, and her mouth: remnants of underpainting, not quite covered.

The concept of this technique was not unprecedented. Establishing the dark and light parts of a picture was recommended in a very early treatise by Leon Battista Alberti, in 1435, who suggested that painters should use 'the greatest art and industry' to work out tone, before they went on to use colour. And early Dutch masters used a method of painting described as a *transparent oil technique*.[30] This was a system of layered painting to give an illusion of volume; which also started with a monochrome underpainting; followed by well-defined, planned layers.[31]

We could say that Vermeer used a method which loosely fits this description; but we can see that his own first layers have particular power because they are complete tonal maps. His dark, strong beginnings are turbo-charged.

How do you then go on, if you have managed to do so much at the very start of a painting; when you have laid out everything almost perfectly in the way you want it?

Then you have to be careful not to cover up what you first put down. If we think of Vermeer's method as being partly prompted by this need, then some of his unusual techniques may be explained.

In *A Woman Holding a Balance* (Fig. 5.5), painted a year earlier than the *Girl with a Pearl Earring* (Fig. 5.1), the various textures of velvet, fur, skin, and pearl; the dead grey softness of the far wall; and the glinting sheen of the coins and the silvered mirror; are all achieved by a combination of layers of opaque scumbles and coloured glazes.

However, if we look very closely indeed at a detail (Fig. 5.6), enlarged by digital technology, we can hardly comprehend initially how it is painted at all. The arm of the woman that is nearest to us has a granular edge. It comes and goes in front of the fur of her costume. The edges of her sleeves are blurred, and her far hand is only just in focus. What is going on here? It seems that the closer we look, the less we see. The border of the coat is not made with the small careful strokes we might expect, but by a few white fluffy movements on top of a pink coloured base, while the pearls are conveyed by some grey shapes, summarily dabbed over with thicker white paint. How does Vermeer manage to convey the differences between neck and headdress; hand and coat; wood and gold, so audaciously?

After looking a while, we may start to see that this picture, just like the *Girl with a Pearl Earring*, is constructed in layers. There are no lines; only gaps

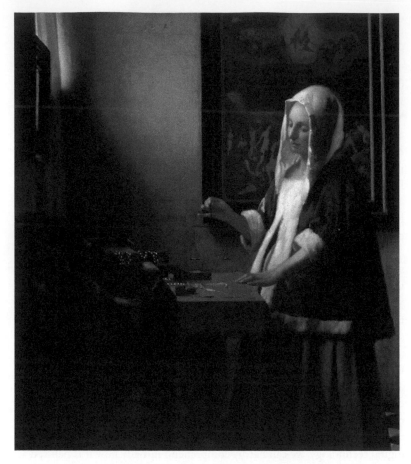

Figure 5.5 Johannes Vermeer (1632–1675), *A Woman Holding a Balance*, c.1663–1664. Oil on canvas, 40.3 × 35.6 cm. National Gallery of Art, Washington.

between shapes, on the edges of forms, working as contours in their own right. We may recognize the underpainting showing in the deepness of the shadows; and see its vestiges in the gap between her arm and cuff. There it is in her dark blue coat; in the greenness of her arm; and in the deep yellow of her skirt, where the folds of cloth are coloured by the black beneath. We eventually see that the woman's serene face is made only from smudges of tone, overlaid with a thin warmth, becoming rosier on her mouth and her cheek.[32]

Vermeer treads softly, not precisely; giving us suggestions as to what we can understand as a pearl, sleeve, or hand; adding paint, but leaving previous

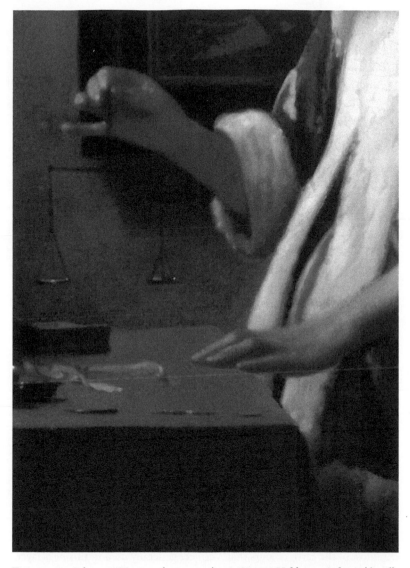

Figure 5.6 Johannes Vermeer (1632–1675), *A Woman Holding a Balance* (detail), *c.*1663–1664. Oil on canvas. National Gallery of Art, Washington.

layers showing. His technique is so self effacing, and so apparently effortless, that we go where he leads us: beyond the woman's outstretched finger and down to the winking golden scales; and we hardly stop to appreciate the painterly techniques that enabled her creation.

Although the technical explorations of the *Girl with a Pearl Earring* (Fig. 5.2), and the *Woman in Blue Reading a Letter* (Fig. 5.3) show what appear to be almost complete underpaintings, Vermeer painted on top of these in discrete layers: both vertically and horizontally. That is to say, not only was each layer put on as a separate entity, each part of each layer was painted in isolation too.

The Rembrandt scholar Ernst van de Wetering comments on the islands of paint in Rembrandt's pictures, which showed that the artist tackled only parts of the painting at a time. He even tried his own studio experiment to try to reconstruct the master's technique. However, he found on analysis, that whereas his own work showed traces of all colours everywhere, Rembrandt's did not.[33] This 'unsuccessful' experiment turned out to be very valuable, showing how the need to paint in stages partly determined the look of the picture;[34] and how sophisticated seventeenth-century painters were in the management of their work.[35]

It is a dizzying prospect to think about how Vermeer organized himself to paint. Did he plan in advance, or did he proceed knowing how one layer would work beneath another? How did he know what to leave where? The confident, final outcomes show that he was in complete command of his technique: using one set of colour after the other; playing them in variation.

In contrast to her silky turban, the *Girl with a Pearl Earring* (Fig. 5.1) appears to be wearing a woollen coat, pleated stiffly at the shoulder, rather like an academic gown. In his first *inventing* layer, Vermeer roughed in the shape of this garment in dark paint; then after this had dried, used an earth colour, yellow ochre, applied in a very thin layer over the top. This turned the yellow to green where it touched the underpaint;[36] and gives an impression of a fabric with a texture rough to the touch. Although yellow ochre is transparent, most of the earth colours that Vermeer generally used in this next layer, the *dead layer,* were opaque; and they were mostly dull too (Fig. 5.7). The *dead layer* was a precursor of things to come: it established the organization of the picture; and provided a base for colours to be applied later.

Earth pigments are non-reactive, and they are cheap; and so Vermeer could create the effect of a nubby woven carpet on the table of the *Young*

Woman with a Water Jug (Fig. 11.1), by putting down burnt sienna, and strengthen it in places with the more expensive vermilion later. We know that earths are underneath other colours of his, because we can just see them vibrating between the bricks and the edge of the gable in *The Little Street* (Fig. 0.3); forming the stalks of the laurel wreath on the head of the girl in *The Art of Painting* (Fig. 1.4); and providing the shadows near the window in *Lady Writing a Letter with her Maid* (Fig. 2.2).[37]

He liked the earths: the off-yellow ochres: almost bright as sunflower, or dull as baked mud and faded corn. He liked green earth; putting it under skin tones, where its soft, wet clay colour[38] gave contrast in the shadows.[39] He liked the siennas: the autumn-baked brick reds, and the deep apricot. As all these earths descend to darkness, so the level of manganese in them increases. By the time we reach the umbers they have become very fast driers indeed, and vary in colour from khaki, to bitter espresso[40] (Fig 5.7).

For the next step: the *working up*, Vermeer must have reached to the back of his *kas* to retrieve his carefully preserved bladders, and opened his jars of expensive pigments. The colours he had to choose from now were fewer in number, and more often toxic than not. He had the heated lead colour of massicot yellow, the chemical compound of vermilion red, and the bright green verdigris. He had the cheap blues of azurite, smalt, and dark blue indigo; and finally the wonderful ultramarine (Fig. 5.8).

This *working up* layer, gave Vermeer the most scope for experimentation. Here, he could overlay his dull beginnings with thin layers of brighter colour; and he could use ultramarine, just as it was; or add it into white, as he did in the turban of the *Girl with a Pearl Earring* (Fig. 5.1). These brighter colours are rarely pushed right up against each other: Vermeer left them to sit a small distance away from each other in patches, so little haloes of previous layers surround each shape.[41]

In most of Vermeer's paintings, there are only a few things painted in these bright hues: the back of a chair; a skirt, or bodice of a girl; a splinter of glass in a windowpane; the edge of ribbon; the fleck of a carpet. But even curtailed, these colours speak out in their purity against the glowing dullness of the chalky and dusky earths. We have only to look at the *Woman with a Pearl Necklace* (Fig. 5.9) to see how much power just a little bright colour, put on at the *working up* stage, can project in his hands.

Standing in a flood of light opposite a small mirror, a girl, dressed in a now familiar short yellow coat, looks at her reflection. We follow the path of her gaze. Back and forth, back and forth. How does Vermeer control us

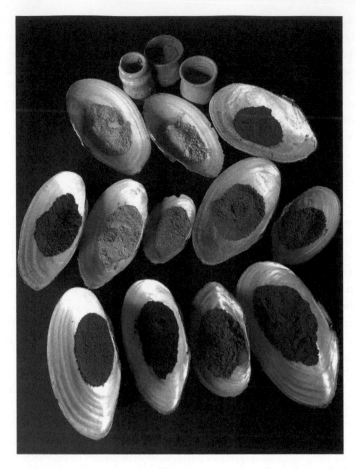

Figure 5.7 Seventeenth-century pigment pots, and earth pigments in shells, for the *dead layer*. Top row: yellow ochre, light yellow ochre, iron oxide. Middle row: black earth, green earth, orange ochre, red ochre, brown ochre. Bottom row: raw sienna, burnt umber, raw umber, burnt sienna.

so? Part of his power is his manipulation of the compositional forces: the diagonal of the fall of indigo cloth that leads us down to the edge of the table; the vertical of the girl that pulls us up again; and the big horizontal movement that comes in this case from absence: the empty space that connects her to the other side of the room, as she looks at the mirror.

But we are conscious also of the force of the colour. Our eyes shift along the window top to the smooth, egg yolk curtain, and then rebound to her

Figure 5.8 Pigments for *working up*. Top row: ultramarine ashes, smalt. Second row: ultramarine, azurite. Third row: indigo, vermilion (synthesized cinnabar). Fourth row: lead yellow (massicot), verdigris.

thickly padded, deeply honeyed coat. The painting of the silk conveys a contained warmth within, while the fur front seems to be flattened, as it repels the cold. We can imagine how the textures would feel under our hand. The silk cool and smooth, the fur cool and soft, both insulating the girl from the chill air. What made Vermeer add the ribbon in her hair? The red star waves for attention, and makes us look again at her face and consider her self absorption; her necklace; and her isolation.

Off-stage we can hear Vermeer playing his cadenza, but in the end, we are unaware of the contrivance of his supreme achievement. Only dimly do we notice the perfect placement of shapes and colours: in the end we consider only the girl.

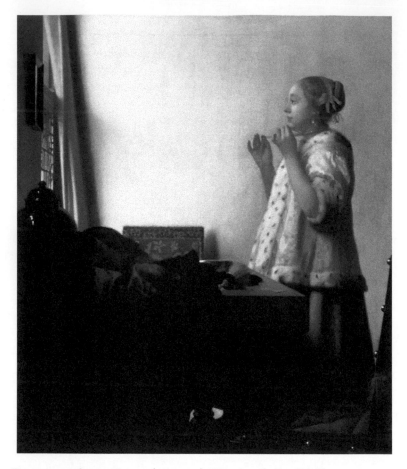

Figure 5.9 Johannes Vermeer (1632–1675), *Woman with a Pearl Necklace, c.*1663–1664. Oil on canvas, 51.2 × 45.1 cm. Gemäldegalerie, Staatliche Museen zu Berlin.

We might feel the thin warmth of the new spring sun reflecting off the girl's coat, but Vermeer used only a small quantity of bright pigment in this picture. The advice given by Karel van Mander in his book on painting, published in 1604, recommended 'skilful glazing' in the 'making of velvets and beautiful silks, when a glowing translucent effect is needed'. This would help Dutch painters to emulate the 'glowing manner', seen in Italian painting, which was much admired.[42] Vermeer needed maybe only a teaspoon or two of lead-tin yellow to make his opaque paint, and a similar amount of

lake pigment for the paint on top, to give added depth and suggest texture. The red is most likely the powerful, but opaque and toxic, vermilion.

The last stage in the traditional order of painting was called the *finishing layer*. There is a mystery about glazes, but they are just transparent pigment ground into oil, applied thinly. Coloured glazes give depth and intensity to a painting; and rather like looking though a sheet of coloured cellophane, can be used to harmonize the whole picture by giving everything a little of the same coloured tint. Lake pigments (Fig. 5.10) were mostly used for this, as they are really only coloured chalk, which is transparent in oil.

The *Girl with a Pearl Earring* (Fig. 5.1) wears a coat covered with a thin red lake glaze that has faded now.[43] Vermeer may have used a touch of cochineal lake on her lips,[44] a colour still in use today in modern lipstick, and in cherry coke.[45]

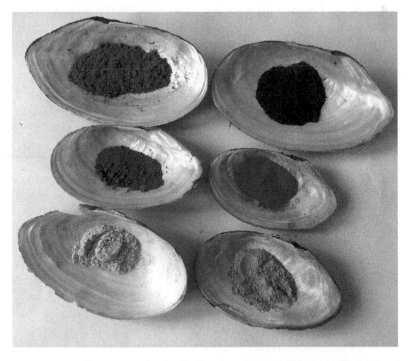

Figure 5.10 Lake pigments for the *finishing layer*. Top row: Brazil wood light, Brazil wood dark. Middle row: cochineal, madder. Bottom row: weld, stil de grain (Buckthorn).

We might not expect a material we would regard as a nuisance to be used in this particularly precious picture; but the dark background is made from indigo, overlaid with a yellow lake glaze made from 'dyer's weed'.[46] These two organic pigments, together make a dark, liquid green. Instructions at the time suggest that if enough oil was used with indigo, then this would protect it from fading.[47] Vermeer must have thought the risk was worth taking, because as a complementary colour to red, and as a contrasting tone, the deep green background enhances the warm flesh tones of the girl's face; and pushes her forwards towards us. The other glaze Vermeer chose to use in the *Girl with a Pearl Earring* (Fig. 5.1) was made from the pigment he liked best. He ground up his ultramarine very thinly, and put it over the dark areas of her turban and behind her neck.

It is not quite clear when exactly Vermeer put on the highlights in this picture; when it was he built up the reflection that glints from her earring.[48] Did he do it before the *finishing* layer or after? Were the two pale pink spots on the corner of her mouth covered with a reddish glaze? Or did Vermeer add just a little carmine to the opaque paint, so that they wouldn't stand out too strongly? Technical analyses do not provide precise answers to these questions.

But now, all Vermeer had left to do, was to seal up his picture. He applied a 'rather translucent final paint layer', mostly made of linseed oil.[49] Just oil, with a tiny touch of colour, was enough to do the trick.

Since its rediscovery, this picture has suffered, like a spoiled child, from a little too much attention. Past restorations have not all been kind. It appears that the paste, used to stick on a new canvas backing in 1882, was water-based. This shrank the canvas, giving less space for the paint layer, causing it to buckle. Efforts to retouch the picture, and cover up losses in paint, became more noticeable with age; and some of the cracks visible on the girl's face were deliberately filled and darkened. The most recent restoration in 1995 had to try to identify which touches of paint were original and which not. It was discovered that a few flakes of paint, which had been dislodged from the surface by previous treatments, had floated off, and had been stuck back carelessly. This had created an extra reflection on her earring, which has now been removed. Every effort was taken to conserve the image, while trying not to compromise Vermeer's 'original intention'; although we may never know precisely what that was.[50]

This picture may not sparkle quite as it once did, but still it glows. It has come through time untouched in essential; miraculously escaping the ultim-

ate fate of so many of the paintings produced in the Dutch Golden Age, which disappeared completely.[51]

She looks at us again; ready at any moment to bolt back into obscurity, just as soon as we glance away. The small, silvery world that rests gently against her collar, gives back the light from the room in which Vermeer stands. Even if we think we might communicate with her for a sliver of a second; her image was not captured in an instant. She is the result of many hours of patient work in the studio, overlaying one layer of paint on top of another. We can understand there must have been much skill needed to paint such a picture, but we know also that there is some kind of alchemy at work here. Apart from the phenomenal ability of a brilliant painter, could the power of a lens have contributed to her magnetic presence?

Lawrence Gowing thought that the underpainting of the *Girl with a Pearl Earring* was '…a direct transcription of the incidence of light on the screen of a camera obscura.'[52] But if we do imagine Vermeer might have used an optical aid, how easy was it for him to find a lens, and set it up? We have to ask where he might have got such equipment, and how he would have known how to use a camera obscura.

Figure 6.1 Johan van Beverwijck, *Schat der Ongesontheyt* (Amsterdam 1672), vol. II, p. 87 (printed for the first time in the edition of 1651).

6

Through the Lens

It is 1621, and Constantijn Huygens sets off for London, to learn something of the rudiments of diplomacy. He is destined to become a major player in the politics of the Dutch Republic, and rise to become the secretary to the Princes of Orange, and a patron of the arts and of science. We will see that his influence and connections will extend far, not least because he lived to the astonishing age of ninety one.[1]

But here, he is only twenty-five, young enough for his parents still to feel able to dispense advice. They are anxious that he might fall under the influence of a fellow Dutchman, Cornelis Drebbel, billed as a showman and inventor; but who is perhaps a sorcerer or scoundrel; and whose exciting presence might be too much of an attraction for an impressionable son.

Cornelis Drebbel may have looked 'like a Dutch farmer';[2] but he was a brilliant engineer, who made a number of innovative devices: a machine of apparent perpetual motion, powered by differences in air pressure; a self-regulating clock; a thermostat; an incubator; a new red dye;[3] an air conditioning machine; and even a working submarine, for which it appears he managed to synthesize oxygen for the crew to breathe.[4] Drebbel's fertile imagination and his inventions put him ahead of his time,[5] though his entertainments and illusions meant some saw him as frivolous. However, many now consider him to have been a serious scientist. He had a comprehensive knowledge of optics, was skilled at lens making, and is supposed to have provided an extra lens to improve Galileo's telescope, and to be one of the first to develop the compound microscope.[6] Even though it has been suggested recently that Ben Johnson based his play *the Alchemist* on his activities, and that Shakespeare may have been similarly inspired by him, when creating the character of Prospero;[7] Drebbel died in poverty and obscurity. Only now is he receiving some of the recognition he deserved in his lifetime: his face has

featured on stamps; his submarine played a role in a Hollywood film;[8] and a small lunar crater, at 40.9°S 49.0°W, is named after him.

Constantijn's Huygens' dutiful letter to his father in 1621, reported that he had visited Drebbel, despite his parents' warnings. He laughed off any suggestion of trickery, and said that there was nothing to fear.[9] Furthermore, he had managed to buy from him the latest thrill of the age: a camera obscura.[10] He could hardly hold back his excitement: 'It is not possible to describe for you the beauty of it in words,' he wrote, 'All painting is dead in comparison. For here is life itself'.[11]

We might not be surprised at Huygens' entrancement with what he saw through the lens, addicted as we are to digital screens ourselves; yet the camera obscura image has a particularly beautiful quality; compelling, even today. As our eyes become accustomed to darkness, the image resolves itself as a topsy-turvy, parallel universe. It is not like the crisp bright pictures on our mobile phones. This other wide-angled, dreamlike world can appear to run more slowly than our own.[12] Everything is slightly blurry, fading towards the edges; everything is curiously flat and condensed. The colour is clear;[13] as are details towards the centre of the circular image; and there are strong tonal contrasts. The birds fly upside-down, and the wrong way across the sky; the curtains billow in the wind; and the milk flows upwards from the jug: but the figures we see are unaware that we observe their silent movement, and their shadows.

Visitors to the *World of Illusions*, in Edinburgh,[14] can see a living picture of the city spread out before them, on a large viewing dish, projected down from a camera obscura on the roof. People go about their business in the streets far beneath, oblivious to the fascinated voyeurs above. How can this rudimentary technology still draw a crowd? Maybe we are tiring of the relentless fast pace of our lives, and would prefer to see something of the everyday, in its own time. This might explain the advent of 'slow television', watched by half the Norwegian population, which has featured all-day knitting; a seven hour train journey; a burning wood fire; and nothing else at all.[15] In the UK, the reflections of a puddle in Newcastle, streamed online, drew 20,000 people in a single day. Just standing and staring seems to have caught on.

The technology of the camera obscura has been known at least since the eighth century. Early versions were simply a darkened room (hence *camera obscura*), with a small hole to let light in. A projected image from outside

would be cast on a surface inside on the opposite side from the hole: either onto a screen, or sheet of paper, or the wall itself. But the addition of a lens gave the camera obscura a much brighter projected image than one made with a pinhole.

Lenses were being produced in quantity in Europe from the sixteenth century onwards,[16] and if he had the money, Vermeer would have found it easy to buy one, as there were itinerant peddlers, with trays of lenses, going between towns and villages in his day; one of whom we can see in a very early painting by Rembrandt.[17] But there was also a lens grinder and spectacle seller, called Evert Harmansz Steenwijk, who had premises in Delft itself.[18] We can get an idea of what might have been on sale, from a print of an optician's shop made in Italy around 1597 (Fig. 6.2); although being in a colder climate, Steenwijk's establishment is likely not to have been quite so open to the elements. Here the lens seller is putting many spectacles out for customers to try, rather as the chemists display reading glasses today; but it does seem surprising that quite so many people are wearing them all at once.

One of the earliest detailed accounts of a camera obscura with a lens was written by a Neapolitan, called Giovanni Battista della Porta. *Natural*

Figure 6.2 Johannes Stradanus, 1597, *Schema seu speculum principium*. Engraving. Bodleian Library, Oxford.

Magick was first published in 1558; it was a bestseller, going into a number of editions, and was translated into Dutch in 1566. We have a record of some-one in Delft owning a copy of this book,[19] and we might imagine him con-sulting the wide-ranging index inside. There are chapters on *Tempering Steels* next to *Perfuming, Distilling, Cookery,* and *Chaos.* In between experiments with magnets, and recipes for soap, is an early mention of a herb 'called tobacco'. The suggestion is to mix it into little balls with the *ash of cockle shells,* and chew or suck it continually, to stave off weariness, and reduce hunger and thirst.[20] There is other useful information here too: instructions to stop dogs barking; how to write secret messages inside an egg (useful for smuggling into prison);[21] and how to gather various animals together, using 'the things they like'.[22] We find that dolphins like the harp, but horses the flute. We learn that there are ways to lure partridge, elephants, stags, boars, jackdaws, quails, unicorns, weasels, mice, fleas, and frogs; but even della Porta stopped short at any suggestions for herding cats.

Della Porta could not have tried everything he includes in his book; and must have found recipes here and there to copy out; but his chapter on *Strange Glasses* does convey the excitement of first hand experience.[23] He suggests many uses for lenses: *'To read letters in a dark night'; 'To see in the night what is far off'; 'To give light in a great hall'.*[24] He starts a new section in his book for the detailed instructions entitled *To see all things in the dark, that are outwardly done in the Sun.* This, we realize, describes a camera obscura, and includes the use of a diaphragm over the 'centicular lens'[25] to make the projected image sharper. In explaining this secret, della Porta says that it is necessary to wait until viewers' eyes become accustomed to the dark. Then 'you will see (the images) with so much pleasure that those that see it can never enough admire it'.[26]

Constantijn Huygens goes one step further, stating that the camera obscura projection is even better than art. Why did he say this? The art his-torians will have an answer, in connection with his time and culture 'in which images (played) such a prominent role'.[27] But aside from their explan-ations, we can see that he might think that a place on the wall was where reflections of images of everyday life belonged; framed and contained. After all, he was living in a country that had a great thirst for pictures of familiar surroundings.[28] But it was not only the subject matter that concerned the best collectors, they wanted a quality they called *houding* in their paintings. This was the achievement of an harmonious illusion which mimicked the real world,[29] and maybe the camera obscura image resembled this ideal bet-ter than most paintings.

Was it the extraordinary reality of the projection that overcame Huygens, and which prompted him subsequently to recommend the use of the camera obscura to artists for use in the studio?

Samuel Hoogstraten, a contemporary author of a well-known painting handbook, thought that its practical use to students would be limited to observing the images it produced. He explained that the camera 'can give no small light to the sight of young artists' because it helps them understand what characteristics 'should belong to a truly natural painting'.[30] We may not be able to understand exactly what he meant by this, but a condensed view through a lens could have been helpful to those trying to find the essential qualities of what they were seeing, before they committed them to canvas. The nub of the question is whether painters would go further than observing a camera image. Would they, or could they, trace from a projection, and somehow incorporate the look of a lens directly into their pictures?

It is a frustration that we actually know very little about what artists might have done with a lens in a studio in the seventeenth century: hardly any written record of its practical use has yet been found; but as the Vermeer scholar Arthur Wheelock has pointed out, it is possible that artists just kept quiet about it, not wanting to reveal how they worked.[31] Hendrik Hondius, writing an artists' treatise in the mid 1620s, states that some painters were already using *perspective devices* but were concealing the fact.[32] Constantijn Huygens actually came across someone whom he thought was doing just that.[33]

Johannes Torrentius was a flamboyant man whose illusionistic still lifes had made him rich. When he met Huygens, he was shown the camera obscura, but said that he had never seen one before. However, his manner was so awkward that Huygens was convinced that the 'cunning fox' did not want to admit that he used one himself. Torrentius had a licentious reputation, and was notoriously secretive about his painting methods: wanting people to believe that there was an element of magic in making his pictures. He claimed that his studio recipes were unique, and that he used neither brushes nor easel; and there are surviving reports that his experimental paint mixtures could be toxic, highly flammable, and sometimes effervescent, producing a noise 'as if a swarm of sweet bees were humming'.[34] The fizz of his personality and his paint led Torrentius into trouble and into prison; he was lucky enough to survive torture, and escape a very long jail sentence; being released after a short time to go into the service of King Charles I in England. It seems that his pictures were destroyed by the authorities along the way, because of objections to pornographic content.

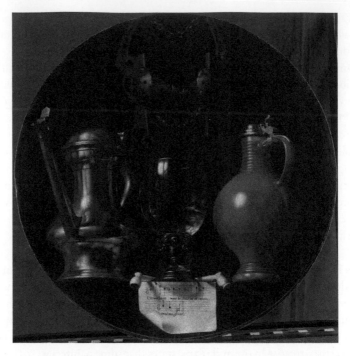

Figure 6.3 Johannes Torrentius (1589–1644) (otherwise known as Johannes Simonsz. van de Beeck), *Emblematic Still Life with Flagon, Glass, Jug and Bridle*, 1614. Oil on panel, 52 × 50.5 cm. Rijksmuseum, Amsterdam.

Only a single work of his has come down to us. Hanging in the Rijksmuseum in Amsterdam is his *Still life with Flagon, Glass, Jug and Bridle* of 1614 (Fig. 6.3). We know only a little about the journey this painting made to reach safety. It was discovered in 1913 in a grocer's shop in northern Holland, where it had been used as a lid for a barrel of currants. When it was cleaned and restored, a royal mark was discovered on the back of the panel, so it may have been out of the country when Torrentius was tried and found guilty of scandalous behaviour,[35] and for belonging to a secret religious sect that was unacceptable to the conservative Dutch Protestant Church.

Unfortunately, we cannot compare this picture to any other work of Torrentius'. But we can note the highly finished quality of the objects and the illusionistic highlights, including the reflection of a window in the glass in the centre. The picture is circular, like the view through a lens, and the objects sit side by side on a ledge, their shapes standing out strongly against

the dark background. Huygens could compare the images he saw in his own camera with Torrentius' still life; and he could have seen similarities with the strong tonal differences, and the softness of the highlights on the flagon and jar, with projected images.[36] Could the use of an optical device explain what Huygens thought was Torrentius' extraordinary improvement in painting technique, and what we might call its 'photographic' appearance?

Huygens was also surprised by Torrentius' painting, not because of its message of temperance and sobriety, which was sharply in contrast with this artist's reputation; but, because even as a connoisseur of art, he still could not say 'in what manner (Torrentius) used colours, oil - and if the Gods may wish, also brushes'. Extraordinarily, even with the scientific technology available to us now, we cannot tell how Torrentius achieved the illusionistic qualities in his picture either. Reports of his working methods do not make much sense. Torrentius said he painted his pictures on a flat surface and did not draw, but painted straight away. Then, he tells us, he was taken over by 'an external force' and was possessed by 'a spirit which is like sweet singing', which allowed him to complete his creations.

Stories of Torrentius' strange working methods were circulated at the time of his trial for heresy, and recent chemical analysis of the paint layers of *Still life with Flagon, Glass, Jug and Bridle* (Fig. 6.3) shows that the rumours were well founded, because Torrentius was not working like other artists of his day. His choice of pigments may have been conventional, but the medium he used to bind them together was not. There is no trace of oils, glue, or tempera, but unusually, the presence of pectins. Could Torrentius have combined his paint with something reactive, like acid, which might have effervesced? Maybe he used resins, which were volatile, and which would set hard, to produce the glossy finish? It is remotely possible that the pectins came from the barrel of currants the painting was covering;[37] but it looks as if we will be kept guessing.

Torrentius was obviously up to something. Huygens had remarked in 1622 that the camera obscura 'was now-a-days familiar to everyone',[38] so we can maybe understand his irritation at the coyness of a painter who feigned ignorance. It looks as if Torrentius is likely to have been aware of the camera obscura, and that Vermeer, starting his career around thirty years later, would have been too. There are a number of contemporary descriptions of projections, some shown for entertainment, and some set up in the interest of scientific investigation.

Walking down the Strand in London in 1636, the adventurer Peter Mundy went into a house belonging to Sir Henry Moody:

and 'the roome being made quite darke, only one little hole in it with a glasse through which a light strooke to the opposite side, where was placed white paper, and thereon was represented, as in a glasse, all that was without, as Boates roweing on the Thames, men rideinge on the other side, trees etts, but all reversed or upside down in their true condition'.

Closer at hand, Isaac Beeckman, making lenses in 1634 in Dordrecht, reported the effect of putting one of them into a hole in the window of his 'dark office'; and tested how the focus of an image of a window across the street varied, as he moved a piece of paper in front of the projection.[39] And the Englishman William Lord Fitzwilliam, visiting Leiden in June 1663, reported 'a curiosity in optics: things outside represented within a dark chamber which has but one little hole where the light comes in', set up on the roof of the university building.[40] This had been constructed for astronomical purposes, and had been used as early as 1638 for viewing sunspots.[41]

Vermeer could have witnessed a demonstration of a camera obscura for himself, if he had travelled only a few miles by water to The Hague in 1655. A gifted engineer called Johan van der Wyck came to Delft sometime between 1646 and 1654, and in taking over Steenwijk's position, and possibly his workshop, appears to have propelled the city to the forefront of the optical technology of the time.[42] Van der Wyck had an illustrious military career to come, and although he did not stay long,[43] he made quite an impression with the optical instruments and lenses he produced. It was he who set up a projection from 'one paire of glasses in the window' in The Hague, 'to represent and conveigh all the objects without upon the Streets upon the table in the middle of the roome'.[44] This description, which has many similarities to Peter Mundy's, was given by a polymath called Samuel Hartlib who was making a visit there at the time. It suggests that what van der Wyck was showing was a camera obscura with a lens.

Most surviving written instructions for making a camera obscura agree that the lens should be one 'thicker in the middle than the edge; such as is the common Burning Glasses, or such which old people use'.[45] Lenses did not have to be specially made for a camera obscura: convex lenses such as those already available in spectacle sellers' shops, or an ordinary magnifying glass would work perfectly well (Fig. F.1).

If confirmation was needed of the ubiquity of lenses in Vermeer's day, and the uses they were put to, it was supplied by a recent discovery in the mud and detritus discarded during construction for Delft's new railway tunnel. Archaeologists sifting through the waste in 2014, made a kind of triage list of any items that needed instant attention, while those of less obvious interest

were left for a while. A little tube of metal, only four inches long was assigned only cursory attention, and was assumed to be a shell casing from World War Two. However, on closer inspection this turned out to have international importance. When the earth and grime was removed, a tiny tinplate telescope was revealed, and identified as the oldest ever found in The Netherlands, maybe even one of the oldest surviving telescopes in the world.[46] This little instrument has low magnification, so it appears not to have been made for seeing stars, or spying approaching armies; but was possibly just a kind of plaything: something to put in the pocket and take out to show friends. Now it sits in state, on purple velvet, in the Prinsenhof Museum.[47]

We have to remember that although Galileo's name became synonymous with the telescope, he did not invent it. That honour should be bestowed on a Dutchman. The difficulty only is knowing which one. For, as happens surprisingly often, the same idea seems to have occurred to several people at once, all of whom wanted to take the credit.[48] There is a story that some children playing with lenses in Hans Lipperhey's spectacle shop in Middelburg[49] put a convex and concave lens one in front of the other, the better to see a distant weather vane outside. It was said that this prompted Lipperhay to make a telescope.[50] However, around the same time, in 1608, Zacharias Janssen and Jacob Metius also put lenses either end of a tube. Sensibly, the reaction of the authorities was not to grant any of them a patent, because they could not work out who deserved it.

There has been much debate as to who actually did invent the telescope ever since, and this question has never been entirely satisfactorily resolved. Information about this new 'far-seeing' instrument travelled fast; and we know that one was made by Steenwijk, later that same year. Whatever their use by scientists and the military, by the end of Vermeer's lifetime they had become commonplace. 'No one was surprised' to find a small telescope in the pocket of a drowned man, washed up near Amsterdam in 1668.[51]

But lenses were not only being directed outside outward to the skies. They were being used to examine the minutiae of the world too. In 1665, Robert Hooke published his famous book *Micrographia*, which included descriptions and illustrations of plants and insects as seen through a microscope; and this may have been an inspiration to a man who lived just round the corner from Vermeer's house.

Anthony[52] van Leeuwenhoek, the son of a basket maker, was born within the same week as Vermeer: their names appear only a few lines apart in the birth records in the Delft Archive. As a young man, Leeuwenhoek was

apprenticed to a draper in Amsterdam, and then returned to Delft to run his own shop. This ordinary beginning gives no hint that he was to become the world's first microscopist. Some think that he became interested in lenses after using one to check the thread counts in the fabric he sold;[53] but maybe he observed the magnifying power of the raindrops that peppered his shop windows as he observed his approaching customers? Whatever the reason, he started making his own microscopes, using tiny spherical lenses, apparently copying a technique he saw being used by a glass maker at a fair.[54] These specks of glass, sandwiched between plates of metal,[55] gave astonishing magnifications of up to 350 times.

Squinting at his little lenses against the light, using samples including his own excreta, Leeuwenhoek saw into a new microscopic world teeming with life: he saw minute creatures and cells that no one had ever seen before, and for which he had no name. He was the first person to describe and provide illustrations for spermatozoa, bacteria, and protozoa, and told his friend the doctor Reinier de Graaf about his findings. In turn, de Graaf contacted Constantijn Huygens, who appears yet again in a story of discovery. Through this route of connections, Leeuwenhoek's letters found their way to the Royal Society in London, who eventually recognized him with a Fellowship. His astonishing observations could not be duplicated with any other equipment until the nineteenth century, when the power of a conventional compound microscope could equal that of his little devices.

Some of the wafer-thin specimens Leeuwenhoek prepared with his own cut-throat razor were re-discovered in the 1980s, down in the vaults of the Royal Society; but the cabinet of microscopes presented to them after his death mysteriously disappeared in the nineteenth century.[56] Leeuwenhoek had made a microscope for each specimen he examined, more than five hundred in total; but only a handful of the originals remain, perhaps because they were extremely difficult to use, requiring excellent eyesight and a great deal of patience.[57] If you try to use a replica of one of these little instruments (Fig. 6.4), you will find it very hard to focus on any sample put in front of the lens, let alone make sense of it. The drawings of Leeuwenhoek's observations were apparently made by professional artists; presumably after he had made everything ready for them.

There is a general hunt on, to see if more of Leeuwenhoek's microscopes can be found, and one did appear relatively recently, in a box of doll's furniture; but it is likely that the significance of such small, rather strange objects was not recognized, and that they were discarded in the past.[58]

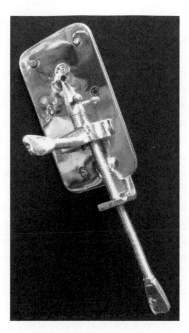

Figure 6.4 Replica silver Leeuwenhoek microscope[59] (shown actual size). Courtesy Michel Haak.

Some scholars have been keen to find links between Lecuwenhoek and Vermeer, maybe because they would like to point to a mutual interest in lenses, or a similar outlook in their conception of seeing. Some think that here is an answer to the question of where Vermeer might 'have learned about optics'.[60]

It is true these two men lived very close to each other, and, in such a small town, could have bumped into each other as they criss-crossed the Markt. It is true that they shared some acquaintances. Then there is the undeniable fact that Leeuwenhoek was appointed as the executor to Vermeer's estate after his death. But we have to be careful before drawing conclusions. At the time, Leeuwenhoek was an officer of the Town Hall, and was required to step into the breach where there were problematic questions of probate. It appears in this case that he was not particularly understanding towards Catherina or Maria Thins.[61] In any case, there were other people in Delft who could have told Vermeer about lenses.[62] Quite apart from Leeuwenhoek, or van der Wyck, there was a surveyor called Jacob Spoors, who had made a

number of optical experiments; had written a book on the subject; and owned a telescope made by his neighbour Steenwijck. Spoors knew Maria Thins, and also Leeuwenhoek.[63]

There are other reasons to argue against Leeuwenhoek's influence on Vermeer. Most of his experiments were made some time after Vermeer produced his best paintings; and camera obscura lenses are rather different from the tiny magnifiers in Leeuwenhoek's microscopes.[64] We should also realize that in any event, Vermeer did not need to know anything about optics in order to use a camera obscura. In his famous diary, Samuel Pepys tells us that he used his microscope without understanding how it worked, although he did lament the fact.[65] Vermeer could have followed the practical directions we have seen were written down in early descriptions of the camera: he could have put up some curtains, positioned a lens in the gap between them; and found the focus by trial and error. After all we use technology all the time without any idea of the inside workings of computers, dishwashers, or car engines.

What we can be sure of is that Vermeer had an active interest in science, because he painted a pair of pictures between 1668 and 1669 that tell us so; though now they have been wrenched apart. These days, *The Astronomer* (Fig. 6.5) lives in the Louvre, while the preoccupied gaze of *The Geographer* (Fig. 6.6) is focused within the walls of the Städelsches Kunstinstitut in Frankfurt. The similarities in these paintings, which are the same size, suggest they were painted to be hung together as 'pendants'.[66] We have records of them being sold as companion pieces four times between 1713 and 1778, after which they went their separate ways. Unusually for Vermeer, both pictures have dates painted on them, but there is discussion as to whether these are original or not.[67]

In 2017 these two pictures were reunited, and were exhibited side-by-side in 'chronological' order, but at least one expert thinks that *The Geographer* should be hung on the left.[68]

Both these pictures seem to show the same man in the same room. There are some identical furnishings: slightly bowed windows, a large cupboard, a globe, and a similar shaped chair; but one has a warmer look than the other, giving the impression of a different time of day. As in many of Vermeer's paintings, the figures he shows are absorbed in themselves; but here, not with a letter, a reflection, music, or handiwork; but in both cases, with thought. In one picture, a man on the brink of an idea, half rises from the chair, as if action is imminent; in the other, he contemplates a globe as he

turns it slowly under his hand. These poses would be difficult to hold for long without backache.

The figure, identified as a man of learning by his loose-fitting robe, is surrounded by cutting-edge technology of his time: the most up-to-date terrestrial and astronomical globes, sea charts, maps, a measuring cross-staff for finding latitude, a set square, and an astrolabe for predicting the positions of the sun, moon, and planets. There are books on top of the cupboard, and pinned to its side we see a diagram, thought possibly to be a celestial planisphere. Astronomy and geography were interlinked disciplines at the time this painting was made, because observation of stars was essential to navigation on land and on water. What is extraordinary is that Vermeer's painting is so precise in the detail, that it has been possible to identify the maker of the globes; and even the edition of the book in front of *The Astronomer* (Fig. 6.5), which turns out to be a text on navigation, written in 1621 by Adriaan Metius, brother of the lens grinder Jacob Metius.[69]

Experts on iconography will tell us of the significance of the subject of Moses hanging on the wall, because he was associated with navigation and geography; but we can see, even without knowing that much, that the man in these paintings is apparently interested in scientific enquiry, and that Delft was not a small provincial backwater, but was well connected to the wider world, and was alive to new technology that stretched boundaries.

We may find it strange that what is lacking in *The Astronomer* in particular, is the equipment we would expect such a scientist most commonly to use, namely a telescope, particularly since the book he is consulting is open at the beginning of Chapter III, called 'On the Investigation and Observation of the Stars'.

However, we should remember that the titles by which these pictures are known today were not given by Vermeer, and the descriptions in the sale catalogues in the early eighteenth and nineteenth centuries were more generally descriptive. The figures in both paintings were given the same names on a number of occasions, and were variously described as 'a Mathematical Artist', 'an Astrologer', 'a Doctor', 'a Scholar', 'a Philosopher', or just 'a Person'.[70]

The quest for the identity of the man in these pictures, and whether he was a real scholar, has led to an interesting debate. Since sale records show that these two pictures were not in the collection of Vermeer's most regular patrons, they were possibly a commission. Although some have dared to wonder if these might actually be portraits of Antony van Leeuwenhoek,[71]

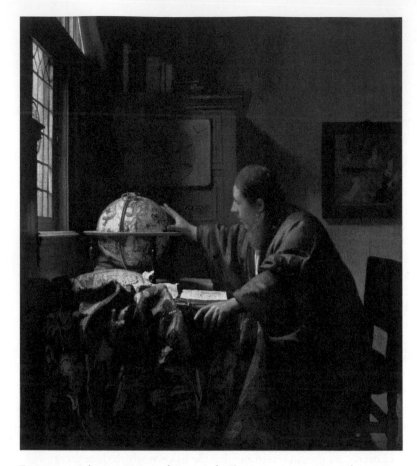

Figure 6.5 Johannes Vermeer (1632–1675), *The Astronomer, c.*1668. Oil on canvas, 51.5 × 45.5 cm. Musée du Louvre, Paris.

there has also been an alternative suggestion that Christiaan Huygens (1629–1695), the son of Constantijn, could be the model.[72] He became a famous physicist and his discoveries were making headlines at the time. He invented the pendulum clock; identified the rings of Saturn; and is known today for his work on the wave theory of light. He was a very competent lens grinder himself, and some of his handiwork still survives in the Boerhaave Museum in Leiden.[73]

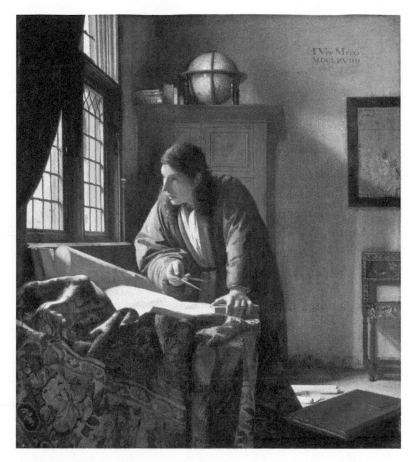

Figure 6.6 Johannes Vermeer (1632–1675), *The Geographer*, c.1669. Oil on canvas, 51.6 × 45.4 cm. Städelsches Kunstinstitut, Frankfurt.

Certainly, the long face, the nose, and the hairline of the man in Vermeer's paintings seem to bear more resemblance to Christiaan than to Anthony (Fig. 6.7a).[74] But on the other hand, in his own portrait, Leeuwenhoek is wearing robes, and holding a pair of dividers, just like *The Geographer* (Fig. 6.7b). Also, it appears from a recently discovered document in the Delft Archive, that amongst Leeuwenhoek's own collection of scientific instruments was a pair of globes, something which features in his own portrait, and in both of these paintings by Vermeer.[75] Is this any kind of evidence?

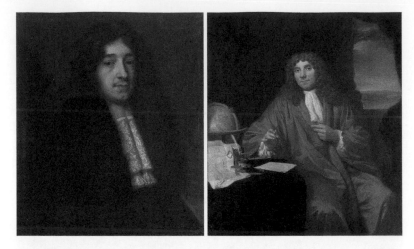

Figure 6.7a Pierre Bourguignon (1630–1698), *Portrait of Christiaan Huygens* (1629–1695) *c.*1688. Oil on canvas, 64 × 54 cm. Royal Netherlands Academy of Arts and Sciences, Trippenhuis, Amsterdam.
Figure 6.7b Jan Verkolje I (1650–1693), *Portrait of Anthony van Leeuwenhoek* (1632–1723), *c.*1680–1686. Oil on canvas, 56 cm × 47.5 cm. Rijksmuseum, Amsterdam.

In the end, there is no documentation of any kind to connect Vermeer with either of these two men. We might like to think that Vermeer's paintings do depict an important man of science; and we can even read a fictional letter from Vermeer to Leeuwenhoek;[76] but it is really quite likely that his sitter for these pictures was no one in particular at all.

If Vermeer did use a lens in the making of his pictures, and did have a camera obscura, then what might this have looked like?

The upside of Huygens' slightly sticky encounter with Torrentius, is that the report of his meeting gives us some more information about his own camera obscura. Some have assumed that it was in the form of a small box with a tube holding the lens which poked out one end, but this kind of camera was not illustrated in the literature until 1685, and wouldn't provide a very big projection, certainly not one large enough to be useful to Vermeer.[77] The descriptions in the earlier treatises we have seen so far, all talk about projecting an image onto a white sheet of paper or fabric; moving it to and fro until the projection is in focus. Huygens does describe just this[78] and tells

us also that his camera was 'lightweight', and that when something was 'lighted by a strong sun', an image could be projected into a 'carefully sealed chamber'.[79] This does not suggest any kind of box, but possibly a lens on some sort of stand, perhaps with curtains either side, that focused an image onto a screen in a darkened space.

There is a contemporary illustration showing two men, still wearing their hats, holding up a screen on which an image of a landscape is projected[80] (Fig. 6.1). Here is a doctor called Johan van Beverwijck demonstrating his room camera obscura in 1663, in the tower of his home in Dordrecht, about thirty miles from Delft.[81] We can reasonably infer from this picture that Van Beverwijck's projection must have come directly from outside. So another factor we have to consider are the light levels of an arrangement that would have allowed Vermeer to paint interior scenes using a camera obscura, where his viewpoints are at right angles to the window, with subjects illuminated from one side.

Professor Philip Steadman suggests with others, that the illumination from contemporary lenses used like this would have been good enough to provide clear projections,[82] and thinks that Vermeer built a little cubicle at the end of his studio and worked inside this darkened space.[83] Steadman's calculations lead him to the conclusion that Vermeer made many of his pictures with a camera obscura in this one room, and he argues that he could possibly have adapted the design of windows or floor patterns, to accommodate the differences we see from picture to picture.[84]

However, a more temporary arrangement of a lens on a stand, and curtains tacked to the ceiling joists, would have provided a camera that could be moved from room to room. Vermeer could have projected an image onto a board and moved his subjects, or the screen, to get them in focus. Could this have been the case with two of Vermeer's early pictures, *The Girl with a Wine Glass* and *The Glass of Wine* (Fig. 6.8)?

Huib Zuidervaart, who has done much research on the history of optics in The Netherlands, recently made some interesting observations. He was intrigued by the stained glass inserts in the windows in both of these paintings, and did some armorial research to see who the devices belonged to. His conclusion was that these pictures, which are both exactly the same size (though one is landscape format, the other portrait), are possibly a pair of marriage portraits;[85] not painted in Vermeer's studio at all; but set in the family home of the gunpowder maker Moijses van Nederveen, just outside Delft. Zuidervaart suggests the figure in the stained glass, once thought to

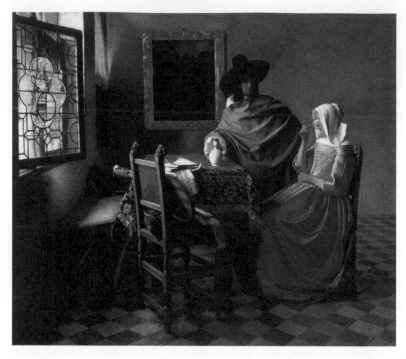

Figure 6.8 Johannes Vermeer (1632–1675), *The Glass of Wine*, c.1658–1659. Oil on canvas, 65 × 77 cm. Gemäldegalerie, Berlin.

represent Temperance, could be Prudence instead: an altogether more appropriate emblem for a manufacturer of gunpowder, particularly considering the damage wreaked on the town by *The Thunderclap* in 1654.[86]

Apart from anything else, we would take some persuading that the room occupied by the figures in *The Glass of Wine* (Fig. 6.8), is identical to that of *The Geographer* (Fig. 6.6) and *The Astronomer* (Fig. 6.5); or that of *The Music Lesson* (Fig. 8.5). It is not just that the floor or the windows do not match; the atmosphere of space and light do not feel quite the same. But how likely would it have been for Vermeer to have set up a camera obscura in different places? We will see that it is possible that the *Officer and Laughing Girl* (Fig. 8.4) was painted in Vermeer's mother's inn; *The Astronomer* (Fig. 6.5) and *The Geographer* (Fig. 6.6) seem to share a room with distinctive curved windows; and *The Milkmaid* (Fig. 1.2) looks as if she is in a very basic space, possibly a kitchen. If the *View of Delft* (Fig. 7.3) was painted using tracings

from a camera obscura, then obviously this must have been done far from Vermeer's home, in a room across the water, overlooking the city.

If Vermeer's camera obscura was nothing more than a single lens, then it would be portable; and this would help to answer the persistent query as to why no optical apparatus was listed in his inventory. It is a surprise to learn that in Holland telescope tubes were sometimes made by chimney sweeps;[87] and that the lenses were often kept apart from their holders, not only for reasons of economy, but presumably to keep them safe, and to stop them getting scratched. A lens on its own is small enough to be secreted away; and might not be recognized as something of value. All then Vermeer needed in addition, were some curtains: something the probate clerk seems to have listed with enthusiasm. Five pairs are shown in the inventory; and we see them in a number of Vermeer's pictures, including the *Girl Reading a Letter at an Open Window* (Fig. 1.3), which depicts a green silk one, possibly borrowed from the Great Hall.[88]

Changing locations would not have been so difficult if the equipment could be carried from place to place; but it might have meant that the most desirable parts of the composition would not always be perfectly in focus, because the lens might not be ideally suited for the situation, and could not always be placed far enough back from the motif. This could be one of the reasons why in some of Vermeer's pictures the back wall is crisply resolved, whereas things towards the front are fuzzy; although it might be that a conscious choice was taken to show some areas as indistinct.

If Vermeer did have some kind of curtained cubicle at the end of the room in which he was working, he could have produced projections equal to, or bigger than the finished size of some of his paintings,[89] but there were difficulties. He had to go into the darkened space, turn his back to the lens, and to his subject in the studio; and look at the image on the wall or the screen.[90] Then not only would he have to work in the gloom, he would have to contend with the shadows that would be cast by his hand when tracing. How could he possibly work in colour? It would be too dark to see much of his palette; and the projection itself would affect the colour of any paint on his brush.

To add to all these problems he would be looking at a projection that was not only upside down, but also back to front.[91] This means that whatever Vermeer might have traced in these conditions could not be corrected by just rotating the image: because even if it was now the right way up; it would still be mirror-reversed (Fig. 6.9).

Figure 6.9 Left: original motif. Middle: image as seen in a room camera obscura. Right: camera obscura image rotated.

As far as Constantijn Huygens was concerned, the camera obscura would have been absolutely perfect apart from this last drawback; and he made a customer complaint about his purchase. He asked Drebbel to 'set the images...right side up and justify the reputation he has long claimed for himself'.[92] Unfortunately, we don't know if the great inventor ever rose to the challenge, and did anything about it.

We do now know that Huygens was told how to correct the orientation of the image in a camera obscura by Henricus Reneri (1593–1639), a professor of philosophy in Utrecht. This involved the use of an extra lens '*the size of the opening of a drinking cup*' in diameter. But the problem with using two lenses inside a camera obscura, is that the image would be likely to be more distorted than when it is projected through just one lens; and that it reduces the space for working. We can only speculate whether this was a theoretical, rather than a practical solution, and if Reneri was overly optimistic in his suggestion about how well it would work.[93]

Anyhow, even in a possible scenario where the image is corrected in orientation, the problem of painting in reduced light still remains.

The Vermeer expert, Jørgen Wadum sees the practical obstacles that the camera obscura presents as insurmountable, believing 'no painter would ever sit with his palette full of bright colours in a dark room painting an upside-down image'. But how then do we explain Huygens' comments, which show that he thought the camera obscura might be very helpful to painters? Writing in 1622, he wondered why painters had neglected 'such a pleasant and useful aid to them in their work'.[94]

There is a strange contradiction here, because even if the projection is attractive, we can see that there are problems associated with its practical use. Have we lost a piece of the puzzle along the way?

Not until we have explanations as to how Vermeer could have managed this technology; and what might have been the advantages for him to use a lens, can we possibly conclude he may ever have put up with the inconveniences and the uncomfortable conditions inside the camera booth.[95]

In any event, before Vermeer ever got to the point of using a projection, he had to find the equipment necessary to make a camera obscura. Lenses may not have been so hard to find in Delft; but we have to wonder if Vermeer would have had the means to buy one suitable for the task. Even though it seems he was 'not poor by the standards of his day', he still had the burden of a large family to feed.[96] Would he have needed to borrow money from Maria Thins, or from his patron Pieter van Ruijven, as he had done on other ocassions?[97]

Could Constantijn Huygens have been able to help? He was a champion and connoisseur of the arts, and a promoter of Rembrandt and van Dyck.[98] He was interested in science; he had wealth; and he lived not far away in The Hague. He knew all about the camera obscura. Might he have told Vermeer about it? Might he have even lent Vermeer the equipment he bought from Drebbel, all those years ago, which he probably had no use for now?

This is not an impossible scenario, not least because quite a few experts think that the documentation we have, shows they could have been acquainted; and because two visitors who went to see Vermeer, may well have gone there expressly at Huygens' suggestion.[99]

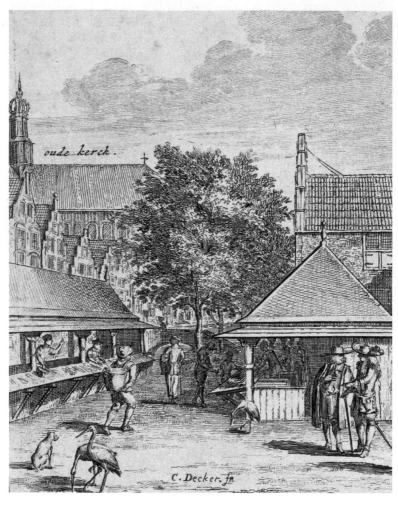

Figure 7.1 Coenraad Decker (1650–1709), *The Fish and Meat Market in Delft*.[1] (detail) from Dirck van Bleyswijck, *Beschryving der Stadt Delft* (1667), Engraving.

7

A Glimpse of Vermeer

Below the high towers, the stall holders raise their voices as they sell their wares. They have been here since first light to lay out their goods; and the produce from the farms outside the town walls waits invitingly in barrels and baskets: all kinds of vegetables and roots; fresh eggs and butter; and many cheeses, for which the Dutch are still known worldwide. There are stalls selling shoes, clogs, tinware, ironware, pewter, cloth, and china. There are fish and eels in tubs; birds alive in little wicker cages; and sellers with second-hand goods. Everywhere there is a throng of people, eager to be out, to share a joke, exchange gossip; and to buy something to wear, or to eat. It is market day in Delft.

Sailors and workmen spill out from the taverns with their jugs of ale, voices raised in laughter and in argument. Some storks peck at scraps near the fish counter, and boys play sticks by a canal, crowded with the boats and barges that have brought goods into town. Above the clamour and the hubbub of a hundred conversations, the deep hour rings out from the leaning steeple of the Oude Kerk.

Midday on the 11th August 1663.[2] A man stands on the stoop outside a house on the Oude Langendijk. He is waiting to see Johannes Vermeer.

It is hard to believe that when this stranger knocks on the door it will be answered by Vermeer himself: the painter who is so elusive, and for whom we have so many questions. We want to know a great deal. We want to know what kind of person he is; what he looks like; the names of his children.[3] We want to know what his house is like and how he starts a painting. Who was his teacher? Who are his models? Does he prepare his canvases, and his colours himself? Can this caller please look in the studio, and give us some clues as to how Vermeer creates his masterpieces?

We might be breathless with questions ourselves, but Balthasar de Monconys was either not motivated to make a decent record of his visit, or suffered from a complete lack of enquiry. This is what he wrote in his diary:

In Delft I saw the painter Vermeer who had no work at all to show (me): but we saw a painting at the baker's, for which 600 livres had been paid. Since this has only one figure in it, I believe that 6 pistoles would have been too high a price.[4]

We have reason to be deflated. This brief record can only be described as inadequate, with the further indignity of the assertion that Vermeer's picture was overpriced by a factor of ten.[5] Monconys could have no idea that every word in these few lines of writing would be picked over thread by thread, hundreds of years after his death. We have to be grateful for any evidence of Vermeer as a living person; but we are left straining to see small clues from an immense distance; breathing on a cold window pane to decipher any slight traces left behind.

It might seem strange that Monconys' report of his visit to Vermeer is this brief, when the reports of his journeys through Europe, Egypt, and the Holy Lands, between 1645 and 1663 are comprehensive, and leisurely. But then, although he appears appreciative of art, this was not his main interest. He was spotted in England on his tour by a fellow Frenchman, Samuel de Sorbière, who was making his own voyage of discovery. He found Monconys in a general state of excitement '…in his element, full of the conversation of Physicians and talking of nothing but Machines and new Experiments.'[6] The embellished indexes in the back of Monconys' books list his main preoccupations: *Physical Experiments; Machines and Artifices; Rare Animals, Plants, Stones and Birds; Secrets and Recipes; and Famous Men.*[7] Vermeer is absent from this last list, but then Monconys has not featured many painters, preferring instead to highlight illustrious personages such as the Prince of Portugal, the Prince of Orange, the Duke of Florence, and 'other great men of Italy'. It seems that Monconys thought himself as something of an ambassador for science, meeting 'natural philosophers' wherever he could, in order to exchange and spread the knowledge of his age.

The joy of Monconys' journal is that he is insatiably curious. In the space of any few pages there are a jumble of observations on subjects as various as the local architecture; the production of metals; a cure for sciatica; a fish with a head like a dog; new card games; excellent melons; and the effect of the moon on the tides.[8] Only occasionally do his emotions get the better of him. Some events are exciting: a live volcano, a strange fruit called a banana, and an encounter with pirates; but sometimes he cannot hold back comments on the privations of travel. He complains of unspeakable mattresses; the necessity of travelling by donkey; and the unfortunate theft of his pistols. We might feel that Monconys' recording, though in some ways delightful, is also undiscerning. It is a frustration that much inconsequential

information flows from the pages, when perhaps his most important moment of all is dismissed so curtly.

Monconys was a French diplomat; he was well connected, and of a social standing several tiers higher than Vermeer.[9] The very fact he went to call, makes us consider that Vermeer was not operating in a vacuum, but was part of a social network that extended far beyond Delft. It has been thought that Vermeer was not well known outside his home town, but here could be evidence to the contrary in the person of a visiting dignitary. However, this argument only holds water if there is evidence to suggest that he came specifically to see Vermeer, maybe because someone had made a suggestion that he should seek him out.[10]

The inevitable arguments over this, centre on two excursions made by Monconys in 1663, and the degrees of separation between him and Vermeer.

On the 3rd August, we find Monconys on the way to Delft by boat, gliding through countryside which, he remarked, 'looked like a pleasure garden'. He made a tour of the town, and saw the tomb of William of Orange in the Nieuwe Kerk, just yards from the Oude Langendijk.[11] If he was going to call on Vermeer, it seems strange that he didn't visit then, when he was so close by. Then, on the 8th August, we find Monconys with Constantijn Huygens, in his house in the Hague. The discussion was all about Art and Optics. The two men admired some pictures together, and compared various lenses in their possession.[12] Monconys was back in Delft once more on the 11th August, this time calling on Vermeer. Had Monconys returned because Huygens had told him he had missed something of significance;[13] or did he tag along with his travelling companion, a priest called Père Léon, to visit a fellow cleric who lived very close to Vermeer's house? Could the visit have been accidental: perhaps prompted by one of the passengers on the ferry, who happened to be a painter himself?[14] From these few facts it is difficult to do more than notice coincidences.

Maybe we should look again at Monconys' exact choice of words in his diary entry. There is something to suggest that he was particularly interested in Vermeer after all. He says there was none of his work (ses ouvrages) to see. This could possibly indicate that he was not interested in any of the other pictures in stock at the Oude Langendijk, painted by other artists, but only by those that came from Vermeer's own hand.

There is something more. Monconys uses the word 'point' not 'pas'. He is saying that Vermeer had nothing *at all* to show of his work.

This prompts various questions. Was there really no work to see, or could it be that pictures were kept out of sight? Painters of Vermeer's time were known to be secretive, and did not necessarily want to share their methods, or show work in progress.[15] However, Monconys was an important man and

would probably have arrived with impressive introductions. It might have been difficult to turn such a visitor away without offence. The only acceptable reasons not to let him in, and make him welcome in the great hall with a glass of wine,[16] would have been illness, or extreme inconvenience; or that the particular purpose of the visit could only be satisfied elsewhere. If there was no work to be found at the Oude Langendijk, then why was this?

Experts have fretted over the very small size of Vermeer's oeuvre. There is still disagreement about how many pictures are left to us, and the answer depends on whose opinion you believe. There are no drawings, studies, or prints by his hand, so we can make no comparisons with preparatory or parallel work, which could help with dating and identification. It seems we have between thirty three to thirty five of Vermeer's pictures in total:[17] a tiny figure, especially if compared with the output of some of his contemporaries such as Rembrandt,[18] or Jan Steen,[19] who both produced hundreds of works.

Matters are not helped by Vermeer's reluctance to date or sign his paintings, and by the lack of much supporting documentation. Descriptions of his pictures listed in wills, inventories, and those in sale catalogues of the era, have been paired with those we have; but this procedure has provided only an incomplete result.[20] Not all the paintings agreed to be by Vermeer appear on a list; and others that are described in detail are missing.

For a picture to be accepted as a true Vermeer, it is not enough that the paint structure is identical to what is known of his working practice; that the materials used are authentic;[21] that the subject matter and manner of painting bear a strong resemblance to pictures we know to be his; or that objects and costumes worn by his models reappear. Irrefutable stylistic and scientific evidence has to be present, but so also does strong documentary provenance. Connoisseurship cannot be trusted on its own either. The art world was stung by the spectacular forgeries of Han van Meegeren in the 1940s, who fraudulently convinced scholars of his day that paintings had been found from an early 'missing period' of Vermeer's working life.[22] The experts do not intend to be caught napping again.

Some sort of catastrophe, such as fire, could have destroyed some of Vermeer's paintings,[23] but his output may never have been that large; and the positively identified pictures we have, could be a good fraction of his complete work. It has been reckoned that Vermeer might have painted between forty-five and sixty pictures in total, so maybe there are only very few of his masterpieces left to be discovered in Dutch attics.[24]

We may find it difficult to believe that Vermeer had no work in progress to show Monconys in August 1663, especially since there were often unfinished

pictures to see in other artists' workshops;[25] but there is a possible reason why there was nothing to admire at the Oude Langendijk. It could be that at this time, his studio was not in his house at all, but elsewhere in the city.

Monconys arrived during the period in which Vermeer is estimated to have been occupied with his great *View of Delft* (Fig. 7.3). Though no one has suggested this before, all Vermeer's painting gear could had been moved across town to paint this picture. He may have decided to concentrate his efforts in one working space, rather than having to retrieve anything from home when he needed it.

There is a suspicion that the *View of Delft* was a commission, possibly offered by his wealthy client, Pieter van Ruijven,[26] who is thought to have owned about twenty of Vermeer's works. As a patron, he may have footed the bill for the rent of an upstairs room overlooking the water. Apart from giving Vermeer a quiet, dedicated space in which to paint, this change of working base would have had the additional benefit of taking some pressure off the accommodation in Maria Thins' house; because by 1663 he and Catherina may have had as many as six children.[27]

There is a clue in the picture itself, which suggests a timeframe for this painting: there are no bells visible in the sunlit tower of the Nieuwe Kerk. These were taken down for restoration between early 1660 and late summer 1661. Some experts think that Vermeer finished this painting sometime between 1662 and 1665, maybe working on it for several summers in a row.[28] We can imagine, solely on the basis of the large size of this canvas,[29] that it must have taken Vermeer quite some time to complete it, but there is technical confirmation of this too. Underneath the stripes on the skirt of one of the women in the foreground, is an older, cracked layer of paint. This means that the picture was left for some while to dry between painting sessions.[30] Maybe Vermeer did not have to hurry to finish, and the reason for a small output was that he was just too busy with other affairs. There could possibly have been a time when income from painting was helpful, but not essential, and he could rely on Maria Thins' munificence and other earnings from picture dealing. But it could also be that he worked at this painting intermittently over a long period, because he had to wait for the weather to turn warm enough; and because he could only work in good light. A rented room next to the open water could have become uncomfortably chilly, especially if he had little control over the heating arrangements.

We know the place Vermeer would have had to be to see the vista he offers us in the *View of Delft* (Fig. 7.3). Old maps show a house beyond the Kolk, the little triangular harbour on the south side of town (Fig. 7.2);[31] and Vermeer

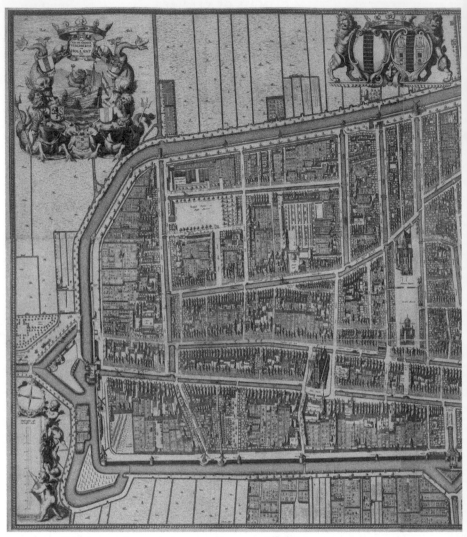

Figure 7.2 Dirck van Bleyswijck (1639–1682), *Map of Delft* (*Kaart Figuratief, Staat I*), 1675. Delft Archive, B&G inv. nr. 108599.[32] North is on the left of this map.[33] Vermeer painted from a spot on the South of the city, overlooking the triangular harbour of the Kolk, at the bottom right of this map. We can see the Markt, with the Nieuwe Kerk at the top and the Stadhuis at the bottom, running roughly East–West, right at the centre of the city. The epi-centre of *The Thunderclap* was in the empty space at the top left of this map, which subse-quently became the horse market. Vermeer's view encompassed the part of the city that escaped much of the damage caused by the explosion in 1654.

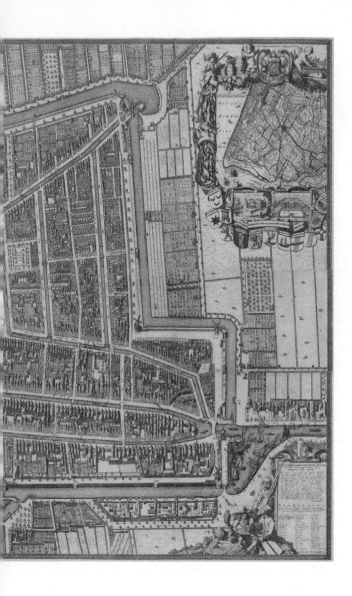

Figure 7.3 Johannes Vermeer (1632–1675), *View of Delft*, c.1661–1663. Oil on canvas, 96.5 × 115.7 cm. Mauritshuis, The Hague.

must have looked out of an upstairs window to see the shore beneath him, and the herring boats moored in front of the water gate to the town. However, in comparison to his view from this spot, what we see today is a broken music box. Although we can get our bearings from the church tower and the water's edge; the foreground is now sadly gap-toothed. The bridge and town gates have disappeared completely, as has the gravelly beach (Fig. 7.6). Only the sky and the changeable light remain absolutely true to the painting. The wind, springing up in sharp gusts, reminds us why the water riffles away from the little figures on the shore, and why they are bundled up in shawls and hats.

No reproduction of the *View of Delft* (Fig. 7.3) does justice to this masterpiece. If you are lucky enough ever to stand in front of this painting in the Mauritshuis in The Hague, you are likely to find its effects as captivating as do many other visitors. They have also turned their backs on one of the most famous pictures in the world, to follow the gaze of the *Girl with a Pearl Earring* (Fig. 5.1). She is actually not looking at us after all, but at the town

in which she was born, the town in which she was painted. Together we see straight into a tranquil, newly-washed, early summer morning in Delft 1663;[34] as if through a window in the wall.

The painting is pure compelling illusion: seventeenth-century virtual reality. We are not just looking at a scene from the outside, we experience the atmosphere ourselves. We stand on the rough sand with our cheek against the fresh breeze, looking out across the water. The sun has not risen high enough for warmth, though we see the early light on the towers of the town. We smell the promise of rain; and catch the tarry dankness of the boats, as they bob gently in the water, tugging and scraping on their moorings. The feeling is not of action, but of anticipation. Could the group on our left be waiting to hear the bell, to indicate it is time to board a ferry? The boat they are standing by has a cover, rather like the protective tarpaulins described in journals of the time; and the clock hands on the gatehouse tell us it is ten past seven: there is twenty minutes or so to go before the next regular week-day service.[35] However, there is strangely little activity for a transport hub normally as busy as the Kolk: it was the terminus for barges to Rotterdam, Schiedam, and Delftshaven; and a port for herring boats (or 'busses' as they were called). But it is quiet enough now to hear the lapping of the water at the quay. Maybe it is a Sunday, and the people have not gathered for a journey, but for a conversation before church?

The men and women appear not to cast any shadows on the sand. However, the buildings across the calm water are doubled in monumental-ity by their strong dark reflections on the Kolk. The clouds look threatening, and we see the silvery underside of leaves, as they curl in the wind.[36] There is something about the quality of the light; of the little speckles of illumin-ation; of the ripple of glinting water; that feels immediate. Vermeer con-vinces us that his painted illusion is an expectant reality.

Of course, we know at the same time that it is not. This is a morning in Delft, but at the same time, it is a painting on a wall. Visitors in the Gallery approach this picture with bewilderment: they peer at the roofs tiles and the bricks, and at the tiny figures on the far shore; they squint at the clouds and the water. It makes no difference how closely they look; they cannot under-stand how it is all made only of paint.

Vermeer has put the last piece of jigsaw into the puzzle, leaving not a crack of evidence as to how he worked. Close to, the forms lose meaning, and appear abstract: they are roughly dabbed with thick paint in some areas, with thin glazes in others. There are surfaces that are cratered with texture, some that are smooth as silk.[37] And Vermeer has touched his canvas

Figure 7.4 Johannes Vermeer (1632–1675), *View of Delft* (detail), *c*.1661–1663. Oil on canvas. Mauritshuis, The Hague.

everywhere with the smallest brush; everywhere there are little points of paint: an encrusted bead of white on the edges of the roofs; sequins sparkling on the dark boats. Nothing is in crisp focus; everything, everywhere, appears bejewelled with light.

It was the extraordinary qualities of this painting that re-awakened an interest in Vermeer in the late nineteenth century;[38] the very one that Proust wrote about so eloquently; and in front of which one of his characters breathes his last.[39] It has been described as the nearest thing to a photograph, by more than one art critic[40] and there has been continuing, vigorous discussion as to how Vermeer ever produced such a remembrance of a moment in time.

However, the experts tangle themselves up in a mixture of conflicting emotion, rationalization, and reasoning. They wonder at Vermeer's consummate sleight of hand, but at the same time, they are in agonies about what is truthful and what is not. They point out that Vermeer is playing with us

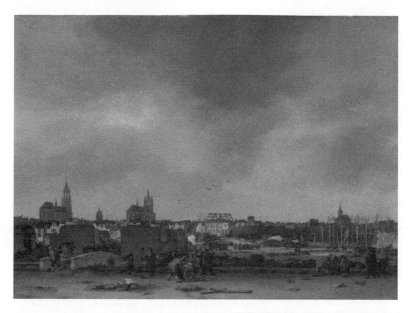

Figure 7.5 Egbert van der Poel (1621–1664), *A View of Delft, after the Explosion of 1654*. Oil on oak, 36.2 × 49.5 cm. National Gallery, London.

from the start: showing us Delft from its very best side, and depicting a scene that is tranquil and undisturbed, while much of the far side of town must have still been in a semi-derelict state after *The Thunderclap* munitions explosion only nine years before (Fig. 7.5).

The critics go on to explain that Vermeer's buildings are not quite correct in position, or size, when compared with old maps, and other contemporary pictures.[41] And they point to the variable lighting of the scene, concerned that the reflections and the shadows are not consistent. They say this cannot be a real view of Delft.

Here they have plainly missed the point. It is because we know this to be a picture, that we are so astounded. We understand we are not seeing an absolute truth: we are looking at a painting; but one made so well, that we believe its deceptions.[42] Of course we would like to know more of Vermeer's painterly conjuring trick; but to have any understanding as to how the *View of Delft* was made, we have to think inside out: from back to front. We have seen something of the work of the artist in his day: the preparation and planning; the slow build up of paint; the careful choice and order of pigments.

We have to remember that the final image we see, the top surface, will include painting that was done last of all.

The creation of this picture must have been the result of very many viewings of the subject over a long period. The sky; the brightness of the light; the shadows; the colours and textures; would all have changed with the time of day, the weather, and the seasons. The reflections in the Kolk would have been less variable, but would have differed in intensity depending on the disturbance of the water, and the sun on the buildings.[43] At some points, the boats may have been bathed in light, at others obscured in shadow; so the lighting in this picture is bound to be inconsistent, because it is a composite view. We might imagine we are experiencing an instant; but we are not. We are seeing a time-lapse. And just because this picture looks 'realistic', it does not mean that Vermeer could or did put down everything he observed; or that he did not adapt and change what he saw to strengthen visual effects.[44] There must have been a selective accumulation and moderation of facts, which might have produced an image that is 'convincing, beyond all disbelief',[45] but which is inevitably as artificial as all paintings must be.

Vermeer had to decide where he would stand to observe Delft, in order to establish his composition. Which window should he use? What might he like to include from here, or from any other viewpoint, and what should he ignore? One of his trademarks is the attention he pays to the construction of his picture, and the dynamics of the movements within it. He thought carefully about the weight of shapes, and where he wanted the viewer's eye to travel; where he wanted it to rest.

We see clearly some of his compositional choices: the figures of the two women align with a dip in the roofline on the left, around the point of the golden section of the canvas format.[46] We can see that Vermeer has 'marked' the centre of the canvas, with the side of the Schiedam Gate. This point is also just at the place where the sandy far shore ends. We can see the repeated rhythms of horizontals, from a sea-blue horizon, down the ridges of the roofs of bright houses; then we register a chequerboard of alternating light and dark buildings stepping down towards the right of the canvas. Vermeer chose to make all these movements important, chose to provide a strong structure underpinning his picture, to provide dynamic energy.

Looking beneath the surface, using modern scientific techniques, it is possible to see where Vermeer changed his mind; and how he adjusted his picture as he worked.[47] He strengthened and lengthened the reflections of

the buildings to extend from shore to shore; he enlarged the shapes of the boats; moving the twin-towered Rotterdam Gate out of the sunlight and into shade;[48] and he also eliminated the figure of a man, wearing a large hat, in the foreground.[49]

If this picture appears 'real' to us, it is not because things are very detailed, but because Vermeer has grasped the essentials of the tone and the shapes, and has left much for us to interpret ourselves. It is not like looking at a high definition image on a screen, or even a photograph; but like glimpsing something out of the corner of our eye, something we feel to be familiar.

Scholars have long wondered whether Vermeer painted the *View of Delft* with the aid of a camera obscura.[50] Could the use of a lens possibly account for the slightly out of focus quality,[51] the veracity of the tonal balance, the almost square image, and the hugeness of the sky? Was anything traced directly from a lens, or could it be that Vermeer observed the flickering light on the boats and water through a camera; and this influenced the way he rendered it in his painting?[52]

Despite the fact there seems not to be undue anxiety about whether Vermeer might have used drawing aids, such as strings or rulers; very great worry is expressed as to whether Vermeer might have done anything more than look through a lens, and been affected by what he saw. The idea that he might ever have traced something from a projection, and then have transferred this information to a canvas directly, is rejected outright by some.[53] The real problem is that no one has ever suggested a practical solution as to how this ever could be achieved, particularly with as large a picture as the *View of Delft*,[54] and as a result it has not been possible to judge whether using such an optical device would compromise his position as a painter of genius or not.

It may be worth thinking again about what it is that makes Vermeer's painting so compelling. The *View of Delft* (Fig. 7.3) hangs in the Mauritshuis right next to a picture which has all the construction you could wish for, but no comparable power. Pieter Jansz. Saenredam drew near perfect architectural studies of his subjects, and transferred these onto his canvas[55] before adding colour. But his work looks pallid in comparison to the *View of Delft*. What is lacking is not care or skill, but tonal strength. In this, Vermeer does not falter. As one expert put it: 'The emotional impact of the painting derives from the bold silhouette of the city against the sky, the reflections of the water, and above all from the dramatic use of light to focus the composition and articulate the space.'[56]

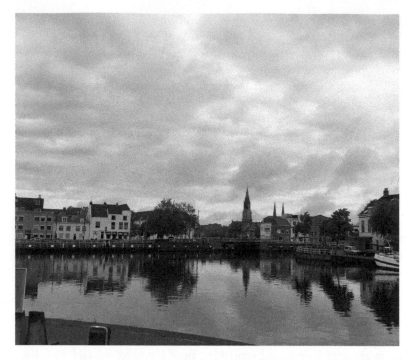

Figure 7.6 Photograph of the site of the *View of Delft*. This photo of the Kolk, taken in May 2016, is not from quite as high a viewpoint as Vermeer would have had from the first floor room of a house on this spot. The day is gloomy; but the water is calm, and so the reflections are strong. The twin spires in this picture belong to the Maria van Jessekerk, just behind the Oude Langendijk. Both the Rotterdam and the Schiedam Gates were demolished in the early 1800s.[57] The sandy beach of Vermeer's day is likely to have extended farther into the water than the shore does here, as it is now contained by an embankment.

It appears Vermeer worked on this difference in tone before he did anything else. He put down the bare bones of the image working on a buff-brown canvas. He blocked in the buildings and their reflections in dark paint; and filled in the sky with white, before he created the billowing clouds.[58] Working slowly, he applied the flat earths, and then gradually turned up the volume on the brightness and suggestions of detail in his picture, choosing from his more expensive pigments. Finally, he applied some coloured veils of glaze.[59]

This is familiar to us now. We see that a tonal plan is the start of the conception of this image; and that its power remains beneath the shadows on the water, and the sunlit roofs.

If, at the time of Monconys' visit, Vermeer was working in a studio over-looking the Kolk, why did he not take him to see this extraordinary work? Maybe because, even today with the road bridge, it is a good twenty minutes walk away across town. Monconys might have been keen to get on else-where, or perhaps Delft was too crowded with market-goers for a comfort-able stroll to the city bastion. People were not just gathering in the Markt: there were pubs at every corner; and many bridges would have been con-gested with buyers looking for shoes, butter, fruit, and vegetables.[60]

We can imagine other possible explanations. It could be Vermeer hadn't finished his *View of Delft* and didn't want to explain himself. It could be that he believed that the picture at the baker's would be enough to impress his visitor, and he didn't need to show him anything else. But if he had thought this, he may have made a misjudgement.

The short description we have in Monconys' journal could be interpreted as suggesting that not only was he shocked by the price of Vermeer's work, he also didn't particularly like what he saw. He does not hold back his enthu-siasm for some other paintings presented to him only a few days later. He talks of the 'incomparable delicacy' of the brush of Gerrit Dou in Leiden, where he saw a picture that was just as expensive, and that also had only a single figure.[61] When Monconys went on to see Dou's former pupil, Frans van Mieris,[62] he was particularly taken with some red velvet in a painting with three figures, offered for sale at an eye-watering 1,200 livres: double Vermeer's price. Monconys said that van Mieris was painting the velvet 'so well that one is convinced it is (real) fabric'. We cannot but notice that such accolades, although not that expansive, are completely absent in the account of his visit to Delft.

It was maybe that Monconys was calling on artists' studios out of curios-ity rather than with an intention to buy work. He took the opportunity to see art collections where he could, confirming the interest of a connoisseur. Whatever his opinion on art, his notes on the prices of paintings are useful to us, because they do show that someone was valuing Vermeer in his day. But we are prompted to wonder what factors Monconys included in his crit-ical appreciations. He seems to have liked detailed painting; but how did he judge a painting's worth? We do not know what was paramount to him: the size of the canvas, the number of figures, the reputation of the artist, or the materials used in their making.

The man who owned the picture that Monconys saw in Delft was most probably the very same Hendrick van Buyten who held the family debt for bread and bartered it for paintings after Vermeer died. He was rich, had

several premises,[63] and possibly owned as many as four paintings by Vermeer.[64] It is unlikely that these would have been kept in the dusty conditions of the shop, but safe at home, where they could be appreciated at leisure. But why did Vermeer choose to take his visitor to the baker and not to his main patron, the wealthy Pieter van Ruijven who we know had a bigger collection of his pictures?[65] Maybe Vermeer did not want to disturb him, or maybe van Buyten's house was a more convenient stop for Monconys.

We might like to imagine Vermeer strolling through Delft with his visitor, walking the short distance from the Oude Langendijk, down the side of the busy Markt, to the baker's home, called 'the Golden Cup'. This house still stands, and has a prosperous air even today; although it has obviously undergone some changes with its new plate-glass windows. It stands on a wide canal, not far from the trading centre of Delft, just round the corner from where the Dutch East India Company had its headquarters. Unless Vermeer sent one of his children running ahead, his would have been an unexpected visit; but maybe Van Buyten would not have minded Vermeer's sudden appearance, even if he was accompanied by strangers, because his kindness to Catherina after Vermeer's death suggests that the friendship between the two men may well have been 'longstanding and close'.[66]

Which of Vermeer's paintings did Monconys see on van Buyten's wall? Three paintings by Vermeer were found in the baker's house after his death, one large and two small. The descriptions in his death inventory identify two of these, which must have been the pictures given to van Buyten by Vermeer's widow, Catherina, to pay off her huge debt for bread. The first had two figures, including a person 'writing a letter'; and the other showed someone 'playing on a zither'.[67] So these were most probably the unfinished *Mistress and Maid* (Fig. 4.7); and either the *Woman with a Lute* (Fig. 0.1); or *The Guitar Player*. The third painting, with 'only one figure.' is thought, by a process of elimination, to be the *Woman in Blue Reading a Letter* (Fig. 7.7).[68]

When Monconys gazed at this serene picture, was he seeing what we see now? New-born from the easel, the painting must have radiated its fresh light cleanly, without interruption from the grime, or the touches of the restorer's brush, that obscured it in later years. We are fortunate that this picture has recently had much attention;[69] and so now, once again, the colour glows and the girl reads uninterrupted, completely unaware we are watching her, absorbed in the paper that is folded stiffly in her hand. She holds her arms tight by her sides; sounding the slow words in her head; bracing her body for the news the missive might bring. Why does she read against the light?

Figure 7.7 Johannes Vermeer (1632–1675), *Woman in Blue Reading a Letter* (detail), *c*.1663–1664. Oil on canvas. Rijksmuseum, Amsterdam.

What can be in her letter? Many experts have spent time explaining the meaning in this picture: suggesting alternative interpretations, dependent on whether we believe this woman to be pregnant or not, and what might be the nature of the message she has received.[70]

We might only notice the way the woman fits so perfectly into her space, trammelled between the table, chair, pole, and map; and see the weight of the rectangular divisions that anchor her against the rough plaster wall. We might feel the slight shade of the bar across the window, and the angle of the heavy chair leg at her feet; and notice how she stands at once in front of the

map and becomes part of it at the same moment, her hair ribbon fading into the hanging chart. She casts no shadow: we doubt her substance; and yet she stands solidly against the newly washed light, which streams into the room, breaking into the kinds of blue only the poet Rainer Maria Rilke can describe.[71] We recognize his *cold barely-blue* in the walls, *blue dove-gray* in her skirt, *ancient Egyptian shadow blue* glimmering on the table top, *waxy blue* on the chairs, and an intense *densely quilted blue* in her housecoat; providing warmth against the coolness of the Delft air (Fig. 5.4).

How did Vermeer play his blues with such delicacy and assurance? In a painting it can be as Christiaan Huygens believed it was in nature: that blue and yellow make light.[72] Nothing would come alive in this picture without the dull ochres, the olive green, and the faded wet and dead leaf colours, that are juxtaposed with the blues; nothing would sing without the deep golden bows at her breast and arm, that fold against the azure silk.

Over time, this picture became obscured by uneven layers of old, yellowing varnish, and had been slightly altered by previous restorers. Efforts to retouch the painting had led to changes in its appearance: one of the chair legs had become thin, and also an extra row of pearls on the table, not painted by Vermeer, had appeared on the table.[73] It seems that some small, white dots had been misinterpreted by the restorer and he had added highlights. The picture had been slightly extended too, which made the composition feel less immediate.[74]

This painting also needed urgent attention, because the heavy heated irons,[75] used in the past to attach a new canvas to the back of the picture, had caused some of the surface to blister: there were small spots of missing paint and also areas where it had been flattened. Cleaning and careful restoration corrected these past mistakes, stabilized the paint surface, and revealed colours and small details, which had been lost.[76] Now we are better aware of the curve of her neck as she concentrates on her letter; we observe the pressure of her thumb, squeezing out a sharp shred of paper; and our eye can travel unhindered down to the loose end of her sleeve and up to her face once again. Not just the paint, but the equilibrium is refreshed and re-established.

We might admire this picture, but it would appear that Monconys was not much taken with it. Should we condemn him for not being rightly appreciative of what he saw and who he met that day? Just because his diary entry is uncharacteristically short, we should not infer any emotional undertones in his encounter. Perhaps there is no record of conversation between him and Vermeer, because words could not flow easily. Monconys did not speak

Dutch, and it is unlikely that Vermeer spoke French. Possibly, Père Léon could have translated, but he may have gone off on other business once they arrived in the town.[77]

Some scholars would like to put a particular interpretation on Monconys' visit to Vermeer. They think the two men had something important in common.[78]

Reading more of Monconys' diary in its old French with its strange phonetic spellings, it does not take long to see that he had a very strong interest in science, and was mad about lenses; so much so that his luggage must have been weighed down with glass. He searched out anyone who shared his passion for microscopes and telescopes, and listed all the lenses he bought, together with the prices he paid for them. He tells us enthusiastically of the many experiments he witnessed and the cabinets of curiosities he saw; and of his meetings with a number of notable scientists of the day.

It becomes clear also that Monconys was part of a huge academic network: the visits he made in just a few days around The Hague in August 1663, linked through connections to the most serious thinkers of his era; giving Monconys access to a greatly diverse practical and theoretical enquiry, which today would be encompassed by atmospheric physics, meteorology, botany, calculus, oceanography, metaphysics, epistemology, political philosophy, ethics, optics, philosophy of mind, and philosophy of science.

Monconys' route to Holland, took him via England. Volume 2 of his diary opens in May 1663, with him waiting impatiently in Dover, after his boat crossing, having to kick his heels waiting for a horse to ride, because 'the English never travel on Sundays'. When he finally got to London, one of the first people he saw was Henry Oldenburg, the secretary of the Royal Society, and in the course of his visit, he met Christiaan and Constantijn Huygens, who he saw again later in The Hague.

Adding to these events of interest to us, it is possible that Monconys may have seen a working camera obscura in London. He visited Richard Reeve,[79] the best instrument maker in the capital, and saw an optical arrangement, which included a bi-convex lens, producing an image on a 'leaf of glass'.[80] He was unable to buy the telescope he wanted, but was shown instead some kind of lantern with a lens. A year later, Samuel Pepys also visited Reeve, and while purchasing a microscope, was given an instrument called a 'scotoscope'.[81] Pepys remarked in his diary that this was a 'curious curiosity and is to (see) objects in a dark room'. Some think this could have been a camera obscura.[82]

Could it be that it was Monconys' interest in the uses of optics, that led him to Delft? After all, we have seen that it was a place well known for lenses. Maybe he was going there to acquire some more for himself, and possibly to see how they could be used not just in innovations of science, but in those of art. Perhaps he was there to see how a camera obscura could be used in practice?

Monconys could have been standing on Vermeer's doorstep, not as a chance visitor, or even as a potential buyer of pictures, but waiting in the Saturday sunshine to have a conversation about a great interest he might have shared. An interest in lenses.

If this was indeed the case, then we have to ask how Monconys would have known that Vermeer might have been using optics in his work. Vermeer may have been as secretive about his methods as other painters were.

It may seem obvious that such information could have come via Constantijn Huygens; but there is a complete lack of concrete evidence to prove that he and Vermeer were ever acquainted. However, the consensus among art historians now is that 'it is almost unthinkable' that they were not;[83] and their suspicious were given further credibility as a result of a chance discovery in the Royal Library in The Hague in the 1980s. A researcher came across the diary of Pieter Teding van Berckhout (1643–1713), who was to become an important citizen of Delft, and who moved in the highest social circles. Written in French when he was twenty six, van Berckhout recorded two visits he made to Vermeer in 1669, six years after Monconys' trips to Delft. He arrived by boat, in company with Constantijn Huygens.[84] Although he writes in the first person: 'I saw an excellent painter named Vermeer...'; experts have wondered whether he is likely to have gone to the painter's house on his own; or whether he would have gone with Huygens, who appears likely to have organized the visit.[85]

How is it that Huygens is always at hand, always in the right place at the right time; but at the same time is so elusive? Did he take van Berckhout to the door, but no further, as he didn't want to set foot in Vermeer's house because it was a Catholic establishment? It may not have been seemly for him to have gone there as a senior member of the elite, and as a Protestant himself; or was it that he did not need to visit, because he already knew what was in the studio?

However, if Vermeer did know Huygens personally, then we would have to imagine him as a painter whose work commanded attention from those of importance.

Van Berckhout must have liked what he saw in Vermeer's studio, as he returned a month later, and used even more enthusiastic language to report on his visit. Now Vermeer was described as 'famous'; and van Berckhout added that 'the most curious and extraordinary thing' about his painting was 'the perspective'. All these statements have given rise to further argument. What did van Berckhout mean by 'perspective'? Did he mean that Vermeer had constructed his pictures using drawing techniques, or could it be a reference to the illusion he created?[86] What did he mean by 'famous'?[87] How well known was Vermeer, had his reputation spread beyond Delft? What did he mean by 'curious'? Did he think Vermeer was painting in an unusual way? As we might expect by now, there are no definitive answers to any of these questions.

It seems that van Berckhout did not buy anything at the Oude Langendijk; or he might have said so. Was this because the prices were too high, even for his deep pockets, or were the paintings he saw not for sale? We can't be sure what was on display, but a likely contender is *The Art of Painting* (Fig. 1.4), which was probably a showcase piece; made to encourage clients to commission work. It is possible that either *The Astronomer* (Fig. 6.5) or *The Geographer* (Fig. 6.6) was there to be seen too. It may be no coincidence that van Berckhout's father-in-law, Adriaen Paets, appears to have acquired the former for his collection some time later.[88] We do not know van Berckhout's motivation for visiting Vermeer; but we cannot but be interested in the fact that after his death at the age of seventy, at least one camera obscura, some microscopes, and other scientific instruments, were listed among his possessions.[89]

The two visitors we know came to Vermeer's studio, responded very differently to the work they saw. Whereas van Berckhout's diary is full of effusive praise, Monconys is more than tight-lipped: he says nothing at all.

Did he not like Vermeer's style, which was looser and more abstract than that of the meticulous Dou, whose paintings he admired so much? Or was it that he did not understand the extraordinary qualities of what he was seeing?

He may not have appreciated the luminosity of the *Woman in Blue Reading a Letter* (Fig. 5.4). He may not have understood how it might satisfy a craving for sun, on the many days that were dull. As a traveller from a warmer climate, and visiting in summer, he may not have had any idea about how bad the weather could so often be in Delft.

Figure 8.1 A window in Delft.

8

The Brightness of Day

It rains. Brewing in darkness, the storms roll huge heavy clouds across saturated land, and it rains relentlessly, filling the dykes and ditches. The squalls sweep across the cobbled streets, and swirl in arcs across canals; piercing their swollen surfaces with a thousand hissing needles. Water drums against brick, stone, and tiles, it sheets from the steep roofs, and twists in fat, dark streams out of the gutters onto the alleyways. The sky grumbles: there is more yet to come.

Doors and shutters may be made fast against the downpours, but wet comes in regardless. It comes on coats and hoods; on soaking footwear; on the hoar of woollen cloaks; it drips down the chimneys, and seeps through everything; finding the smallest berth. People desert the streets: they seek shelter and warmth in their inner kitchens; but the peat fires burn feebly in the grates.[1]

Inside is damp; damp, and cold, and dark. Sodden garments, hanging heavily out to dry, consume some of the little light that issues through the windows. The dull curtain of rain, and the granite sky, dim everything to dusk. There is nothing to be done, but sit in the grey, and wait. This is not a day for going out; this is not a day for painting.

It is not insignificant that the Dutch have twenty-six words for rain, more than the Inuits have for snow.[2] Delft may not now be quite as cold as it was in Vermeer's day,[3] but it is wet still, with an average of sixty millimetres of rainfall a month throughout the year.[4] Then, without plastic and nylon, waterproofing was a major concern. 'Books of Secrets' included recipes to make fabrics and leather impervious, using precious beeswax, and oil. There are directions to protect 'hoods, riding coats, gloves, wagons, and baggage covers' using fish glue and honey. Just in case you thought this might not be fragrant enough, there is also helpful information for waterproof shoes, suggesting that the 'leather of a cow that (has) laid in a ditch' is best of all for the purpose.[5]

Modern tourist information recommends bringing an umbrella to Delft to cope with its 'moderate maritime climate',[6] but they were not available in Vermeer's day. Invented in ancient China as a protection against the sun, they did not reach Europe until the seventeenth century, and they were uncommon then. A contemporary of Vermeer, Gerrit Dou, shows us some paper sunshades in his paintings (dated *c.*1632 and 1652);[7] and the diarist John Evelyn writes of seeing one, as a curiosity, in London in 1664; but it took until 1768 for a Paris magazine to report on their general use for wet weather. It commented that umbrellas were carried everywhere in case of rain, except by those who would 'prefer to risk getting soaked' rather than 'to be regarded as someone who goes on foot…(as) an umbrella is a sure sign of someone who doesn't have his own carriage.'[8] It is not known who in Delft would have bothered with such a distinction, but the need to keep dry is still essential now. There has been a recent local initiative to solve the irritating problem of umbrellas turning inside out, and a storm version has been invented, that will resist winds of up to a hundred kilometres per hour.[9] Its asymmetrical shape allows it to stay open on a bicycle, or even while whizzing downhill on skis. In the spirit of Mary Poppins, there is also some astonishing film of skydivers, checking its performance on descent. However, it is certain that a parachute, not the umbrella, brought them safely to earth.

Open to the North Sea, the wind sweeps across the low lands of The Netherlands, often bringing cloudy and wet weather. Vermeer must have experienced very many changeable and gloomy days. So it is difficult to explain the particular radiance of his paintings. Was there a special light shining in his corner of Holland? Some people believe there must have been, even though they have not found it yet.[10]

Vermeer shows us figures in luminous spaces, with shadows that appear to be truthful,[11] but he would not have had strong sunlight for long. Was it all imaginary? We find that Vermeer was not the only Dutch painter to show fine weather in his paintings, despite the evidence that the prevailing conditions of the time were not good. We see pictures of Winter: some of extreme cold; some of fun and games on the ice, but where cloud formations do appear, they sometimes have been adjusted to suit the composition rather than the truth.[12] People did not need to be reminded of miserable days: they experienced them for real often enough; so maybe we cannot be surprised that artists either made cold days look entertaining, or tended to show good weather in their pictures, which they knew would sell better (Fig. 8.2).

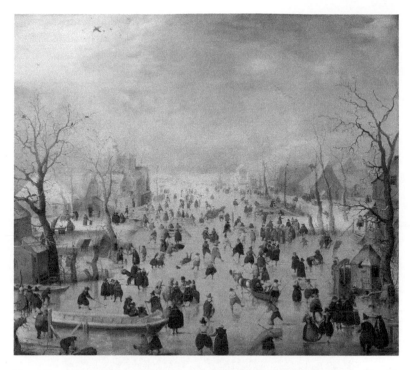

Figure 8.2 Hendrick Avercamp (1585–1634), *Winter Landscape with Ice Skaters* (detail), c.1608. Oil on panel, 77.3 × 131.9 cm. Rijksmuseum, Amsterdam.

It is something of a surprise to discover that while the seventeenth century was a 'Golden Age' for the Dutch Republic and Dutch painting, it was not a time of golden weather. The particularly harsh winters and wet seasons of the time affected countries all around the world, and were contributory to a general economic downturn. The reduced food supply made people vulnerable; and the century saw a global increase in starvation, disease, and political disturbance.[13] The Dutch economy was robust enough to resist this trend, and still managed to prosper until 1672, when the English and the French invaded. Then the land beyond the towns was flooded deliberately, in an attempt to impede the enemy; but in the process of making the terrain impassable to men and ships, the water ruined the crops.

This was the *Year of Disaster* for the country,[14] and for the Vermeer household too. The cares of the outside world broke down the doors of the Oude

Langendijk, and came rushing in. Maria Thins lost money because her tenant farmers could not grow anything, and so could not pay their rent; and the market for paintings collapsed completely, leaving Vermeer without an income. He borrowed money; he bought bread 'on tick' from the baker; he sold stock *'at a great loss';* and ran into *'great debts.'*[15]

It is probably not fanciful to suppose that Vermeer's creativity was crushed by these events. We can see for ourselves how depression sat on his shoulders, as he contemplated the change in his fortunes. *A Lady Seated at the Virginals* (Fig. 8.3) was one of his last pictures;[16] and by then, he had lost heart, his energies eclipsed. The window is closed, the shutter is black, and the girl sits in the gloom. She looks at us vacantly, without the interior conscious intensity, evident in so many of Vermeer's other models, and she makes no effort to convince us that she knows how to play her musical instrument. We see her lumpy hands sitting heavily on the keyboard,[17] her attention elsewhere. This

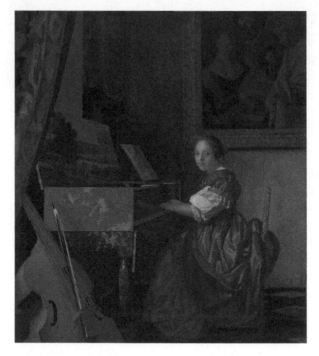

Figure 8.3 Johannes Vermeer (1632–1675), *A Lady Seated at the Virginals*, c.1670–1672. Oil on canvas, 51.5 × 45.6 cm. National Gallery, London.

picture is an empty shell. We hear no music, and we sense no connection; we miss the glow of feeling; we miss the glow of light.[18]

Added to the greyness of his days, Vermeer's nights were long and disabling. We are so used to our twenty-four hour lifestyle, lit by electricity, that we forget completely that it could be black for up to thirteen hours in the winter at his latitude. Artificial lighting in Vermeer's house was limited to the glow a fire could give, and to any candles he could afford. Naked flames, and smouldering hearths, left overnight to be rekindled the following morning, were a fire risk; and Delft suffered its share of conflagrations.[19] Some tasks, such as laundry, spinning, or baking were still performed in the dark hours. However, painting could not be one of them. Even if Vermeer got up between the two periods of sleep, which seems to have been a common pattern of rest during long nights of darkness,[20] he is unlikely to have been able to do more than think about the work ahead in the daytime. He would not have been able to prepare his palette, or set out his colours at night, let alone see his picture properly.[21]

We might wonder how he coped in the restless dark of the tall house in the Oude Langendijk near the end of his life. Maybe he lay awake in the chill before dawn, worrying how he would manage to provide for his large family, whose coughs and murmurs came through the walls; as the latest baby lay damply snug between him and Catherina. He had few stratagems to employ, and little power to improve his own tottering finances; but we do know he went on various forays at Maria Thins' request, to collect in debts she was owed, in order to scrape together what they could. There is even a suggestion that, in his desperation, he used her capital illegally to raise a loan of his own.[22] It must have been a wrench to be pulled away from artistic endeavour, and come to terms with the fact that the ability, in which he had so much pride, suddenly had no purpose. He had been made Master of the Guild once again in 1671, but such a position must now have held only a shadow of its former glory.[23]

1675 was known as the year 'without a summer', and maybe the incessant greyness of the skies[24] contributed to Vermeer's downfall; adding to his depression and despondency; his 'decay' and his 'decadence'. He died on the 13th or 14th of December, one of the shortest and darkest days, possibly as a direct result of despair.[25]

* * *

Back in happier times, when Vermeer was working best, we can see how much he enjoyed the sun, how he revelled in its strength, as it glinted on one

surface, and diffused on another. We can see his delight in the sheen of silk fabrics, the gleam of metal and pottery; we see his eye capturing the bright frosting of the panes in the windows; the glint of smoothness on the surface of a pearl; the soft depths of a feather hat; the roughness of a wall. With him, we experience the breadth of a room through its shadows, which play this way and that, in singles and in doubles; we see the iridescence of light bouncing back from polished wood; brushing across velvet, gently touching the faces and hair of his models. We sense the soft, cool air tangentially, as the sun slants through the casements.

There can be no claim that Vermeer was the only painter of his time to be fascinated with the play of light. We have only to look at the work of some of his fellow artists, such as Pieter Janssens Elinga, Emmanuel de Witte, or Gerard Ter Borch.[26] But Vermeer's works appear illuminated from within, as light shines cleanly through the spaces he depicts: it pervades everything he sees, revealing new textures as it strikes each surface. Indeed, we feel that the light itself can be the main subject of his pictures.[27]

If we were in the room with the *Officer and Laughing Girl* (Fig. 8.4), we would have to screw up our eyes to see out of the window. Mid-morning sun turns the edge of the man's vivid red coat quite pale; it reflects off the whitewash on the back wall; it brightens the girl's face and her bleached muslin cap. Light sparkles on the metallic braid on her bodice, on her drinking glass, and on the dimples in the window glass; and then briefly shimmers against the soldier's hat ribbons, before it finally disappears into the shadows.

The girl leans slightly forward, stemming her eagerness by hanging onto the glass between her hands, her open face constrained by the protective cap she wears. The officer has a jaunty, swaggering air; his elbow juts out, his hand on hip. He wears the coat of the militia; and his black beaver hat[28] lets us see only a little of his expression. Their faces are level with each other, and we can almost hear the rumble of his comment and her answering, slightly uncertain laugh. We are transfixed by the communication between this couple, because of the compositional triangle in the space that Vermeer has made between them, echoed by the smaller shape between the officer's arm and coat. We look at one face, are led across the horizontal of the mapholder to the other; and then follow the line of an arm, and go round; jumping over the frisson of the tiny electric spark on the table: the space keeping the man and woman a world away, yet only a finger width's apart.

Vermeer probably painted this picture before he moved to the Oude Langendijk, because it is generally considered to be one of his early domestic

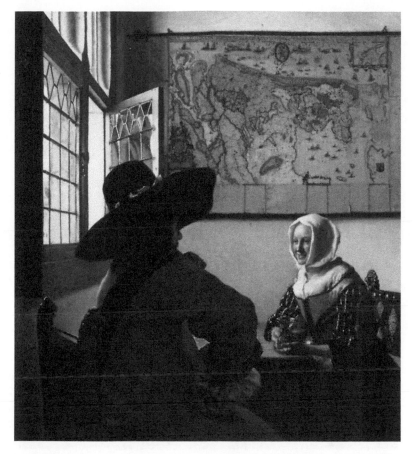

Figure 8.4 Johannes Vermeer (1632–1675), *Officer and Laughing Girl, c.*1657. Oil on canvas, 50.5 × 46 cm. The Frick Collection, New York.

interior works, painted around 1657. The strength of the light through the window could provide a clue as to the location itself, as might the reflections in the glass. Could Vermeer have worked upstairs in his mother's inn, in a room that faced south, overlooking the Market Square? The sandy coloured curves in the window might be reflections of the arches of the Nieuwe Kerk, adding to the balance of possibilities that Vermeer made this picture in his old family home.[29] The strong lighting in this picture could also be an indication of something else. It is powerful enough to have illuminated the screen of a camera obscura.

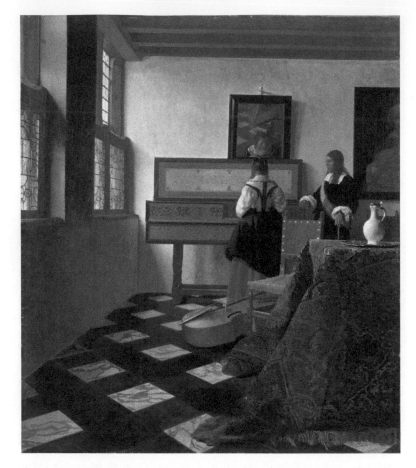

Figure 8.5 Johannes Vermeer (1632–1675), *The Music Lesson*, c.1662–1663. Oil on canvas, 74 × 64.5 cm. Royal Collection Trust, The Queen's Gallery, London.

We are so familiar with photographic images now,[30] that we also don't notice immediately that the man is a huge figure: that she is less than half the size of him.[31] Is it that we are too absorbed by the magnetic tension and the emotional chemistry between the two of them, to take all this in? The disparity of scale between the officer and the girl is what led the American photographer and lithographer Joseph Pennell, to put forward the idea in 1891 that Vermeer might have used a lens in his work.[32] We are accustomed

to distortions like this because we look through lenses all the time: carrying our cameras with us wherever we go;[33] but if we consciously search for exaggerations of scale in Vermeer's pictures, we will find them without much difficulty. The chairs in the foreground of the *Woman with a Lute* (Fig. 0.1), the *Woman in Blue reading a Letter* (Fig. 5.4) and the *Woman with a Pearl Necklace* (Fig. 5.9) loom abnormally large; as does the table in *The Music Lesson* (Fig. 8.5), where its shape extends halfway up the canvas.

At first sight, *The Music Lesson* (Fig. 8.5) seems strangely put together. If you were going to make a picture of a musical ensemble, you might make the people the main feature; and not leave them marooned behind a jumble of objects.[34] We are kept at a distance from this couple, who pay us no attention at all.[35] We become more engaged with them, once our eye has moved past the white jug to reach the back of the room; then the mirror reflection draws us in to look again, and see a triangle: now formed by three heads, as they are absorbed in their private moment. But here we might stop to check something strange; because the looking glass does not reflect what we might expect. In the mirror, the woman's head turns towards the man, but the head of her standing figure does not.

The mirror is 'cantered' forward in accordance with the fashion of the time,[36] and in order to see this reflection, Vermeer would have had to stand right next to his model.[37] But this is not consistent with us also being able to see what appear to be the legs of an easel.[38] However, Vermeer could have moved around as he created his pictures: getting closer in to make a study of the woman's head, or the printed paper pattern on the virginal;[39] incorporating this information into his painting at a later stage. We may have an idea that he only ever looked from one fixed viewpoint, or that using a camera obscura would constrain him to use only one position. But Vermeer could have developed a way of working that allowed for flexibility.

Can we spot the man himself? Somehow, we are not surprised that Vermeer is nowhere to be seen: that he has quietly absented himself.

The title, *A young lady playing the Clavicen in a room, with a Listening Gentleman*[40] may not trip off the tongue as easily as the picture's present name; but who might be teaching who, if it is indeed a music lesson? In other paintings of the time with similar subjects, often the man takes charge, in a possible scene of courtship, and turns the pages of the music, or leans over the woman, as in Vermeer's *Girl Interrupted at her Music*. Here there are no predatory overtones: the couple appear to be performing together on equal musical terms,[41] as the man sings to the woman's percussive accompaniment.[42]

The illusion is that we are observing things just as they are: Vermeer makes no distinction between the wall and the underside of the man's sleeve, or between one or other leg of the virginals. The feeling of the moment is strengthened by the cropped view; by Vermeer's unfussiness as to the casual position of the chair on the far right; and by the apparent veracity of shadows, which fade in series on the back wall.

In the 1950s, the famous Danish architect Steen Eiler Rasmussen considered the construction of Dutch houses of this era, and the light the rooms would have received. He commented on the shadows in this picture; and recognized such an accurate representation of natural illumination, that he could work out which of the upper or lower shutters would have been open.[43]

Our eyes do seem to see something familiar in the softness of focus, and the quiet quality of the light playing on the tufts of carpet, which turn silver in the sun, and iridescently blue in the shade.[44] We feel the alternate coldness of tile and the warmth of wood; we feel the smoothness of bright metal on the tacks of the chair, on the plate, and on the jug lid. There is nothing harsh, nothing out of place; the picture has a rightness about it, in which we can believe.

If we stand back and take a wider view, we register familiar features we have seen in Vermeer's pictures before: the picture frames on the wall, the musical instruments, the chairs with their lions' head finials, the covered table. It is almost as if we have come home. We do not have to announce ourselves: we can just step into the cool space on the left, pick up the viola da gamba, and make a duet into a trio.

The Music Lesson (Fig. 8.5) has borne much of the brunt of the protracted arguments about whether Vermeer painted fictions or facts. Were his paintings constructed using perspective drawing, and executed in stages: were they a composite of small truths, with elements and objects taken from different places, and done at different times? Or did Vermeer paint just what he saw in front of him, with the help of a camera obscura?

In 2001, Professor Philip Steadman published the conclusion of his research, which made the assumption that the spaces shown in Vermeer's pictures were real, and that the room and everything in it actually existed. He found similar furnishings, maps, and tiles; and using their size, reconstructed a virtual studio using architectural and mathematical calculations.[45] He worked out where Vermeer would have been sitting to paint; and then, using this position, calculated the size of a projection of the scene through a lens from this viewpoint. In a number of cases, the scale of Vermeer's paint-

ings matched exactly that of the real objects in the projection on the wall.[46] Steadman used his drawings to make a half scale model of the room in *The Music Lesson* (Fig. 8.5), and found that when he simulated a North light through the 'window', that the shadows fell right into place.[47] Some critics have thought that Steadman's arguments are circular, because he had to make some assumptions about the size of the studio.[48] However, reading his research carefully, this is not the case: he does provide some compelling evidence for the use of a lens, even though his architectural calculations cannot work for all of Vermeer's pictures.[49]

At the other end of the spectrum of theories, are those of scholars of Vermeer who do not believe he was depicting any kind of reality here; but that this, along with his other pictures, were fictional constructions.[50] Some of their interest has focused on small holes in a number of Vermeer's pictures, which, in the case of *The Music Lesson* (Fig. 8.5), is found in the left-hand sleeve of the girl playing the virginals. The position of these holes corresponds to the 'vanishing point' in each composition, where all the receding lines in the picture converge; and some think that this is irrefutable proof that Vermeer made this picture using perspective techniques.[51] They think that he attached a chalked string onto a pin, and snapped it onto the surface of the canvas to provide structural guidelines for painting, which was a commonly used method of marking out straight and diverging lines.[52] Supporters of this theory point out that other painters used this method, including another Delft painter, Pieter de Hooch, whose father was a mason.[53] Bricklayers still use strings today to check if walls are level and straight.

In many books on Vermeer there are diagrams showing how this process might work. The painter attached several strings to the side of the canvas strainer with nails, and then marked out straight lines on his canvas at the beginning.[54] But it is perhaps easier to analyse the angles of views and vanishing points in a picture once it is finished, than to try and construct one from scratch using such a system.[55]

The perspective lines drawn using a method like this seem mostly to be used to indicate diagonals, such as we see in the floor tiles of *The Music Lesson* (Fig. 8.5).[56] The shapes on the floor, here, do indeed seem very precise, and there are scratch marks in the paint, where Vermeer has marked them out,[57] so maybe he did use strings to work out these divisions. However, we will see that there would be nothing to stop him using a camera obscura in addition, to help in other ways, in other parts of his picture.

The argument that *The Music Lesson* is only a figment of Vermeer's imagination is further inflated by the assertion that he could never actually have observed even the most basic elements of this scene. Experts point to the ceiling beams in this picture, which they believe are running across the wrong way for Dutch houses of the era;[58] they remind us that no musical instruments at all are listed in the probate inventory;[59] and they say that Vermeer is unlikely to have been able to afford these, or expensive furnishings or carpets; and certainly not such sumptuous marble tiles. There is a suggestion, made recently, that rather like good weather, there was an over-representation of patterned stone floors in Dutch painting 'to construct or emphasise the pictorial perspective.'[60]

Was Vermeer's marble floor in this painting imaginary, or should we take seriously an eyewitness account made by the Englishman William Mountague? His book *the Delights of Holland*, published in 1696, includes the following entry:

'One would think Marble grew here; that is, that there were great and vast Quarries of it in this country, for rich and poor, old and new Houses, have all their first floors pav'd with black and white Marble; not coarse and ordinary, but very good of the Kind, with great variety in the manner of laying it.'[61]

It was recently observed that the dimensions of the tiles in *The Music Lesson* (Fig. 8.5), as calculated by Steadman, corresponded almost exactly to those in the Pazzi Chapel in Florence, which could possibly indicate a standard size for marble tiles for use at home and for export.[62] However, this does not provide conclusive proof that Vermeer was depicting a particular floor. In any case, Mountague's *first floor* is probably what we would now call the *ground floor*, where tiled floors were more generally found; and it is likely that Vermeer's upstairs studio had a wooden floor, which was lighter, and also warmer. It is possible, as Steadman suggests, that Vermeer could have laid some loose tiles down, saw how the light fell on them, and then played the changes with patterns;[63] but he could also have drawn them onto his pictures, working them out by geometry.

And as for the ceiling beams: if you go to The Netherlands, you can find a number of houses of the right age, where beams run at right angles to the window. It is interesting that the beams on the top floor of the Petronella Dunois doll's house (Fig. 1.6), run away from the 'windows', like those in *The Music Lesson* (Fig. 8.5). Since these are not structural to the model, it seems reasonable to assume that they are illustrative instead.

What about the musical instruments? John Michael Montias discovered that Vermeer came from a musical family. He may have inherited a lute or violin,[64] but then these may not have been listed in the probate inventory because Catherina did not want to leave behind things of sentimental and monetary value for the probate clerk to find.[65] However, this argument does not take us far when it comes to the various keyboard instruments we see in Vermeer's pictures. They are something else. It is just not credible that any kind of harpsichord could have belonged to him. They were top-of-the-tree, luxury items; and you had to be very rich indeed to have one in your home.

Could Vermeer possibly have borrowed one? He appears to have depicted them faithfully: the measurements of the virginal in *The Music Lesson* proportionally match those made by Ruckers, one of the most famous harpsichord firms of the day.[66] But would an owner let such a precious possession out of his sight or even allow it to be moved? We do know that there were harpsichord owners in Delft;[67] but our minds turn almost inevitably to Constantijn Huygens, in The Hague, whose name 'runs like a silver thread through the music of his age'.[68] Quite apart from anything else, he was known as a most accomplished composer and performer, and owned an impressive collection of musical instruments, with 'several virginals and harpsichords'.[69] Huygens bought one from the Ruckers' workshop[70] with the help of a friend called Diego Duarte, a rich banker from Antwerp, who owned one of Vermeer's pictures.[71]

These coincidences reassure us that Vermeer could possibly have set up a tableau which included a virginal from someone who could spare it for a while, or who wanted a 'portrait' of a favourite possession. Vermeer may well have had to work away from home in order to include one in his pictures, but since the camera obscura is a portable device, he could still have used one to observe the scene and trace directly from a projected image.

But maybe we don't really expect or want everything in a picture to be 'real'. Part of the thrill of seeing a painting is comprehending how we have been tricked. We think we are seeing cobbles in the foreground of *The Little Street* (Fig. 0.3) but Vermeer has not attempted to show us each one individually: they are just wiggles of paint. We see the soft coat of the *Girl with a Red Hat* (Fig. 4.8), but up close, the brushstrokes are relaxed and carefree. Vermeer glories in his ability to control the materials of his craft; and we enjoy marvelling at the power of a brush that can turn pigment into fretwork, silk, or pearl. We know that we would be less excited to see a real model framed as if

in a painting; than a painted model who looks real. We want to be deceived; just as long as we are not made foolish in the process.

Visual illusions were all the rage in seventeenth-century Holland. Some artists, wanting to give the viewer a double take, painted curtains into their pictures, as if just drawn aside.[72] Vermeer used this device a number of times. Sometimes it helps emphasize the depth in his pictures, as in *The Art of Painting* (Fig. 1.4); but a curtain complete with a painted rail, can make us feel we are looking out onto an extension of our own space, as in *Girl Reading a Letter at an Open Window* (Fig. 1.3).

We have seen that Fabritius' *Goldfinch* (Fig. 2.4) was a *trompe d'oeil* painting; to be tacked up to convince people they were seeing a real bird chained to its feeding bowl.[73] Others painted letter racks, and still lifes; including Cornelius Gijsbrechts (1630-1675), who then went even further, and produced a painting of the back of a painting. This was to fool visitors searching for his latest works; who would pick up a canvas in his studio, to find to their surprise that it looked the same on both sides.[74] Rembrandt joined in this craze for casual deception, and painted a young girl, propped in a window frame, to be viewed from outside. This apparently was very convincing, until it was noticed that she didn't seem to move much.[75]

Anamorphic paintings, which made sense only when viewed from a particular spot, were also popular. We can see Vermeer's interest in this kind of optical illusion, in the decorated lids of the keyboard instruments in his pictures. He seems to have had fun with these landscapes, which do not seem distorted from our point of view; but if seen from the position of the performers, would appear stretched out.[76]

There were peepshows too. Fabritius painted his own strange little *View of Delft*, whose distortions make some think it was meant to be displayed on a curved surface, and viewed in a triangular box.[77] Another more famous example, set on a stand, and also in the National Gallery in London, is by Samuel van Hoogstraten. He wrote that a perfect painting should be 'like a mirror of nature, which makes things which do not actually exist appear to exist... deceiving the viewer in a permissible, pleasurable and praiseworthy manner'.[78] His own illusion is enchantment. Inside the tiny Tardis is a complete Dutch interior. We look through one of the viewing holes in the side, to see his sunlit rooms: the mistress of the house asleep in bed, the dog waiting patiently in the hall, and a letter on the mat. We see a real space. We imagine for a moment, that we are inside it ourselves.[79]

Vermeer's deceptions have different qualities. We have climbed through his looking glass, where the rules are not the same as in our our own universe. The world in here is freeze-frame, and attractively soft and blurred.[80] It is its lack of focus, which makes us want to move into his spaces to find more detail; but no matter how hard we try, we can never get close enough.

We would like to speak with the *Lady Writing* (Fig. 8.6).[81] She glances up from her task to consider us briefly; but her mind is elsewhere. She is thinking of her message; thinking of the phrase she has just written; and of the one she will write next. Is her missive one of love? She will not tell us; and our interruption must not be long, or the ink will blot on her paper. We look around: see her pearls with their yellow ribbon, and the quill in her hand;

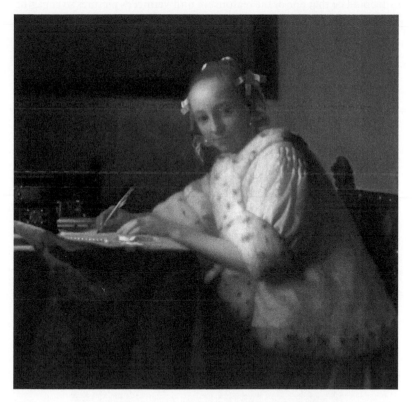

Figure 8.6 Johannes Vermeer (1632–1675), *A Lady Writing* (detail), c.1665–1667. Oil on canvas. National Gallery of Art, Washington.

and notice with surprise that even though we have drawn nearer, her face is even less distinct than it seemed from a distance. We might hope for a moment of familiarity, but she recedes just as fast as we approach.[82]

In some ways, Vermeer's paintings mimic the way we see. We know that when we focus in one place, other things at the edges of our vision are unclear. But we know too, that if we look in the right direction and get near enough, we will find more visual information. It is thought that we may actually be better at judging facial expressions and emotions by using 'general' information from our peripheral, rather than our central vision.[83] Maybe the blurred effect on this young woman's face mimics this, and so has an influence on how we feel about her.

It could be that one of the reasons we find Vermeer's pictures so engaging is that the juxtaposition of distinct and indistinct is sometimes unexpected, giving us a feeling of intimacy and distance at the same time.[84]

We notice this here: the lady's far arm is particularly indistinct, yet objects apparently just as far away, like the writing box, are very clear. This variation in focus appears in some of Vermeer's other paintings too. An example is found in *The Lacemaker* (Detail, Fig. 8.7). As we observe her patiently working her bobbins, we notice that the ringlets in her hair, her fingers, and the strands she is holding, are clear and sharp; while only a little nearer towards

Figure 8.7 Johannes Vermeer (1632–1675), *The Lacemaker* (detail), c.1669–1670. Oil on canvas, laid on panel. Musée du Louvre, Paris.

us, threads spill out of the cushion in an extraordinarily abstract fashion. These gestural swirls and squiggles of paint are unusual. If we look very closely we see that the wool is made from free flowing lines and blobs made of liquid paint, making us imagine that Vermeer could only have achieved this by putting his picture down flat, and dribbling colour onto the canvas from a height: rather in the manner of a seventeenth-century Jackson Pollock.

There are other puzzles in *The Milkmaid* (Fig. 1.2); where the bread, which threatens to fall off the table, is shown with little highlight dots, fuzzing the crusty edge; yet the plaster wall in the far background shows all sorts of nicks and blemishes and the very crisp presence of some nails.

It is actually quite difficult to paint something deliberately blurred, since we automatically see everything sharply, as our eyes rove to and fro. One expert suggests that the variable treatment of focus in Vermeer's pictures indicates an observation of peripheral as well as direct vision. Zirka Filipczak thinks that Vermeer did not just record the evidence of his own eyes, but some from another lens too.[85] If the focal length of the camera was a bit too long; or was fixed to focus on the back wall; then objects or figures further away would be better resolved, than those in the middle or front of the room. If information like this was put down in combination with that from direct observation, then together they would send conflicting signals to the viewer. The overall effect would be to put the subject 'out of visual reach'[86] and make it seem elusive, and in the process, maybe more desirable.

It is worth comparing the out-of-focus effects in Vermeer's pictures with the work of Gerrit Dou, one of Rembrandt's first pupils, who had set himself up in Leiden in the mid-1600s. He was one of the most successful painters of the Dutch Golden Age,[87] and his paintings could cost as much as a small house.[88] He paid minute attention to every single detail, over every single square millimetre of his pictures; and visitors were astounded at his careful preparation,[89] and his vision of verisimilitude.

In 1665, one of Dou's enthusiastic admirers organized an exhibition of his 'fine painting', which included his *Woman at the Clavichord* (Fig. 8.8);[90] which might have been an inspiration for Vermeer's *Music Lesson* (Fig. 8.5).[91] We can see some shared features: both have girls playing a musical instrument near a window; in both, there is a viola da gamba; a round jug; a decorative fabric; and a chair with a lion's head. In Dou's work, we can see meticulous illusions: the gauze over violet silk, the weave in the carpet, the hairs on the little vine leaves, a reflection in a glass of wine; and all this without the appearance of a brushstroke.

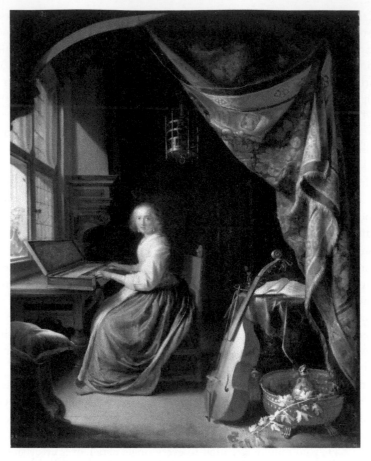

Figure 8.8 Gerrit Dou (1613–1675), *Woman at the Clavichord*, c.1665. Oil on panel, 37.7 × 29.8 cm. Dulwich Picture Gallery, London.

Although Dou's work was considered fit for royalty in his time,[92] the wind changed in the nineteenth century. His reputation plunged from celebrity superstar to that of embarrassing relative, and his pictures were consigned to storage. Critics disdained their detail, and now remarked on their lack of emotion, mystery, and sincerity.[93] There were technical problems with his paintings too. Dou had built them up layer upon layer; but the once enamel-like surfaces became wrinkled and cracked.[94] They have now been restored and conserved, and are valued once more; but their scale and

size mean that they are not easy to view in a gallery. They were meant for collectors, and close admiration at home. When you look at them yourself, you can decide whether they are miracles of painting; or whether all that exactitude, all in perfect focus, is all perfectly lifeless.[95]

We might be aware of the young woman's self-consciousness, as she sits under the drape of curtain, artfully pulled aside. We might wonder how many hours she had to pretend to play on her keyboard, since it took Dou three days to paint the end of a broom 'the size of a fingernail'.[96] We are very aware that this is a stage set. But we cannot doubt that Vermeer's pictures are constructions too.

Most artists are thrilled and scared in equal measure by their blank canvas. Even if they were successful the last time, they know now that they have to start all over again. Painters have to organize themselves; because a good picture, whether figurative or abstract, has to balance. Everything has to be right at once: the weight of composition, tone, colour, and brushstroke. And then, as Pierre Bonnard (1867–1947) remarked in the twentieth century, the eye needs to travel over the picture 'without a hitch'.[97] The artist should have control of the dynamic forces and the focus of his painting, but this needs to be done so that the viewer is not held up on his journey, and is not aware of the hard work involved in its making.

People talk of the colour and texture of music, just as they speak of the rhythm of painting. There are many parallels in their making. If you are composing music, you have to think of the basic structure first. What kind of a piece do you want to make? One with a group of musicians or one that features a soloist? One that has movements or not? Once you have made the big decisions, you can establish your main themes, the key, and the tempo; and then you can work out the melodies. You can go on to make progressively smaller changes: building up the form of your music by putting in repeating phrases; indicating the loudness and softness of a passage; writing in a trill; a plucked string; a few bars with a different pulse; a pause.

It is a shock to many beginners to find that any organization at all is required for painting: that there are important choices and decisions to be made, in order to achieve any success. In the early twentieth century, the painter André Lhote reported disparagingly of the dismal results of amateur painters he saw in the countryside putting out their canvases like butterfly nets, to 'catch' a picture: as if that were all the effort required.[98]

We do not notice how Vermeer has woven structural elements into his pictures; we just see an end result that appears effortless. But his pictures have dynamic strength, which comes from the constraint of an underlying supporting structural grid, just as strong as the geometric forces that could be observed in the landscape outside. We cannot know how much Holland's farmland, rigidly divided by water, consciously influenced Vermeer's paintings;[99] but we understand that he felt strongly the power of divisions. We can see that he placed his figures carefully within the rectangles of picture frames, windows, and maps; and also that he appreciated the effect of emptiness against presence.

Giorgio de Chirico, a metaphysical painter of the twentieth century, spoke of the 'perfect knowledge of the space an object should occupy in a picture'. This, he said, establishes a 'new astronomy of things attached to our planet by the magic law of gravity'. Vermeer might not have understood this statement, since the apple did not fall on Newton's head until around 1687,[100] but we can see that balance is of paramount importance in his paintings.

There is steel in the insistence of the horizontals and verticals, standing against the diagonals of an arm or a coat; and we know that we would not be satisfied if the *Woman in Blue Reading a Letter* (Fig. 5.4) or *A Woman Holding a Balance* (Fig. 5.5) were shifted even a centimetre out of place.[101] However, we should not underestimate the effort such compositions must have taken.[102] Although science has revealed that Vermeer juggled the positions of elements within his pictures, he must have had a good idea of what he wanted to achieve early on in the painting process, because, as we have seen in the *Woman in Blue Reading a Letter* (Fig. 5.3), many of his underpaintings apparently show themselves to be almost complete versions of the final masterwork.[103]

Vermeer's preparations could possibly be compared with a modern photoshoot.[104] His set-up may have been composed of existing possessions, rather than those available for sale in upmarket shops; but just the same, he had to think carefully about the way all his props might fit together to showcase his model, at the beginning of the process of making a picture. It has been suggested that Vermeer may have looked through a lens to help him 'frame' his compositions, moving between the camera obscura and his studio 'shifting furniture, rearranging drapes, asking his model to turn her head or fold an arm';[105] and it is possible that if he could see his subject in this way, then this could have helped him decide where to crop; what to use; and what to eliminate. But Vermeer could not take lots of quick shots through a lens and compare them like contact prints; he could not take one 'shot' at all. If he wanted a record of the

image he saw, he would have to draw it, or trace it manually from a projection; and that would take time, just like every other part of his painting process.

There is much contention over whether Vermeer's pictures have qualities that might have come from a lens, and one recurring feature which has been put forward as evidence of his use of the camera obscura, are the many little highlights on his pictures, which art historians call the *pointillés*. We have already seen some of these, spread like a shower of stars on the water in the *View of Delft* (Fig. 7.3); but examples appear in many other places. There they are again on the curtain in *The Art of Painting* (Fig. 1.4); and on the still life between us and the *Girl Reading a Letter at an Open Window* (Fig. 1.3). It is as if Vermeer viewed his scene through the unevenness of glass, and put down its granular quality directly.

The arguments come to a crescendo over the highlights on furniture. Vermeer seemed fascinated by the way light occasionally caught on the chair finials: the ones with the distinctive lion's head carvings that we see in no less than ten of his paintings,[106] including the *Officer and Laughing Girl* (Fig. 8.4). Small, soft highlights sparkle like a crown on the carving of the chair finial in one of Vermeer's smallest pictures: *The Girl with a Red Hat* (Fig. 4.8). These seem blurred: rather like the out-of-focus effect seen through a lens. These speckles were put on at the end of the painting process, on the last layers of the painting's surface; but were these added as an artistic choice; or were they an observed truth of an optical effect, not normally visible with the naked eye? In 1964, photographs of a similar lion's head carving were made using an old camera, and the visual outcome was said to be almost identical.[107] This revelation was seen by some as proof that Vermeer must have worked with a lens; even though one expert pointed out that Frans Hals had also painted a similar finial in soft focus; and in his case, no fuss had arisen about whether he might have used an optical aid or not.[108] Also, other painters of Vermeer's time used dotted effects, painters who appear not to be interested in lenses at all.[109] The insistence of some scholars that these circular highlights have particular similarities with an optical effect, when seeing small reflections through a lens, has to be balanced against the fact that the easiest shape to put down with a round brush, is a round spot.

But here's the thing: even if we can believe that what we see in a picture is real, even if it was possibly captured by a lens, it does not mean that it is reality. All painting is artifice. But Vermeer's work is unusual, in that things

appear in his pictures in a parallel way as they do in our own vision. We may
not realize it, but because of all our experience in the past, we actually do not
need very much information to orientate ourselves in a room, to recognize a
figure, or to interpret an indistinct form.[110] We can make our way in our sur-
roundings, because we know that all we have to do is to approach closely, if
we need more detail.

Many comments on Vermeer marvel at his accurate depictions; but actu-
ally, his work often conveys only suggestions of form. James Welu found that
originals still exist of some of the maps Vermeer shows us; and that the
painted versions are faithful to contours, cartouches, and compass roses, and
the same placements of the little boats sailing fancifully on the printed seas.
However, we cannot read them precisely. The shapes seem right, there are
indications of topographical features; but they are painted as if from a dis-
tance and can never swim into sharp focus, not even under a magnifying
glass.[111]

The same lack of precision can be observed in the pictures that hang in
the background of Vermeer's paintings. Some have a particular shorthand
quality about them. We see a *Last Judgment* hanging behind *A Woman
Holding a Balance* (Fig. 5.5); and on the walls of the rooms of *The Concert*
(Fig. 10.3) and *A Lady Seated at the Virginals* (Fig. 8.3) is a painting identified
as *The Procuress* by Dirck van Baburen (1595-1624). We notice an abstraction
of shapes in these pictures-within-pictures, where dark paint has been put in
around the lightness of figures. There is no linear quality. We might almost
think they have been traced.[112]

There is a huge amount available to read about Vermeer and his possible use
of the camera obscura; in which you might expect to find explanations
about how he could have used information from a lens. However, many of
them reiterate difficulties; rather than making any attempt to find practical
solutions. There seems to be an assumption in these discussions, that the
challenge is to trace everything you see in one of Vermeer's pictures at once,
and that it would be possible to make a complete finished coloured painting
by such means. However, none of the attempts that have been made so far to
transpose such an image from a projection to a canvas, has worked. They
have not conformed to what we know of the structure of layers in Vermeer's
pictures; and each has had to sidestep the problem of the artist's ability to
recognize the colour of paint under a coloured projection.[113]

The answer to the riddle could be much simpler than ever supposed so far.
Maybe Vermeer used his camera selectively, at only one point in the process

of constructing his picture? Maybe the answer is hiding in the dark under-paintings of his pictures, which glimmer through the coloured paint? They establish the main dynamics of his compositions: the structure and focus, the dark and the light; and also provide a guide to shapes, which Vermeer preserved, as he painted his way up the layers to the finish.[114]

Vermeer may have worked out his own way of using a camera obscura. He may have looked at the projected image to see where the light fell, and then traced just the shadows, using dark paint. Maybe he used this monochrome beginning as his *inventing*, and then painted on top of this in colour later.[115] Maybe there was an advantage to having an upside down, back to front image in the camera booth, because he had developed a way to correct it.

This all might seem impossible. Yet, if we start by thinking of being in his studio ourselves, with the materials and equipment he had at hand, we can make an imaginative reconstruction, to see if we can work out how an optical image can be used to make a basis for a painting.

Let us imagine that we are standing in a corner of Vermeer's sunlit room, waiting to see him start his picture. After all his preparations, his beginning may have been quite quick to make. Maybe Vermeer could observe his brightly lit model through a lens, and could work fast enough to capture a moment before the shadows softened; and before the clouds dimmed the brightness of day.

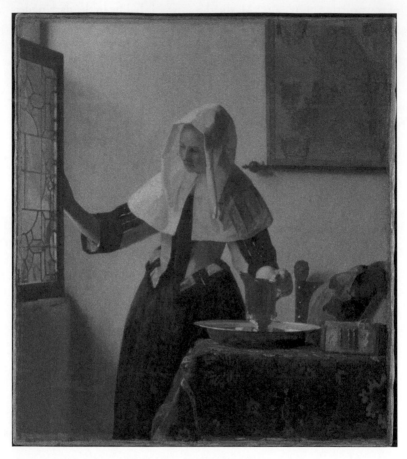

Figure 9.1 Johannes Vermeer (1632–1675), *Young Woman with a Water Jug*, *c.*1662. Oil on canvas, 45.7 × 40.6 cm. The Metropolitan Museum of Art, New York.

9

Into the Dark

The early light pushes through the cloudy glass; showing a crack of gold at the window's edge. The air shimmers from the jug and the plate; its warmth gradually bringing out small scent from the varnish on the papery map; and a musky echo of a night of celebration from the little jewellery box.

The girl looks away from this refinement and stands quietly in the studio, her hair not visible behind the newly goffered coif. She has been standing here some while. She can stand and do nothing. A change from the normal morning routine: working from daybreak at relentless chores; to empty the night pots, build up the fires, scrub the floors, air the bedding, sooth a baby's tantrum. Today she won't have to put on her clogs to slush though the Spring wet to the market.[1]

She stands, waiting, hand on the window; waits some more.

Vermeer comes and goes. Now he is before her, looking closely at her face, shifting objects on the table, adjusting the cloth on the chair; now he stands back, considering. He fiddles with his brushes, then disappears behind the green curtains. He does not speak. The girl waits, and her arm aches. Out of the corner of her eye, she sees the deep, round eye of the lens, shining like a pool.

Vermeer waits too, adjusting his eyes to the gloom[2] then looks again at the image as it brightens on the wall, as he has done already twenty times this morning. Should the map be shifted again? Is the extra chair at the front an encumbrance or not?[3] It is difficult to be sure about these balances, because the image he sees through the lens is upside down, and also back to front. It glows before him; red, yellow, and blue: carpet, jug, and dress.

Vermeer has been up since dawn, making all the preparations necessary: he has put up the curtains, adjusted the lens, pushed the furniture here and there; worried over the best position for the girl. Her arms need to be supported,

but she has to appear free, as if the moment is only transitory. She has reached for the window, and will pull it wide, to see the open sky.

He considers again: the model is ready and waiting; and the light, for once, is perfect. Can the girl raise her hand a little higher this time, and turn her head ever so slightly more to her right? Coming out of her reverie, she shifts her shoulders, and her body makes a fluid connection between window and jug.

Ignoring the discarded efforts on the floor, Vermeer pins a new piece of oiled paper under the jewelled image, shining on the screen. He loads his brush with the black paint that he dares not make any thinner. All at once, he starts tracing the darkest shapes he sees first: the skirt and sleeve, the glimpse of the chair behind the fabric, the shadows between the ridges on the box, shadows on the edge of the window and the corner of the room. His brush licks from one darkness to another, joining hand and window; joining platter, carpet, and chair.

It is hard working out relative tone in the gloom behind the curtain. The paint he puts on obliterates the colour of the image that beams through from the other world beyond the curtain; and the light flutters, as his hand and brush cast intermittent shadows on the screen. But Vermeer does not stop, he considers again; and puts down the next series of shapes he sees, using a gentler pressure of the brush this time, so they are a little less dark: the pattern on the tablecloth, the side of the coif, the shading on the girl's forehead. He looks and traces until his eyes hurt, and he can go on no more.

Maybe about twenty minutes passes before Vermeer utters a word. Then the girl lets out her breath with a sigh. It was an age since she was left alone, as if spot-lit on a stage; not daring to move.

Vermeer has unpinned the oiled paper from the wall, and holds it by the corners; as he edges through the gap in the curtain, into the light of the studio. He squints at the painted tracing he has made; then moves to the table where his canvas lies ready. He turns the paper with wet paint face down, and positioning it carefully, puts it abruptly straight onto the face of the dry, dusty canvas. He strokes the paper with his hand. The tracing transfers some of its darkness.

Behold! He holds up the canvas to his astonished model. There she is: fuzzily believable. The grainy image against the gleaming smooth ground shows hardly a line, nor even much of a brushstroke. There are indications of texture and of pattern, but the main impression is that of darkness against light. Strong light, which pauses on the edge of the window frame, before

rushing in over the cluttered table, the map, and chair; over the girl, filling her headdress like a luminous sail.

This image, now miraculously the right way up, and also the right way round, can be directly compared with the girl herself, as she stands still; still holding the cold latch in the brightness of the morning, her breath curling in the air.

Vermeer stretches; he needed all his skill and concentration in the cramped space to catch the balances and connections of shapes quickly, before the paint dried. At least the image couldn't alter as he moved his head:[4] it came steadily through the single eye of the lens, fixed firm in its focus. He let the brush ebb and flow, dancing over the pattern on the table-cloth, pushing into the rich darkness of the shadows in the fabrics, register-ing the small tense gaps between the back of a hand and chair, the uneven void under an arm, and a tiny diagonal on the table between basin and cloth. He did not touch the paper where he saw light. He left the lime-washed wall, left the linen on the girl's shoulder; he left the window glass, and the golden edge of brightness on the rim of the plate.

In the dark, he recorded only darkness. A dark image he could transfer onto his creamy canvas.

It is a relief now to be out in the studio, where now he can see not one, but two completed images right before him: one printed on the canvas, and the other still visible on the tracing paper. He pins the paper to the studio wall for future reference, but puts the canvas with its wet print carefully on his easel. All he needed to make a transfer directly from lens to canvas was this piece of paper: a piece of paper coated with oil, to make it transparent; strong enough to hold the paint; and then to let it go.

He sits on his stool and looks near and far. First at the print on the canvas, then the girl; at the girl, then the canvas. He checks the weights and the bal-ances and the connections of his composition. How does his new print com-pare with what he sees?

The result is good: it will make a beginning.

<p style="text-align:center">* * *</p>

We look at Vermeer's work and it appears effortless, yet we know that within it is formidable organization, and a command of painting technique. But his masterpieces are made in a way that we do not understand. How can any-thing be beyond us? We, who have the technology at our command to pro-ject a voice across the world: to tranquillize a tiger: to cure a plague. We

know his pictures are made from base things, scraped from the earth, or extruded from plants: mostly not from materials of particular value to us now. They were not made with complex equipment; but with tools that were simple, that were possibly frayed, old, and worn. They were made in the ordinariness of a home.

And yet for some, Vermeer's paintings could be said to define the transformative process we call art. Some of his work has the power to make us feel something beyond ourselves, without an awareness it was fabricated at all.

Scientific analyses can tell us what pigments and oils were on his canvas, and indicate the order in which the paint was applied. It cannot tell us what Vermeer actually did. But we want to know how it is that we can see light coming from his pictures: light that shines through to us from the seventeenth century.

Quite apart from whatever the weather was in Delft, Vermeer's subjects seem to be illuminated more strongly than you would expect, that they contain more light than they receive through the windows.[5] We see this in the starched sleeves and soft bonnet of the *Lady Writing a Letter with her Maid* (Fig. 2.2): they look so bright, that they remind us of an over-exposed photograph.[6] There is little gradation in tone, just abrupt jumps from light to dark; culminating in an unaccountable brightness on the wall behind the letter writer's shoulder, which seems to be more than an artist's trick to make his subject stand out clearly. Vermeer had no pool of light into which to dip his brush,[7] so how did he conjure it out of the pigments on his palette?[8]

Paintings are made by using opposites. If you want something to appear large in a picture, then put down something small. If you want your red paint to glow more, put something green next to it. If you want something to appear light, then use something dark; something very dark. Vermeer's underpaintings are very dark. Why? Possibly because, if he was tracing in reduced light over a coloured projection, he had to trace with something dark. Light tones won't show up; anything coloured will be altered by the light coming through the lens.

Ready to drive home after a night out, you look for your red car where you thought you had left it. But it has been transformed: the yellow sodium street lighting has turned it a strange dark brown. Only white things appear yellow under its light; all other colours change. No painter can judge a colour under coloured light; or for that matter, mix colours in the gloom. But where the shade defines a model's face, where the shadow falls on folds of cloth; you can record these differences using something that is dark itself.

The fictional account at the beginning of this chapter, showing Vermeer beginning his *Young Woman with a Water Jug* (Fig. 9.1) is conjectural, but perfectly possible. He may have realized that the orientation of the camera obscura was actually a printing reversal, and that he could correct it using printing itself. His method could have been to make a tracing on an impervious surface, such as oiled paper, in a dark medium that would transfer, such as oil paint; using a brush.[9] Then he could come out of the camera booth and 'print' the image he had made onto his canvas, turning it back the right way up, and the right way round, in the process. The very dark prints made like this might accentuate the apparent illumination in his work, because some of what we interpret as light could come from the white ground of the canvas itself. This might explain why the light that shines appears to be greater than the total coming through the windows.

But another great advantage to using a camera obscura in this way would be that once it had dried, he could use a print on canvas as an underpainting. Then he could work on top of it in colour, in the light of the studio; looking straight at his model, just like any other artist. If he never covered up these dark beginnings completely with subsequent layers of paint, then the feeling of illumination would remain on the canvas.

We actually process light/dark differences, and colour, in completely separate parts of our brain.[10] We only need comparative brightness (or luminance), to recognize depth, and to interpret a three-dimensional space. We know, from our own experience, that we do not need colour for an image to make sense to us: we can interpret a black and white photograph easily enough. Therefore, it is not so much of a disadvantage for a tracing from a projection to be made only in dark and light. If you have a monochrome image on your canvas, you can transform it by adding colour later, in a second step.

The art historian Alejandro Vergara came to the conclusion that if Vermeer had used a camera obscura, that he might have worked in a systematic but selective way something like this. He thought he might have used an optical image 'to define the basic geometric structure of his composition and the distribution of the light, combining their use with his observation of the real world'.[11] It is possible that Vermeer could have made tracings to record tonal differences; but with the proviso that he combined this with direct observation of his subject while in the light, palette in hand. Otherwise he could not have painted as he did. How else could he have judged the slight differences of colour between opal, eggshell, linen, and frost; between topaz and mustard; between pearl and chalk?

A two-step process could explain the effects we see in some of Vermeer's pictures, where edges of a dark first layer are still visible on the finished work, or where his underpainting is only partly covered, left behind, maybe because it provided a structural guide to the whole composition. A tonal underpainting, possibly made using a camera obscura, fits the visual evidence of Vermeer's pictures. It fits the scientific analysis of the layers in his paintings, and it fits the little documentation we have about the practical use of the camera obscura at the time.

Jean-François Nicéron, writing a book on optics in 1652,[12] says of the camera obscura: 'if a painter imitates all the shapes he sees, and if he applies the colours that appear so vividly, he will have a perspective as perfect as one could reasonably desire'.[13] In 1568 Daniele Barbaro suggests that after seeing things projected through the lens, 'as they are in reality... colours, shadows, movements, clouds, the ripples of water, the flight of birds... you can draw with a pencil all the perspective that appears there, and then shade and colour it as nature displays it to you'.[14]

Both these examples seem to suggest that the tracing process comes first, and the colouring second. But there is also something else in Barbaro's writing, just one word, which confirms what tool was used to make tracings inside the camera. This clue has gone unnoticed until now. All English translations of this passage of Barbaro's book say that the image is drawn with a *pencil*.

However, in the beautifully printed original, produced in Venice, we read that Daniele Barbaro's word for this is *un penello*, which means *a paintbrush*.[15] This changes how we see this process, because the amount of tone, and the kind of mark that can be put down by one or the other, is quite different. There is confusion here possibly because, until the graphite drawing tool that we know so well became commonly used in the early eighteenth century, the word *pencil* in English did indeed mean *paintbrush*. The English miniaturist Nicholas Hilliard talks of applying his paints with a *pensile* in 1624;[16] Edward Norgate mentions *pencills* in 1650;[17] and Marshall Smith, writing a handbook called the *Art of Painting* in 1692, calls his paintbrush a *pencel*.[18] Whatever the spelling, it appears that the change of use of this word, and its different meaning and significance, has been misunderstood. Barbaro is actually talking of tracing under a projection with a paintbrush and paint; otherwise, he might have used a word such as *penna* to indicate a hard drawing instrument.[19]

But is it at all likely Vermeer ever would have thought of using printing in the process of painting? It needs someone who is familiar with optical reversals and printing methods to come up with an idea like this.

We must remember that Vermeer was living in a wet, watery country: he saw reflections everywhere. He had only to step outside his own door to see the church spire and the houses in the Oude Langendijk upside down in the canal; he could see light back from the sky in the wet stone and the windows in the streets. He had not to go far to see the river: the boats running with sails downwards; to see sharp, criss-crossed splinters of sky in the ditches and furrows of the muddy fields beyond. There were reflections inside his house; from polished wood, brass, and silverware; from washtubs and sinks, scrubbed tiled floors; and from the mirror in his own hall.

Vermeer knew all about printing reversals too. The presses were being pulled just across the Markt, in the shop called the Golden ABC, which still stands today (Fig. F.2). This was run by Abraham Dissius and his son Jacob, who was eventually to own some of Vermeer's masterpieces, through his wife's inheritance.[20]

Vermeer knew how printers worked: they were members of his own guild; and this tremendous technology, and the problems associated with it, must have been discussed at meetings.[21] He lived in an age of an explosion of printed material, and books were everywhere.[22] They could be bought in Delft on Market day in the Town Hall; from the weekly book fair, not far away, in Leiden; and from the numerous booksellers in The Hague. David Beck, a Dutch schoolmaster, who wrote a diary in 1642, was a keen reader; and tells us of 'nosing around' for books in The Hague, and of visiting a bookshop in Delft.[23]

Vermeer had a little library of his own,[24] which experts fret over now. But we cannot say for certain that all the books that appear in his paintings belonged to him. We cannot identify the *five books in folio*, and the *25 other [books] of all kinds* found *above in the back room*; or even the *five or six old books* found in the *little hanging room*. But Vermeer could have read widely. David Beck certainly lent and borrowed titles from friends, and Vermeer could have done the same.[25] Was he interested in tracts on science or astronomy, treatises on painting, manuscripts, or books of secrets? Did he look at moralizing 'emblem' books or old sermons? We can only make some tentative guesses about Vermeer's reading; and about the contents of the *three bundles of all sorts of prints* found in his studio after his death. These last, just possibly, might have been a source of inspiration for some of the subjects and construction of his own paintings.

We have already seen Vermeer's interest in printed maps, which appear so frequently in his paintings. Experts are keen to discuss their topographical, historical, political, and conceptual significance,[26] but they also had a practical

presence in the pictures, providing dynamic orthogonal strength to his compositions. James Welu thinks that Vermeer's art dealing activities might have included the sale of wall maps, which were popular decorative objects at the time;[27] and so we might wonder if Vermeer used some of his stock-in-trade as props, swopping them over when a client wanted to buy one. The art historian Svetlana Alpers points out that those shown in Vermeer's pictures were complex, sophisticated works, produced by as many as four different printing methods: etching, engraving, woodcut, and moveable type.[28] There is a certain symmetry in proposing that they themselves might possibly have inspired a method that allowed them to be accurately depicted in Vermeer's paintings.

We may have to think outside the camera box, if we are ever to find any answers to Vermeer's brilliant but perplexing achievements. He appears to have done something, or used something, that is beyond our knowledge; and one of the questions posed about his painting methods sounds a bit like a police report. Looking at the lack of drawing in Vermeer's underpainting, Karin Groen wonders if 'a material was used that evades detection by the available examination techniques', and if there might be 'something extra in Vermeer's underpainting that would make the use of the camera obscura feasible'.[29]

What material can hold a painted tracing, and transfer this image to another surface? The most likely, the most easily available thing, is paper. Just a piece of paper. A material that cannot be detected by looking at the painting itself, but one that Vermeer is quite likely to have had in his studio. We know that Vermeer owned prints on paper; we know that he must have known printers who used paper; and we know that other painters of his time, including Rembrandt, worked on paper; so it is not unreasonable to suggest that Vermeer might easily have had some paper in the studio himself.

If oiled paper had been applied to a canvas to transfer a tracing, it would leave no tell-tale mark. Also, because the oil degrades the paper, it eventually falls apart, and any evidence of its presence is destroyed.[30] Tracings made on oiled paper have a limited use, and a limited life span.[31] Maybe this is why no drawings of Vermeer's have ever been found.[32]

To make paper transparent, all that has to be done is to brush it with oil; then it becomes strong enough to hold oil paint,[33] and impervious enough to allow this to be transferred to another surface. Oiled paper was commonly available in Vermeer's day, and had a number of practical uses. It was

found in the kitchen for wrapping food; in the garden for covering garden cloches; and in the house for the shades at windows.[34] It had long been used for tracing. Cennino Cennini valued it for its transparency; and he gave detailed instructions as to how to make it in his treatise.[35]

A number of tracing techniques were known to artists of the seventeenth century. Vermeer may have heard of Durer's drawing machines, which the master used to transfer images in around 1525, 'by pressing a sheet of paper to print off greasy lines he had drawn' from the glass of the apparatus;[36] and Pieter Jansz. Saenredam (1597-1665), living close by in Haarlem, routinely transferred information from his drawings to his painting surfaces, by blackening the back of his drawing paper and using a hard stylus.[37] Sir Theodore Turquet de Mayerne describes the technique of 'a Dutch painter, Retermond' from The Hague, who was using a similar system.[38]

So much for tracing; but was there an artist who ever combined printing and painting together? Extraordinarily enough there was. The Amsterdam artist, Hercules Segers (c.1589–c.1638), worked in a very experimental fashion, engraving metal printing plates to use to print images of landscapes on paper and fabric, on which he then painted.[39] Some of his prints were created with a method of his own devising, where he used a paintbrush on the plate, before the process of etching;[40] and he made some prints using oil paint, rather than ink.[41] His pictures were much admired by Rembrandt, who bought a number of his works, and who reused one of his printing plates.[42]

Despite his innovations, Segers never prospered; and a pupil of Rembrandt, Samuel van Hoogstraten, wrote that he was reduced to making prints on his shirts and bed sheets; and that those he made on paper were used as wrappings by sellers of butter and soap. He tells us also that 'The unhappy Hercules' died after falling down the stairs while drunk.[43]

It is just possible that Vermeer could have heard about Segers; but we are entering the realm of conjecture to infer that this is where Vermeer might have got any ideas that printing could be combined with the painting process, or that such a technique might be helpful to manipulate camera obscura images.

Before we go further in supposing anything about Vermeer's working practice, or making any assumptions about whether he used projections from a lens in his work, we need to find out if a camera obscura was ever a practical technology, and whether there was a way of correcting images easily. Is it conceivable that Vermeer could have used a tracing/printing/painting method at all; or it is just a wild guess?

The best way to find out whether such a method is viable or not, is to try it for real, and then see what the results can tell you. I thought I would do it myself.

* * *

How do you even begin? Some things about painting have not changed in 350 years: the balance of a brush in the hand; the touch of roughness or permeability of a surface, the variable ease of the passage of paint; but obviously very many other things are different. Ideally, one would create a complete mock-up of a seventeenth-century studio with an authentic camera obscura; but I took the decision to concentrate on the problem of transferring images from projections to a canvas, using materials available at the time, and using painting procedures discussed in contemporary treatises.[44]

Much investigation has been done into the quality of seventeenth-century lenses; and the general conclusion has been that they would have been good enough to copy from if used inside a camera obscura.[45] We have Huygens' descriptions too, which suggest that such images could be clearly seen.[46] So the experiment I set up in the studio did not look at this aspect of the camera obscura, instead, it considered how it could have been used. The aim was to make a tracing under a projection; to use oil paint on oiled paper to act as the printing plate; then to see if it was possible to make a legible print onto a canvas, prepared with authentic ground layers.

The idea might sound simple, but there was immense preparation needed before any of this could be done. I had to find the right pigments, oils, linen, glue, and paper. Then because the canvases with their ground layers would take so long to dry, they needed to be prepared first of all.

Decisions had to be made about which of Vermeer's images would be used at the very beginning. Some of his pictures have been more carefully examined than others, and have substantial technical and art historical literature associated with them. These were at the top of the list, so that their constituent materials could be matched as authentically as possible.[47]

Ten canvases were stretched on slotted wooden supports,[48] using fine Belgian linen, with a similar thread count to Vermeer's pictures;[49] and one was made on a strainer in trampoline form, to include the possibility that this might affect the outcome.[50] Threading a canvas took a good deal of time. Just like a best handkerchief, the edges of the linen had to be rolled and hemmed by hand, to enclose a string, to prevent fraying or tears. Then this fabric was laced onto a wooden frame that had been drilled with holes. All

the canvases were brushed with warmed diluted size on the front, and round the edges of the stretchers. This kept the fabric tight, filled the holes in the weave, and protected it from the linoleic acid in the oil paint.[51] When dry, the surface was rough; and so it was smoothed down with a pumice stone, as suggested in a number of treatises, to prevent the texture showing through subsequent layers of paint.[52]

Despite the many scientific examinations of Vermeer's paintings there are still arguments about the exact composition of the grounds on his canvases,[53] even one as famous, and as well researched, as the *Girl with a Pearl Earring*. As a result, it seemed sensible to vary the grounds on the experimental canvases. Each was made with slightly different ratios of the pigments Vermeer had used himself, to see if this would make any difference to the results.[54] These paints were prepared by hand, then applied with a large culinary spatula to the canvases, as this was the nearest equivalent to the large knife illustrated in de Mayerne's treatise (Fig. 4.4).[55] This experience was not unlike icing a very big cake. As each canvas received its priming, it lost its lightness and tightness. The paint muffled the vibration, and it sagged a little under the weight of a new coating.

This first layer of paint included a large amount of lead white paint. It took about two hours to prepare and knife on enough ground for two canvases, and to clean up afterwards. And then there was the problem of where to leave the wet canvases, so they would be unlikely to become accidentally damaged. Once the canvases were covered with this priming paint, they had to be left to dry for about three months, before any further work could be done.[56] When finally ready, the surface was beautifully soft: smooth as skin.[57] To make the surface perfectly flat, the small ridges left by the priming knife were rubbed down with a pumice stone, which left a slightly dusty surface.

Meanwhile there could be no waiting around for paint to dry: there was much to do. The right pigments had to be found, and although most were bought from specialist suppliers,[58] some colours, were home-synthesized in the kitchen, using recipes found in old treatises. This required further research and experimentation. It took time and effort to crush lapis lazuli, and filter water through wood ash in the preparations for refining ultramarine using Cennini's method. It took time to make lake pigments. But the difficulties of these processes confirmed that this was not something a painter would have done himself unless he had to; or unless there were significant savings to be made.

All pigments have to be treated with caution, since some are toxic, and all are dusty. Some had to be pounded in a mortar, before they were ground in oil using a muller on glass.[59] And because each colour was made up in small quantities, it tended to dry out quickly; so new batches had to be prepared just before any experimental session. It was difficult not to be anxious about waste; but here was a direct bond with the seventeenth-century painter, who had to be careful and economical with ingredients.

For simplicity, I decided only to use one kind of oil throughout this experiment; and that was cold-pressed linseed oil, which was Vermeer's preferred medium.[60] This is not the thick boiled oil, used in woodworking; nor oil refined by chemical processes; but an altogether more expensive version, available in art shops.

Brushes equivalent to those available in the seventeenth century, were bought ready made. Hand-bound brushes are still made today, some using quills; some with the hairs just bound to a stick. The simplest form of brush, with string wound round the outside, is sold in Italy as a small fresco brush, and was found to be the best choice for tracing. It was just big enough to hold enough paint for some to be deposited on an impervious surface; and was still small enough to allow for some detail.

Last, but not least, suitable paper had to be found for tracing. After a bit of digging around, a few pages of blank seventeenth-century paper turned up in the antique market in the form of old French legal documents dating from before 1684.[61] Despite its age, this worked extremely well.

When the paper was brushed with linseed oil,[62] it became transparent enough for text placed underneath it to be easily read (Fig. 9.2). Only a few antique sheets were available; and so experiments were also made on new, laid, unbleached, handmade paper; manufactured from cotton and flax fibres.[63] This was extremely expensive,[64] but then it was costly in Vermeer's time too, because there was a general shortage of old rags, which was its main ingredient.[65] The new paper was supplied in 'Royal' size, a format with a long history.[66] Cennini mentions a 'Foglio Reale' and a 'Royal' paper was made in Holland in 1674.[67] The dimensions of the paper for tracing and transfer was not critical for this experiment, since tracings could be made on multiple sheets, and the images lined up by registration, but it is interesting that over half of Vermeer's paintings are smaller than the Dutch 'Royal' size.[68]

To start, an image of one of Vermeer's paintings was projected onto a board in the studio at actual size, upside down and back to front, as it would have

appeared in a room camera obscura; and at an approximate light level that a lens of the time would have produced (Fig. 9.3a).[69]

Then the image had to be measured and adjusted to be the same size as the original painting; and the oiled paper needed to be prepared. The dark paint for tracing was ground under the muller; and the precious canvas, which was stretched and primed, and was now dry, was retrieved from storage. It was rubbed smooth, leaving the surface dusty and absorbent.

The step into the dark, to make a tracing and a transfer, proved more difficult than imagined. Immediately it became apparent that even though the idea was good, some elements of it would not work satisfactorily. A small brush would not carry enough paint onto the oiled paper to make a mark, while a big one obliterated the image too quickly. The paint was sometimes too runny, and dripped down the tracing. Then if it was made thicker, it dried too quickly and would not make a print. If, however, the paint was too dense and sticky, then it was impossible to convey any differences in tone.

The oiled paper was very wet, and so when it was pressed onto the prepared canvas the image swam off it, leaving a mass of indecipherable marks. And all this did not include the difficulties with the tracing; because as soon

Figure 9.2 An old French legal document (dated before 1684), brushed with cold-pressed linseed oil, on the left-hand side, with a copy of *The Times* placed underneath.

as a brush was held up in front of the light source, it cast a shadow on the projected image. Luckily it is easily possible to wipe off the paint from a printed transfer from a prepared canvas with a thinner,[70] leave it to dry, and try again. However, unsuccessful tracings could not be re-used; and it was necessary to start all over again with a clean sheet, if the image on the oiled paper had been spoiled.

Figures 9.3a, 9.3b, & 9.3c Top left: image projected on a board set on an easel. Top right: tracing on oiled paper under the projection. Bottom: tracing removed from the projection.

The problems had to be addressed one by one. The most pressing of which was the consistency of the paint. Numerous experiments to find a good paint for tracing on oiled paper, showed that the best for the job was a dark paint that was not too dense. It would have been possible to trace in any dark colour; but for simplicity, I tried some blacks.[71]

Different black pigments produce paint of different thicknesses, depending on how fine its particles are. Imagine for a moment that you are trying to make two mixtures from a solid and a liquid combined. You are making one batch using the gravel in your path, and the other using fine sand. Which would mix together better with oil? You know that the gravel will not combine, that it will be gritty; and when it is spread out, lots of little bits will be standing up. The sand, on the other hand, is likely to clump together, as it does in a sandcastle. It is just like this with pigments. Some are naturally fine, like lamp black; which takes up a great deal of oil, as each small particle becomes coated; and some have larger particles of hard material which are difficult to break up, like bone black, and produce a much thinner, grittier paint.[72]

I found that bone black was strong enough to put down a dark mark, and that it did not spread and run like the very oily, glossy paint made with lamp black.[73] However, it took some time to achieve the ideal consistency; and to find a brush which would be big enough to hold sufficient paint, but small enough to transfer important details.

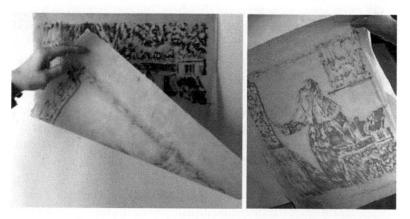

Figures 9.4a & 9.4b Taking the tracing from the board and turning it over.

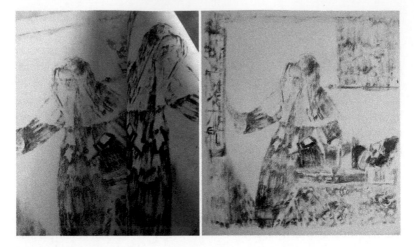

Figures 9.5a & 9.5b After the oiled paper 'plate' is pressed on the canvas, it is lifted back, to reveal the print.

Then I had to try to solve the problem of too much oil in the oiled paper. I went back to Cennini's treatise, and there was the answer, right before me. He suggests that once you have brushed the paper with oil, you should leave it 'for the space of several days' until it becomes 'perfect and good'.[74] What happens in this time is that the oil on the surface hardens a little, without affecting the transparency of the paper. Then, when it is squeezed or pressed, less oil comes out.[75]

Off we go again: the paper is not absorbent, and it is slippery; so it takes a number of movements of the brush to make marks. The tracing is a bit rough, and it gradually obliterates the projected picture. It seems easier to start tracing the darkest areas of tone; and then try to make thinner marks in lighter areas. When judgements of relative tone become impossible, then it is time to stop (Fig. 9.3b). The paper is unpinned, and brought into the light (Fig. 9.3c). Now the paper tracing is turned over, so the wet side faces downwards (Figs 9.4a & 9.4b). It is placed straight onto the face of the canvas, and pressed against the surface. Once the print has transferred, then the tracing is lifted up slowly, away from the canvas... and there is the completed print (9.5b).

This part of the process was the most tricky and difficult to control. Sometimes the print transferred immediately onto the light ground of the canvas by itself. On other occasions the prints needed the pressure of a hand,

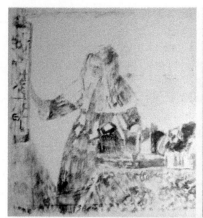
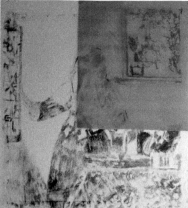
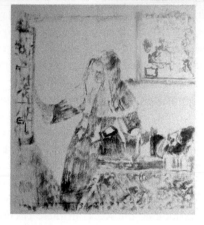

Figures 9.6a, 9.6b, & 9.6c Top left: print on canvas with map rubbed off. Top right: print with new tracing in place, showing registration marks. Bottom: print with new tracing transferred.

or to be rubbed over with a wooden spoon, particularly when the tracing paint did not have much oil in it, such as after several proofs had been made.

The sum of the sketchy marks transferred to the canvas provided a tonal plan of the whole composition; and in the case of a tracing and transfer of *Young Woman with a Water Jug*, gave an impression of the various textures of glass, metal, and woollen carpet. Extraordinarily, some small details came through too, as where the girl's fingers are visible at the window, through the apparent confusion of the patterns in the leaded glass (Fig. 9.5b).

Sometimes there were elements in a print I did not like, or which had not come out well. Here, the map was too rough (Fig. 9.5b). So this part was wiped off with an oily rag (Fig. 9.6a).[76] If the paint had dried completely, then this part of the canvas could be rubbed with a pumice stone, to remove just this part of the print. A new tracing of a small part of the projection was made with oil paint on a little piece of oiled paper (Fig. 9.6b). Then a crisper, better looking 'map' was transferred to the existing print, using registration marks (Fig. 9.6c). I found that good marks could be made using stick charcoal, which would only transfer if given extra pressure.[77] This method would be good for an error caught at an early stage, otherwise changes of composition could always be done conventionally, by overpainting.

The discovery that registration could be used successfully in conjunction with this tracing and transfer method led to the realization that whole images can be built up in parts, and pieced together. Maybe the *inventing* layer for the *View of Delft* (Fig. 7.3) was made up like this? Although it is a picture that exhibits a number of 'photographic' features, no one has yet suggested a method by which the images from a camera could ever have been transferred onto such a large canvas.

There is a craze at the present time to transform hotels rooms with the very best views, into 'living cameras'. All you have to do, apart from paying the bill, and choosing the best destination, is to block out all light apart from a small chink in the window, and allow the complete room to be transformed into a live panoramic cinema. The photos taken on long exposures of these projections are spectacular.[78] But if he had a lens in the window, then Vermeer would not need complete blackness to see the image on the wall in the room overlooking the Kolk. In these circumstances, the lens would collect enough light for it to convey an image that could be seen in semi-darkness. It would be even brighter than projected images seen at right angles to the windows, as they might be in his studio room.

Here, just as in the hotel, the room itself would become the camera: Vermeer could put curtains at the window, around the lens; then the image could be cast onto a screen for tracing.

Vermeer could determine what size canvas he wanted to use, by checking the dimensions of the total projection, and he could then trace and transfer the image in sections. The top of the tallest towers in the *View of Delft* (Fig. 7.3) reach just below half the height of the canvas: then there is just sky remaining. So Vermeer would only need to use two sheets of paper the size of Dutch 'Royal' to trace all the townscape. This paper size would leave

room for an overlap and for registration marks; and, as it happens, Vermeer indicated the exact centre of the composition clearly, with the top of a boat mast, just by the side of the Schiedam gate. The slight disjunction and compression noted in this picture could be an indication that he may indeed have traced this image; rather than it providing proof that he did not use a camera obscura at all, as some experts suggest.[79] Once he had transferred his tracing to the large canvas, Vermeer could have supported it on one or two easels next to the window, to work in colour, and observe the scene and the changing light.

Although the camera obscura might be most useful to the painter in establishing the very first *inventing* layers on his canvas, there is nothing that would stop him re-entering the camera obscura booth, and making tracings and transfers at any stage of the painting process. I found that once it had dried, it was possible to put back the original tracing paper on top of the projection, and trace details. It was even possible to mark the position of highlights.[80] Small tracings can be successfully printed onto a painted surface, provided it is completely dried first. However, there are some constraints in working like this. It is very difficult to control a large area of printing on a previously painted surface, because its surface is unabsorbent; and unless absolutely dry, very slightly tacky.[81] Obviously you would not want to destroy any good area of paint with a pumice stone, even if this might help a print transfer. In any event, paint needs to be bone dry before it can be rubbed down, or it tends to peel. I discovered that only tracings made with thin paint would transfer onto a very slightly sticky surface, although it tended to run a little; and that thick paint did not work, as it pulled or puckered as the oiled paper was lifted from the print. But this was not so much of a disadvantage; as once on the canvas, thin marks could always be strengthened with thicker paint later.

It appeared to me that although highlights could be traced and transferred like this, that it was only helpful where they were particularly crucial, such as on the earring in the *Girl with a Pearl Earring* (Fig. 5.1). Lots of spots or dots would be difficult to transfer, and would not be worthwhile to trace, not least because the paint would probably dry on the oiled paper before they could be transferred.[82] The insistence of some experts, that these little highlights are a stylistic choice; that they are an imitation of an effect seen in a lens, rather than a direct transfer from a tracing; may well be correct.

Trying things out in the studio revealed another use for an oiled paper tracing. Not only would it provide a very useful reference drawing for the composition, which could remain on display throughout the painting

process;[83] but also, there was enough paint remaining in it to give three, or even four proofs. This is significant, because it gives latitude to play around with the image. You can print a proof on a piece of ordinary paper or canvas,[84] and then, if you want, take a knife or scissors to it: cutting and cropping to see how it would look, and comparing it with the original tracing. Should the figure or a piece of furniture be moved? The artist can delay adjustments to the set-up in the studio; the canvas size; or the format of the image, by trying them out using prints first, before final decisions are made.

We might see the little stack of canvases left behind in Vermeer's studio in a different way now. Maybe they were not waiting for new completed works. They could have been used in the process of composition to check how an image looked; or used as a backup if the print did not come out well the first time. Then they could have been cleaned for re-use.[85]

It could be said that we are so familiar with Vermeer's images that the results of this experiment cannot provide fair comparisons with his own paintings. So an experiment was made using a modern image instead, to see if the effect of the tracing was similar.

A digital photograph was projected upside down and back to front on the board on the easel and then traced in exactly the same way as before, using paint and oiled paper; then a print was made on a canvas (Fig. 9.7b).

The result produced just the same blurred effect. The roughness and darkness of the print, in contrast to the light ground, was similar in tone and texture to the prints made from projections of Vermeer's paintings.

If Vermeer had made prints on a canvases like this, then he would obviously not have done it in the same circumstances as this experiment. The

Figures 9.7a, 9.7b, & 9.7c Left: digital photograph. Middle: print on prepared canvas from a tracing under a projection.[86] Right: detail of print.

boundaries of the picture would not have been decided for him at the start. The projection on the wall would have been bigger than his paper; and the image would be in focus at the centre, curving and fading away towards the edges.[87] It would also be round. He would have had to decide how much of the projection he wanted to use, how big a piece of oiled paper to put under the image; and then what size or format canvas he wanted to use to receive his paper plate, and make a print.[88]

There is something more for us to consider about the distinctive quality of Vermeer's work, which may give an indication he used a lens in his work. This is something we understand as soon as we look through two lenses at once.

The stereo viewers on sale at the Vermeer Centrum in Delft are the forerunners of virtual reality headsets.[89] Their double eyepieces are focused on Vermeer's masterpieces, which have been digitally configured to provide two versions, one slightly shifted, to give an illusion of volume and depth. They lack moving stereo images, with accompanying soundtrack, but still they kick you with the realization that Vermeer must have been looking at something solid before him. The Milkmaid (Fig. 1.2) looks truly monumental through the viewer: she is no longer outlined against the wall, but is standing some distance from it. We feel the solidity of the turn of her hips, and the strength of her control of the heavy jug, with its thin string of milk, dribbling into the bowl. We get a frisson to realize that up until now, the painting by Vermeer we thought we knew so well, was actually so flat: that it lacked much depth at all. We are so used to seeing 2D images, on tablets and screens, on billboards and adverts, that we do not think about this much.

All painters end up with a flat artefact. But for most, their completed work is produced with the help of both their two eyes during the whole process; and they respond to this by trying to indicate depth and volume in a number of ways. They may shade the side of an object, overlap shapes, or use small dabs of paint, as in Impressionist painting. The use of chequered black and white tiles is another trick which makes us believe we are looking into a recessive space.[90]

But in a painting by Vermeer there are contradictions, because there is sometimes no recognition of big jumps in space. We see this in the Young Woman with a Water Jug (Fig. 9.1), where there are areas that are as flat as a pancake. The wall pushes forward through the smallest of gaps, with extraordinary presence. We see it right next to the Girl's hand as she holds her pitcher. We see it next to the lip of the jug and her hip. What distance is

there between her and the chair; or between her shoulder and the map finial? When our eyes have made their way towards the window, along her arm to her hand holding the catch, then we finally feel there might be some air behind her, that she is not embedded in the back wall. Then suddenly we understand her solidity inside the curve of the coif, and her volume inside the roundness of the bodice. This appreciation of mass comes and goes, because when we look down at the deep blue of the girl's skirt we encounter flatness again, despite a brighter line wandering between it and the darkness of the wall.

This flatness goes hand in hand with another strange quality we see in Vermeer's work. Quite often one element in his pictures seems very close to another, yet we know there is a depth of space between them. It cannot be happenstance that shapes just fail to touch each other. A map finial almost pokes into a head in the *Woman with Lute* (Fig. o.1); her sleeve almost brushes the table top; and her lute is perilously close to the horizontal of the map holder. The more we look, the more we see such tensions in other pictures: a hand does not quite touch the chair in the *Young Woman with a Water Jug* (Fig. 9.1); and an elbow is only a fraction from a window ledge in *The Geographer* (Fig. 6.6). These stylistic jolts are the visual equivalent of a pinch on the arm. Vermeer is so sure of his command of composition, that he is able to try something triumphantly new. The tiny gaps between shapes leave us to judge the distances and depth in his pictures; and force us to provide our own three dimensional interpretation of the scene.

One expert said that 'visual bonds...take precedence over spatial organisation' in Vermeer's pictures.[91] And if Vermeer was looking through only one lens while he was composing his images, then the space he saw would be compressed: he would be less conscious of depth, and more aware of the relationship of one shape to another. Artists have used a number of devices in the past, including optics, to help them 'fool their visual systems into seeing the world as flat'. This is because a monocular view is very helpful in the challenge to transform a 3D experience into a 2D image.[92]

We might continue to argue about whether Vermeer did use a camera obscura or not; but if we fail to consider the practicalities of how he might have done so, then we cannot know whether a lens could ever be partly responsible for the immediacy of his subjects and their magnetic presence. If a camera obscura was going to be useful, then he needed to correct the orientation of the image presented to him in his curtained booth. He needed to end up with an image that was the right way up, and the right way round,

so he could compare it with his subject, and paint in colour in the light of the studio. But if a tracing and transfer solution sounds unlikely, then could he have done this another way?

Various solutions have been suggested. One is that charcoal dust could have been pounced through holes made in a tracing on paper.[93] This is a traditional way of transposing images, used in fresco painting, but no vestige of such a method has been found in Vermeer's pictures.[94] There was even an idea that the camera obscura projection was never corrected by Vermeer at all, and that we are seeing a mirrored reflection of his own reality in his paintings.[95] And there have been experiments to try and prove that Vermeer could have worked directly onto his canvas from a projection in daylight, using complex optical arrangements.[96]

None of these suggestions has produced an outcome that can explain how Vermeer could have transferred optical effects straight onto his canvas, while simultaneously explaining the strange appearance of his underpaintings, and conforming to the known methods of his time.

But here, in a simple printing technique, we have found something new. Using dark paint, we can trace in reduced light; and by using paper to work on, we can transfer this image to a canvas, and also correct its orientation. Not just this. We will see that results of this method provide answers to puzzles no one has been able to explain before.

* * *

The task of an artist is to make his picture transcend the means by which it was made; and very few ever have managed this better than Vermeer. As we look, we hardly recognize that the figures we see in their light-filled rooms are only part of an artefact: a construction of shapes, made with a few layers of pigment and oil on a canvas; and that inside the strata of paint, the colours rise and fall. A dark layer from underneath rises upwards; then a top layer is submersed by a glaze or a scumble.[97] Each has its own purpose; and we cannot tell from looking on the surface, where one begins and another ends.

We remember the dimness of an April morning; the cold pressing on our back. Quiet. We hear the birds' small rustling; some short chirrups, and tweets of greeting. We hear a beat of wings; feel a flurry of air. Then, one after another, a voice lifts in clear unhesitant tune. We recognize the repeating phrase of the skylark, chaffinch, and wren; but as the music rises, we cannot follow any individual thread of song. Instead, from all around, come bursts of glittering chorus, tumbling onto the grass.

Figure 10.1 Studio Print, first proof (detail).

10

Printed Light

When you do an experiment, you hope that the results might be interesting and informative. You don't expect a shock.

But when the first print was pulled back from a tracing of a projection made in the studio, the girl seemed caught in the headlights; her grainy presence contrasting strongly with the creamy ground. The printed image showed a striking resemblance to Vermeer's own underpaintings, with their dramatic tonal qualities and their unusual lack of line. Could it be that in an effort to correct the camera obscura image, Vermeer hit upon a method something like the one used in this experiment; and was attracted by the way that the falling sunshine could be caught by default?

Although it must have taken Vermeer some considerable time and effort to plan his compositions; to make the balances right, with his models, maps, and furniture; the act of making a tracing under a projection, is reasonably fast. Indeed, if you want to use oil paint as a kind of printing ink, you have to work quickly, otherwise the paint stiffens, and will not transfer to another surface. Then, to see anything clearly through the lens, the subject has to be well lit, which in Vermeer's day meant that he would have had to work at a time when the sun was out and when shadows were strong.[1] Put these two requirements together, and we can see that any use of the camera obscura by Vermeer required him to move at speed, in order to capitalize on any good weather, and to use his paint before it dried.

It is very difficult to trace with much variation of tone under a projection, and so marks are either dark or very dark. By painting the shape of the shadows on oiled paper, the illumination appeared by itself, as the image was transferred to the light-toned ground on the canvas. But maybe this was also part of the means by which Vermeer was able to convey the feeling of an arrested moment in time. This process might not be done in a blink of an eye; but it is possible to trace the essence of a projection in the span of half

Figure 10.2 Tracing being lifted from a studio print.

an hour or so, and transfer it to a canvas. Since it is dark and uncomfortable inside the camera obscura, you do not want to stay there any longer than necessary. However, whatever you put down can always be refined later; when you can sit more comfortably out in the light and air of the studio.

One of the compelling qualities of Vermeer's work is its quality of suppressed energy: the feeling of a moment observed.[2] Could this partly be due to the opportunity to trace the energy of his subjects, and the reality of the shadows, at speed?[3] Nearly all Vermeer's models stand in active positions, not in poses they could hold all day. Some rest their arms on a table, as in the *Officer and Laughing girl* (Fig. 8.4); or on a musical instrument, as in the *Woman with a Lute* (Fig. 0.1). Other figures put their hands in their laps; or brace their elbows close to their sides as they read a letter, hold up their necklace, or beat time to music. Exceptions include *The Milkmaid* (Fig. 1.2). Here the woman steadies her jug with two hands, to support its weight, and control the thin stream of liquid. This must have been difficult to manage for long, but then this subject might have been a real servant, used to physical work.[4]

If you tried to make a plan of a picture without using any lines, you might find it very difficult indeed, even if you are an experienced artist. You might want to use a contour to show where the edges of a shape or an area of shadow is, before you 'shade it in'. But Vermeer appears to have had an 'almost solitary indifference to the whole linear convention'.[5] He does not use much in the way of line; he uses tone instead.[6]

These unusual beginnings could be explained by the use of a rudimentary printing process. When marks made with oil paint are printed onto the dusty surface of a canvas, they spread out under the pressure of a hand. As a result, lines disappear; edges become indistinct, and you are left with dark shapes. This could possibly account for the tonal qualities of Vermeer's underpaintings; and also to the abstraction we see in his finished pictures. Lawrence Gowing wrote, 'Vermeer seems almost not to care, or not even to know what it is that he is painting...nothing concerns him but what is visible, the tone, the wedge of light.'[7]

What can we make of the white shape under the table in the *Woman with a Pearl Necklace* (Fig. 5.9)? We might imagine that it is a plate that has fallen on the floor, behind the table leg. It is only when we look for some time, that we can reason that it must be part of a patterned tile, showing through a gap in the tablecloth. It is difficult to understand why Vermeer would want to include this apparent distraction. Yet if we blot this out, by holding up our hand as we look, then we see immediately that the picture has much less life without it.

What exactly is in the jumble of things on the table in *The Astronomer* (Fig. 6.5), where two light wing-like objects wave under a force of their own? We cannot quite explain, but assume in the end they are the end of a document. The more we look at Vermeer's paintings, the more we see things we do not read at first glance; the more we see unexpected shapes and inconsistencies. But again, this is akin to our own experience of looking, where we focus on what is paramount to us, and ignore the details of our surroundings. The richness of uncertainty adds to our experience of Vermeer's work, and demonstrates his confidence that what is important to him, will be important to us.

Gowing remarked on Vermeer's 'unshakeable detachment'; and he used the bulbous hand of the painter, in *The Art of Painting* (Fig. 1.4), as a particular example where Vermeer did not try to avoid putting down something which was not immediately recognizable; and which he points out, was an

effect other artists of his day did not embrace. To see an object without pre-
conceptions, as if 'for the first time'.[8] was a way of working which became
valued in the twentieth century; but it is difficult to do, because it is easier to
put down what you expect to see, rather than what you actually observe. You
might be keen for your viewer to understand clearly what it is you are depict-
ing, and so alter what you see to provide clues.[9]

But Vermeer goes for visual honesty; and Lawrence Gowing goes on to
ask why Vermeer does not distinguish between one object and another, why
does he not identify 'what the darkened forms are', and 'how they are div-
ided'?[10] But just try to trace an image in the gloom, with what feels like an
unsuitably large brush, when everything is reversed and also inverted. What
chance would you have to recognize what objects or figures you were seeing?
This is precisely how it is inside the camera obscura; and if you cannot be
sure, where one thing starts and the other ends, then you might trace them all
as one shape. We cannot believe that Vermeer did not care what he was paint-
ing; but maybe in recording his composition in reduced light, and also at
speed, he traced everything together; everything abstractly.

Having an image presented upside down and back to front is not neces-
sarily a disadvantage. The art historian Martin Kemp is not alone in consid-
ering this quite the opposite.[11] It might help in the process of composition
not to be able to recognize elements in the motif, but to see them just as
shapes to be balanced instead. And, if everything is traced at once, then
everything becomes linked, one to another.

We see this in *The Concert* (Fig. 10.3)[12] where the musical trio and their
surroundings are strongly interconnected. Are we not welcome? We seem to
be kept well back behind the table, and the stringed instrument on the floor.
The intensity of the group's concentration, as they give a private perform-
ance, does not encourage us to join them either.

There is tremendous tightness in the construction here. If you took a
piece of tracing paper, and put it over a reproduction of this picture, to ana-
lyse its composition, even before you found the strong diagonals of the floor,
your pencil would hover over the strength of the repeating verticals and
horizontals. They connect across the painting: picture frame to harpischord;
table to woman; chair leg to head. The grid pushes its fingers into the group
of figures, which bends out in a bow, mirroring the arc of the viol that juts
out towards us. Vermeer has used the back of the chairs, and the side of the
harpsichord, to move us through space; and the rectangles flick round, car-
ouselling on the pivot of the side of an ebony picture frame. We can see that

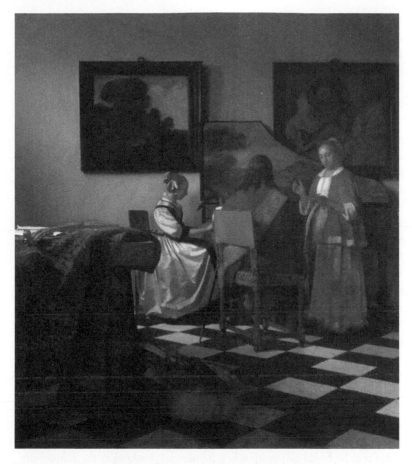

Figure 10.3 Johannes Vermeer (1632–1675), *The Concert*, c.1663–1666. Oil on canvas, 72.5 × 64.7 cm. Isabella Stewart Gardner Museum, Boston. (Present whereabouts unknown.)

the severity of the pattern on the floor plays against the beat of curves and folds, as the melody is passed from one player to another.

The darkened silhouette of the girl lies flatly enclosed against the wall, as she concentrates on her keyboard.[13] We cannot see her hands, nor the strumming of the lute:[14] the making of the music is hidden in the soft air between the man's bulk and the harpsichord. We strain to hear it, strain to see; but the light in the room is fading fast; the figures turn away from us; and then we notice the frayed paint, and the dulled colours.[15] It is with dismay that we

find that this picture's musical presence is now denied to us forever. It was carried off by thieves in March 1990; and a veil of silence and obfuscation has fallen over its fate. Today we can only hear the song, and its accompaniment, in dimmed, old, muffled reproductions.

The Isabella Stewart Gardner Museum in Boston waits patiently in hope; and has left an empty frame in the gallery, in readiness for its return.[16]

We might think of Vermeer as a refined painter, but underneath the smoothness of his finished work, is quite a surprise. His first layers are rather rough.[17] There are 'broad brushstrokes' on the lower layers of the knee of the lady in *The Love Letter*;[18] and 'a loosely-brushed rough textured underpaint' beneath *A Lady Writing* (Fig. 8.6).[19]

The experimental images on canvas, made from tracings in the studio, also showed a variety of textures, including the imprint of brushstrokes. It was not possible to make very precise tracings, because only a medium-sized brush would transfer enough pigment to the slippery oiled paper to then make a print on the canvas. The results looked similar to a rubbing of a coin under a piece of paper, made with a wax crayon. There were no half-tones in the studio prints, and they transferred incompletely; giving a result that would have horrified any printmaker worth his salt. This effect was the result of a combination of factors: the variable amount of pigment, uneven brushstrokes on the oiled tracing paper; the texture of the handmade paper; the nature of the rubbed surface on the canvas; and the difficulty of applying an even pressure, either with a hand or with a wooden spoon.[20]

Can we imagine Vermeer, of all people, working like this? But it might have been useful to him to be able to transpose the essence of a complex composition to his canvas at a very early stage; and be secure in the knowledge that he could tidy it up when he pleased, looking at the subject directly. This might explain his almost superhuman confidence in being able to put down his *inventing* without making significant changes. Art historians have been amazed by the complete tonal plan he put down in the first layers of *The Art of Painting* (Fig. 1.4), a picture measuring more than a metre square,[21] whose essentials were hardly corrected at all.[22]

Another distinctive feature of Vermeer's pictures is their 'peculiar atmospheric, feathery quality... found hardly anywhere else in painting'.[23] But one explanation for this could come from my experiments. Not only did prints made in the studio lack line; they were also indistinct and blurred. Maybe this effect in Vermeer's painting was not a deliberate stylistic choice at all, and not the result of tracing something out of focus either. Maybe Vermeer

used a printing process that produced a planning layer, which *looked* out of focus; and then he chose not to cover up this first layer completely. We have seen that he was keen to allow parts of his underpainting to show through on the top surface of his pictures. So if he did use a print as part of his *inventing*, then it is this that would be seen underneath thin layers of paint, and at the edges of forms, where he chose to leave his first layers partly uncovered.[24]

A tracing made in the studio from a projection of *The Music Lesson* clearly shows that although the brushwork on the oiled paper is in itself quite rough, it conveys considerable information about tone, shape, and pattern (Fig. 10.4). The figures in the print made from this tracing may be indistinct; but they appear to be standing in strong light. We can see this could provide a very solid foundation for further work; and we can imagine the painter putting this on his easel. Now, we can see him working much more slowly, looking straight at his models in his quiet room, over a period of days and weeks; adding colour and detail, and refining the pattern and the texture.

Figure 10.4 Left: Studio print of a detail of *The Music Lesson* (Fig 8.5). Rough brush strokes are still visible; and the image has smudged a little, after printing onto the trampoline canvas. Right: The tracing on oiled paper, used to make the print, showing the paint side uppermost.

The use of a print as the basis for *the inventing* might explain why Vermeer's work appears to have two systems of vision, as some have suggested.[25] The practical use of the camera, rather than the lens itself, may be the root cause. Did he look first with the one eye of the lens, then with both his own eyes? Did he make slightly imperfect, blurred prints by tracing from the camera obscura projection, and then subsequently paint on top of these, using direct observation?

When the trial prints were made in the studio, it took some while to get the balance of all the materials right, so that a clear print could be made. As we have seen, one of the crucial choices was finding a pigment that would not be too strong, and bone black was found to work best.

An investigator who was looking into the lower layers of Vermeer's *Woman with a Pearl Necklace* (Fig. 5.9), was 'astonished' to find that Vermeer used two different kinds of black in his underpainting: both lamp, and bone black; and she was equally surprised to find that these were applied with 'a rather quick sketchy stroke, done with a broad brush'.[26] We already understand that Vermeer would have needed a brush of reasonable size, if he was to trace on oiled paper, but my experimental tracing and transfer technique can also provide a reason why two kinds of black might appear in his underpaintings.

There was a bewildering choice of blacks at the time, and they all had different properties and different uses. It is a long list: earth black;[27] sea coal black;[28] lamp black; cherry stone black; vine black; charcoal black; peach, date, or almond stone black; walnut shell black; bone black; ivory black; even 'burnt toast', described as a 'bread black'.[29] Some blacks are warmer in colour than others: bones produce a brownish colour, while vine black, often called 'blue black', was recommended for painting ruffs, or the shadows in the face, when mixed with white.[30] There were recipes to suggest how to prepare and use all of these different pigments in painters' treatises.[31] 'Cheristone' black was suggested as being good for draperies;[32] and if a painter wanted 'a most extremely deep black', then lamp black,[33] and ivory black could be used together; by putting one, as a glaze, over the other.[34] Painters could follow a recipe for making ivory black; and put some bits of an 'old combe, fanne handle or knife'[35] in a closed crucible, with a 'littel salt'; and place it in the fire for a quarter of an hour.[36]

In Cennino Cennini's day, bones for pigments were generally those left over from meals. He suggests looking 'under the table' for discarded capon

carcasses to use for bone white (presumably only if you could beat the dogs to it), and it seems that bones from mutton or beef were generally burnt for bone black.[37] You can make this pigment quite easily yourself, if you can crush the bone small enough; but even if you prefer to buy the commercially made bone black, and grind it under the muller, it will release a distinct smell of cindery Sunday dinner.

Out of all of these, Vermeer chose mostly to use bone black, the pigment that was found to work well for printing in the studio. Its thinness will allow the painter to indicate some differences in tone, as it is not as dark as the fine soot of lamp black; and it is a better choice in the lower layers, because it is less oily too. Vermeer would have been keen to follow the *fat over lean* principle of painting, to reduce the risk that his picture might crack because of uneven drying.[38]

The reason why there are two kinds of black in his underpainting could be that Vermeer chose to use bone black wherever he could, as it worked better for tracing; and then he fortified areas he wanted to be very dark or more precise, with lamp black afterwards. If both these blacks were applied one after the other, once the first had dried; they would both be part of the *inventing*.

All blacks are slow driers, which is frustrating if you are waiting to progress with your picture. But there were tricks that Vermeer could use, to combine blacks with fast drying pigments in some way. One method was to add a quick drying dark pigment to the black, directly on the grinding stone. Traditionally, verdigris was added to bone black and umber to lamp black:[39] each mixture having one cool and one warm pigment in combination. Alternatively, he could treat the oil medium in which pigments were to be ground. This was done either by boiling it on its own, or by adding a lead pigment: either litharge, or minium.[40] These could be put in a bag and 'suspended to the handle of the pipkin' in the fire,[41] to clear the oil of sediment.[42]

The efficiency of a third method to speed up drying was confirmed as a result of trying to make a better print on the canvas in my studio. A number of canvases had been prepared at the beginning of the experiment, to receive the oiled paper tracings. But their surface was smooth and unabsorbent. This meant that when a print was made, the paint tended to run, ruining the image. But when the ground surface was rubbed with a pumice stone[43] to increase its 'tooth'; then the particles of dust absorbed the oil from the tracing and stabilized the print, giving a better result. What was actually happening at the same time, was that the fast drying lead crystals in the white paint were

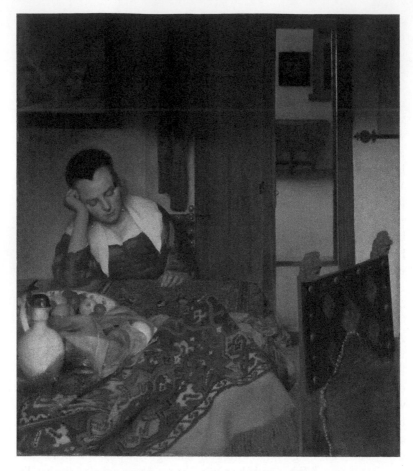

Figure 10.5 Johannes Vermeer (1632–1675), *A Girl Asleep*, *c.*1656–1657. Oil on canvas, 87.6 × 76.5 cm. The Metropolitan Museum of Art, New York.

re-exposed, and they combined chemically with the black paint, which helped it to dry.[44]

There she is, fast asleep and dreaming, when she should be working (Fig. 10.5). She has found a chair for a moment's rest, propped her head on her hand, and balanced her elbow a little too near the edge of the table. Any minute now, it will slip, and she will wake with a start. Some have assumed

that this picture is the one described in a sale catalogue of 1696, showing a 'drunken maid, asleep at a table'.[45] But others question whether she is inebriated at all, or whether she is even a servant.

If we see where Vermeer shows maids waiting on their mistresses, their costume is drab. Those in *The Love Letter*; *Mistress and Maid* (Fig. 4.7); and *Lady Writing a Letter with her Maid* (Fig. 2.2) all wear a plain brown dress with a blue apron, in contrast to their mistresses' silks, fur, lace, and jewellery. This corresponds to a distinction between people of different classes at the time. The feeling that divisions of social rank should be respected even culminated in a dress code, issued in Amsterdam in 1682, which tried to curb excessive finery and ornament worn by maidservants such as jewellery or 'anything than modest and demure clothing'.[46]

This woman's luxurious dress and pearl earring would flout convention, if she was a maid; and could indicate that she is, in fact, the mistress of the house. One expert suggests that rather than being the worse for drink, she may be suffering from melancholia instead: her state of mind possibly reflected in the confusion of objects on the table.[47]

Whatever the moral lesson in *A Girl Asleep* (Fig. 10.5)[48] the fact that she is sleeping means we can tiptoe past, and explore our surroundings without waking her. We look around. We see an awkwardness, and an unwieldy composition. There are odd angles and some funny unidentifiable shapes; with a chair and a picture on the wall abruptly truncated; and a carpet bunched up towards us. Further back, there is an abstract pattern of squares and rectangles, providing quiet contrast to the clutter of the foreground.

Vermeer painted this early in his career, before he really got into his stride, and we know he chopped the edges of the canvas, and changed his composition several times. There was once a dog and a man in the doorway; and maybe Vermeer took them out to change the story, or to simplify things. The art historian, Arthur Wheelock, said that Vermeer 'had to struggle to set his still life convincingly on the table'.[49] And we might agree that he did not succeed. He seems to have tried various options in this area of the painting. At one point, there was an extra plate near the girl's hand, and also a bunch of grapes on the table, just by the dish of fruit and the wineglass.

There are a number of investigative scientific techniques now available to conservators to enable them to look below the surface into the layers of a painting. One technique, called 'neutron autoradiography', was used to identify some of the chemical elements in the pictures, which can indicate the presence of particular pigments, though it does not show in which layer they are sitting.[50]

Figure 10.6a Detail of vine leaves from the fourth autoradiograph of *A Girl Asleep*. The Metropolitan Museum of Art, New York.

Figure 10.6b Detail of sleeve from a trial print of *Young Woman with a Water Jug* on an unabsorbent surface.

The resultant images of *A Girl Asleep* (Fig. 10.5) are startling, though we have to be wary of making false interpretations.

Let us look at the vine leaves under the tablecloth (Fig. 10.6a).[51] Isn't there something a bit reminiscent of a William Morris design about them? Their edges are so well defined that it is difficult not to wonder if they could be the result of a print, included at some point in the painting process.

If the leaves were made by printing, then they would not have been put onto a dusty ground surface, because Vermeer would already have put on several layers of paint by then. The surface of the canvas would have been sealed up with paint and oil again; and so, instead of looking fuzzy, because of absorption, the image would be sharp, although the paint might run a bit. Interestingly, experimental prints made on an un-rubbed painted surface in the studio looked very similar in texture, where the pigment clumped together, and sat on the surface (Fig. 10.6b).[52]

In whatever way Vermeer painted his bunch of grapes, he obviously did not think much of the result, as it disappeared from view under other layers of paint as he resolved his composition.

Back in the studio, it seemed important to try to move the experiment a little further along, to see how easily prints could become incorporated into a

painting. This was done in a spirit of enquiry, rather than in an attempt to emulate Vermeer's work. In any case, the figure that appeared in the print (Fig. 10.8), turned out to be only a 'cousin' of the *Girl with a Pearl Earring* (Fig. 5.1): the very slight differences in the tracing made her into someone else completely. But she still came to life when colour was added on top of the black and white print, even though she had much less presence and expression than the original. Despite the dark paint on the oiled paper being applied quite roughly, and despite the imperfection of the transfer to canvas, it was very interesting to see how strongly the power of the underpainting came through further thin layers of paint.[53] Very little colour was needed to establish the basis of the image. If Vermeer had used a printed underpainting like this, he could have gone on to change it as it suited him, observing his subject directly in the light of his studio. Of course, no refinement like this could be made to the experimental image, since there was no model to see.

A single layer of yellow ochre was applied to the coat in the studio print, and this turned green where it touched the dark painted shadows. It looked remarkably like the coat the girl was wearing in Delft in 1665. However, hers may once have been warmer than it is now, as it seems that a glaze, added to give it a reddish glow, has now faded.[54] In other areas of Vermeer's painting it appears that the grainy quality of his underpainting helped to define important shapes in the picture, such as the folds on *the Girl's* turban. It is thought that Vermeer just brushed a thin glaze of ultramarine over the underpainting here, leaving some of it still visible.[55] When the same was done to the studio print (Fig. 10.8), the results looked quite similar.[56]

Painting the face of the girl in the print required the dark first layer to be covered up a bit more than the turban, and so an opaque mixture of lead white, yellow ochre, and bone black was brushed over the central part of this area. This softened the dark underpaint, and the shape of the shadow came to define the shape of the nose, just as it does in the original painting.

The two glistening pink dots at the corner of the mouth of the *Girl with a Pearl Earring* came to light again in the restoration of 1995, having been hidden for years under dirty layers of varnish. They were painted one on top of the other.[57] Could it be that Vermeer was uncertain about the first dot of paint, or was it a guide mark made from a small tracing of a projection, which was then strengthened with another touch of paint?

The arguments continue as to whether the highlight dots we see in Vermeer's pictures are the result of direct tracings from a lens at all; or whether he added them to give extra visual effect. Some are in places where

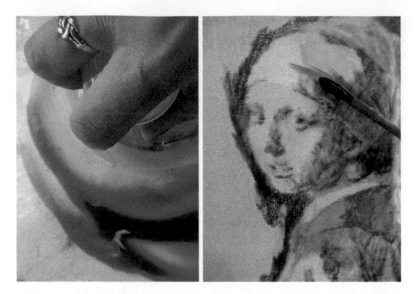

Figure 10.7a & 10.7b Grinding an ultramarine glaze and starting to apply it to a studio print.

'technically they could not appear', such as the apparent reflections off the dull surface of a loaf of bread (Fig. 1.2). Others could possibly correspond to what can be seen through a camera obscura.[58] Experts can make up their minds as to which might be which; as it is easily possible to trace some thin highlights, and transfer them to the very top surface of a picture where required, but in the end, it may be easier to put them down by eye.

Have we resolved the question as to whether Vermeer used a lens or not? It is unlikely that we have. At the extreme, this proposition is 'a fantasy': a suggestion that should be rejected out of hand. For others, 'the evidence about his use of optical devices is about as sure as it could be'.[59] As we look at Vermeer's serene pictures, we may not care either way; but we should be aware of the tremendous depth of feeling on the matter.

If there are some on one side, who think it is abhorrent to suggest that Vermeer used any kind of aid to make his paintings; there are those at the far end of the other, who suggest that he did not need to know how to paint at all: he just needed a few mirrors and a lens to copy what he saw, dot by dot. There is little common ground here, apart from the passion of the beliefs that are held; and it seems that the two camps have become so

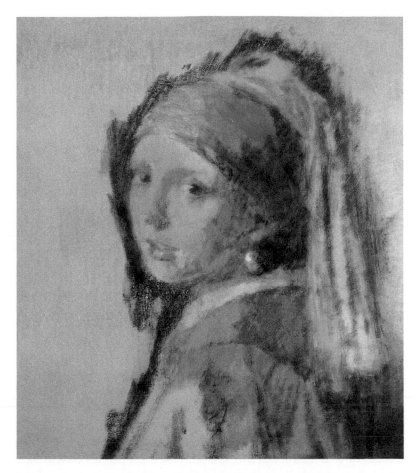

Figure 10.8 Second studio print with some added colour.

used to bellowing at each other through megaphones over a chasm, that they have forgotten how to build a bridge.[60] Can we not meet somewhere near the middle?[61] There is no prize for finding a solution; and we should be able to find answers to this question, without antagonism.

But there is an elephant in the room in these discussions, which cannot be avoided. Some are very anxious indeed that the use of a lens might be seen to amount to 'cheating', and would compromise Vermeer's genius. They fear that a camera obscura may be all too easy to use, and require no sensitivity; and that its use does not require any artistic ability. Despite the fact that the

art historian Martin Kemp thinks that its use would 'in no way' prescribe artistic choice; and also that the expert Alejandro Vergara, sees Vermeer's use of the camera as 'an instrument at the service of his creativity';[62] there are those who suffer from a nagging worry that using a camera obscura could be as easy and as dispassionate as taking a picture on a mobile device today. But the reality is very far from the case. The camera obscura bears limited comparison to a photographic camera. Although both project an image through a lens, the effort required to use them is very different. The photographic version provides a positive picture using film or digital technology, but the image from the camera obscura is merely a projection. To capture and transfer this to a canvas requires skill, judgement, and time; and its product can only ever be a part of the process of making a painting.

We may also have been hampered in the search for solutions to this question by the result of the desire to find a single definitive answer to Vermeer's painting method. But we can see for ourselves that he was not consistent. He used more than one viewpoint; he looked near and far, and he altered his compositions to refine their balance. He may not have seen everything together at once, but assembled some paintings in parts.[63] He may not have just used one studio room, but set up a lens and tacked up some curtains to make a temporary camera obscura, moving operations to the place that suited him best. Did he work in van Ruijven's home, or even in Constantijn Huygens' house in The Hague? It may have been easier to take the artist to the subject, rather than manoeuvre every part of the subject to the artist.[64]

Could the camera obscura ever be judged as a 'source of his style'?[65] Experts have found it difficult to judge what impact its use would have had on Vermeer's work because, until now, they have not found a simple way that it could have been used, and have not been confident that it would fit into the traditional methods of painting at the time. They may have joined the extensive discussion in the literature on Vermeer about optical effects; but much of this concentrates on the surface qualities of his pictures, on paint that he would have had to put down at the very end of his painting process, on the top layers. But my practical experiment shows us that it is not likely that the information from a lens would be put on last, using some kind of 'paint by numbers' system; but that it would be transferred at the start, to what would become the very bottom of the picture: down in the dark beginnings instead.[66]

It is perfectly possible that Vermeer took advantage of the new technology of his age, and used some information that he had traced from a projected

image; and also used some he had observed directly; and that he put them both together. We can see that Vermeer could have hit upon a successful technique that he never shared with anyone else: a method that gave his pictures a particular 'look'.[67] But this does not mean that every brushstroke would be affected by a lens. He might have made a tracing using oiled paper; but there was nothing to stop him also piercing it with a tack, to mark a vanishing point; or to use strings to help him indicate the angles of the walls or the floor tiles. He could find the vanishing point in a composition he had composed optically, and then superimpose ruled lines on some parts of his picture to help him make the patterned tiles in *The Music Lesson* (Fig. 8.5) or *The Concert* (Fig. 10.3).[68] He could have used multiple tracings one over the other, or cropped and worked on the paper until he achieved the balances he wanted. And, he could paint by eye. Within the strictures of a traditional working practice, he still had freedom to innovate and to adapt; and, for all his structure and order, he could have had an unpredictable way of working, which diverged from rules and from convention.

Gowing was convinced that Vermeer chose 'the optical way'. He wrote: *'We are in the presence of the real world of light, recording as it seems, its own objective print.'*[69] And indeed, my experiments have shown that it is possible to trace from an optical image, and to transfer this to a canvas by printing. We can never know if Vermeer worked this way; but we should remember that this is not a mindless process, and not a short cut to success.

Using a camera obscura is as far from pressing the button on the shutter of a modern device as we can imagine it to be. It will not provide a perfect, instant, or coloured image straight onto a canvas. But the strength of this process lies in the fact it is simple and incomplete. The painter's individuality and means of expression remain free and unfettered.[70] He can use his judgement to decide which elements of a projection to use on the canvas, and how to incorporate them into a painting, without being robbed of his 'artistic liberty'; and without compromising his brilliance.

As if through a keyhole, we spy a postcard from another age. Even if the sunlit beginnings are rough, we recognize the *Young Woman with a Water Jug*, and also see other elements we never knew were there. They were buried in lower layers of paint, and now are revealed by infrared reflectography (Fig. 10.9).[71] We see a chair Vermeer placed carefully in the corner, which later, he decided to eliminate. One of its large lion's heads would almost have connected with the woman's sleeve, leaving a little gap

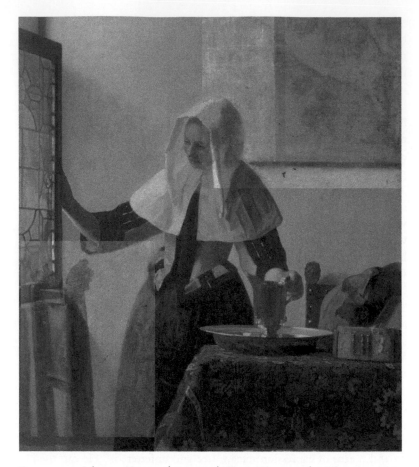

Figure 10.9 Johannes Vermeer (1632–1675), *Young Woman with a Water Jug*, *c*.1662. Composite of three images, with infrared reflectograms revealing some lower layers of paint. The Metropolitan Museum of Art, New York.

which could have been a distraction, drawing our attention away from her face.

The girl herself was there from the very start of the composition; though the contrasts in the room seem stronger in the monochrome *inventing* than they do to us in the image we now know so well: the edge of her headdress, and a strip of window frame gleam very brightly in the underlayers; and darkness laps at her shoulder and her skirt.

We see all these differences, and are relieved that in the end, Vermeer came to the conclusion he did. It is one we do not doubt is right.

The young woman pauses, her hand on the rim of the window pane, relying on the thinness of a hinge, to steady herself as she stands. Her slightest movement would disrupt the perfect visual cadence Vermeer created. As fragile and vulnerable as she is, we see her strength. Her touch may be featherlight; but her substance is real.

Can she be made of printed light?

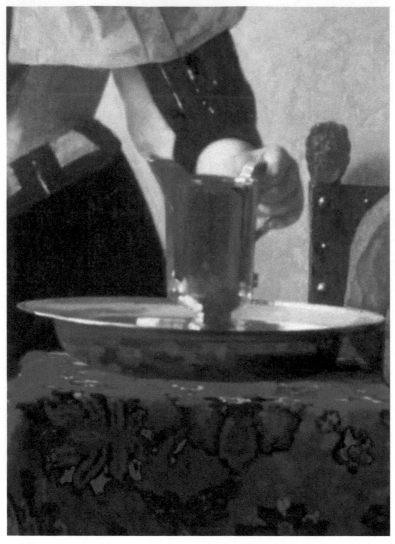

Figure 11.1 Johannes Vermeer (1632–1675), *Young Woman with a Water Jug* (detail), *c*.1662. Oil on canvas. The Metropolitan Museum of Art, New York.

Coda

Famous Artists by Sarah K. Bolton was published in London, Edinburgh, and New York in 1892. It probably cost quite something in its day, because its blue cloth covers are beautifully stamped in red and gold, and there are portrait engravings inside, interleaved with tissue paper. The book opens stiffly; its thick silky paper un-creased. Adverts on the end papers announce that the publishers are proud that their products are 'beneficial and stimulating', and impressive enough to render them 'particularly suitable for rewards or prizes'. A torn label inside the cover suggests that the Hutcheson's Educational Trust did indeed buy one for this purpose. Proudly received by the young pupil, it may have been left on the shelf at home. It looked like heavy reading.

What is curious about this book is not that its author was a woman, but that the choice of artists, in a series entitled *Great Lives,* appears to be incomplete. Who was considered to be worthy contenders for the title of 'Famous Artist'? The list is not long: '*Michael Angelo, Leonardo da Vinci, Raphael of Urbino, Titian, Murillo, Rubens, and Rembrandt'.* But we might think there is a name missing. Where is Johannes Vermeer?

It is ironic that just around the time *Famous Artists* was being written, Vermeer's paintings were rediscovered. Possibly, Sarah K. didn't know much of this, or maybe she did not want to produce a cutting-edge publication; but it is interesting that she chose such strangely prescient words to put on her title page: words that fit Vermeer's life, where so much was achieved in such a short time:

Do not act as if you had ten thousand years to throw away. Death stands at your elbow. Be good for something while you live and it is in your power. (Marcus Aurelius).

We are certain that Vermeer used his time fruitfully. His abilities were obviously much appreciated by his peers, judging by his election twice to the post of Headman of his Guild; and he was included in a commemorative poem published in 1667, to honour Fabritius, who had been 'at the height of his powers' when he died. The author sees Vermeer as the Phoenix rising out of the ashes, as a worthy successor: 'happily there arose out of the fire, Vermeer, who masterfully trod in his path'.[1]

Arnold Bon, the editor of this book (who happened also to be the poet) changed the last line of the poem, mid-edition, to read, '...Vermeer who masterfully emulated him', maybe to make Vermeer appear even more impressive, and comparable in stature to Fabritius.[2] Was it Vermeer himself who wanted his reputation to be puffed up as much as possible? We may prefer instead to consider him as a shy retiring type; particularly since he appears to have hidden so much from us.

But even though we have heard him described as 'famous' in his time, Vermeer's standing diminished after his death. Did his pictures just fall out of fashion; or could it be that his particular style, with its optical qualities, was not appreciated? Alternatively, could the sad circumstances of his demise have affected the way his memory was preserved? A creditor might want to forget a failure to collect dues owed, and the debtor too.

The reason for the fog of obscurity descending could be that Vermeer was not widely known beyond his home town. His small coterie of loyal patrons might never have invited many people into their homes to show their collections;[3] and with such a small output, it is perhaps not surprising that his name fell out of notice. It took some time after his death for his paintings to circulate much beyond Delft. He was forgotten, his pictures largely ignored; and some even suffered the indignity of being ascribed to other more saleable painters.[4] He was not included in an important book of Dutch artists in the early eighteenth century[5] and few might have thought information about him worth preserving, or could have imagined that his reputation as a painter would eventually become that of a peerless genius.[6]

We have the French journalist and art critic Théophile Thoré (otherwise known as William Bürger) to thank for bringing Vermeer out of the black hole in which he had languished. Around 1866 his eye spotted something others' had not: that here was something outstanding. He tried hard to restore Vermeer's reputation by collecting and publishing information about him, and bought his paintings for himself where he could. It was he who found a sale catalogue of 1696, which lists more pictures by Vermeer than have so far been found. Connoisseurs the world over mourn the loss of such

paintings as the *'Portrait of Vermeer* ... uncommonly beautiful painted by him', and a second *'View of Some Houses'*.[7]

Thoré was bewildered by the small amount of information he uncovered about Vermeer, whom he called the 'Sphinx of Delft'. He climbed ladders in museums, looking for his work in dark recesses, high above the best hanging spaces;[8] and he leafed through the few documents he could find. It was a hard task, yielding little. A hundred and fifty years later, we know hardly any more than he did then.

If Vermeer were here today, he would be surprised by many things: by our excesses and our wastefulness; our obsession with communication; our disdain of hats. He would be astonished by the huge press of people rushing past, with strange, thin, elastic clothes; by the light that turns night into day; and by the mechanical clamour of a steel city. But he might appreciate the images that now assail us from all sides, especially those that move; since they, unlike those from his own lens, are the right way up.

He might be very pleased that his own pictures have survived the test of time, and be gratified that they attract quite so much reverence and discussion. He would not know the titles of all the experts who discuss their meaning and significance: the art historians, the psychologists, the painting conservators, photographers, economists, and architects; the inventors, physicists, psychotherapists, philosophers, sociologists, and anthropologists. However, Vermeer might not be surprised that painters still take an interest in the way he went about his work.

It is a profession's prerogative to discuss its challenges *in camera,* just as he did in his guild; each to find others who understand a little of how it feels to start with a blank canvas: to work from scratch over and over again, and never to have complete control of the outcome. Painters know how difficult is the slow and uneven progress of a picture; and how important is the interior knowledge, painfully acquired over time, that allows the hand to follow the eye, to put one colour here, and reach for another; just as a musician reads a note and plays without conscious thought. Painting is the practicality of using all available means to achieve the end. It is experimentation, and it is embracing the possibility of the accidental. It was so even in Vermeer's day, or no painter's work would look any different from any other.

Answers to the riddles of Vermeer's life and work can only ever be incomplete, and there are some questions unlikely ever to be resolved. Will we find out what Vermeer looked like, for example? We know that he belonged to

the town militia because *an iron armour with helmet* and *a pike* were listed in the probate inventory.[9] But although there are a number of contemporary group portraits of swashbuckling home guards, kitted out with swords, sashes, and feathers; none appears to feature Vermeer and his comrades-at-arms.

We seem also to have lost the one painting which may have given us a clear depiction of his face, although some think that we can recognize him as the man with frizzy hair, on the edge of one of his early paintings, *The Procuress*. Others think he could be the painter, with his back turned towards us, sitting in the red stockings in *The Art of Painting* (Fig. 1.4). But there is no more certainty about this, than anything else about Vermeer.

There may be yet one very small clue left. Several artists in the Low Countries made self-portraits of themselves, half-hidden within their pictures, just around Vermeer's time. One example is a *Vanitas Still Life* (Fig. 11.2), painted in the 1630s, where we can see Pieter Claesz. at work at his easel, in a mirrored ball.[10]

In 2012, the Mauritshuis in The Hague acquired another example of a hidden self-portrait. Clara Peeters was keen to show herself in her still lifes, and you can often find her reflections more than once in the same painting. Look carefully, and you can see her head twice in the rounded metal lid of the jug, in her *Still Life with Cheeses, Almonds and Pretzels* (Fig. 11.3).[11] These pic-

Figure 11.2 Pieter Claesz. (1597–1661), *Vanitas Still Life*, c.1630. Oil on panel, 36 × 59 cm. National Museum, Nuremberg.

Figure 11.3 Clara Peeters (active 1607–1621), *Still Life with Cheeses, Almonds and Pretzels* (detail), *c*.1615. Oil on panel. Mauritshuis, The Hague.

tures, together with a twentieth-century painting by Pierre Bonnard, can possibly help us recognize if Vermeer ever did the same thing.

In Bonnard's *French Window* (Fig. 11.4), we can see the painter's reflection in a mirror hanging on the wall. As in many of his pictures, there are uncertainties about the interpretations of shapes, where one extraordinary jewelled pattern abuts another. We cannot identify the large cream trapezium edged with turquoise behind the girl's head, nor where the edge of the card table sits ahead of us. Bonnard seems to have painted this interior just as he saw it; and he has compressed himself behind the model, his head looking like a strange knob on top of hers.

What can this have to do with Vermeer? Is there a self-portrait of him anywhere, in any reflection? Suddenly a shape similar to Bonnard's seems to strike a chord. We look; but the more we try to identify what we see, the more the forms slide away from us on the surface of the shiny jug in *Young Woman with a Water Jug* (Fig. 11.1).[12] Clearly, there are verticals of a pair of

Figure 11.4 Pierre Bonnard (1867–1947), *The French Window*, 1929. Private Collection (Dauberville 1499). ADAGP Paris.

green curtains, hanging slightly unevenly on their rings; and at the bottom, a light blue crown-shaped form. Could we see this as Vermeer's shirt? Could the splodge above the blue be his head? There is a tiny pink horizontal near the base of the jug: could this be Vermeer's arm and the large, brown rectangular shape be his palette? Is there even a diagonal on the left, which could be an easel?

We may want so much to see Vermeer in his paintings that we are willing to be deceived; that we want to believe we can see a gap between the curtains, see a lens on a stand. This is fanciful thinking. Maybe there is a small figure in a bluish shirt near the bottom of the jug; but maybe not.

If we try to draw ourselves using a cylinder as a mirror, we might get a similar kind of distortion; however, other evidence is against us. It appears that even if these little strokes of paint do represent a person, it is not in the right place to conform to the sightlines of the painting. It does not correspond to a reflection of the viewpoint of the picture, or to the distance between the jug and where Vermeer must have been sitting, to paint the scene.[13] But does everything have to be set in stone? Things do not necessarily conform to rules. What was to prevent Vermeer using more than one

viewpoint in his picture? After all, he appears to have done this in the reflection in the mirror in *The Music Lesson* (Fig. 8.5).

We have seen that there can be no one explanation for all the anomalies there are in Vermeer's work, so we should allow the possibility that he produced his paintings using a number of techniques together. He could have used perspective drawings, and pins and strings; he could have painted from observation: close by, and from a distance. And we can now acknowledge that he could have incorporated some information from a lens in his work too; not only by being influenced by the effects he saw through them; but also by transferring tracings, and transferring these to his canvas directly. The frustration is, that whatever answers we suggest to the puzzles Vermeer left behind, the only certainty is that we will never know if we are right. He has left his masterpieces behind; accompanied only by a deep silence.[14]

* * *

In the depths of The Metropolitan Museum of Art in New York, far, far away from anything Vermeer knew, the woman still holds her jug by the window, in the clear calm of morning.

Is it possible, that in all this time, no one has noticed another figure, reflected in the light of Delft, quietly observing us?

NOTES

PRELUDE

1. Montias (1982) and (1989), and in Blankert et al. (2007), p. 43, who says that the reason we know in broad detail anything about Vermeer's domestic life is 'largely due' to his mother in law's 'mania' for changing her wills.

2. This print was coloured by hand after production, by someone who did not necessarily have local knowledge, so maybe this is the reason why the Town Hall windows are shown to be green here, instead of the traditional red.

3. The wording on the plaque where the Mechelen once stood is incorrect in stating that this is the site of Vermeer's birthplace.

 The Mechelen is unlikely to have had a back door, apart from an opening to allow unloading from the canal. The backs of all the houses on the South side of the Voldersgracht are sited directly onto the water. However, the inn could have had a side entrance in the passageway before the bridge. There is another print (Schrenk, after Rademaker, c.1720) showing the Mechelen with a front door giving onto the Markt.

 In 1661, The Guild of St Luke moved premises into the newly renovated upstairs hall in the chapel of the old men's house on the Voldersgracht. Montias (1982), p.96. The work may have been unfinished when Vermeer became Headman in 1662. See Blankert et al. (2007), p.130, who suggests that Vermeer could have been involved in planning these new quarters.

4. For information on Optica prints, see Kaldenbach (1985); also Paulus Swaen Auction and Gallery <http://www.swaen.com/optica.php>; see Kemp (1990), p. 207, for an explanation of the zograscope.

5. The advantage of this system is that it shows the view of the square in the same orientation as the artist would have seen it.

6. Bailey (2001), p. 47; Montias (1989), p. 72.

7. Reynier used the name 'Vos', which means 'fox'; and also the name 'Vermeer'. He worked first as a silk weaver, before becoming a picture dealer and publican. For details of his colourful life, and his financial affairs, see Montias (1989) Chapter 4, pp. 55–84.

8. Montias (1989), pp. 72–73, see also Montias in Blankert et al. (2007), pp. 28, 32. Vermeer's father bought the Mechelen in 1641 for 2,700 guilders, but his down payment was very small, and he had to borrow the rest.

9. Stoops were seen as part of the house frontage. See Lokin (2000), p. 35. See also Grijzenhout and Sas (2006), p. 13, for an analysis of the border between public and private space in a painting by Jan Steen, known as the *Burgomaster of Delft*.

10. Bells from both the Nieuwe Kerk and the Oude Kerk can be heard in the Markt, and they ring slightly out of turn.

11. See a painting by Jan van der Heyden, *View of the Oude Canal Delft*, 1675, in the Nasjonalgalleriet, Oslo. For information on the reasons for the leaning tower, see van der Gaag (2015), pp. 16–17.

12. See Plomp (2000), p. 28, who says that some churches employed dog-catchers to control this nuisance. See also pp. 78–85 (catalogue numbers 9 and 10), showing the interior of the Oude Kerk in Delft, in paintings by Hendrick Cornelisz. Van Vliet (*c*.1611–1675). Also a painting by Emmanuel de Witte, *Interior of the Oudekerk in Delft*, 1650, in Blankert et al. (2007), p. 61.

13. It was said that rich people could afford to be buried inside the church; poorer people had their graves outside.

14. Kaldenbach in Franits (2001), p. xxiii, V4.

15. See the website for the Oude Kerk in Delft, where it says it is possible to visit the grave of Vermeer. However, although the position of the family plot bought by Maria Thins was identified, the graves have since been moved and re-laid.

16. Liedtke (2008), pp. 89–91, concludes it is 'a composite of houses...modified for artistic reasons'.

17. Van Maarseveen (2016), pp. 86–100. This rundown of the various theories of the location of *The Little Street*, does not include that of Philip Steadman, who suggests this could be a view from the back of the Mechelen. See <http://www.vermeerscamera.co.uk/essayhome.htm>; for more information on this discussion; and for the controversy over Grijzenhout's views see <http://www.essentialvermeer.com>. Interestingly, the Rijksmuseum has recently altered the caption of *The Little Street* in the gallery in accordance with Grijzenhout's theory.

18. Grijzenhout (2015), pp. 26–28, used the tax ledger of 1666–1667 that recorded the dredging of canals in Delft. It detailed the 'width of the frontage of the houses', and the positions of gateways. Grijzenhout looked for a pair of gateways situated side by side, as seen in *The Little Street*, to provide part of his evidence to identify the site of this painting.

19. Grijzenhout (2015), p. 30.

20. See Delfia Batavorum (2104), pp. 127–129, 131; van der Gaag (2015) pp. 34–35.

21. Grijzenhout (2015), p. 30, believes there is 'room for the view' that the house in the picture was one that escaped the fire of 1536 and is shown on a map of 1620. However, it would be difficult to confirm this with precision since the painted map may not show the 'absolute truth' of the city after this catastrophe. Lokin (2000), p. 35, suggests the house is late sixteenth-century, and he comments on the designs of the crossbar windows; so it may have been built after the fire of 1536, not before.

NOTES TO PAGES 6–11

See also *Delfia Batavorum* (2104), pp. 81–83, for an account of the fire. The present house on the site dates from the nineteenth century.

22. In the seventeenth century, this was a poorer part of Delft, occupied by a number of butchers and tradesmen. Vermeer's aunt, Ariaentgen Claes van der Minne, lived at 42 Vlamingstraat, until 1670. See Grijzenhout (2015), p. 44.

23. See Liedtke (2008), pp. 91–92.

24. See the Buster Keaton comedy *Steamboat Bill, Jr.* (1928).

25. Vermeer's father ran a pub called the 'Flying Fox' (De Vliegende Vos) in this house on the Voldersgracht, before taking over the Mechelen when the lease ran out. Montias (1989), p. 72. It is possible that he took the name Vos to identify himself as its landlord.

26. See http://www.antiquesdelft.com/.

27. Van Geenen (2013), pp. 112–113.

28. See the Chronology of Vermeer's paintings in this book, pp. xxii–xxv.

29. *Diana and her Companions, c.*1654–1656, Mauritshuis the Hague; *Christ in the House of Martha and Mary*, 1655, National Gallery of Scotland, Edinburgh; *The Procuress, c.*1656, Gemäldegalerie, Dresden. Questions about attribution remain over another painting, *St Praxedis, c.*1655, which is in private hands, and is a copy of a work by the Italian artist Felice Ficharelli (*c.*1605–1669). See Buijsen (2010), p. 66; Wadum (1998), pp. 214–219; and for a brief summary, see Tazartes (2012), p. 34.

30. See overviews in Vergara (2003), pp. 206–207; and in Buijsen (2010), pp. 43–44.

31. Jenkins (1993), pp. 143–157.

32. Arasse (1994), pp. 69–75; Williams (1995), pp. 273–275.

33. Gowing (1997), p. 137: See also Groen in Lefèvre (2007), pp. 204–205.

34. For explanations of analytical techniques used for the investigation of paintings, see Noble et al. (2009), pp. 206–207; Cook in Sheldon et al (2007).

35. Personal communication with Martin Kemp. Kirsh and Levenson (2000), pp. 182–192.

36. Pennell (1891), pp. 294–296.

37. See Schwarz (1987), p. 120.

38. See Liedtke (2008), pp. 179–188; Ducos in Cottet and Cottet (2016) 12'26"-13'40". Kemp in Lefèvre (2007), p. 243.

39. Rembrandt van Rijn (1606–1669) depicted a *Pedlar Selling Spectacles* (*The Sense of Sight) c.*1624–1625, Museum De Lakenhal, Leiden.

40. See Wheelock (1977), p. 163; Wheelock (1995), pp. 18–19.

41. Wheelock in Luijten et al. (2106); p. 18. Hockney (2001); Logan (2006), p. 248, says Rubens promised 'not to withhold' secrets from a student of his.

42. Montias (1989), pp. 339–344.

43. Montias (1982), pp. 88–93; 104–105. Unfortunately the records of the Guild of St Luke, Delft, for the years after 1650 have been lost.

44. See Bomford and Roy (2009) for an outline of traditional painting techniques.

CHAPTER 1

1. Montias (1989), pp. 339–344 <https://premium.weatherweb.net>.
2. See the chapter by Sluijter (2015), pp. 89–111, on ownership of paintings in the Dutch Golden Age. See also Westermann (2001), especially p. 31, and Lokin (2000), p. 41.
3. See van der Sman (1996), pp. 136–140.
4. Montias (1989), p. 212. Catherina stated that, because of 'the long and ruinous war with France', Vermeer had been unable to sell any of his own paintings or those he had in stock, and so 'owing to the very great burden of his children, having no means of his own, he had lapsed into such decay and decadence, which he had so taken to heart that, as if he had fallen into a frenzy, in a day or day and a half he had gone from being healthy to being dead'. Montias suggests that Vermeer probably died of a stroke or heart attack.
5. The papers may have been written out by the same man who noted down each item in the house, but such perfectly spaced, parallel inventories could not have been made in the dusty rooms of the Oude Langendijk. It would have been too difficult. Even so, the hand on the documents we have shows corrections, as well as signs of haste towards the end. The writing is looser here than in the careful introduction, and the last entry fits uncomfortably towards the bottom of the page.
6. Paper dimensions: folio folded 32.8 × 21.0 cm; unfolded 32.8 × 42.0 cm.
7. Montias (1989), pp. 221–222. See also Haks and van der Sman (1996), pp. 97–98. There is debate as to whether the jug Catherina inherited could have been the one in this picture, as it was probably made for wine, not water.
8. Kaldenbach <https://kalden.home.xs4all.nl/>.
9. Montias (1989), pp. 217–218. This debt was equivalent to two or three years' supply of bread; and maybe the baker allowed this debt to grow, so he could exchange the debt for 'a painting or two.'
10. Montias (1989), p. 217.
11. Blankert (1978), p. 55.
12. The arguments over Vermeer's estate and *The Art of Painting* are detailed in Montais (1989) Chapter 12, 'Aftermath', pp. 216–245. A summary, and the involvement of Antony van Leeuwenhoek as executor, can be found in Montias in Blankert (2007), pp. 62–66.
13. We know of this move because on 27 December 1660 Vermeer and Catherina had to register the death of a baby, and gave their address as the Oude Langendijk. Blankert et al. (2007), p. 216. See Figure F.2.
14. For details of Maria Thins' stormy marriage and estrangement from her husband, Reynier Bolncs, whom she had married in 1622, see Montais (1989), Chapter 7, pp. 108–128. Bolnes had been violent towards her on occasion. She was allowed a legal separation in 1641, and a division of assets. Maria also benefitted from inheritances from her siblings, who never married, see ibid. p. 112.

15. See Montias (1989), pp. 154–55, and Kaldenbach <https://kalden.home. xs4all.nl/>, where he puts forward a number of alternative suggestions as to the arrangement of rooms inside Vermeer's house. Kaldenbach was responsible for the installation of the plaque on the side of Vermeer's old family home in the Oude Langendijk (see Fig. 1.1).

16. See Montias in Blankert (2007), pp. 45–46.

17. See Montais (1989), pp. 154–170 for information about Willem Bolnes, who caused a good deal of trouble to Maria Thins.

18. A creditor to Vermeer's estate was a woman called 'Tanneken', who is presumed to be a servant of the household, and who witnessed assaults by Willem Bolnes on Maria Thins and Catharina in 1663. See Montias (1989), pp. 160, 223–224.

19. We do not know the names of all Vermeer's children. See p. 267 n. 3 in this volume. See the family tree: Montias (1989), Chart 1, pp. 370–371; or in Binstock (2009), Appendix E, pp. 312–314. There has been confusion about how big the Vermeer family was. This is because although the church register stated that Vermeer died leaving 'eight children under age', Catharina said she had been left with 'eleven living children'. See Montias (1989), pp. 213–214, who thinks that the burial register 'was in error'.

 Philips (2008), p. 64, tells us that in 'Early Modern Europe', roughly a quarter of infants died before their first birthday, and 'between 40 and 50 percent died before the age of ten. If a child reached the age of fifteen, then it 'could expect to live another thirty to thirty-five years'.

 In his *Delights of Holland*, Mountague (1696), pp. 6, 39, describes the air in Holland as 'not healthful, being thick and foggy and too near the sea'. William Temple, who was the British ambassador in The Hague from 1668–1670, wrote that even though the Dutch were keen on cleaning their houses, 'They are generally not so long liv'd as those in better airs'. Temple (1680), p. 220.

20. See van Suchtelen et al. (2001), pp. 12–15; Parker (2014), pp. 1–8.

21. People used footwarmers, one of which we see in *The Milkmaid* (Fig. 1.2). Embers from the fire were put inside a little earthenware pot, and this was inserted into a wooden box, open one side, with holes on the top.

22. Zumthor (1994), pp. 56–57, says that people wore 'layers of garments' to protect themselves from the cold. He quotes Oliver Goldsmith's colourful pen portrait of 'the true Dutchman who cuts the strangest figure in the world...he wears no coat but seven waistcoats and nine pairs of trousers, so that his haunches start somewhere under his armpits...the Dutch woman wears as many petticoats as her husband does trousers.' See Phillips (2008), p.69.

23. Schama (1988), Chapter 6, pp. 375–480, mentions that many travellers reported on the cleanliness of Dutch houses at the time. See Lokin (2000), p. 34, who quotes Bleyswijck, the city's biographer as extolling Delft's water as 'pure and clear,...(the canals) flushed out on a daily basis by opening nearby sluices'.

24. Thornton (1983), p. 326.

25. Delft's brewing businesses had declined because of pollution from the dyeing works in the city. To discourage other waste being thrown into the canals,

brick privies were constructed to help keep the water clean. See Lokin (2000), p. 42. Privies have been a useful source of archaeological evidence of the domestic life of the time. For sanitation, see Phillips (2008), pp 70–74.

26. See Kaldenbach, as above.

27. There are a number of suggestions online, that the Milkmaid might be preparing a bread pudding, with milk and bread as the main ingredients. This could be cooked slowly in her earthenware basin, in the embers of a fire.

28. For divisions between living and working space, see van der Wulp (1996), p. 46. Lokin (2000), p. 42.

29. Lokin (2000), p. 36.

30. There are now houses opposite the site of Maria Thins' house in the Oude Langendijk, but it is clear from Dirck van Bleyswijck's *Kaart Figuratief* (Fig. F.2), published in the year of Vermeer's death, that there would have been an unobstructed view across the Markt from the upstairs windows.

31. See <www.vermeerscamera.co.uk>. Roger Hawkins and Leo Stevenson suggest that light from the canal outside Vermeer's studio could have been reflected upwards into the studio room.

32. Kirby in Bomford et al. (2006), pp. 20–22.

33. Steadman (2001), p. 98.

34. See text exchanges between Steadman, Kaldenbach, and Warffemius, <https://kalden.home.xs4all.nl/vermeer-info/house/h-a-steadman-ENG.htm>.

35. See Kaldenbach <https://kalden.home.xs4all.nl/>.

36. Steadman (2001), pp. 90–93.

37. Chalk has a refractive index close to that of oil, and so becomes transparent when it is mixed with it. Current investigative techniques cannot detect chalk in the lower layers of a painting. See Waiboer in Cottet and Cottet (2017).

38. Montias (1989), p. 340.

39. Steadman (2001), pp. 74–80.

40. Wald (2010), p. 313–315.

41. See Leidtke (2008), pp. 50, 171.

42. See Pijzel-Dommisse (2007) for the dolls' houses of Petronella Oortman and Petronella Dunois. For that of Petronella de La Court, see <https://www.google.com/culturalinstitute/beta/asset/doll-s-house/GQHdZ3n3-HaTXA>.

43. Montias (1989), p. 222.

CHAPTER 2

1. See the many illustrations of Delft tiles in ten Broeke, van Sabben and Woudenberg (2000). Also information about *Delft Blue* <http://www.royaldelft.com/home_en>.

2. See Schama (1998), pp. 375–378; Lokin (2000), p. 38.

3. Verdigris is a difficult pigment to use; it is a wonderfully bright blue/green, but has the unfortunate tendency to turn black. Painters were advised to avoid it where possible (along with other problematic pigments such as orpiment

and minium), even though its colour looks attractive. See de Mayerne in Fels (2010), p. 302.

4. Letter 649, Sunday 29 July 1888, <http://vangoghletters.org/vg/letters/let649/letter.html>.

5. The massicot available today is lead yellow. Lead-tin yellow is no longer produced. See Harley (1982), pp. 95–98. A recipe for massicot is preserved in the Plantin-Moretus Museum in Antwerp. Campbell et al. (1997), p. 14, suggest that there may yet be more information about its preparation to be found by studying the historical literature on pottery glazes.

6. Some of the irises' petals were overpainted with thin red, to make them violet. See the van Gogh Museum website <https://www.vangoghmuseum.nl/en/collection/s0050V1962>.

7. Cobalt blue was first made in 1797 and synthetic 'French' ultramarine in 1855. See Carlyle (2001), pp. 470–478, 491–496, 521–530.

8. The paint tube was invented by an American, John Rand, in 1841.

9. De Mayerne in Fels (2010), p. 146, lists the colours that can be stored under water.

10. Jean Renoir (1962), p. 73.

11. An example is letter 687 from van Gogh in Arles to Theo in Paris on Tuesday 25 September 1888: <http://vangoghletters.org/vg/letters/let687/letter.html>. Van Gogh comments that Prussian blue was three times cheaper than cobalt or French ultramarine blue.

12. Van de Wetering (2009), p. 140. See also de Mayerne in Fels (2010), pp. 239–240, for some pictures of the suggested organization of paints on the palette.

13. All artists' guilds in the various towns of the Dutch Republic were named after St Luke, the patron saint of painters.

14. Montias (1982), p. 133.

15. There were some exceptions to this rule: paintings could be sold at fairs, and used as prizes for lotteries. See Montias (1982), pp. 100, 183–219, and for a comprehensive study of the guild in Delft.

16. The role of the guild in Delft in this respect is not clear, but guilds elsewhere had done this in the past, See Bomford et al. (1990), pp. 6–7. However, Montais (1982), pp. 74–75, indicates that there was 'no price or quality control for goods sold by masters in the rules of the Guild of Delft in 1611'.

17. Montias (1982), p. 131.

As a picture dealer, Vermeer's father, Reynier Jansz. Vos was a member of the Delft Guild of St Luke himself. As a result, he may have been able to pay a reduced fee to the guild for Vermeer's training. If Vermeer had studied elsewhere, then the costs would have been higher. Montais (1989), p. 73, suggests that the fees and living expenses for Vermeer's apprenticeship would have 'made a sizeable dent in the family budget', and could explain why Reynier Jansz. Vos had trouble paying his debts.

Monitas (1989), p. 98, notes that in a 'hundred years of intermittently intense research on Vermeer…not one document has turned up on the young artist's apprenticeship'.

18. See Bailey (2001), pp. 1–16.
19. *The Goldfinch* has its own website. See <http://puttertje.mauritshuis.nl/en/a-source-of-inspiration>. This includes a reference to the possible damage to this painting made by *The Thunderclap*.
20. For a discussion about the possible ways *The Goldfinch* was made to be displayed, see Gordenker (2014), p. 50; Brown (1981), pp. 126–127.
 For a detailed description, technical evaluation, and report of the restoration of this painting, see Noble et.al. (2009), pp. 146–155.
21. See the photograph of *The Goldfinch* in the exhibition in Edinburgh, *The Times*, 4 November 2016, p. 7.
22. Montias (1989), p. 339. One painting by Fabritius is listed as hanging in Vermeer's *front hall*, and there were two in the *great hall*.
23. Fabritius painted *A View of Delft*, now in the National Gallery, London, which some have argued was made to be viewed in a small perspective box with a curved back. See Liedtke (2001), pp. 250–254; Liedtke (1976); Williams (1995), pp. 273–277, and note 10; Williams and Kemp (2016); and also Brown (1981), pp. 43–44.
24. For an overview of opinions about Vermeer's training, see Montias in Blankert et al. (2007), pp. 34–37; See also Montias (1989) chapter 6, in particular, p. 105. Maria Thins was related to Abraham Bloemaert, who was an Utrecht painter. However, Arthur Wheelock believes it possible that Vermeer might have gone to Amsterdam for his artistic education, possibly even to Rembrandt's studio. See him making this suggestion in Marlow (2013).
 Westermann (2008), pp. 26–27, 31, thinks that Vermeer may have learned something of the Utrecht school at home, from the paintings in Maria Thins' collection. She does not think that Vermeer studied under Fabritius, because of his 'lack of perspective or optical realism in his early work'.
25. Bailey (1978), pp. 51–52, who reports of a master, David Bailly in Leiden, who made nothing out of his two pupils, because they 'ate so much and were so idle'.
26. See Montias (1989), pp. 181–186. Wadum et al. (1996), p. 6, says that Vermeer was 'unlikely to have any apprentices as painting was not his main profession'.
27. This idea was suggested by Benjamin Binstock (2009).
28. Herrisone and Howard (2013), pp. 153–154. Also see Logan (2006).
29. Levy-van Halm (1998), p. 141, thinks that there could have been a number of shops selling pigments, 'with plentiful supplies' of painting materials, available to Delft painters.
30. Gerard ter Brugghen published his Verlichtery Kunst-Boeck in Amsterdam in 1616.
 De Boogert, a painter in Delft, made an extraordinary artists' manual in 1692 to show how to mix watercolours. This included a staggering 800 hand-painted pages of samples, which was truly the 'pantone colour chart' of the day. De Boogert may have intended his work to be useful as an educational publication, but it could only be described as a meticulous vanity project, as it could never have been reproduced for others to see. He confirms the

suggestion that artists should not bother to make their own pigments, but buy them instead. Trans. Peter van Dolen <peetr86@hotmail.com>.

De Boogert himself is a mystery, but his colour book has been preserved in the library of Aix en Provence and can be viewed in its entirety online. Aix-en-Provence, Bibliothèque municipale/Bibliothèque Méjanes, MS 1389 (1228). See Jansen (2015), pp. 9–11, for more information. It is possible that a three-volume manuscript of animals and insects, bought by the Prinsenhof in Delft in 2005 and signed by a 'de Boogert', may be the work of the same man. See also the post by Erik Kwakkel on this subject <http://erikkwakkel.tumblr.com/post/84254152801/a-colourful-book-i-encountered-this-dutch-book>.

31. See Levy-van Halm (1998), p. 141.
32. Woad was imported in 'massive amounts' from the Toulouse region of France and used to make indigo, and dye textiles, see Vermeylen (2010), p. 360. But ready-processed indigo was also imported in bulk by the Dutch East India Company (VOC), Balfour-Paul (1998), pp. 44–45. See also the comprehensive guide to pigments in Harley (1982); and in Bomford et al. (2006), pp. 35–47.
33. See Levy van-Halm (1998), p. 138, for technical information about the production of vermilion; and see Harley (1982), pp. 126–127. According to Vermeylen (2010), p. 361, the Dutch product was said to be particularly good. However Berger in Fels (2010), p. 302, tells us that Dutch cinnabar was often adulterated with minium (a paint similar in colour, but which is made by heating lead white).
34. Theophilus, ed. Hawthorne and Smith (1979), p. 40.
35. See Bomford et al. (2006), pp. 41–44. Balfour Paul (1998), p. 116.
36. Chenciner (2000) provides a comprehensive study of the madder trade and its production
 For descriptions and a picture of insects used to make red lake, see Harley (1982), pp. 131–138.
37. See Butler Greenfield (2006), pp. 185–202 ; and see also Bucklow (2016), pp. 29–34.
38. Levy van-Halm (1998), p. 139, gives details of a Delft apothecary, Dirck Cluyt, who made a red-lake pigment on his premises in 1580. See also Zuidervaart and Rijks (2014), pp. 26–27, who include a painting by Cornelis Willemsz de Man, c.1669, of an apothecary's shop with a chemical laboratory in the background.
39. Le Brun in the 'Brussels Manuscript' in Merrifield (1999), p. 808, note 14, where he describes using 'cuttings of fine scarlet' together with Brazil wood to make a 'common lake'. See also Kirby and White (1996), pp. 65–69, who tell us that the alkali reduced the shearings to a 'gelatinous consistency'.
40. Buckthorn is *Rhammus cathartica L.*; weld is *Reseda luteola L.*; and dyers broom is *Genista tinctoria L.*
 Although it may seem counter-intuitive, unripe buckthorn berries produce a yellow colour (*stil de grain*), while the ripe berry, gathered in the Autumn produces a green, used in watercolour (*sap green*). See Ball (2010), p. 157; Kirby et al. (2014), p. 17; Harley (1982), pp. 86–88.
41. This is a mordant, as used in dyeing fabric.

42. For a good lake pigment recipe, see <https://sunsikell.wordpress.com/2011/01/10/how-to-make-a-lake-pigment/>. For chemical analysis of the making of dyes, and a further exploration of lake-pigment recipes, see Kirby et al. (2014). The Royal Society of Chemistry's website also provides information and a worksheet for the preparation of a lake pigment: <http://www.rsc.org/learn-chemistry/resource/res00001951/how-to-make-a-lake-pigment-paint?cmpid=CMP00006389>.

43. Goedings and Groen (1994), pp. 88–89; see also Roy and Kirby (2006), p. 43. Hermans and Wallert (1998), p. 285, quote from a source who suggests that *schietgeelen* was made 'in the shape of human excrement', and this explains its name.

44. See Harley (1982), pp. 143–146. She suggests that Brazil wood was an 'economy range' colour in comparison with carmine and madder lake, because it faded so badly.

45. There are a number of contemporary eyewitness accounts of the 'Rasphuis', see Schama (1998), pp. 17–24. Temple (1690), p. 173, wrote that the Rasphuis was 'where are secured those who have been near hanging, and have escaped with burning between the shoulders'. For women, there was the Spinhuis, where 'incorrigible and Lewd Woman are kept in Discipline and Labour' in the gentler trades of sewing and spinning. See Evelyn (1999), p. 34.
 The use of the Rasphuis declined when processing Brazil wood using windmills became more cost effective, and eventually died out in 1766. See Hermens and Wallert, *The Pekstok Papers* (1998), pp. 269–95, for this, and for further information about the production of lake pigments.

46. See Levy-van Halm (1998), p. 140. We know that Dirck le Cocq stocked painting materials, and we know that Vermeer owed him 6 guilders 13 Stuivers. However, the debt is listed as being for medicines, not painting materials. See Montias (1989), p. 318.

47. For summary information on the VOC see <https://www.rijksmuseum.nl/en/rijksstudio/timeline-dutch-history/1602-trade-with-the-east-voc>.

48. Merrifield (1999), pp. 726–755.

49. Ultramarine remains blue when heated, while the cheaper mineral azurite will turn black. See Ball (2001), p. 104.

50. De Mayerne in Fels (2010), p. 229.

51. De Mayerne in Fels (2010), p. 186.

52. Cennini, Broecke trans. (2015), p. 73: 'Watch that you do not spatter your mouth with it lest it does you harm.' Quite apart from its toxicity, orpiment was difficult to use because it was reactive. See Harley (1982), pp. 93–94.

53. Trevor-Roper (2006), 341.

54. De Mayerne's treatise includes many of his own invented recipes. See Trevor-Roper (2006), pp. 337–348.

55. For an exploration of the relationship between art, science, and alchemy, see Bucklow (2010).

56. This is included as part of *Lost Secrets of Flemish Painting* by Fels (2010). According to Trevor-Roper (2006), 367–368, there were problems publishing other works by de Mayerne after his death.

57. De Mayerne's original Manuscript is in the British Library: *B. M. Sloane 2052*. For recipes quoted, see Fels (2010), pp. 244–246, 252.

58. See van de Wetering (2016), part II. For the books left in Vermeer's house, see Wadum in Wheelock and Broos (1995), p. 67, who thinks 'it is conceivable' that some of these were manuals for painters. It is just possible that Vermeer knew Constantijn Huygens Jr. who had several painting treatises in his library, including those by van Mander and da Vinci. Roodenburg (2006), pp. 390–392. See Chapter 6 in this book.

59. Cennini's text has been translated into English a number of times, the most recent, with annotations is by Broecke (2015) (see 'Bibliography and Further Reading' in this book). See also Bucklow (2006) and (2010).

60. Cennini, trans. Herringham (1930), p. 50.

61. Although the materials Cennini mentions in his book are not very different from those available to Vermeer, many of his recipes are for water-based paints for use in fresco, rather than for oil.

62. Noble et al. (2009), p. 176.

63. Kühn (1968), pp. 159, 191–192.

64. Finlay (2002), pp. 225–240.

65. A trip to Italy was considered a useful part of a young Dutch painter's training; Constantijn Huygens was surprised that Rembrandt and Lievens had not been there. See van de Wetering (2016), p. 15.

66. Vermeer was described as an 'outstanding' painter in this deposition. Montias (1989), Document 341, pp. 333–334. See also Bailey (2001), pp. 192–194. Vermeer's statement on the 24th May 1672 was witnessed by his patron Pieter van Ruijven. Lammertse (2006), p. 87.

67. See Carlyle (2001) for properties of pigments. See Kuhn (1968) for an analysis of the pigments in each of Vermeer's paintings.

68. Van Eikema Hommes (2004), pp. 9–16.

69. These three lazurite nodules: Lapis lazuli, from Sar-e Sang, Badakhshan, Afghanistan, were provided by David Margulies, along with the following information: 'Lapis lazuli is a sulphur-bearing sodium alumina-silicate. Recent research has found that lapis lazuli consists of a variable combination of 19 different minerals, depending on the geographical location, and even where it is found within the specific rock formation. Two of the minerals are well known in the literature, being the white calcite and the fool's gold of iron pyrite. There are two distinctive forms. The most common is rock-like. The other type is that of a purer crystalline structure in the form of a nodule (as seen in the illustration) also known as lazurite, sitting in or on a matrix of calcite crystals. It is sulphur in the form of a trisulphide anion that provides the sought-after blue of lapis lazuli.'

70. <https://www.nationalgallery.org.uk/search?q=vermeer+and+music>.

71. Levy-van Halm (1998), p. 140, quotes a price for ultramarine of 20 guilders per ounce in Holland in 1647. Delamare (2013), pp. 109–117, gives information about prices of ultramarine. Painters were paying in gold for their pigment, and so some direct comparisons can be made. Patrons supplying ultramarine

to painters in the past tried to guard against the substitution of less valuable blues, such as azurite, for ultramarine, by legal contract.

Dürer recorded that he bought 'good quality' ultramarine in Antwerp in 1521 (he paid twelve ducats for an ounce of pigment). See Vermeylen (2010), p. 357; Campbell et al. (1997), p. 34.

Lapis lazuli is also found in Chile and in Russia, but the quality of the stone from there is inferior to that found in Afghanistan, the production of which is now controlled by the Taliban. See *The Times,* 28 February 2017, p. 34. Also see Finlay's (2002) travelogue, pp. 338–345.

72. Finlay (2002) suggests also that ice-cold water could be poured on the rock after it was heated to make it crack. See also Searight (2010), p. II.

73. Wood (1872), pp. 171–172. Captain John Wood saw the lapis mines in December 1838 and reported seeing the traditional process of extracting lapis lazuli from the mines, by using heat to crack the rocks with the use of fires 'fed by furze'. When the rock was 'soft', then it was beaten with hammers to find the blue mineral. At the time, Wood reported three different grades of stone. These were described as the *Neeli,* or indigo colour, the *Asmani* or light blue, and the *Suvsu* or green. See Finlay (2002), p. 341, who reported that the best lapis was called *Supar,* which means 'red feather'.

74. The miniature painter Hilliard (1598), pp. 72–73 writes that 'the darkest and highest blewe is the Ultramarine of Venice.' See Vermeylen (2010), p. 357.

75. Searight (2010), p. 167.

76. Levy-van Halm (1998), p. 140, suggests that ultramarine was available as a powdered pigment by Vermeer's day, and that artists did not have to process lapis lazuli themselves.

77. Roy et al. (1997), pp. 10–11.

78. See the note in Cennini, trans. Broecke (2015), p. 92. She thinks that it would have been much more profitable for artists to prepare ultramarine themselves using Cennini's methods, rather than buying the pigment already prepared. She made her own experiments, but with small samples of lapis. She considers that the recipe in the treatise is not there just to show how important ultramarine was to painters; but was 'intended for practical use'.

79. Personal communication with David Margulies.

80. Some recipes insist that the turpentine must be a product of the larch tree, others say that colophony (pine resin) is suitable. See the discussion in Broecke (2015), p. 91.

81. It is interesting that Cennini specifies that the beeswax must be *new.* There must have been few materials that were both malleable and waterproof available in his time, and so beeswax must have been re-used a number of times, and could have eventually become quite dirty. Used in this state it could introduce impurities into the pigment. See Cennini, trans. Broecke (2015), p. 91, note 10.

82. Cennini, trans. Herringham (1930), p. 49, recommends lye, but others suggest that water works just as well. See Bucklow (2010), pp. 47–74 for a detailed

examination of old methods for purifying ultramarine, and the relationship of these recipes to alchemy and chemistry.

83. This is called a hydrophilic reaction.
84. Costaras (1998), p. 157. See Plesters (1966), p. 79; see also, Albus (2000), pp. 347–355. These are unlike the small, round, even particles of modern French ultramarine, which might be almost identical in chemical composition, but which lack the same light-reflecting quality. Kuhn (1968), p. 168, tells us that the size of the largest ultramarine particles in Vermeer's paint is 30 microns.
85. This process is called levigation. See Thompson (1956), pp. 76–77, for a description of this method. I am indebted to David Margulies, an expert on lapis lazuli, who demonstrated this; and who is of the opinion that levigation is a better option than Cennini's method when making ultramarine. (There is now a more modern industrial means of extracting lazurite from lapis lazuli, called the 'froth flotation' method).
86. Verslype (2012), p. 18, note 18.
87. See Costaras (1998), p. 157.
88. Smalt is difficult to grind into oil because it is so coarse and 'lacks body'. There are directions in treatises for 'strewing' the pigment onto a ground already covered with white paint instead. Smalt is a fast drier.
89. Bomford and Roy (2009), p. 33. Also, Groen (2104), pp. 111–112; Noble and Loon (2005), pp. 82–86; Taylor (2015), pp. 150–152.
90. Roy and Kirby (2006), p. 45; also, Roy et al. (1997), pp. 35–37.
91. The insoluble extraneous matter, floating on top of the dyeing vat, could be skimmed off, and used for painting. See van Eikema Hommes (2004), Chapter 4; Balfour-Paul (1998), pp. 207–209.
92. Harley (1982), p. 46, quotes a contemporary, who said that ultramarine cannot be stored for long in a bladder.
93. Despite reports (e.g. Taylor, (2015) p. 148), I found ultramarine to be a fast drier, particularly in linseed oil. Ground in walnut oil, it dried slightly slower.
94. Kuhn (1968), p. 168.
95. <www.nationalgallery.org.uk/paintings/research/meaning-of-making/vermeer-and-technique/altered-appearance-of-ultramarine>.
96. Plesters (1966), p. 68. See Taylor (2015), pp. 148–150.
97. For an illustration of this pot, see Schot and Dreu (2105), p. 40.
98. *Loowit* was the name given for the cheaper mix of white and chalk, used 'for less demanding areas' such as grounds or underpaint. The addition of chalk makes the paint more transparent than lead white on its own. See Roy and Kirby (2006), p. 37.
99. Goedings and Groen (1994), pp. 85–87. There was a trade in lead white in the Zaan area of Amsterdam in the seventeenth century.
100. See Thiel and Kuiper (1973) for a full report of the restoration of *The Love Letter* after its theft. At the time, there was much discussion as to whether this painting should be restored with or without the repairs left visible. In the end it was decided that the work should 'little affect the appearance of the picture'

to allow it to 'regain (its) illusionistic effect...at ordinary viewing distance.' Restorations were made with materials that could be removed at a later date.

101. This was noticed and corrected in 1995. See Wadum et al. (1995), pp. 24–26.

102. Wadum et al. (1995), pp. 31–32; Noble et al. (2009), pp. 172–173.

103. Noble et al. (2009), p. 176.

104. When *Young Woman Seated at a Virginal* was sold recently, a technical analysis was commissioned. This showed that the pigments used were consistent with those of Vermeer, but their presence could not conclusively confirm that this painting was his. Its attribution is still disputed. See Sheldon (2012), pp. 14–18, and Sivel et al.(2007).

105. Lammertse et al. (2011), pp. 75–96, provide a modern analysis of the materials used by van Meegeren. There were problems with some of van Meegeren's other pigments too, in particular the massicot yellow, his use of Indian ink to simulate dirt in the cracks he introduced in the pictures, his use of orpiment (which was not anachronistic, but not a colour used by Vermeer) and his excessive use of black. For the original report of the scientific examination of these forgeries, see Coremans (1949), pp. 15–17.

CHAPTER 3

1. See Runia and van der Ploeg (2005), pp. 54–55, where there is a full reproduction, and a detailed description of this painting, and also a second *View of Delft* by Henrick Cornelisz Vroom. It is not clear if these pictures were a gift to the town or a commission. Vroom was rewarded with a gift of 150 guilders.

2. Temple (1690), p. 152.

3. There are many contemporary descriptions of the ferry services departing from Delft. See Liedtke (2001), p. 3; van der Gaag (2015), pp. 36–37; Ray (1738), pp. 22, 25.

4. Bleyswijck (1667).

5. Pepys quoted in Bailey (2001) p. 105.

6. See Wikipedia article on Hendrick Cornelisz. Vroom.

7. See Vossestein (2014), for a comprehensive overview of the water-management system in The Netherlands.

8. Kovats et al. (2014), pp. 1267–1326.

9. See Delft Bavatorum (2014), pp. 118–121.

10. Vossestein (2014), p. 58.

11. John Ray (1627–1705), p. 60 (1737 edition), 'He was born in a Mill', i.e. he's deaf. Ray's *Handbook of Proverbs*, first published in 1670, included Dutch sayings, of which this is one.

12. See an illustration of the kind of equipment needed to break up logwood for dyeing, in Hills (1994), p. 188.

13. William Temple (1690), p. 151, mentioned 'mills of many sorts, chiefly to saw timber for ships'.

14. Campbell et al. (1997), p. 17. Van Hout and Balis (2012), p. 174.
15. See Campbell et al. (1997), pp. 18–19; also Kirby (1999), pp. 17–19 (illustrated).
16. Van de Wetering (2009), p. 12. See Hendriks (1998), p. 231.
17. Van de Wetering (2009), pp. 14–15, who says that making panels was a specialist craft. There was a wide choice of 'standard' size panels. See Groen and Hendriks in Slive (1989), p. 109, who suggest panel dimensions were related to standard frame sizes. Also see van Hout and Balis (2012), pp. 38–40.
18. Montias (1989), pp. 78, 80, suggests that it would have been useful to Vermeer's father, Reynier Vos, in his capacity as a picture dealer, to have a son-in-law, Anthony Gerritz. van der Wiel as a frame-maker (Anthony was registered as an ebony worker and frame-maker and was married to Vermeer's sister Gertruy). Presumably, it would have been useful to Vermeer too.
19. Both these pictures are on single pieces of wood, but there is dispute over the attribution of both of them.
 See Liedtke (2008), pp. 136–142. See also Arasse (1994), Appendix 2, pp. 99–101; and Wheelock (1995), pp. 121–127.
20. A technical examination revealed a previous picture of a man wearing a hat, which has not been attributed to Vermeer. See Wheelock (1995), p. 127, figs 89a and 89b.
21. Quevedo (1627/1963), pp. 25–31.
22. For flax production see <www.nps.gov/jame/learn/historyculture/flax-production-in-the-seventeenth-century.htm>.
23. See Anonymous (1695).
24. The linen-bleaching trade in Holland lasted for over three centuries: it was not until 1785 that the Frenchman, Claude Berthollet, found that chlorine (discovered nine years earlier by Karl Wilhelm Scheele) was a good whitening agent. Berthollet went on to found a factory to produce *Eau de Javel*, still found in French supermarkets today, and good for clearing drains.
25. Heydenreich (2008), p. 35.
26. Montias (1989), p. 340.
27. Schama (1998), Chapter 6, pp. 375–396, remarks that the Dutch word for cleanliness and beauty was the same: *schoon*.
28. Sutton (1998), p. 70, quotes from an English author called Brinkman, that the Dutch 'kept their houses cleaner than their persons; and their persons cleaner than their souls'.
29. See Phillips (2008), pp. 64, 65, 73–74, who points out that most houses had little water and no soap available. There was not much understanding of hygiene, and people rarely washed themselves. There were problems in cities with the disposal of human and animal waste, and throughout the seventeenth century, there were several outbreaks of plague. Endemic disease was rife, and the number of deaths exceeded the number of births.
 Dekker (2000), pp. 127–128, confirms that 'infant mortality was high in early modern Europe'.
30. Cotton is often preferred today because of its relative cheapness.

31. See van Hout and Balis (2012), pp. 46–47.
32. See van der Woude (1991), p. 294, who thinks that many paintings must have decayed because of the damp, and the pollution from cooking, heating, and lighting in Dutch homes. See note 51, p. 259 in this volume.
33. Although there is evidence that bleached linen was used for painting purposes, where the light canvas could show through water-based media, Vermeer could use natural coloured linen, straight from the loom, as his painting ground was made from several layers of glue, gesso, and oil paint which covered the linen completely.
34. Van de Wetering (2009), p. 95
35. Kirby (2011), p. 37, also Kirby (1999), pp. 23–24.
36. The dimensions are 367 × 292 cm.
37. There are two of Charles Beale's original account books, written in blank pages of printed almanacs for 1671 and 1680. One is in the Bodleian Library, Oxford, the other in the library of the National Portrait Gallery, London. There may have been over thirty of these little notebooks, but they are now lost. Some notes in his hand, *Experimental secrets found out in the way of Painting 3 March 1647 to August 1663* (MS. Ferguson 134) are kept in the University of Glasgow Library.
 Charles not only prepared canvases for Mary, but also processed pigments, including red and yellow lakes and apparently also ultramarine. See Barber (1999), pp. 7, 15, 44–47, 49–50, 57. See also comments by Kirby (1999), p. 23.
38. For detailed information about the relationship of Vermeer's canvas sizes to regional widths of fabric see Costaras (1998), pp. 149–150, and Appendix 2, p. 167; van de Wetering (2009), Chapter 5.
 Van Hout and Balis (2012), p. 46, suggest that regional differences in measurement could possibly have led to misunderstandings between artists and their customers.
39. See <wikipedia.org/wiki/Ell> for the relationship of an ell to an elbow.
40. Simon (2013).
41. Schot and Dreu (2105), p. 20.
42. Costaras (1998), p. 147.
43. Personal conversation with Huib Zuidervaart.
44. Wadum (1995), pp. 9–10, calculates the width between the two selvages of the canvas to be two 'Brabant' ells. The height is about 99 cm. However, see Henriks in Hermans et al. (1998), p. 235, who thinks there may have been specialist looms on which wide canvases were made.
45. Costaras (1998), p. 146.
46. For thread counts in Vermeer's paintings, see Costaras (1998), p. 165. For weave maps see <http://www.frick.org/interact/vermeers_canvases>
47. Stretchers with wooden wedges were not invented until the 1750s. See van de Wetering (2009), p. 117 and Wadum (1995), p. 11.
48. See van de Wetering (2009), pp. 116–213, for a detailed explanation of the way canvases were laced onto frames and what the pattern of stretch marks (called cusping) can reveal about the artist's intentions.

You can see an example of a trampoline canvas in Rembrandt's re-created studio in Amsterdam. The frame is most beautifully made: the holes are drilled at an angle through a depression in the side, and the threading is consequently very neat. But the string could be laced right round a simpler frame or inserted through straight holes in the wood instead. See Schot and Dreu (2015), p. 23.

49. It was not uncommon for Painters to re-stretch their canvases 'several times' in the course of making a painting. Hendriks in Hermens et al. (1998), p. 237.

50. Fifteen of Vermeer's thirty-six pictures no longer have their original tacking edges. See the chart in Costaras (1998), p. 165, for information as to the extent of the ground in each painting.

51. Buijsen (2010), pp. 16–17.

52. See Jenkins (1993), pp. 143–157, for his essay on this picture.

53. Costaras (1998), pp. 146–149.

54. This is an average ratio of around 1:1.2.

55. Costaras (1998), p. 151.

56. Wadum (1995), pp. 9–10.

57. This suggestion is made in Fink (1971), pp. 502–503. See also Steadman (2001), pp. 104–106.

58. A Knoller tolled the bells; a Nob Thatcher was a wig maker; a Long Song Seller sold printed song sheets; a Lumper unloaded the goods from ships: see <www.worldthroughthelens.com>.

59. Van Hout in Hermans et al, (1998), p. 213.

60. Levy-van Halm (1998), pp. 138–139.

61. Groen (2005), p. 143; (2014), pp. 41–42. These 'quartz grounds' meant the canvas could be rolled up with less risk of cracking, and they eliminated the need for double grounds. They were made of a whitish clay or natural earth, like those used in the pottery industry. Other pigments may have been added to adjust the colour.

62. Van de Wetering (2016), Appendix B, p. 304.

63. Merrifield (1999), 'Brussels Manuscript', p. 772.

64. Costaras (1998), p. 151, thinks that Vermeer is likely to have bought ready-prepared canvases.

65. If the canvas weave is not square to its support, it can distort the fabric or even pull the strainer askew, leading to problems when putting a decorative frame around it later.

66. There is a recipe for size in *The Excellency of Pen and Paper*, by an anonymous author (1668), p. 113.

67. Personal conversation with senior conservator, Rachel Turnbull, at Kenwood House, Hampstead, London.

68. Van Hout (2007), p. 212.

69. See Schellmann (2007), for a review of animal glues for size, listing a number of sources of glue.

70. De Mayerne in Fels (2010), p. 232.

71. Cennini, trans. Herringham (1930), p. 90.

72. Different kinds of glues were used for different purposes. See Cennini, trans. Broecke (2015), pp. 142–145, who gives recipes for fish, kid, and sheep glue.
73. Size can be used as a painting medium on its own. Decorated items such as banners, flags, and backdrops, which need to be lightweight and easily rolled up for storage, were traditionally painted using colours ground into warm size. See van Hout (1998), p. 212.

In the twentieth century, Édouard Vuillard adopted this technique for his pictures, painting many of them 'a la colle', often straight onto cardboard, which gives them a particular chalky, flattened look. For a first-hand description of Vuillard's painting method, see Russell (1977), pp. 137–140. In England, paint with glue is called distemper (not to be confused with tempera, which is paint with an egg-based medium).

CHAPTER 4

1. Bailey (1978), p. 96, quotes an early pupil of Rembrandt as saying that his master's appearance 'was careless, and his smock was stained with paint, all over, because it was his habit to wipe his brushes on it'.
2. De Winkel (1999), pp. 64–65, suggests that the painter depicted in this picture by Rembrandt is in working clothes. However, Bonafoux (1992), p. 25, thinks he is 'dressed as if to receive clients'.
3. Arthur Wheelock has suggested that it is possible Vermeer went to Amsterdam to work in Rembrandt's studio: see Seventh Art productions (2013) (extra material). Alternatively, could he have met Rembrandt through Carel Fabritius who had been one of his pupils? Fabritius lived in Delft from about 1650 and died in *The Thunderclap* in 1654, when Vermeer was twenty-two and at the beginning of his painting career.
4. See Chapter 7. Rembrandt had a visit from Constantijn Huygens in 1628, and corresponded with him. Huygens knew both the men who visited Vermeer. See van de Wetering (2009), pp. 88, 173–174. Also Broos (1995), pp. 47–51.
5. There is a comprehensive catalogue entry for this picture in Brown et al. (1991), pp. 130–131. One of Rembrandt's first pupils, Gerrit Dou, was put forward as the subject in this picture, but 'this theory has found little support'. Rembrandt took pupils very early in his career: around 1628. This picture was painted a year afterwards.
6. An easel is illustrated, and described in detail in *The Excellency of Pen and Pencil*, Anonymous (1668), Frontispiece and pp. 91–92, where it is explained that 'it is full of holes on either side to set your Work upon higher or lower at pleasure'.
7. Pieter J. J. van Thiel in Brown et al. (1991), pp. 130–31, says that there is 'no precedent' for this artist's pose, and suggests that it is 'not a work of the imagination, but a true-to-life picture of the artist in his Leiden studio'.
8. This detail is noted by van de Wetering (2009), p. 88. De Winkel (1999), p. 65, suggests that as artists 'did most of their work seated', this is a good reason to have a warm, lined robe.

9. Van de Wetering (2009), p. 251, quotes a letter from Rembrandt to Constantijn Huygens, written in 1639, giving suggestions as to how a picture of his should be displayed: 'My Lord hang this picture in a strong light and where one can stand at a distance, so it will sparkle at its best'.

10. See the discussion of Rembrandt's rough style in van de Wetering (2009), pp. 160–163, including quotes from Contantijn Huygens and Arnold Houbraken.

11. Smith (1753), pp. 1–2, says that the most important property of the grinding stone is that it should not be absorbent, otherwise 'the colours that are first ground on it cannot be well cleaned off, but that some part will still remain in the hollow pores of the stone, which will much spoil the beauty and lustre of the other colours that are ground after it'.

12. Kirby (2011), p. 73.

13. De Mayerne gives a number of recipes for the preparation of oil and suggestions for their suitability in different circumstances. See de Mayerne in Fels (2010), pp. 253–255.

14. See notes by David Peggie relating to the exhibition *Vermeer and Music* at the National Gallery, London, in 2013 <https://www.nationalgallery.org.uk/paintings/research/meaning-of-making/vermeer-and-technique/binding-medium>. It seems that Vermeer used some heat-bodied oils (both walnut and linseed) in *A Young Woman Standing at a Virginal*. Both were also found in an analysis of *The Art of Painting*.

15. It is thought that Rembrandt may have stiffened his oil by putting it onto a hotplate, giving him a vehicle to make very thick textural effects on the surface of his painting. See Dent Weil and Belchetz-Swenson (2007), pp. 329–330.

16. See White and Kirby (1994), pp. 68–71, for a full explanation of heated drying oils.

17. Taylor (1992). De Mayerne in Fels (2010), p. 144.

18. Roy in Bomford et al. (2006), pp. 27, 30. De Hout (1998), pp. 214–217. See Groen (2014), p. 21, who suggests that the colour of the ground 'largely determines' the way the painter works in the underlayers.

19. Costaras (1998), p. 151.

20. See van Hout in Hermens et al. (1998), p. 214; Le Brun in Merrifield (1999), p. 770. Just adding black to the white would give a very cold effect to the ground, so painters often added a red or brown too. See Wallert and de Ridder (2002), p. 39, for the effect of 'Raleigh scattering', where the small size of particles cause the light to scatter more towards the blue end of the spectrum.

21. Van Eikema Hommes (2004), p. 37.

22. Gowing (1997), p. 138.

23. Costaras (1998), p. 165. These are: *Christ in the House of Martha and Mary, The Girl with the Wine Glass, Young Girl with a Flute, Mistress and Maid, The Love Letter, A Lady Standing at the Virginals,* and *A Lady Seated at the Virginals. The Little Street* possibly has a ground made of two layers of grey paint.

24. See Barber (1999), p. 50.

25. Kirby in Bomford et al. (2006), p. 26.
26. Smith (1753), devotes a chapter to refining colours that are gritty, and tells you how to wash pigments.
27. Albus (2000), p. 94. Van Eyck is often credited with the invention of oil paint, but it appears others were using it long before, and it is mentioned in the writings of Theophilus in the twelfth century: see Theophilus, trans. Hawthorne and Smith (1979), p. 27, where he describes making a red oil paint for doors.
28. Volpato Manuscript in Merrifield (1999), p. 738.
29. Smith (1692), p. 74.
30. Merrifield (1999), p. 738.
31. Smith (1753), p. 34.
32. Peacham (1606), p.47. The painter's mussel, *Unio pictorum*, grows up to about six inches (15cm) long. Robert Vlugt of the Salamander Pharmacy in Delft still looks for their shells on the banks of small streams and canals outside the town. Often, he finds them picked clean by the swans.
 Large mussel shells can be seen next to the men grinding paint in Figure 4.2.
33. See van Hout in Hermans (1998), p. 221, n. 63. A cuttlebone was mentioned as perfect for the job in a Spanish painting handbook of 1615.
34. See van de Wetering (1995), pp. 136–143, 148–152, who has made a comprehensive study of Rembrandt's palette.
35. De Mayerne in Fels (2010), pp. 147, 267. Colours could also be incompatible, so you would not want to mix them together on the brush. See van Eikema Hommes (2004), pp. 36–37.
36. Merrifield (1999), Volpato Manuscript, p. 746.
37. Van de Wetering (1995), pp. 141–143. De Mayerne in Fels (2010), pp. 239–30.
38. De Mayerne in Fels (2010), p. 147, recommends pear wood as the best to make a palette.
39. See Montias (1989), p. 341.
40. Albus (2000), pp. 82–98; but Mayer (1951), p. 127, thinks that a 'uniformity of particle size is most desirable'.
41. Pip Seymour (2003), pp. 290–293.
42. Fillers are added for stability, even in the more expensive 'artist's' paints; but these do contain some traditional pigments. The 'student' paints, on the other hand, are likely to be made from synthetic materials, the colours having been made in quantity for other industries, such as for house paint.
 In Vermeer's day, colours were made primarily for the pottery industry, or for dyeing textiles. Some were a side-product of silver refining. See Kirby (1999), p. 30.
43. De Mayerne in Fels (2010), p. 147, says that lamp black, smalt, yellow lake, yellow ochre, and red lake, will not keep under water. In the Volpato Manuscript in Merrifield (1999), p. 740, 'F.' says that 'lake (red lake), *giallo santo* (yellow lake), and *verderame* (the copper pigment verdigris) are spoiled by water'.
44. A later report by Smith (1753) suggests that paint could last as long as seventeen years in a pig's bladder, and that those of an ox or a sheep can also be used for the purpose. See Ayres (1985), p. 90.

45. Natter (2004), p. 114.
46. Smith (1729/1968), p. 73, indicates the strength of a pickle 'strong enough to bear an egg' in order to salt and dry a ham of bacon (this is on the same page as a recipe 'to pot a swan').
47. Baer (2015), p. 217; see also Riley (1994), p. 65.
48. Wieseman (2013), p. 76, and illustrations on pp. 17, 46; also Buijsen and Grip (1994), pp. 302, 306, 374.
49. There a number of pictures of the time showing slaughtered pigs, with children blowing into bladders to make balloons. One example, by Isaac van Ostade, is in the Frans Hals Museum, Haarlem.
50. See <http://themorrisring.org/publications/morris-tradition>.
51. The bladder, filled with lead white in the illustration, was opened after a year. The paint inside was perfectly preserved, and needed the addition of only a small amount of oil for it to be ready to use.
52. The observation that salt appeared to crystallize on the skin of the bladder as it dried, was made by the author. It surprised a senior conservator, who had noted the presence of salt in some of the old paint samples she studied, and wondered where it had come from. She had not thought about the possibility that storage in previously pickled pigs' bladders may have been the source. Personal communication, with Leslie Carlyle.

 Very little research seems to have been done on the impact of paint storage on painting in the seventeenth century, or on the practical use of pigs' bladders. The author is preparing a paper on this subject.
53. A rag fortified with a little thinner, like oil of spike lavender, would also work.
54. De Mayerne in Fels (2010), p. 147.
55. See Wadum (1995), p. 76, who thinks that brushes with hair from squirrel, or otter, were used to paint the *Girl with a Pearl Earring*.
56. Otter's hair is called 'fish hair' in many treatises. See Tree (2019), p. 230.
57. The meaning of the word 'miniver' is discussed in Harley (1982), p. 61. She thinks that this is the hair from ermine, 'the winter coat of a stoat'. Kolinsky sable is now considered the best hair for use in soft brushes. See Turner (1992), pp. 12, 38, 39. In the commentary of her recent translation of Cennini (2015), Lara Broeke talks of 'vair' rather than 'miniver', which she describes as 'the fur from the Russian and Scandinavian squirrel', pp. 32, 95.

 Merrifield (1999), 'Brussels Manuscript' (1635), p. 770, 'Hairs of bears are very good, so are those of martens and similar animals' to make brushes with 'a firm point for painting'.
58. During restoration in 2010–2011, it was found that the format of the *Woman in Blue Reading a Letter* (Fig. 5.4), had been enlarged during previous treatments, and put back on a stretcher slightly askew. This was corrected to fall in line with what was thought to be Vermeer's original intention. See Verslype (2012), pp. 13, 16; and Weber in Verslype (2012), pp. 21–22, discussing the impact of this enlargement on the composition of this painting.

 Older books on Vermeer may have different measurements recorded.
59. Buijsen (2010), pp. 74–75; Bok in Gaskell and Jonker (1998), pp. 67–79.

60. Ray (1738), pp. 22–25.
61. Was this apothecary the same man who took the lease of the Mechelen in 1673, after the death of Vermeer's mother? See Montias (1989), p. 205.
62. These objections are those of Blankert (1978), pp. 73–74. He may not have known of or considered the fact that panels for painting were found listed in the inventory in Vermeer's studio after his death. For a detailed overview of the arguments, see Arasse (1994), Appendix 2, pp. 99–101.
63. Wheelock and Broos (1995), p. 160.
64. Wheelock (1988), p. 101, has reproduced this painting at exact size in this monograph.
65. See Elkins (1999).
66. See for example the work of Willem de Kooning and other abstract expressionists.
67. Wadum et al. (1995), p. 14.
68. The National Gallery, Technical Notes <https://www.nationalgallery.org.uk/paintings/research/the-meaning-of-making/vermeer-and-technique/secrets-of-the-studio>.
69. Armenini (1587/1977), p. 179.
70. Cennini gives directions for making brushes using both quills and binding. He uses the hairs from the tips of the tails of the miniver for the soft brushes he uses for gilding; and selects the straightest and stiffest hairs from the middle of the tail for more general use. He describes making up small bundles of hair, soaking them in water, squeezing them and '…then laying the points very even, take waxed thread or silk, and with two knots, fasten them well together…cut off the end of the quill and put the bundle of hairs into the quill…(taking) care to squeeze in as many as you can…for the firmer and shorter it is the better and the more delicate the work it can do.' Cennini, trans. Broecke (2015), p. 95.

 For oil painting, the suggestion was that the length of a brush handle should be anything between 22 cm. and 40 cm. in length. Harley (1982), p. 63. Anonymous (1668), p. 97.

 The English painter Richard Symonds (1617–1660), recommended rubbing brushes hard on a tile to soften them: see notes on brushes <www.naturalpigments.com>.
71. There is a very good description and an illustration of quill brush making in Turner (1992), pp. 30–34.
72. Cennini, trans. Broecke (2015), p. 95. Although there are references to vulture, hen, or dove quills, these probably indicate the size of suitable quills, rather than referring to what they were made from. See Harley (1982), p. 63; and see also Ayres (1985), p. 124, who mentions swallow quills. Brushes are still sold in quills, still with the name of the bird stamped on the handle. It is interesting that a catalogue of a nineteenth-century brush manufacturer, in London, indicated the largest size brushes sold were eagle quills, see Linton (1852). See also the anonymous writer of the *The Excellency of Pen and Pencil* (1668), p. 93, who provides a chart of brushes in quills, and the qualities to look for.
73. Presumably the white pig has stiffer hair. Cennini, trans. Herringham (1930), p. 53.

74. Anonymous (1668), pp. 93, 97.
75. Metal ferrules were not in common use until 1740 or thereabouts, although Ayres (1985), p. 124, says that 'silver ferrules occasionally appeared in the seventeenth century'.
76. Wadum (1995), p. 76, tells us that some of Vermeer's brushes were square tipped.
77. Harley (1982), p. 65.
78. Cennini, trans. Herringham (1930), p. 54.
79. De Mayerne in Fels (2010), p. 143.
80. See Wheeler (2009), pp. 50–51, who also notes a suggestion in a manuscript on painting (1556–1559) by Cipriano Piccolpasso, that brushes were also made from goat's hair and asses' manes.
81. Levy-van Halm (1998), p. 139.
82. Harley (1982), tells us that, 'far more writers on painting provided information of the sources of supply than described the process of brush-making'; suggesting that commonly painters bought their brushes ready-made.
83. Peacham (1606), p. 47, '…you shall buy them one after another for eight or ten pence a dozen at the Apothecaries'.
84. Anonymous (1668), p. 74.
85. Smith (1692), here the brushes are squeezed of the drying oil and put into a salad oil that does not dry, and so keeps them pliable.
86. See the Volpato Manuscript in Merrifield (1999), p. 740. New fresco brushes are sold with their hairs bound with string like this today. See the catalogue for Zecchi, Florence <http://www.zecchi.it/products.php?category=25>.
87. In Dutch, a 'maalstok' is a painter's stick (malstick), from the verb malen 'to paint'.
88. Anonymous (1668), p. 93.
89. Personal communication, with Ariane van Suchtelen; see her book of 2015, pp. 48–49, for illustrations of palettes used by some painters contemporary with Vermeer. The arrangement of colours on them may not reflect the realistic progress of a picture, where only those colours needed for a day's work were laid out. See also pp. 38, 58–59. It is interesting to note that de Gelder is not showing us a mirror image of a right-handed painter. Many artists' self-portraits of the time show the artist as the viewer would see them, not as they saw themselves in a mirror.

 The expectation of which way round you expect to see others, had to be addressed in our time by the mobile phone industry. When you use a video phone service, you see an image of yourself as in a mirror, but the person you are talking with sees you laterally reversed, as if you are before them.
90. Charles Beale, working to prepare canvases for his wife in the 1670s, stored his canvases all over the house to be ready for her use. See Beale, *Diary and Notebook*, 1671.
91. When bladders were filled experimentally, the small one went harder on the outside than the large one, as the oil migrated to the sides. It was impossible

to know whether the paint inside had hardened too. In fact, after a year, there was still some liquid paint inside. Jelley, *Before the invention of the Paint Tube* (in preparation).

Experiments showed that it was inevitable that some paint put in a bladder will stick to the inside of the skin, and cannot be retrieved once it is opened. A bladder would therefore not be a good storage method for very a small quantity of paint.

See the Volpato Manuscript in Merrifield (1999), p. 740, for ideas about how to deal with paint at the end of the day.

92. This would be a covering of either oiled cloth, oil, or water, depending on the pigment. See note 43, p. 252 in this book.

<div style="text-align:center">CHAPTER 5</div>

1. Liedtke (2008), p. 131.
2. Schneider (2004), p. 69. A painting, thought to be the *Girl with a Pearl Earring*, in the catalogue of the 'Dissuis sale', 16 May 1696, was listed as number 38, and valued at 36 guilders. 'A tronie in antique dress, uncommonly artful'. Monitas (1989), p. 364, in document 439.
3. Runia and van der Ploeg (2005), p. 68. *Girl with a Pearl Earring* (Fig. 5.1) was included in an auction at the Venduhuis der Notarissen in The Hague in 1881. Gordenker (2014), p. 76.
4. We could probably say this picture has become an icon, see Kemp (2012).
5. Marlow (2001), p. 286.
 The pearl earring is unlikely to have been real. Fake pearls, made with fish scales enclosed in glass were imported from Italy. But Vincent Icke, a Leiden-based astronomer, thinks that the pattern of reflections suggests that the 'pearl' could be made of metal. Could she be the 'Girl with a Ball Bearing', as one newspaper put it? See <https://www.mauritshuis.nl/en/discover/news-archive/2014/draagt-het-meisje-wel-een-parel/>.
6. Snow (1994), pp. 3, 4.
7. Schneider (2004), p. 69.
8. Tracy Chevalier imagines this scenario in her historical novel *Girl with a Pearl Earring* of 1999.
9. John Nash (1995), pp. 32–34.
10. These words are attributed to Jan Veth in 1908. See Marlow (2001), p. 287; see also Runia and van der Ploeg (2005), p. 66.
11. This is called wet-in-wet painting, see Wadum et al. (1995), p. 14.
12. As one of Vermeer's admirers said, 'the point is what happens to me when I look at his work. A painting is what it does; not how it was made'. See <www.studio360.org/story/diy-vermeer>.
13. Wald (2010), p. 316; Groen et al. (1998), p. 177.
14. A detailed, analytic scientific report of the *Girl with a Pearl Earring* (Fig. 5.1) was made by Groen et al. (1998).

15. See Carlyle (1995).
16. Costaras (1998), p. 165. The information on the tacking edges appears not to entirely accord with the chart on p. 167.
17. See Wadum et al. (1995), pp. 10–11; van de Wetering (2009), pp. 116–128.
18. Wadum et al. (1995), p. 10. It is unclear from this description whether the traces of the priming knife correspond to the shape of the existing strainer or not. Kühn (1968), p. 191, describes the ground of the *Girl with a Pearl Earring* (Fig. 5.1) (which he calls 'Head of a Girl') as 'white ground, lightly shaded with brown and with a brown paint layer under it from the edge'. He says the pigments used were 'ground lead white, chalk (umber)', and that the medium was 'oil and proteins'.

 Wadum et al. (1995), p. 10, indicates lead white, chalk, red, and brown ochre and black, a view shared by van Eikema Hommes (2004), p. 115. However, Costaras (1998), p. 165, says this ground is composed of lead white, chalk and umber, while Groen et al. (1998), p. 171, writing in the same publication suggest that chalk, lead white, ochre, and a fine black (possibly lamp black) were used.
19. Gowing (1977), p. 137. This X-ray was made as part of the investigation of Vermeer's painting made in response to the forgeries of Henricus Antonius 'Han' van Meegeren. See Coremans (1949), pl. 69. A more recent X ray of this picture can be found in Wadum et al. (1995), p. 20.
20. Gowing (1997), pp. 22, 137–138. Groen et al. (1998), p. 171. See Gifford (1998), pp. 187–190, for analysis of the underpainting in other pictures by Vermeer.
21. This is the view of painter Jonathan Jansen, see <www.essentialvermeer.com>.
22. See Kirby (2011), pp. 47–48; also see van Hout and Balis (2012), pp. 13–30, and 47–48 to see the contrast with Rubens' technique.
23. See Weber (2013), p. 43, who comments on the differences between Vermeer's underlayers and those of other artists.
24. Wadum (1995) pp. 16, 20, 32; Gowing (1997), pp. 20–21
25. See Verslype (2012), pp. 9, 18, note 16. The picture was exposed to the long-wave infrared radiation, the rays of which went right through the upper paint layers, making them appear transparent and allowing scientists to see what lay beneath in the lower layers of painting. The Dutch physicist J. R. J. van Asperen de Boer developed the technique of infrared reflectography or IRR.

 Although there has been a recent innovation at the Mauritshuis to present investigative images of paintings in the collection in the form of an app called *Second Canvas*, the initial IRR scan of the *Girl with a Pearl Earring* only slightly penetrates the surface of the paint; and does not show all the dark underpainting that experts suspect lies beneath the surface. Personal communication, with Abbie Vandivere, conservator of paintings, Mauritshuis.
26. Wheelock (1995), pp. 43–46; Wheelock (2001), pp. 43–49.
27. See Laurenze-Landsberg (2007), pp. 211–225, who analyses two under-paintings: the *Woman with a Pearl Necklace* (Fig. 5.9), and *The Glass of Wine* (Fig. 6.8), using a technique called neutron autoradiography.

28. These first monochrome prints could have a powerful impact on any finished work because of their tonal strength. Looking at Vermeer's work, Wheelock (1995), p. 108, writes that 'shadows…are not surface phenomena, but reach into the very body of the material'. Gifford (1998), p. 187, suggests that dark underpainting established the 'basic play of the light and shadow' in Vermeer's *Woman Holding a Balance*. See also Costaras (1998), p. 153–155.

29. Groen et al. (1998), 172.

30. Alberti (1435), pp. 82–84; Barrett and Stulik (1995), pp. 7–8.

31. Merrifield (1999), Chapter VI, p. ccxciii, describes a method she calls the *Flemish Process*, where 'the picture was begun in chiaroscuro and finished with local colours'.

32. See Gifford (1998), p. 187, describing contours in Vermeer's paintings, some of which were made by gaps, giving a glimpse of layers beneath.
 See the technical notes on *A Woman Holding a Balance* (Fig. 5.5) on the website of the National Gallery of Art, Washington, They say that 'examination has not shown evidence of an under-drawing' but 'a brown painted sketch' indicated by 'areas of wash', <http://www.nga.gov/content/ngaweb/Collection/art-object-page.1236.pdf>.

33. Van de Wetering (2009), p. 150, 'certain pigments occur only within clearly demarcated zones, not in the rest of the painting'.

34. See van de Wetering (2009), p. 135, and his comment on the relationship between style and technique.

35. Van de Wetering (2009), p. 150.

36. Groen et al.(1998), p. 171, 'the black shines through the blue, yellow and flesh paint, giving the yellow its greenish hue'.

37. Costaras (1998), p. 152–156.

38. Green earth is much brighter as a dry pigment, than when mixed with oil.

39. See Le Brun in Merrifield (1999), p. 812.

40. See *Suppliers of Materials* in this book. Sennelier stocks pamphlets (in French) showing illustrations of earth quarries, and production processes of earth pigments. These are produced by *Terres et Couleurs*, a non-profit organization, whose aim is to revive the use of coloured earths. See <www.terresetcouleurs.com>.

41. von Sonnenburg (1973), p. 223, who talks of 'dark halos' in the borderlines between 'areas of light and shadow'. Although he talks of these being 'shaped with a brush', some apparent contours are actually areas where underpainting has been left to be seen. See Gifford (1998), p. 189, illustration no. 7; and Wald (2010), pp. 203, 315, 316.

42. See Taylor (1998) pp. 162–163.

43. Groen et al. (1998), p. 172.

44. Groen et al. (1998), could not identify the red on the lips of the *Girl with a Pearl Earring* (Fig. 5.1), but noted that the red in *The Love Letter* was a lake pigment made with cochineal.

45. You can find cochineal listed on packaging as 'carmine'. Because it is an 'organic' material, it is coming back into use and is supplanting synthetic alternatives.

46. Although Vermeer might have used indigo made from woad, European indigo was less powerful than that produced from plants in India and the Far East. The Dutch East India Company (VOC) was importing quantities of indigo in the cargo of their ships, and this is more likely to have been the source of Vermeer's supplies. See Balfour-Paul (1998), pp. 44–45.
For an analysis of the dark background in the *Girl with a Pearl Earring* (Fig. 5.1), see Groen et al. (1998), pp. 172–175.

47. See van Hout and Balis (2012), p. 55. Although the linseed oil used in the dark background might eventually yellow, this would not matter here.

48. It is possible that the highlight on the pearl was present at an early stage, as an area not covered with underpaint, rather like the tacks on the chairs in *Woman in Blue Reading a Letter* (Fig. 5.4). Van de Wetering (2009), p. 22, suggests that 'with a white ground, every insufficiently covered part of the ground would function as a highlight'. However, Gifford (1998), p. 190, notes that 'underpainted highlights do not always correspond with the highlights of the final image' in *A Lady Writing* (Fig. 8.6).

49. See Groen et al. (1998), p. 172.

50. In the conservation and repair of *Girl with a Pearl Earring* it became clear that the picture's condition had not only deteriorated over the passage of 350 years; but had also undergone a number of restorations and treatments, meant kindly, but which were not all ultimately constructive. Conservators were faced with many challenges: and had to remove old re-touchings, fillings, and yellowed varnish; some of which had been 'pigmented with a little black' to darken it deliberately. It was judged that none of these was original, and so they were removed; only then could any damage be repaired, but this time, they used materials that future generations can easily take away. See Wadum (1995), pp. 26–27.

51. See van der Woude (1991), p. 309, who suggests less than 1 per cent of the five to ten million pictures painted in the Dutch Golden Age has survived.

52. Gowing (1997), p. 138.

CHAPTER 6

1. Constantijn Huygens (1596–1687), see Colie (1956), pp. 93–94, 101–103.

2. This is Huygens' description of Drebbel, see Colie (1956), p. 93.

3. See Butler Greenfield (2006), pp. 170–184.

4. See Harris (1961), pp. 170–181.

5. Drebbel's demonstration of a working submarine in 1630 put him on the map. This underwater vessel was rowed for two miles down the River Thames, watched by over a thousand spectators who were all agog, 'in the greatest suspense', to see if the crew might survive this reckless undertaking. It appears

that Drebbel actually managed to synthesize oxygen for the crew of twelve, by burning saltpetre, which if true, would pre-date Priestly and Scheele's isolation of oxygen by about 150 years.

See Tierie (1932), pp. 60–61. Monconys (1666), vol. 2, p. 40. After taking the King himself out for a spin in his new craft, and testing several versions, Drebbel presented his unusual vessel to the Admiralty for inclusion in the fleet, thinking that it might be useful for spying on the enemy. Unfortunately, for him, this idea was not received with enthusiasm. The Royal Navy was not farsighted enough to see a practical use for it.

William Bourne drew detailed plans for a submarine in 1598, but Drebbel made it a reality, constructing a prototype. His bullet-shaped craft of wood was covered in greased leather, with oars poking out through tight-fitting leather flaps on the sides. Beyond this description, we know very little. Although Drebbel is said to have steered his boat using a compass, he must have had some tricky moments. As a main thoroughfare, the River Thames was a busy place, as it is estimated that on a daily basis there were no fewer than 10,000 small boats between Windsor and London Bridge; and that number does not include the ships, whose numerous masts appeared like a forest to approaching visitors. Monconys (1666) vol. 2, p. 10.

6. See Tierie (1932), pp. 53–56; <www.drebbel.net>; and Harris (1961), p. 183.
7. See < http://proto57.wordpress.com/category/drebbel/>.
8. *The Four Musketeers* (1974), 20th Century Fox.
9. Colie (1956), p. 101.
10. Wallert (2007), p. 59, suggests that Huygens saw Drebbel's camera obscura in 1622.
11. Translation from Alpers (1983), p. 12.
12. This is a real effect: things appear to move more slowly past the wide-angle and small image of the camera obscura lens than they do through our own eyes.
13. Some describe the colour in a camera obscura as 'condensed' or 'distilled', see Kemp (1990), p. 193.
14. See http://www.camera-obscura.co.uk/.
15. See http://www.bbc.co.uk/news/entertainment-arts-25524704.
16. Steadman (2001), p. 6.
17. Rembrandt Harmensz. van Rijn, *A Pedlar selling Spectacles*, *c.*1624–1625, oil on panel. This painting is in the Museum De Lakenhal, Leiden.

'Selling someone glasses' could also mean 'deceiving someone' in Dutch (Ashmolean notes to accompany the exhibition *Sensation* 2016).

Huib Zuidervaart, who has researched extensively into the availability of lenses in Delft in the seventeenth century, reports of a peddler of spectacles, Jan Pietersz (*brillenkramer*) from Leiden, who was convicted of '*landloperij*' (vagabondism) in 1626. Zuidervaart says that 'The travelling and modest nature of these pedlars mean they are very difficult to find in the archives.' However, he did find a record of one in Delft called Jan Harmens, who was active in 1666. But he suggests that generally they had only 'very modest

means of living, and they sold only plain spectacle glasses, no lenses of any sophistication'. Personal communication with Huib Zuidervaart.

18. Zuidervaart and Rijks (2014), p. 6.

19. Zuidervaart and Rijks (2014), p. 5.

20. Della Porta (1658/1957), Book 4, p. 147.

21. Della Porta (1658/1957), Book 16, p. 343. This was a method used to carry secret messages into prison, as an egg was the only thing not examined when brought in for prisoners.

22. Della Porta (1658/1957), Book 18, pp. 330–333.

23. The illustration on the Frontispiece of the English version shows the author with ruff and beard, slightly balding, and looking like a man of experience and learning. It is hard to believe his assertion in the Introduction that he wrote the book at the age of fifteen. Even though he was brought up in an academic household and had a precocious education, he either had much prescience to write up recipes he had found elsewhere, or he was being evasive about his age. Della Porta describes a number of experiments with projections, using mirrors, and convex and concave lenses; and it appears that he also understood the possibilities of microscopes and telescopes; as he explains, if you use a convex and concave lens and 'fit them both together…you shall see both things afar off and things near at hand' (Book 17, p. 368). Did he actually invent the telescope? He did make such a claim, but died before he could finish his treatise on the subject.

24. Della Porta (1658/1957), Book 17, p. 362.

25. This appears to be a derivation of the world 'lenticular', which means he would be using a double convex lens. Barbaro (1568) describes this as a lens, 'such as old men use'.

26. Della Porta (1658/1957), Book 17, pp. 363–364.

27. See Alpers (1983), pp. 8–13.

28. Liedtke (2001), p. 205.

29. Taylor (1992), pp. 210–232.

30. Hoogstraten's book was called *Inleyding tot de Hooge Schoole der Schilderkonst*, and was published in 1678. See Wheelock (1995), p. 19.

31. Wheelock (1977), pp. 6, 163–164: 'it appears that Dutch artists did not readily communicate artistic techniques that enabled them to achieve distinctive results'.

 Della Porta (1658/1957) refers a number of times to his instructions on lenses as being 'great secrets'. In describing the camera obscura, he says (Book 17, p. 363) 'Now will I declare what I have concealed until now, and thought to conceal continually'.

 Hockney (2001), p. 208, comments on the importance della Porta attached to secrecy.

32. Brown (1997), pp. 224–233.

33. See Groen (2007), pp. 195–197, on this encounter; see also Wallert (2007), pp. 58–60.

34. See Brown (1997), pp. 231–2, for documentation on this. There is a blog on Torrentius <www. arthistoriesroom.workdpress.com>.
 See <http://www.torrentius.com/> for details and a trailer for a forth-coming film, *Cold Case Torrentius*, by Martin Kroon.
35. Brown (1997), p. 228.
36. See Wallert (2007), p. 60, who compares the effect of a lens with Torrentius' painting.
37. Wallert (2007), pp. 64–65.
38. Wheelock (1995), p. 18.
39. Mundy (1667), Dijksterhuis (2010), pp. 257–258, 266.
40. van Strien (1998), p. 227. This device had been in use as early as 1638 to observe sunspots.
41. Personal communication with Huib Zuidervaart.
42. See Zuidervaart and Rijks (2014), for a comprehensive study of the optical practitioners in seventeenth-century Delft.
43. Johan van der Wyck left Delft for Sweden in 1657.
44. Zuidervaart and Rijks (2014), pp. 16–17; also p. 21. The authors think it is not inconceivable that Vermeer could have witnessed van der Wyck's experiment himself.
45. See the Frontispiece in this volume for an illllustration by Leurechon, *c.*1624.
46. See <http://www.nltimes.nl/2014/05/14/17th-cent-telescope-found-delft/>, and other websites on the subject of this discovery, including that of the Prinsenhof Museum.
47. See Zuidervaart (2010), p. 10, who suggests the telescope was around for some time as a device to improve vision, before taking its place in around 1608 as a scientific instrument. Filipczak (2006), comments that Leonardo wrote in his journal about making a telescope.
48. See Zuidervaart (2010), and other contributors. Also Dijksterhuis (2010), a publication devoted to the origins of the telescope; and Zuidervaart (2011).
49. Zuidervaart (2010), p. 28.
50. The invention of the telescope is said to have taken place around 1608. See <http://www.space.com/21950-who-invented-the-telescope.html>.
51. Zuidervaart (2011), p. 92.
52. I have followed the spelling on Leeuwenhoek's grave to call him 'Anthony'. Since his daughter was still living when he died, maybe one can assume she was happy with this version. He has otherwise been known as 'Antoni' or 'Antonie'.
53. Zuidervaart and Anderson (2016), p. 2. See also Ford (1991), p. 19, showing magnifications of cloth in Robert Hooke's *Micrographia*.
54. Leeuwenhoek was not the first to use small lenses like this; Zuidervaart and Anderson (2016), p. 5, suggest that 'most likely the device was an invention of the Amsterdam mathematician and magistrate Johannes Hudde (1628–1704)'. It is possible that Leeuwenhoek used burning glasses to melt the glass, rather than a flame that would have left deposits of carbon. Several of these were

NOTES TO PAGES 122–124

found in his house after his death. Personal communication with Huib Zuidervaart. See also Jardine (2009), chapter 11.

55. Leeuwenhoek used brass, silver, and even gold.

56. Ford (1985), pp. 72–75.

57. See Zuidervaart and Anderson (2016), p. 14, on an exciting new find in the Delft Archives of the inventory of Leeuwenhoek's house, made after his daughter's death; and also for much information about the microscopes auctioned after his death. It appears that Leeuwenhoek had difficulties in focusing his little devices, and so made a microscope for each specimen he examined. The number of documented microscopes comes to 559 in all.

58. The Museum Boerhaave, Leiden, *Guidebook* (1991), p. 19, describes the three microscopes they have in their collection as 'unsightly', but maybe the word has been mistranslated. The ingenuity of these little devices appears to be matched by their elegance. Dobell (1932).

59. This reproduction microscope was handmade in silver by Michel Haak in The Netherlands. The screws were cast in silver using Delft clay. The lens took eight hours to grind; in total, the microscope took thirty-seven hours to make.

60. See Huerta (2003) who provides insights into what he calls a 'Parallel search for knowledge during the Age of Discovery'; Alpers (1983); also Steadman (2001), Chapter 3.

Laura Snyder (2015), pp. 268–71, believes that Vermeer and Leeuwenhoek must have known each other, and that they could have been friends.

61. Montias (1989), pp. 225–226, does not think the fact Leeuwenhoek acted as Vermeer's executor indicates any personal connection. This is a view shared by the historian Gary Schwartz: see <https://garyschwartzarthistorian.com/2016/09/30/348-today-in-delft-340-years-ago/>.

62. See Zuidervaart and Rijks (2014), for a comprehensive survey of optical practitioners in Delft in the seventeenth century.

63. Zuidervaart and Anderson (2016), p. 10; Zuidervaart and Rijks (2014), pp. 10–15, regard Spoors as an important figure. He published a 'book of wonders' which included a discussion on optics, and which mentions the importance of proportion in painting. He measured the height of the tower of the Nieuwe Kerk with Leeuwenhoek, and together they did the surveying work required for the *Kaart Figuratief* (Fig 7.2), published in 1675, the year of Vermeer's death.

64. An interesting posthumous connection is the fact that Vermeer used red lake made from cochineal, a relatively recent import from the New World. Leeuwenhoek was asked by Robert Hooke in 1685 to identify what this substance was: whether grain or insect. Initially, Leeuwenhoek identified it incorrectly as a grain. See Butler Greenfield (2006), pp. 186–202.

65. Liedtke (2001), pp. 125–126. Samuel Pepys looked at his microscope in the company of Richard Reeve and John Sprong (both instrument makers) on 19 August 1666, but said he learned nothing about the principles of optics. See Jardine (1999), p. 49.

66. Liedtke (2008), p. 150, thinks that there is 'every reason' to suppose that these two pictures 'were painted as pendants'. Johnson Jr. and Sethares (2017) have put forward some technical evidence to confirm this view. Using 'weave density maps' they have concluded that the canvas of both these paintings came from the same bolt of cloth. See p.248, n.46 in this book. Blankert (1978), p. 165. The dimensions of these two pictures are within 1mm of each other.

67. Liedtke (2008), p. 150, quotes technical evidence presented by Waldeis in 1997 to indicate that the dates are original.
 An early owner of *The Astronomer* liked his acquisition so much that he commissioned a watercolour copy to be made of it. The copy shows the date 1673. However, it could be that a simple transcription of an X to a V is the culprit (MDCLXVIII or MDCLXXIII). We have to consider also how likely it is for Vermeer to have returned to the subject again, after a lapse of five years to set up the same room with such faithful similarity, and whether his model would have aged much in the intervening time. If he had been using this room as a studio, it would make more sense to paint the two at the same time. Both pictures share stylistic features and the same relaxed feeling, not evident in Vermeer's later paintings, and also the indication is that by 1673 Vermeer was not producing much because of the market crash in Holland.

68. Liedtke (2008), p. 150, does not give his reasons. This might have an impact on our appreciation of these works if we are seeing them both together. Vermeer's work shows great sensitivity to the compositional structure, which is evident here in the placement of objects and balances of shadows and illumination.
 The exhibition in 2017, *Vermeer and the Masters of Genre Painting*, which included both these pictures side-by-side, displayed *The Astronomer* hanging to the left of *The Geographer*.

69. For links between astronomy and navigation, see Liedtke (2009), p. 150.
 For the identification of the sea chart, maps, and globes in this pair of paintings see Welu (1975), pp. 541–557. Vermeer included a celestial globe in *The Astronomer*, and a terrestrial globe in *The Geographer*. See also van Berkel (1996), pp. 13–23.
 For the identification of the book in *The Astronomer*, see Welu (1986), pp. 263–267.

70. Blankert (1978), p. 166.

71. Both Wheelock (1977), pp. 106–108, (1995), p. 172, and Steadman (2001), pp. 49–53, think that this might possibly be the case, but Montias (1989), p. 225, thinks it unlikely.

72. Huerta (2003), p. 111.

73. See van Helden and van Gent (1999).

74. Leeuwenhoek was born in the same week as Vermeer: his birth is noted on the same page of the register. Christiaan was three years older, although we should remember that both men may be wearing wigs, and are at different stages in their careers in the illustrations shown. Leeuwenhoek sat for his

portrait when he was at the pinnacle of his endeavours, aged about fifty-seven; he lived to be ninety, and is buried in the Oude Kerk in Delft.

75. Zuidervaart and Anderson (2016), p. 11. Leeuwenhoek also owned a telescope, but we cannot say at what point he acquired this, or the globes.

76. Herbert (1991), pp. 146–150, who had such a strong desire for a connection, that he gave Vermeer words we know were never uttered.

77. Steadman (2001), p. 19, deduces that apparatus Huygens bought from Drebbel 'was some kind of closed box', but thinks that Vermeer's own camera is likely to have been a booth, constructed at the back of his studio.

A box camera appears in the film version of *Girl with a Pearl Earring*. Pathé Films (2003). But see Steadman review of Snyder (2015) <www. amazon.com>. See also Hockney (2001), pp. 203–210. Robert Boyle (1671), p. 18 talks of making a camera using a '*pretty large box*' with oiled paper, stretched over one end '*like the leather of a drum*'. He says that the images '*did not a little delight*' him.

78. Huygens talks of an image being projected either onto 'a plate' or 'a white bord [*sic*] … parallel with the wall … that can be moved backwards and forwards', i.e. brought into focus; and says that Drebbel should take the credit for this. See Tierie (1932), p. 52.

79. Colie (1956), p. 106.

80. We can see the image projected onto the sheet is upside down, but it would also have been laterally reversed.

81. See Liedtke (2000), p. 178, for this image that he dates to 1642. Also, Loughman and Montais (1999), p. 83, where they confirm that Beverwijk's room camera obscura had a 'spectacle or crystalline glass'.

82. There has been much recent research into the quality of lenses in the seventeenth century, and the general conclusion is that images from a camera obscura would have been good enough for copying to be done. This accords with Huygens' observations. See Cocquyt (2007); Groen (2007); Lefèvre (2007); Molesini (2007); Staubermann (2007); Wald (2010); Wirth (2007).

When Balthasar de Monconys visited Huygens on the 8th August 1663, he admired a lens which was 'six-and-a-half inches' across (16.5 cm.), which would have had very good light collection. See Monconys (1666), p. 145. Could this have been one of the big lenses Christiaan Huygens had ground himself, and which is now in the Boerhaave Museum, Leiden?

83. Steadman (2001), p. 105. This arrangement would also work with curtains instead of a cubicle.

84. Steadman (2001), pp. 105, 68–69.

85. Wheelock has suggested that as pendants, one may be representing the pure, and the other a corrupted relationship. See Seventh Art Productions (2013).

86. Personal communication with Huib J. Zuidervaart, who suggests the figure is Prudence, because she may be holding snakes, rather than ribbons or reins.

87. Zuidervaart (2011), pp. 49, 54–55, who notes that the tubes for telescopes in Holland were often basic plated iron pipes, and on occasion made by chimney sweeps, presumably because they knew how to make iron chimneys.

88. See Montias (1989), p. 339.

Pictures were often kept behind curtains to protect them from dust, as shown in a painting by Gabriel Metsu *Woman Reading a Letter*, c.1664–1666, now in the National Gallery of Art, Washington. This is illustrated in Waiboer et al. (2017), p. 119.

A number of artists including Vermeer, used curtains in their pictures as an illusionistic device, painted drawn back, to reveal a scene behind.

89. See Steadman (2001), p. 104.

90. You can see David Hockney demonstrating how to do this, in a film made by the BBC to accompany his book *Secret Knowledge*.

91. See Steadman (2001), pp. 7, 9, 12, for diagrams of the orientations of images from various types of camera obscura.

92. Tierie (1932), p. 52.

93. Buning (2013), pp. 108–114. In 1633 Reneri wrote to Huygens and told him that the answer was to use two lenses. One a large convex lens 'equal in size to the opening of a drinking cup', and the other, 'an ordinary spectacle lens of a sixty or seventy year-old man', placed in front of it. Reneri seems to have come to this conclusion independently of Kepler who had published this arrangement of lenses in 1611 in his book *Dioptrice*.

A large lens, such as described by Reneri, must have been more difficult to come by than ordinary spectacle lenses. Reneri is known to have had some made especially for his experiments. The use of two lenses would mean that the image could be traced the right way up; but the painter is still unable to work in colour. Personal communication with Robin Buning.

There is an illustration of a camera obscura with two lenses in Leurechon (1653), pp. 7–8, who says this it may 'excellently help' the painter in the 'lively painting of things', but who gives no further instructions.

della Porta (1658/1957), p. 364, also describes methods for correcting images from projections. In particular, in a section of his book called *That all shall appear right*, he recommends the use of a concave 'glass', presumably a mirror, which would have the same effect as a convex lens. This might be difficult to use, since it could not be put in line with a lens, as it would block the image. The corrected image would have to have been viewed from the side.

David Hockney (2001) used a concave mirror in his experiments, though there is contention as to whether these would have been easily available at the time.

94. Wadum (1998), p. 204. Huygens in Wheelock (1977), p. 163.

95. We can imagine that the set-up inside the curtains might have been a bit like being in a childhood den: cramped, but just workable. Some models of camera obscura were actually made in the form of a tent for use outside. Kepler had one in 1620, which was seen by the English diplomat Henry Wooton. See Steadman (2001), p. 11.

96. Montias (1989), p. 186,

97. Montias (1989), p. 248. Vermeer borrowed two hundred guilders in 1657, possibly as an advance against 'one or more paintings'.

98. See van de Wetering (2009), pp. 88, 173–74, on Huygens' visits to the studios of Rembrandt and Lievens in 1628.
99. Westermann (2008), p. 33; Broos (1995), pp. 49–50.

CHAPTER 7

1. This detail of an illustration of the Fish and Meat Market, was one of twenty-two images made of public buildings in Delft, which were used to surround Dirck van Bleyswijck's *Kaart Figuratief* (Fig. 7.2). They can be seen together in the entrance of Delft's town Hall today. See Wheelock et al. (2000), pp. 48–51; Liedtke (2001), pp. 506–508.

2. The 11th August 1666, was a Saturday in the Julian Calendar. The Gregorian calendar was not adopted until 1700. See <http://www.webexhibits.org/calendars/year-countries.html>.

 There are two market days every week in Delft, established since the Middle Ages. One in the main square on Thursdays, and the other centred round the Turf Market on Saturdays. See van der Wulp (1996), p. 47.

 Storks were kept by the town council to clear fishy refuse, see van Bleyswijck (1667). See van der Wulp (1996), pp. 47–48.

 See also the section on Delft Markets in Kees Kaldenbach's book <https://kalden.home.xs4all.nl/>.

3. Unfortunately, we do not know the names of all Vermeer's children. Montias (1989), pp. 214, 370–371, provides a family tree, but has names for only ten of his fifteen offspring: Maria, Elizabeth, Cornelia, Aleydis, Beatrix, Johannes, Gertruyd, Franciscus, Catherina, and Ignatius. Some have commented on the fact that Catholic names were given to the boys, which suggests that Vermeer adopted this faith. See also Binstock (2009), Appendix E, pp. 314–316.

4. Author's translation of Monconys (1666), Book 2, p. 149. The sum of "6 pistoles" is equivalent to sixty livres.

 Original reads:

 'A Delphes je vis le Peintre Vermer qui n'auoit point de ses ouvrages; mais nous en vismes un chez un Boulanger qu'on auoit payé six cens livres, quoyqui'il n'y eust qu'une figure, qui j'aurois creu trop payer de six pistoles.'

5. Leitdke (2001), p. 12, tells us that 600 livres (or guilders) was 'approximately equal to the annual salary of a skilled craftsman and to the price of a very small house'.

6. Sorbière's *Voyage to England* was first published in French in 1664, and then in English in 1709. On p. 27 he says he had 'often pressed' Monconys to publish his journal.

7. Monconys (1666), vol. 3, *Table des Hommes Illustres, et bons Ouvriers, dont il est fait mention en ces trois volumes* (unpaginated).

8. Monconys (1666), vol. 2

9. Liedtke (2001), p. 146, says that 'Vermeer's family background would be described today as lower middle class.' See also Baer (2015) (with Kennedy), pp. 175–176. Ruestow (2004), p. 160, points out that 'Delft was a conservative city deeply conscious of class divisions'.

10. Schwarz (1985), p. 124, suggests 'that one of Monconys' Dutch scientist friends may have called to his attention a painter in Delft who used with some amazing results an optical contrivance and that, therefore, his paintings may have had a particular interest and appeal to him'. Roodenburg (2007), pp. 385–386.

11. Monconys (1666), vol. 2, pp. 132–133.

12. See Monconys (1666), vol. 2, p. 145.

13. Broos (1995), p. 48, says that Monconys 'returned...but with a single purpose, to meet Vermeer'.

14. Liedtke (2001), pp. 12–13, pours cold water on the idea that Monconys came to Delft especially to see Vermeer. He has identified the fellow passenger on the barge: a painter called Gentillo, who was apparently originally from Rome, but who had moved to Brussels (also Léon's home town).

15. Wheelock (1977), p. 164: 'It appears that Dutch artists did not readily communicate artistic techniques that enabled them to achieve distinctive results'. Hockney (2001) is based on the premise that painters have always kept their methods and techniques to themselves, see p. 200.
 See also Massing (1995), p. 20.

16. We can see evidence of wine consumption in five of Vermeer's paintings. Kaldenbach <https://kalden.home.xs4all.nl/> comments that as wine was more expensive than beer, it was an indicator of class.
 Seven glass flasks and three wine glasses (roemers) are listed in the inventory of Vermeer's possessions. Montais (1989), p. 340.

17. See Montais (1989), Appendix A, pp. 265–267, and Weber (2013), p. 6–10.

18. The Rembrandt Research Project worked to make a list of all the paintings, etchings, and drawings Rembrandt ever produced. The number of 'certified' works has varied over the years, as they have confirmed some to be by his hand, and de-attributed others. The numbers are disputed, but it is thought that he produced around 300 paintings, 300 etchings, and more than 2,000 drawings. See <https://en.wikipedia.org/wiki/Rembrandt>.

19. It is thought Jan Steen painted around 800 pictures of which about 350 still exist. See <https://en.wikipedia.org/wiki/Jan_Steen>.

20. See Broos (1995), pp. 47–48.

21. There has been much discussion in the last few years about a picture that some attribute to Vermeer, titled *Young Woman Seated at a Virginal*. It has no cast-iron provenance, but shares material characteristics with other pictures that are accepted as his. See Sheldon and Costaras (2006); Sheldon (2012); and Sivel et al. (2007).

22. Van Meegeren was a Dutch forger who convinced the connoisseur Abraham Bredius that he had found some paintings from a 'missing' period of Vermeer's career. One of these forgeries, *Supper at Emmaus*, was purchased for a huge

sum by the Museum Boijmans in Rotterdam in 1937 (where it is presently displayed on a staircase, outside the galleries). The story of this scandal has been told a number of times, but the book by Lammertse et al. (2011), published by the Museum, gives a comprehensive account; and includes up-to-date details of the technical analysis of the paint layers of van Meegeren's work. See also Coreman (1949) for a contemporary account of the scientific examination, which confirmed the paintings as forgeries. This investigation found damning evidence from the pattern of cracks, showing that a new painting was made on top of another much older one; and it discovered that Bakelite had been used, instead of oil, as the painting medium.

23. This is suggested by Kaldenbach <https://kalden.home.xs4all.nl/>.

24. For provenances of Vermeer's paintings see Liedtke (2008), pp. 194–198.

25. Alpers (1988), p. 99.

26. Liedtke (2008), p. 195, suggests that Pieter van Ruijven owned this picture. John Michael Montias (1989), pp. 68–73, 246–247, 253–257, identified van Ruijven as a patron of Vermeer, and deduced that the pictures he had bought were inherited by his daughter Magdalena, who married Jacob Dissius. Also, see Montias (1998), pp. 93–99, and p. 282 n. 20 in this book.

There is a further connection between van Ruijven and Vermeer, because Vermeer received a loan from him in 1657, though Montias (1989) argues that this was probably an advance or a commission for a painting. Montias thinks that 'the relationship between van Ruijven and Vermeer clearly went beyond the routine contracts of an artist with a client', because he witnessed Vermeer's sister Gertruy's will in 1670, and because his wife Maria de Knuijt left a bequest of 500 guilders to Vermeer in her will (he predeceased her so did not benefit), pp. 248–250. See Westermann (2008), pp. 31–33.

27. Montias (1989), pp. 370–71.

28. Kaldenbach <https://kalden.home.xs4all.nl/> for his Chapter, 'A Precise Dating for the View of Delft', where he suggests that Vermeer might have begun *View of Delft* around 1660 to 1661 and completed it 'sometime between 1662 and 1665, when the painting was delivered to its first proud and happy owner'.

Liedtke (2008) gives the date range 1661–1663, while Wheelock (1995) suggests 1660–1661.

29. 96.5 × 115.7 cm. (3 ft. 2 in. × 3 ft. 9½ in.).

30. Jorgen Wadum interview <www.essentialvermeer.com>. Costaras (1998), p. 156, also mentions this, and two other areas in *View of Delft*, where one layer of paint has not adhered well to another, suggesting an interval between painting sessions.

31. In the *Kaart Figuratief* (Fig. 7.2) the house can be seen sitting just above the cartouche on the bottom right. See Wheelock and Kaldenbach (1982), p. 19, and a map showing Vermeer's viewpoint for this picture on p. 32, calculated by W. F. Weve. See also Liedtke (2008), p. 94.

32. The Delft Archive has the only extant copy of the first version of this map: *Kaart Figuratief* (*Staat I*), Archief Delft, B&G inv. nr. 108599.
33. Maps often ran with East at the top in this era, because of the relationship with the sun's rising and setting.
34. Kaldenbach <https://kalden.home.xs4all.nl/>, suggests that it is early summer because the trees are in leaf. See Bailey (2001), pp. 108–111.
35. Van der Wulp (1996), p. 41.

 Mountague (1696), p. 68, tells us that the 'Passage-Boat' was 'very large… containing between thirty and forty people' and that it was 'cover'd with a tarpaulin (a Piece of Canvas dipt in Tar or Oil) which in wet weather keeps out the rain, and in hot, the sun, and that (it) is to be thrown up to let in the air when they (the passengers) please'. When it is time for the boat to leave, it 'stays for no body, but puts off every Hour, just as the Clock has done striking'. Anthony Bailey (2001), p. 108, points out that the clock-hands show the time 'for the benefit of barge passengers'. Liedtke (2001), p. 3: 'The service between Delft and The Hague ran twice hourly in both directions, taking between one and one and a half hours to arrive'. Van der Gaag (2015) pp. 36–37.
36. The trees appear to be blue, but this is probably because any yellow lake glaze applied on top has faded over time.
37. A number of scholars have suggested in the past that sand was added to the paint to make it stand out in a three-dimensional way from the canvas, but this has since been disproved. Some of the lively texture of the surface can be explained by a reaction of the lead white paint with the oil (lead soaps). Costaras (1998), p.160. See also page 52 in this book.
38. Thoré-Burger, quoted in Wheelock (1995), p. 73.
39. Marcel Proust, *À la Recherche du Temps Perdu* (published 1913–1927).
40. Vaudoyer (of 1921) in Arasse (1994), p. 92; see also Clark (1961), p. 65.
41. Wheelock (1995), pp. 77–80; also Wheelock and Kaldenbach (1982), pp. 10–12, 16–18.
42. See Wheelock (1988), pp. 27–28, for a discussion of Samuel Hoogstraten's advice to painters, and the idea that pictures should not copy nature, but rather appear to do so.
43. Some commentators on this picture have not appreciated that the reflections of the buildings remain constant, except when the water is disturbed. Vermeer's viewpoint is towards the North. The buildings facing South-East would have benefited from the morning sun.
44. See Huerta (2003), pp. 51–53. Grijzenhout (2015), p. 56, suggests that the changes Vermeer made, in comparison with what he saw, were 'really quite modest'.
45. Liedtke (2008), p. 97.
46. This is a proportion considered particularly pleasing to the eye, it is defined mathematically as $(\sqrt{5} - 1) \div 2$, which is approximately 0.618: about the same proportion as a kilometre to a mile.
47. See Wheelock (1995), p. 78; and Wadum (1995), p. 32; also <www.essentialvermeer.com>.

48. See the radiograph given as an example <http://www.essentialvermeer.com/catalogue/view_of_delft.html#.VzF__2QrKNE>; see also comments by Wheelock (1995), p. 78, illustration no. 57.
49. Wadum (1995), p. 33.
50. See Wheelock and Kaldenbach (1982), p. 20; Arasse (1994), p. 70; Jardine (1999), p. 110. Westermann (2003), pp. 225–226, suggests that the 'visual characteristics' of this picture suggest the use of a camera obscura; and 'can hardly be explained in other ways'.
51. See Filipczak (2006), p. 261, for evidence of the possible use of the camera obscura in Vermeer's pictures and its similarity to our vision, central and peripheral. This is discussed in more detail in Chapter 8.
52. Wheelock(1995), p. 80, suggests: 'such reflections would appear as diffuse circular highlights in an unfocused image of a camera obscura, and would only appear in sunlight, not in the shadows as they are here painted'.
53. See Liedtke (2008), where in the Appendix he presents his rebuttal of Vermeer's use of a camera obscura.
54. See, for example, Wheelock and Kaldenbach (1982).
55. See Wadum (1996), p. 69. Saenredam made detailed drawings, possibly using architectural drawing techniques, which he transferred to a panel with the pressure of a stylus, after first rubbing the back of the paper with black chalk. See also Wadum (1996), pp. 40–41.
56. Wheelock (1995), p. 74.
57. See Wheelock and Kaldenbach (1982), pp. 31–36, for an analysis of the buildings in Vermeer's painting. The Schiedam Gate was demolished in 1836 and the Rotterdam Gate in 1834.
58. Wadum (1995), p. 11–13, to see an X-ray, and for a commentary on the structure of this picture; also Wheelock (1996), pp. 120–127.
59. See Noble et al. (2009), p. 174. The yellow lakes, applied in glazes, have faded in this picture, and the trees are now blue. It is probably not possible to tell if Vermeer used further coloured glazes, sometimes applied at the end of a painting process to harmonize the picture. Some glazing layers could have been removed in old restorations, along with varnish.
60. See Broos (1985), p. 47. Goods were unloaded straight from boats on the canals to bridges, where they were sold. See van der Wulp (1996), p. 47; see also Kaldenbach <https://kalden.home.xs4all.nl/>.
61. For a review of Dou's career, and his meticulous work, see Baer et al. (2000).
62. Monconys (1666), vol. 2, p. 153, 13 August 1663. Monconys calls van Mieris 'ce fameux peintre Mirris'. Van Mieris' work is generally small, see <https://en.wikipedia.org/wiki/Frans_van_Mieris_the_Elder>.
63. It appears that wealthy citizens of Delft were keen to invest in property: Montias (1982), p. 121.
64. Ben Broos (1995), p. 47, who thinks that van Buyten owned 'at least' four paintings by Vermeer. However, it depends whether the painting, described as 'a figure playing a cittern', was *The Guitar Player* or not.

65. Montias (1998), p. 100, wonders whether a later visit to Vermeer, by Pieter van Berckhout was made to van Ruijven's house, rather than to the Oude Langendijk. Broos (1995), p. 49.

66. Montias (1989), pp. 216–217; Montias (1998), pp. 102–103. Who was with Monconys when he went to the baker? He says 'we saw'. Is he referring to his son, who he mentions elsewhere in his diary, to Père Léon, or to Vermeer?

67. See Broos (1995), p. 47.

68. Weber (2013), p. 10.

69. For a detailed report on the recent restoration of this painting, see Verslype (2012), pp. 2–19.

70. See Weber (2013) and Wheelock (2001), for full analyses of this picture.

71. Rainer Maria Rilke (1991), pp. xx, 59, 60.

72. A comment by Christiaan Huygens, see Weber (2013), p. 39.

73. Weber (2013), p. 13.

74. Weber (2013), pp. 13, 18. See also Weber in Verslype (2012), pp. 21–27.

75. Wadum (1995), p. 26

76. Verslype (2012), pp. 2–19.

77. See Ruestow (2004), pp. 160–169.

78. For an overview, see Schwarz (1985), pp. 119–131, and Steadman (2001), pp. 44–58.

79. It is interesting to find that Christiaan Huygens had visited Reeve's shop in 1661. See Jardine (1999), p. 47.

80. Monconys (1666), vol. 2, pp. 17–18. Monconys also mentions 'a machine to draw everything one sees' belonging to Christopher Wren, but this could have been a pantograph or the equipment illustrated in fig. 73, p. 72.

81. See Jardine (1999), pp. 42–49. Robert Hooke acted as an 'expert advisor' to Reeve, and it appears that he designed the 'scotoscope'. Some think this could have been a form of camera obscura (see below). See Nuttal (1988), pp. 135–136.

82. Pepys, ed. Latham and Matthews (1983), Volume 10, p. 609.

83. Liedtke (2001), pp. 14–16; Broos (1995), pp. 49–50, thinks that Huygens 'could have performed a minor but vital rôle in the theatre of Vermeer's life'.

84. Monconys calls Huygens 'M. de Zulcon'; van Berckhout calls him 'Monsieur Zuylichem', because he had inherited the title Lord of Zuilichem.

85. See Broos (1995), pp. 49–50, and p. 63, n. 24. Roodenburg (2007), explains that it was not uncommon for group visits to be made by the elite to artists' studios. See also Jardine (2012), pp. 45–51 for further information about Constantijn Huygens' brokerage in the art world of his time.

86. Wadum (1995), pp. 71–72, has taken the word 'perspective' as used by van Berckhout, to refer to a careful mathematical construction of pictures. In a looser sense, this word could just mean a 'view' or a 'scene'.

87. Van Berckhout uses the word 'célèbre'. For the complete text, see Broos (1995), p. 50.

88. Liedtke (2008), p. 197. Nicholas Paets, another member of the family, was the lawyer who drew up van Ruijven's will, which included the bequest to Vermeer. Westermann (2003), p. 225; Montias (1989), pp. 250–251.

89. See Kaldenbach <https://kalden.home.xs4all.nl/> on van Berckhout; see also <www.essentialvermeer.com>.

CHAPTER 8

1. Van Strien (1989), p. 113. Peat was a common fuel in The Netherlands at the time. It burns without smoke but has a distinctive smell. Those who were travelling at night 'always knew that they were approaching a town'. See Phillips (2008), pp. 69, 73, for the difficulties of keeping warm and dry and the use of peat as a fuel and its effect on health.

2. Vossestein (2014), p. 41.

3. See van Suchtelen et al. (2001), pp. 12–15.

4. See <http://weather-and-climate.com/average-monthly-Rainfall-Temperature-Sunshine-inches,delft,Netherlands>.

5. De Mayerne in Fels (2010), pp. 155–156.

6. Vossestein (2014), p. 67.

7. Paper sunshades probably came to Holland from Japan via the Dutch East India company.
 There is an open sunshade in Dou's painting, *The Quack*, 1652, Museum Boijmans Rotterdam, and one folded up in *A Scholar Interrupted at his Writing*, c.1635, the Leiden Collection.

8. See <https://en.wikipedia.org/wiki/Umbrella>.

9. This umbrella is called the *Senz*™. See <https://www.senz.com/en/discover/explore-our-umbrellas/>.

10. See Kaldenbach <https://kalden.home.xs4all.nl/>, who remarks that 'a special kind of Delft daylight is quite hard to perceive, even by staunch believers'.

11. Rasmussen (1959), pp. 202–204.

12. See Walsh (1991); also Ossing (1991)

13. Parker (2014), Introduction. Brook (2008), pp. 12–14, who points out there may have been a connection between the cold weather and the plague.

14. In the history of The Netherlands, 1672 is known as the *Rampjaar: The Year of Disaster.*
 See <https://en.wikipedia.org/wiki/Rampjaar>.

15. See Montias (2007), pp. 58, 60. Vermeer borrowed 1,000 guilders in the last year of his life. However, Donald Haks, in Haks and van der Sman (1996), p. 104, suggests that Vermeer's financial downfall was avoidable. He remarks that 'in theory' he might have managed better if he had moved to a place with a better art market; if he had taken on pupils; painted more pictures; and had fewer children. But maybe these were never realistic options.
 The debt of 726 guilders Vermeer owed to his baker was the largest Montais (1989), pp. 217–218, had come across in any Delft inventory. He reckoned that this was equivalent to 8,000 pounds of white bread, equivalent to two or three years of bread deliveries: i.e. from around 1672 onwards. Montias speculates that van Buyten allowed Vermeer to build up this debt so he could obtain paintings in lieu of the money.
 See Catherina's statement to the High Court. Montias (1989), Document 367, pp. 344–345, regarding Vermeer's sale of paintings at 'great loss'.

16. See Liedtke (2008), pp. 167, 198.
17. In a review of the *Vermeer and Music* exhibition at the National Gallery, London, in 2013, Brian Sewell described Vermeer's 'egg faced women' playing on their instruments with 'trotters'. See <http://www.arthistorynews.com/articles/2302_Sewell_on_the_Nationals_Vermeer_and_Music>.
18. See Montias (1989), p. 215, for his description of this last painting, 'Vermeer lost confidence, the inner conviction that imparted life energy to his art'. Montias (2007), p. 60, suggests that there is a 'perceptual diminution of energy in his last works'.
19. People were obviously worried about the risk of fire. Montias (1982), p. 172, notes a dispute between the painter Hendrick van Vliet and his apprentice, about a candle not being snuffed out, even though the boy had left the room. Candles were expensive and ordinary families used ones made of tallow, rather than beeswax, which 'were smelly, burned rapidly and quickly deteriorated, often within twenty minutes or half an hour', so they could not be left unattended for long. See Muizelaar and Phillips (2003), pp. 56–61.
 Three-quarters of the city of Delft burnt down in 1536, and there was another fire in 1618, when the buildings in the Markt had to be covered in wet tarpaulins in an attempt to save them. See *Delfia Bavatorum* (2014), p. 18. After this, the town fathers insisted on firebreaks, and the new rows of houses had to have gaps at regular intervals. These were used as entrances to passageways, a traditional part of Delft's architecture. van der Gaag (2015) pp. 26–27.
20. Ekirch (2005), p. 164.
21. See Muizelaar and Phillips (2003), pp. 56–61, who comment on the lack of light in Dutch houses at night. Thornton (1983), p. 268.
22. Graham-Dixon (2003) bases the title of his film, *Secret Lives of the Artists: the Madness of Vermeer* on the idea that Vermeer suddenly lost his reason, and may have collected money belonging to Maria Thins for his own purposes. Montias (1989), pp. 211–212, thinks this kind of behaviour would have been 'out of character with the whole life of Vermeer as we know it'.
23. Montais (1989), p. 206.
24. Parker (2014), p. 7.
25. Vermeer might have hoped for some help from his rich patron, Peter van Ruijven, but he died in 1674. We now understand the link between depression and the lack of sunlight, called 'seasonal affective disorder', which could be linked to a lack of vitamin D.
 Montias (1989), p. 212, Document 383, pp. 351–352. He suggests that Vermeer could have had a heart attack or stroke as a result of being 'frantic over his inability to earn money to support his family and repay his debts', but Brook (2008), p. 230, suggests that Vermeer's death could have been as a result of a 'deadly infection'. See Chapter 1, note 4 in this book.

26. We know that Vermeer knew Ter Borch as he was a witness at his wedding. See Montias (1989), pp. 102–104. See Vergara (2003), pp. 210–212; also see Liedtke (2008), p. 184, on other painters fascinated with light effects.
27. Liedtke (2001), p. 150: '...his fascination with light is hardly unprecedented - but few painters focused so exclusively upon its properties for their own sake rather than for their usefulness to dramatic effect'. See also Schama (1998), p. 61.
28. See <www.essentialvermeer.com> for a discussion of a beaver hat. See also Brook (2008), Chapter 2.
29. If you go to Delft, you could test this idea by repeating a small experiment made by the Vermeer enthusiast, Tim Jenison. Stand in the space left behind where the Mechelen once stood, just opposite the new Vermeer Centrum, and look in the direction of the Town Hall. Then hold up your black smartphone screen as high as you can, facing towards you and slightly to the left, to try to replicate the position of a window as it might have been propped ajar in an upstairs room. Then you can see the curves of the church tracery. Although this is hardly scientific evidence, maybe it could be considered 'circumstantial observation'. See the film *Tim's Vermeer* (2013) (additional material).
30. Williams (1995), p. 275; Gowing (1997), pp. 20–21.
31. See Kemp (1990), pp. 193–196; Vergara (2003), p.208.
32. See Steadman (2001), p. 27. Pennell (1891). In a later book Pennell describes using a prism on a stick. Pennell (1925), p. 179. This is a camera lucida. He says that this produced a distortion he called 'photographic perspective', a quality he recognized in Vermeer. See also Hockney (2001), drawing with a camera lucida, and a concave mirror.
33. Kemp (1990), p. 193: such contrasts have now 'lost much of their original element of surprise'.
34. See Shawe-Taylor (2015), p. 161, where it is clear that the feature of the table being so large, disturbed some commentators as far back as 1844.
35. Wheelock (2001), p. 41.
36. Thornton (1983), p. 252.
37. Liedtke (2008), p. 107, 'We are suddenly much closer to the woman, as if we have risen from our seated position to stand next to, to stand over her'.
38. Steadman (2001), p. 84, calculates the angle that this mirror must have been at in order to give its reflections.
39. See Broos (1995), p. 51, who suggests that the virginals Vermeer depicted are so accurate that he 'must have observed them directly'.
40. This was the title of this picture at the 'Dissius' sale of 1696. Montias (1989), p. 364; however, the lady is actually playing a virginal. Broos (1995), pp. 128, 132. In the eighteenth century, this picture was attributed to Frans van Mieris. Then, the instrument was called '*a Spinet*'.
41. Shawe-Taylor (2015), p. 162, thinks that the gentleman is singing, as 'his mouth is clearly open'. He does not think that he is a music teacher, or a suitor, but someone enjoying 'decorous music-making'.

42. For a demonstration of a muselar virginal, very similar to the one in this painting, go to <https://www.youtube.com/watch?v=Tv6q39gjLcg>. This instrument produces a buzz at lower registers. Buijsen and Grip (1994), pp. 72–74, 238.

43. Rasmussen (1959), pp. 199–206, explains that the shadows are 'softened by reflected light, and especially by light coming from the other windows' so that 'the shadows recede, not gradually, but in stages'.

44. The effect of blue could be the result of ultramarine 'sickness', see <https://www.nationalgallery.org.uk/paintings/research/meaning-of-making/vermeer-and-technique/altered-appearance-of-ultramarine>.

45. Steadman (2001), pp. 90–100. For his scale drawings for the reconstruction of Vermeer's studio and the viewpoints he calculated, see pp. 102–103. It has been possible to identify nearly all the paintings shown on the walls of Vermeer's pictures, which may have been a part of Vermeer's selling stock, or which belonged to Maria Thins, see Weber (1998). Filipczak (2006), p. 263, points out the changes to these, which were made probably for compositional purposes. See Steadman (2001), p. 95, figs 46 and 90, for examples of matching chairs and tables with those in museums. See Shawe-Taylor (video, Google Arts and Culture) for his views on this painting.

 Montias (1989), pp. 191–193, lists some items in Vermeer's probate inventory that 'may be identical' to objects in his pictures. Liedtke (2008), pp. 105–106, looks at objects that Vermeer 'did study from life'.

46. Steadman (2001), pp. 102, 104, 119–120; see also p. 140. Sometimes Steadman's arguments are difficult to follow, because his wording suggests that the size of the virtual projection from the lens, matches almost exactly with the size of Vermeer's canvas. But it appears he means the extent of the view Vermeer chose to show. The projection from the lens must have been bigger than the part chosen by Vermeer, because the image would fade and curve towards the edges.

47. Steadman (2001), p. 86, fig. 40, and colour plates 5 and 6.

48. Liedtke (2008), pp. 185–188.

49. Steadman (2001) was unable to make architectural drawings of all the spaces shown in Vermeer's pictures, because in some there is not enough information in them to do so. He prefers to think that Vermeer worked mostly in one room, although this is not borne out by the inconsistent depictions of window and floor patterns. See pp. 64–72.

50. Wieseman (2011), pp. 4, 18, sees Vermeer's paintings as constructs, and discusses their 'plausible reality' in her book.

51. See Wadum's article in Wheelock and Broos (1995). See Kemp (1990), pp. 342–343, who explains the basis of perspective construction. McNaughton (2007), pp. 10–11.

52. See Liedtke (2008), p. 35. Wadum, in Brandenbarg and Ekkart (1996), pp. 31–49.

53. Sutton (1998), pp. 40–41.

54. A promotional film for the Prinsenhof Museum in Delft, animating important historical events, using some paintings by Vermeer and de Hooch, shows an artist 'at work'. Strings are attached to the canvas, but thereafter a veil is drawn

over the next steps in the painting process. See <https://www.youtube.com/watch?v=OlKCKWQxHhw>. However, Wadum in Wheelock and Broos (1995), pp. 69–74, provides a description of the procedure, and also a demonstration in the DVD, Gill et al. (1996).

55. See Heuer (2000), p. 89; Steadman (2001), pp. 153–155. There were treatises for artists showing how to construct drawings using geometry. Kemp (1990).

56. Wadum in Wheelock and Broos (1995), p. 72.

57. Wadum, the Frick Lecture. See the blog relating to *Tim's Vermeer* (2013) at Janson <www.essentialvermeer.com>. Here, some photographers comment that the lighting on the tiled floor is very different from that in the rest of the picture, adding to speculation that Vermeer might have constructed this painting using several different means. See also Heuer (2000).

58. Liedtke states this in an article online, in a rebuttal of Hockney's ideas: <http://www.webexhibits.org/hockneyoptics/post/liedtke.html>.

59. See Liedtke (2008), p. 20.

60. Fock (2001), pp. 83–101.

61. Mountague (1696), p. 60.

62. See <http://www.chriseckersley.co.uk/section745248.html>. Ekersley found that the tiles in Michelangelo's New Sacristy are half a *braccio* square: (29.18 cm.), suggesting a standardized size.

63. Steadman (2001), pp. 114–115.

64. Montais (1989), pp. 11–12, tells us that the stepfather of Vermeer's father owned a lute, a trombone, a shawm, two violins, and a cornet, but whether any of them would have come Vermeer's way is not clear. Wheelock and Broos (1995), p. 128, think that the bass viol, and other objects in the picture, such as the chair and wine jug, which 'are identical to those in other Vermeer paintings…were probably owned by the artist'.

65. Montias (1989), pp. 221–222.

66. Buijsen and Grip (1994), p. 334.

67. Buijsen (1996), p. 114.

68. Buijsen (1996), pp. 113, 120. Huygens was a gifted musician who composed over eight hundred works, only a few of which survive; on this point see also Wieseman (2013), pp. 15–17. Buijsen thinks this scenario possible; or that Vermeer may have seen a harpsichord at 'the home of the music lover, Cornelis Graswinckel', who was related to his principal patron, Pieter van Ruijven. We might have expected van Ruijven to own a harpsichord himself, but there is no mention of one among the musical instruments left to his daughter after his death, see Montias (1989), pp. 253–254, 359. Vermeer may have had rich and influential contacts, through his membership of the Delft Militia, who could also have owned expensive musical instruments. See the Coda in this volume.

69. For Huygens' musical interests and talents, see Legère (1994), pp. 82–86.

70. See Buijsen (1996), pp. 116–117, 119. Huygens acquired the harpsichord in 1648; it was one with 'a tailpiece', like that with the curved lid seen in *The Concert* (Fig. 10.3). We are told this instrument had 'a very sweet and lovely

harmony and has been much praised by all the music lovers'. It was made by
Johannes Couchet, a maker much admired by Huygens, who was a member
of the Ruckers family, and who had taken over the workshop.

71. Buijsen (1996), pp. 115, 118, 120, suggests that this picture, which showed a
young woman playing on the virginal, came to Duarte 'directly from Vermeer';
through Constantijn Huygens; or that Constantijn could have given it to
Duarte as a gift. But this cannot be substantiated.

Vermeer's patrons appear to have been connoisseurs, who would have been
particular about the depiction of instruments.

72. There are several paintings of church interiors with a curtain painted on a rail
at one side. Gerard Houckgeest painted the *Interior of the Oude Kerk in Delft*,
in 1654, see Westermann (2008), p. 45. See Liedtke (2000), illustration IX,
for an example by Emanuel de Witte: *A Sermon in the Oude Kerk in Delft*,
*c.*1651. Nicholas Maes also used this device in his *Eavesdropper with a scolding
Woman*, 1655. Curtains were often used to protect paintings from dust in
Dutch houses, as seen in *A Woman Reading Letter* by Gabriël Metsu,
1664–1666.

73. See Brown (1981), p. 47, for a suggestion as to how *The Goldfinch* might have
been displayed. See also Stone-Ferrier (2016).

74. Gijsbrechts (1670–1672) sold a painting of a letter rack to Balthasar de
Monconys in 1664, so we have some sort of connection here with Vermeer,
who Monconys had visited the previous year. See Koester (2000), pp. 55, 12.
Gijsbrechts is mentioned in Monconys' diary on 17 March 1664, where he
is called 'Corneille', a French variation of his first name, Cornelius. Monconys
(1666), Book 2, p. 373.

75. Wheelock (1995), p. 15.

76. See Steadman (2001), pp. 116–117, for analysis of the landscape paintings on the
lids of the instruments in Vermeer's paintings; see also Weber (1998). Buijsen
(1996), p. 120, says that the correspondence indicates that the harpsichord
Huygens bought with the help of Duarte was undecorated. See also Nicéron
(1652) whose influential treatise includes instructions on using a camera
obscura, and who was very keen on anamorphic drawing. See the illustrations
and explanations in his book.

 For an analysis of the landscapes on the walls of the rooms in Vermeer's
paintings, see Elise Goodman (2001).

77. See Williams and Kemp (2016); and Liedtke (2000), Chapter 2, pp. 39–79,
Illustrations III–IV, for a complete analysis of this painting and suggestions
as to how it could be viewed.

78. Brusati (1995), p. 159.

79. See Kemp (1990), pp. 204–205, for a full analysis of van Hoogstraten's
perspective box; see also Brown et al. (1987), pp. 60–85; Liedtke (2000),
pp. 46–50.

 The Tardis is the fictional time machine of 'Dr Who', and is bigger on the
inside than the outside.

80. Arasse (1994), pp. 69–70.
81. There is discussion as to whether or not this picture was made as a portrait. See Liedtke (2008), p. 124.
82. Gowing (1997), p. 25, has observed that 'the illusion [Vermeer] seeks is not closeness but distance'.
83. Livingstone (2002), pp. 68–73.
84. Filipczak (2006), pp. 266, 268.
85. Filipczak (2006), p. 261, points out that it was 'biologically impossible' for Vermeer to 'study the appearance of unfocussed forms' without a lens, such as you might find in a camera obscura; see also in the same volume, pp. 271–272.
86. Wheelock (2001), pp. 41, 52, talks of the *Woman in Blue Reading a Letter* (Fig. 5.4) being 'kept at a distance'.
87. See Bakker <http://www.theleidencollection.com/scholarly_essay/gerrit-dou-and-his-collectors-in-the-golden-age/>.
88. Baer et al. (2000), p. 31; Vergara (2003), pp. 209–210.
89. Baer et al. (2000), p. 39. According to Joachim von Sandrart, Dou ground his own colours on glass, and made his own brushes. He was careful to protect his materials and equipment by storing them away from dust.
90. In 1665, twenty-seven paintings by Dou appeared in a special exhibition, organized by Johan de Bye. The venue was a house rented especially for the event, just opposite the Town Hall in Leiden. See Baer et al. (2000), p. 30.
91. Marlow (2013). The relationship between Vermeer and other Dutch genre painters of his era, and the common themes in their paintings, has been explored in detail in Waiboer et al. (2017), which also includes an item by Wieseman, pp. 135–139.
92. Baer et al. (2000), pp. 31–32.
93. Wheelock in Baer et al. (2000), pp. 15–17, 21.
94. Boersma (2000), p. 61: 'The build up of [so] many layers contributes to the brilliance of Dou's surface, but it has also played a part in creating the extremely wide craquelure and wrinkling that often disrupts his surfaces.'
95. See Wheelock in Baer et al. (2000), pp. 12–24, for an essay on Dou's reputation. See also the essay by Henri Matisse, titled 'Exactitude is not truth' of 1947, in Flam (1990), pp. 117–18.
96. This painstaking approach was very time-consuming, and on a visit to his studio, the painter Joachim Sandrart reported that when he admired the care Dou had taken to paint the end of a broomstick 'no larger than a fingernail', the painter's answer was that he actually hadn't quite finished: he reckoned he still had three more days left to work on it. See Wheelock in Baer et al. (2000), p. 15.
97. Pierre Bonnard is quoted as saying this to Tériade in 1942. Terasse (1992), p. 23.
98. André Lhote (1950), p. xv: 'neither dust in the eyes nor the cruel glare of the light deters thousands of French people from their touching task of dabbing a brush set there as a snare for pictures'.
99. The Dutch landscape was maybe just as important to Vermeer in the seventeenth century as it was to another famous Dutch painter, working 250

years later. The criss-crosses of Piet Mondriaan's canvases echo the structure of his homeland, and reflect his preference for man-made constraints on nature.

100. Newton may have thought about gravity in the summer of 1666 when he left London for the country to escape the plague, but he did not publish his ideas in *Principia* until 1687. See <http://www.independent.co.uk/news/science/the-core-of-truth-behind-sir-isaac-newtons-apple-1870915.html>.

101. Gowing (1997), pp. 18–19, comments on Vermeer's 'unshakeable logic in the divisions of (his) space and surface' and 'a deliberate ordering of space and pattern' For de Chirico see Friedenthal (1963), p. 233.

102. See Wheelock (2001).

103. See Wald (2010), pp. 313–314.

104. Williams (1995), pp. 272–277.

105. Steadman (2001), p. 157.

106. Are these the *Spanish chairs* listed in the inventory? Nine red leather chairs were the property of Maria Thins, listed as part of the furniture in the Great Hall, and two were found in the studio room.

107. See Seymour (1964); and Steadman (2001), for a detailed overview of the 'photographic effects' in Vermeer's paintings.

108. Liedtke (2008), pp. 97, 182; see also Hockney (2001). Arasse (1994), pp. 69–71, discusses Vermeer pointillist effects in relation to the camera obscura. Franits (2016), pp. 74–77, in agreement with Liedtke, thinks the *pointillés* in Vermeer's paintings cannot be used as evidence that he used a camera obscura.

109. Liedtke (2000), pp. 155–156, points out that the paintings of both Willem Kalf and Gerrit Hougkgeest used similar dotted effects. See also Filipczak (2006), p. 260.

110. Personal communication with Colin Blakemore. See also Livingstone (2002).

111. Welu (1975), p. 534. Vermeer gives us an illusion of detail, but it is enough to identify the map in *Young Woman with a Water Jug* (Fig. 9.1) published by the Dutch cartographer Huyck Allart, whose engraving can be dated by the absence of a polder, known to have been constructed in 1612.

Vermeer is not the only Dutch painter of his time to depict maps in paintings, and the *Seventeen Provinces* by the cartographer, Visscher, hanging on the wall in *The Art of Painting* (Fig. 1.4) also appears in works by Nicolaes Maes and Jacob Ochtervelt. An unassembled original of this particular print (in nine separate sheets) was found only in 1962 by Albert Flocon in the Bibliothéque Nationale. This lacked the decorative town views around the sides that Vermeer shows us. See Welu (1975), p. 536.

Cartographers nonetheless have been so confident that the contours in Vermeer's paintings are accurate depictions, that they have been used as historical sources in their own right. See Alpers (1983), particularly in Chapter 4, 'The mapping impulse in Dutch Art', pp. 119–168, for the political and art historical significance of the maps in Vermeer's paintings.

112. See Weber (1998), pp. 295–307, for an analysis of Vermeer's pictures-within-pictures. The *Last Judgment* behind the *Woman Holding a Balance* (Fig. 5.5) is thought possibly to be by Jacob de Backer (1555–1585), because of the similarity of the poses of the figures in his pictures. See Janson <www.essentialvermeer. com>. See Wheelock (1995), pp. 97–99, for the significance of this theme in Vermeer's painting. Gowing (1977), p. 22, compares the pictures in the backgrounds of Metsu and Steen with those in Vermeer's work. He says that they are profoundly different, describing one in a painting by Vermeer as 'a pure visual phenomena' with a 'flat toned surface'.

 Vermeer shows *The Procuress* by van Baburen (1622) in two of his own pictures (*The Concert* (Fig 10.3) and *A Lady Seated at the Virginals* (Fig 8.3)). Liedtke (2008), p. 171, illustrates them one next to the other for comparison.

113. Wirth (2007), pp. 174 and 167–178, used an 'Experimental Historical Camera Obscura', which does not resemble the equipment available to Vermeer. He used ambient light in order to be able to see what he was painting.

 Jension (2013), and reported in writing in Jenison et al. (2016), pp. 49–85, made complex optical arrangements and a 'comparator mirror' to allow him to work in the light with colour. He has not been completely transparent about his methods, but his equipment appears to have been anachronistic; and the appearance and structure of his resultant painting does not correspond with that of Vermeer. See the extensive discussion about Jension's work in Janson's blog at <www.essentialvermeer.com>.

 Jane Morris Pack has painted inside her own camera obscura in colour. However, she had to pre-mix her paints before taking them into the booth. She has written a paper about her experiment, which can be found at <http://www.janepack.net/camera-obscura-project>.

114. We know that the first layers on Vermeer's canvases were dark. See Groen (2007), p. 204; Wheelock (1995), p. 108.

115. Groen (2007), p. 208, considers this possibility, as does Steadman (2001), p. 111.

CHAPTER 9

1. We don't know who Vermeer's models were. Could they have been the maid, or might they have been friends or family? See Binstock (2009).
2. Della Porta (1658), p. 363, suggests that your eyes need to adjust to reduced light when using a camera obscura.
3. Vermeer originally painted a chair in the foreground of this picture, but removed it later. See Wheelock (1995), p. 106; see also Fig. 10.9.
4. Obviously, apart from the movements of the model, once the composition is established, the projection does not change.
5. Wadum (1998), p. 201.
6. See Steadman (2001), p. 43, who describes this effect as 'posterization': where mid-tones are absent. Gowing (1997), p. 153, describes this picture as having 'an unarguable, unfeeling fall of light'.

7. Leonardo da Vinci suggested that to make something that is both dark and light stand out clearly, an artist could alternate the tone. We see this in the *Lady Writing a Letter with her Maid* (Fig. 2.2): where the woman's shirt is light, there is a dark wall behind it; where the wall is light, the shirt is dark. This is referred to as a 'counter-change'. Vermeer sometimes used a bright line to emphasize this effect, as in the right-hand side of the woman's skirt in *The Milkmaid* (Fig. 1.2) and the left hand side of the skirt of the *Young Woman with a Water Jug* (Fig. 9.1). See Wadum (1998), p. 207. See Kemp (1990), pp. 193–194, for a discussion of Vermeer's interest in the effects of light. Kemp (1989), pp. 97–115, for Leonardo's comments on shadows.

8. Friedenthal (1963), p. 184, Cézanne said that for the painter 'light does not exist'.

9. See Groen (2007), p. 210, who comments that if Vermeer was to have traced from a projected image, he could perhaps 'have used a brush with paint'.

10. Livingstone (2002), pp. 36–38. The part of the brain that can interpret dark and light is an older evolutionary system than the one that deals with colour, and is as 'anatomically distinct as vision from hearing'.

11. Vergara (2003), p. 208.

12. Nicéron (1652), whose title page for the volume *La Perspective Curieuse* states that it will be *'Oeuvre tres-utile aux peintres'* ('very useful to painters').

13. See Steadman (2001), pp. 4–24, for a review of the camera obscura.

14. For a translation of Barbaro, see Hockney (2001), p. 210.

15. Barbaro (1568), pp. 192–193.

16. Hilliard (1598/1992), pp. 76, 100.

17. Edward Norgate (1665–1667), (1627/1997), p. 66.

18. Smith (1692), p. 73.

19. Translation by Piernicola Ruggiero, Pisa.

20. Montias (1982), p. 284; Montias (1989), pp. 252–267. Jacob Dissius was married to Magdalena, the daughter of Pieter van Ruijven, who was Vermeer's patron. She had inherited her father's collection of paintings. Magdalena died in 1682, and her husband Jacob in 1695. Their collection of pictures, which included twenty paintings by Vermeer, was sold in an auction now known as the 'Dissius' sale on 16 May 1696.

21. See de Nave (2004) for a description of the printing process, and the presses in the Plantin-Moretus Museum, which would have been similar to those available to Jacob and his father Abraham Dissius.

 See Montias (1982), Chapter 9, pp. 272–317, for information about printers belonging to the Guild of St Luke in Delft.

22. Huerta (2003), pp. 103–104, says that from 1630–1670, The Netherlands was the 'publishing centre of the world'.

23. Blaak (2009), pp. 89–93.

24. Montias (1989), 339–344. Vermeer could have travelled to buy books.

25. Constantijn Huygens Jnr. owned books on art, including Karel van Mander's 'Schilder-boek'. Could Vermeer have borrowed any of these? Roodenburg (2006), pp. 391–392.

26. See Alpers (1983).
27. Welu (1975), p. 534, 'at the time [Vermeer] was painting, wall maps enjoyed great vogue as interior decoration'.
28. Alpers (1983), pp. 120–121.
29. Groen (2007), pp. 203, 205.
30. See Kühn (1986), pp. 201–202.
31. Cook and Dennin (1994), pp. 11, 18.
32. Swillens (1950), p. 111; Montias (1989), p. 326; See also Groen (2007), p. 203. But Wheelock (2016), p. 18, suggests that preliminary drawings may not have been valued in their own right, and were discarded by artists during the painting process.
33. When paper is oiled, it becomes heavier and stronger. See Ward (2008), p. 457.
34. Van de Wetering (2009), p. 21.
 See also <mileslewis.net/australian-building/pdf/finishes/finishes-paper. pdf> for historical uses of oiled paper. Jensen and Malter (1995), p. 253; Martin (1905), p. 13; Fahy (2003–2004), p. 253, note 31; Hicks (2007), p. 45.
35. Cennini, trans. Herringham (1930), p. 21.
36. Hyatt Mayor (1946), pp. 17, 20: 'The artist kept his eye steady…while he outlined his subject in paint or fatty crayon or soap.'
 In connection with Vermeer, Fink (1971), p. 504, lists an 'offset of the drawn image with a transferable material' as one of the possible methods of transfer of an image from a camera obscura. However, he provides neither details nor argument for its use.
37. See Wadum (1996), p. 69: Pieter Jansz. Saenredam made detailed architectural drawings possibly using perspective techniques, which he transferred to a panel by pressure with a stylus, after first rubbing the back of the paper with black chalk. See also Wadum (1995), p. 196.
38. De Mayerne in Fels (2010), p. 183.
39. Segers engraved plates and printed onto canvas, painting on top of them afterwards. He also sometimes made counterproofs, where he used one wet print to make another. See Rowlands (1979), p. 19.
40. Cornelis and van Sloten (2016), pp. 12–16. Segers invented a method we now call a *lift ground* printing technique, which was only rediscovered in the late eighteenth century. A mixture of gum arabic or sugar combined with ink, is used to compose the image on the plate. Then the wax-etching ground is applied over the whole plate, before it is put into warm water. The sugar mixture breaks down the covering ground leaving the plate exposed where the brush has been. Then the plate is put into acid to 'bite' it, making a printing plate.
41. Both oil paint and printing ink are made by combining oil with pigment, but the oil in printing ink is heated, making it much more viscous. It appears that on occasion Segers printed using coloured paint, sometimes onto a coloured ground.
 In 2016–2017 the Rembrandthuis and the Rijksmuseum/ The Metropolitan Museum of Art, New York staged shows of Hercules Segers' work. For a technical analysis of Segers' work, see Wallert in Leeflang and Roelofs (2016), pp. 141–150. Van Berge et al. (2016).

42. It is now known that Rembrandt owned at least eight of Segers' prints. An analysis of his re-working of Segers' plate, which Rembrandt probably acquired after Segers' death, can be found in Cornelis and van Sloten (2016), pp. 23–31, 34–41. Strikingly, Segers' idea to make several different 'states' of his work, was a method much used by Rembrandt as well. Some of Rembrandt's pupils: Philips Koninck, Jan Ruyscher, and Pieter de With produced prints themselves, which show parallels with Segers' work. Some of these are over-painted with washes, and in Ruyscher's case, printed in coloured paint.

43. This anecdotal description is by Samuel van Hoogrstraten in 1678, quoted in Hercules Segers Foundation/Rembrandt House Museum (2016), p. 9. See also Cornelis and van Sloten (2016), pp. 10–12.

44. For a complete report of the experiment, see Jelley (2013).

45. See the contributions by Carsten Wirth, Giuseppe Molesini, Klaus Staubermann, and Tiemen Cocquyt in Lefèvre (2007). Steadman (2002), Section 5 online, has done numerous tracings from a lens, and his recent experiments with Robert Wald have shown that images projected through a camera obscura would have been clear enough to copy from; see Wald (2010), pp. 318–319. Groen (2007), p. 210, agrees that this would have been possible.

46. See Huerta (2005), pp. 43–44.

47. Costaras (1998); Gifford (1998); Groen (2007); Groen et al. (1998); Kühn (1968); Wadum (1995); Wadum et al. (1995); and Wheelock (1995).

48. Stretchers with wedges, such as used in these experiments, were not available until the 1740s. Nearly all of Vermeer's paintings have been re-stretched (some possibly from trampoline canvases) onto strainers. See Costaras (1998), pp. 149–150.
 These canvases were made as near as possible to the same sizes as Vermeer's originals.

49. L. Cornelissen & Son of London supplied 'Fine Belgian linen of weight: 265 g/m² and with a thread count: warp: 17 thds/cm. Nm 12 preboiled linen; weft: 15.4 thds/cm. Nm 15 wetspun linen.' See Costaras (1998), p. 147, whose analysis of Vermeer's canvases, tells us that 'The thread count is often equal for warp and weft, with 14 × 14 per cm.² and 15 × 15 cm.² recurring.'

50. Van de Wetering (2009), pp. 95–6, 117–122, provides information and illustrations of the construction of trampoline canvases. Laced canvases can be seen at the Rembrandthuis. Schot and Dreu (2015), pp. 22–23, 30–31.
 The one I prepared in the studio gave equally good results to the canvases on stretchers. Using a trampoline canvas gives the opportunity to crop the image: See Wheelock (1995), p. 103; Wadum et al. (1995), p. 11.

51. The size was made with about one-part rabbit-skin glue to twenty parts water. The traditional test, to achieve the right proportions was used. This is to make the glue up, and when it has cooled to a jelly, see if it just breaks apart in the hand: Mayer (1951), p. 201. See p. 70 in this book.

It is not clear that chalk was put into the glue layer in Vermeer's *Girl with a Pearl Earring*. See Groen (2007), p. 201. Scientific analysis seems unable to confirm whether it was in the sizing or in the ground layer.

52. Cennini, trans. Herringham (1930), pp. 96, 100, 141, 235, indicates the use of a pumice stone. She translates Cennini as also suggesting using a rasp or a knife blade (*mella di cotello*) to smooth down gesso, but any blade would have to be used with great care as it could tear a canvas. De Mayerne in Fels (2010), p. 148, also mentions use of a pumice stone in the preparation of canvases for oil painting. Van de Wetering (2009), p. 129, quotes from an Italian manuscript, of *c.*1680, where a pumice stone is recommended to smooth the glue layer.

53. Wadum et al. (1995); Groen et al. (1998), pp. 169–183; Groen, Preprint 333, pp. 195–210. See also Gifford (1998), pp. 185–199. In Costaras (1998), pp. 145–164, 165, a chart gives information on the compositions of all the grounds of Vermeer's paintings. See also Kühn (1968), pp. 155–202; van Eikema Hommes (2004).

54. The proportion of chalk to pigment in the ground was not specified and so various ratios were tried and noted, using earth colours, blacks, chalk, and lead white. All the mixtures worked equally well, but varied slightly in tone and warmth. Some grounds for the canvases were matched with the known base of the paintings that were being traced in the studio. See Costaras (1998), Appendix 1, p. 165. For grinding of paint see Swillens (1950), pp. 121–127; and Mayer (1951), pp. 123–128.

For a scientific analysis of the priming layer of *Girl with a Pearl Earring*, see Groen et al. (1998), p. 170. Groen (2014), p. 21, suggests that the colour and texture of grounds 'play a role in the final effect of the painted surface'.

Vermeer may not have prepared all of his own canvases, but may have bought some of them ready made. Then he may have had to moderate them to his liking. See Levy-van Halm (1998), pp. 138–139; Costaras (1998), p. 145.

55. De Mayerne in Fels (2010), p. 137; van de Wetering (2009), p. 129; Schot and Dreu (2015), p. 25.

56. One double-layer canvas was prepared in the studio with a lower layer of red earth, chalk, and cold-pressed linseed oil. A ground of lead white and chalk was applied as a second layer, so the wait for this was even longer. See p. 75 and p. 251, n. 23, in this book. Also see Van Hout and Balis (2012), pp. 47–48 and Costaras (1998), p. 165. Double grounds were common in Rembrandt's work, see van de Wetering (2009), p. 131.

57. Costaras (1998), p. 165, lists how far the ground extends in each of Vermeer's paintings.

58. See the Suppliers of Materials in this book.

59. The painter Dou also used a glass plate and muller to grind his paint. See Baer and Wheelock (2000), p. 39, where it is suggested that the use of glass means that the colours will be pure (maybe because it is easily cleaned).

60. For the use of linseed oil see Kühn (1968), p. 173, who suggests that the medium used by Vermeer contained 'mainly oil'. Groen et al. (1998), p. 171,

report that linseed oil was used as the binding medium for *Girl with a Pearl Earring*. For a summary of the properties of linseed oil, see the glossary in Kirby et al. (2010), p. 456. De Mayerne in Fels (2010), p. 151, says that linseed oil is the best medium for oil painting. See also Wadum (1995), p. 76, who confirms that scientific investigations show that Vermeer used linseed oil.

61. Old French legal documents of about the same age as Vermeer's paintings were acquired for this experiment; these have a stamp-duty mark, and were made in Angoulême. The duty mark changed every thirty years to prevent fraud. The paper used in this experiment must have been made before 1684, the date written in script on the paper. Thanks are due to Anthony Davenport for supplying this antique paper, and for information about the Angoulême paper industry. Laid paper such as this was made throughout Europe in the seventeenth century. For a description of a paper mill contemporary with Vermeer, see Fahy (2003–2004), pp. 243–259.

62. For a description of how to oil paper, see Cennini, trans. Herringham (1930), p. 20; and Cennini, trans. Broecke (2015), p. 44.

63. Cennini states that paper made with cotton can be oiled. Shepherds Falkiners (Bookbinders) supplied paper 'RM 1790's laid', made by Ruscombe Mill, based in France. A handmade laid paper, made for repairing the endpapers of old books, it is 65 gsm, close in weight to the seventeenth-century paper acquired previously. It is made from linen and cotton, is internally sized, and unbleached. In Vermeer's time, sheets of paper would have been sized individually, in gelatine, size, or starch, to decrease the absorbency of the paper and to stop ink and colours running. See Kühn (1986), p. 199.

64. In 2017, this cost £13 per sheet.

65. In the seventeenth century, a large quantity of paper was imported to the Netherlands from Europe, and through trade routes from Japan. Rembrandt is known to have had a good collection of paper, some of them exotic, probably purchased from a paper merchant in Amsterdam. Between c.1647–1665 Rembrandt regularly used Japanese papers for his etchings. This paper is smooth and shiny, in contrast to the rougher, matt appearance of western papers. <https://www.rembrandthuis.nl/en/bezoek/tentoonstellingen/rembrandts-etchings-and-japanese-echizen-paper/>

66. McKerrow (1927), p. 105, lists Royal size as 20 × 25 inches (50.8 × 63.5 cm.). The size of handmade paper is limited to the weight and size of the deckle, which cannot be too large or heavy for the papermaker to dip and shake: (information from a personal conversation with Neil Hopkins of the Two Rivers Paper Company, Watchet, Somerset).

Even today, books are made in a format called 'Royal size'. The name comes from the use of a Royal piece of paper, folded up to make a 'signature'. See <https://en.wikipedia.org/wiki/Book_size>.

67. This 'Royal' paper was (59.5 × 46 cm.) and dated 1674 by the watermark. See also Cennini, trans. Herringham (1930), p. 24; Gaskell (1972), pp. 67–68, 73–75.

68. For dimensions of Vermeer's canvases, see Costaras (1998), p. 167.

69. As assessed *in situ* by Martin Kemp, who thought that the brightness of the projection on the board in my dim studio would not have been dissimilar to that which could have been achieved at the time.

70. Oil of spike lavender was used for this purpose.

71. Deep colours show up as just dark under the projection. It is impossible to say what hue they actually are. So nothing would stop you tracing in colours such as deep brown, blue, green, or red. Some colours were traditionally used in combination in first layers, to speed up drying. If you were transferring a tracing at a later stage than the *inventing*, then possibly you might use a colour associated with the current layer on which you were working.

72. Van Eikema Hommes (2004), pp. 11, 142. Bone black particles are about 10 microns in size, and a particle of lamp black is about 1 micron: 1/1000 mm. These two blacks found in Vermeer's paintings are both slow-drying pigments: see Pip Seymour (2003), pp. 166, 167. In the past, ivory or bone black was used in conjunction with verdigris, while lamp black (smoke black) was paired with umber to speed up drying: see Harley (1982), p. 160. See Cennini, trans. Herringham (1930), pp. 31–32.

73. See Mayer (1951), pp. 114–117, 127–130; De Mayerne in Fels (2010), p. 149, confirms that bone black has 'almost no body'.

74. Cennini, trans. Herringham (1930), Chapter 26, pp. 20–21.

75. I also tried blotting freshly made oiled paper, but it was difficult to control how much liquid I could remove.

76. An alternative was to use a thinner, which would dry quickly, like oil of spike lavender.

77. Some paint marks transferred by themselves, but those made with stick charcoal required pressure, using a wooden spoon. Marks made with ink on the oiled paper will not transfer at all once dried.

78. For some examples <http://photographyblogger.net/how-to-do-big-room-camera-obscura/>.

79. Wheelock and Kaldenbach (1982).

80. I marked the position of highlights on the oiled paper using white paint. Although you could not see this under the projection, it did not matter, because you could observe the brush marking the spot. See Jelley (2013).

81. Whereas you would rub the paint on the ground layer to make it absorbent, so it would receive a print easily; it is likely that you would not want to destroy any painting you had done at a later stage.

82. It is necessary to remember that if tracings of spots were made in white, then the lead paint would dry fast.

83. Because the oiled paper is transparent, the tracing can be righted and used as a reference drawing.

84. You could make a proof on a piece of canvas cut from a 'trampoline' canvas. Hendriks in Hermens et al. (1998), p. 237. Canvases may have been re-stretched several times during the painting process.

85. If the paint had dried, the canvas could be cleaned by abrasion.

86. This print was made the same way as the other experimental prints in this experiment. The digital photograph was projected upside down and back to front, and a tracing was made onto oiled paper. The paper was used as a plate to make a print on a prepared canvas.

87. See Steadman (2001), p. 140.

88. There is argument about whether Vermeer would have used standard size canvases or not. These came to a head with a difference of opinion between Laura Snyder (2015), pp. 156–157, and Philip Steadman: see his review of her book at <https://www.amazon.com/review/R22326DX82NKS5>.

89. Copyright Rijksmuseum, produced by 'The Amazing Card' <www.courtesy.nl>.

90. Livingstone (2002), pp. 107, 150–151, who shows us various methods by which artists convey depth, including the use of chequered tiles.

91. Wheelock (1995), p. 107: Vermeer 'consciously orchestrated his composition so that the visual bonds between elements take precedence over the logic of spatial organisation'.

92. Livingstone (2002), pp. 101–105, suggests that seeing 'the world as flat' is a help to artists working on a two-dimensional surface.

93. Steadman (2002), p. 112; Kemp (1990), p. 196; Cennini, trans. Herringham (1930), pp. 117–118; and Cennini trans. Broecke (2015), pp. 139–140, 177–178.

94. Groen (2007), p. 203.

95. This was considered by Philip Steadman. See <www.vermeerscamera.co.uk>, *Afterthoughts and a Reply to Critics*, p. 2. Steadman also briefly considered the possibility that a projection could be viewed on a screen situated in a room beyond the studio, which would have meant that a projection would be upside down, but not laterally reversed too. However, Steadman acknowledges a counter argument by Jørgen Wadum, that studies of the topography of Vermeer's house suggest there would not have been enough space for an extra room to have existed, in order for this to have been done.

96. Wirth (2007), pp. 10, 149–194, made an 'Experimental Historical Camera Obscura'.

 Tim Jenison (2013) used two mirrors and a lens to create a complex optical arrangement, which he claims Vermeer could have used. In both these cases, the suggestion is made that tracing in the camera obscura can be done in daylight.

 Some believe that lenses were not used by Vermeer at all, and that mirrors could account for some of the unusual features of his pictures. There has been a suggestion that Vermeer painted *The Art of Painting* (Fig. 1.4), using an arrangement of two mirrors, and that it actually shows the artist himself. Although there was an established pictorial convention to show a subject through a doorway, could *The Love Letter* actually be a view of a reflection? It seems unlikely, since the subjects look right handed, and the 'mirror' would have been unusually large for the time. See Nigel Konstam <http://www.verrocchio.co.uk/nkonstam/blog/2010/01/04/vermeers-method/>. See also Pénot (2010), p. 272.

97. See Hebborn (1997), pp. 116–117, for diagrammatic cross sections of an old master painting.

CHAPTER 10

1. Hockney (2001), p. 253.
2. Williams (1995), p. 274. He calls this quality 'projected visible actuality'. See also Westermann (2008), p. 43.
3. Jenison (2013), suggests in his film that Vermeer could have traced from an image over several months regardless of variable lighting conditions. The claim is made that when the sun goes behind a cloud that this 'makes no difference' since the paints are dimmed too. But what would be missing would be strength and consistency of shadows.

 Jenison's assertion is somewhat negated by the fact that he set up his experiment in the strong reliable light of San Antonio, Texas, which is very different from the conditions in Delft. He took so long to complete his picture, that his models were compelled to wear neck braces to keep their poses.
4. See Netta (2004), pp. 258–259, for a discussion of the qualities of light and the illusion of time in Vermeer's pictures.
5. Gowing (1997), pp. 20–21.
6. Groen (2007), p. 209. Wald (2010), p. 313: 'very few indications of under-drawing(s) have been detected in the work of Vermeer'.
7. Gowing (1997), p. 19.
8. Gowing (1997), p. 23. Matisse, as quoted in Flam (1990), pp. 148–149: 'The effort to see things without distortion takes something very like courage; and this courage is essential for the artist, who has to look at everything as though he saw it for the first time.'
9. See Steadman (2001), pp. 27–28.
10. Gowing 1997, p. 20, 46.
11. Hockney (2001), p. 250: a letter from Martin Kemp to David Hockney, 12 January 2000 It is a 'stunning asset for an artist, who sees how to use it'. Livingstone (2002), pp. 104–105, says that 'looking at a scene upside down (also) helps to flatten it'. See p. 202, and the discussion on the advantage of a monocular view when composing a painting.
12. One might think that this is a companion picture to *The Music Lesson*: after all, the subject, the size of the canvas, and some of the furnishings are nearly identical, and the compositions of both seem similar; both with figures who ignore our presence, positioned right at the back of the room. But these two pictures stand powerfully by themselves, and appear not to have been sold together. Experts seem keen to stress the differences between them rather than their similarities. See Liedtke (2008), p. 108; also Wheelock (1995), p. 113.
13. See Wheelock (1995), p. 118, for an analysis of the order of painting in the girl's profile.
14. See Wieseman (2013), Glossary, pp. 72–75, for information about musical instruments.
15. The skirt of the singer has lost its blue pigment and we see only the dark underpaint. Wheelock (1995), p. 118.

16. See Goldfarb (1995), pp. 92–93. *The Concert* was acquired by Isabella Stewart Gardner at auction in Paris 1892. She put a handkerchief to her face, to tell her agent when to bid for this painting. This confused the Louvre and the National Gallery in London, who both withdrew, thinking they were competing against each other. Gardner carried her prize off anonymously to her house in Boston. It was stolen along with other paintings on 18 March 1990.

In 2013, the FBI announced that they had solved this crime, but the pictures have never been recovered. There is still a five-million dollar reward for the return of *The Concert*.

See Sooke <http://www.telegraph.co.uk/culture/art/art-news/10524230/Art-theft-the-stolen-pictures-we-may-never-see-again.html>. See also Drefus (2004), a film about this theft.

17. Laurenze-Landsberg (2007), p. 216.
18. Blankert et al. (2007), p. 199.
19. Gifford (1998), p. 192.
20. For more examples see Jelley (2013), pp. 28–29. Where the tracing paint was very wet, images transferred using almost no pressure at all. Otherwise, rubbing with the hand was enough to push the paint onto the surface of the canvas. After the first print had been made, however, a wooden spoon was used for subsequent proofs, when less liquid was left on the oiled-paper 'plate'.
21. See Haag et al. (2010), pp. 194–195. The dimensions of *The Art of Painting* are 120 × 100 cm.
22. Wheelock (2010), p. 267; Wald (2010), p. 313: 'there is physical and visual evidence which shows that his compositions were very well planned before he started to paint'.
23. Williams (1995), p. 275. Wadum (1998), pp. 204–205; and Groen (2007), p. 209, both comment on Vermeer's use of *sfumato*.
24. Von Sonnenburg (1973), p. 223, who talks of 'dark halos' in the borderlines between areas of light and shadow. See Wald (2010), pp. 203, 315, 316.
25. See Chapter 7 and references to the work of Zirka Filipczak.
26. Laurenze-Landsberg (2007), p. 216. See also Groen et al. (1998), p. 171, who comments on different carbon blacks 'giving their own distinct effect'.
27. There are many kinds of black earth: see Spring et al. (2003), pp. 96–114.
28. Harley (1982), p. 157, suggests that either this refers to coal produced by opencast mining or coal transported by sea.
29. de Boogert, trans. van Dolen. See p. 240 n. 30.
30. Harley (1982), p. 158.
31. De Meyerne, in Fels (2010), p. 226, suggests that the 'best of all blacks' can be made from the 'foot' bones of sheep.
32. Norgate (1997), p. 62, suggests this. See also Harley (1982), p. 158.
33. Cennini (1930), pp. 30–31, discusses the merits of different blacks and how to make and grind them. Lamp black can be made by burning linseed oil in a lamp, and retrieving the pigment where the smoke has settled. It is a very fine,

light pigment and does not need to be ground further before being added to a medium. See also Kühn (1968), p. 174; Harley (1982), pp. 159–161.

34. See van Eikema Hommes (2004), p. 11; and de Mayerne in Fels (2010), p. 138.

35. Peacham, quoted in Harley (1982), p. 159, says that ivory black was often made from the waste of 'combe'-makers 'for a shift', implying it is not the best solution.

36. Harley (1982), p. 159. Hilliard (1992), p. 70, calls it 'veluet' (Velvet black). For obvious reasons, it is not desirable to use this pigment any longer.

37. Cennini (1930), pp. 9, 27–32; Finlay (2002), p. 112; Bucklow (2009), p. 24.

38. Mayer (1951), pp. 133–134. See a discussion online with Catherine Metzger, conservator specializing in Flemish and Italian Renaissance paintings at the National Gallery, Washington, who mentions this point. <http://www.sanders-studios.com/instruction/tutorials/historyanddefinitions/nationalgallery.html>.

39. Harley (1982), p. 160.

40. These are both made by heating lead white. At first, the pigment goes yellow making massicot; then heated to a higher temperature it changes to orange, making minium, also called red lead. With even further heating, it makes Litharge (lead monoxide). For further information on lead colours, see Harley (1982), pp. 95–98, 123–125, 166–172.

41. De Mayerne (2010), p. 138, gives directions for making a fast-drying medium to mix with the pigment using lead monoxide boiled in oil. See also the Volpato MS. in Merrifield (1999), p. 740, 748 and notes pp. ccxxxvi–ccxlv.

42. Pierre le Brun, in Merrifield (1999), p. 816.

43. De Mayerne (2010), p. 223, 233. In the *Excellency of Pen and Pencil* (1668) p. 98, the author suggests scraping the primed canvas with a knife, once it is 'strained upon (the) frame'. A knife might smooth the surface when applying a wet ground, but it is likely to abrade a dried surface. Scraping or rubbing breaks into the dried oil film, and increases its absorbency, while reducing the greasiness of the paint layer. Any *inventing* applied on top would stick better, while mistakes still could be corrected using a rag with oil or thinner. See Chapter 9, n. 52, in this book.

44. Personal conversation with Jaap Boone.

45. Liedtke (2008), p. 67, argues that the same Dutch word '*meyd*' is used in an auction catalogue of 1696 to describe this girl, and another who is very obviously a servant. Conversely, Kahr (1972), pp. 116–118, suggests that titles in auction catalogues were probably used to identify a painting rather than to explain its content.

46. De Winkel (2015), pp. 56–60. This ban was not at all successful.

47. See Wheelock (1995), pp. 39–40.

48. For an exploration of the meaning and morality of this painting, see Kahr (1972).

49. Wheelock (1977), p. 274. See Liedtke (2008), pp. 68–69.

50. On the use of neutron autoradiography for the analysis of paintings by Vermeer, see Ainsworth (1997), pp. 18–26, in particular, plate 10a, p. 23. See also Blankert et al. (2007), pp. 181–182, and Laurenze-Landsberg (2007), p. 211.

51. See Ainsworth (1997), p. 102. The leaves showed the presence of copper. This could possibly come from some azurite. Copper-based pigments were traditionally used in combination with bone black to speed up drying.
52. See Jelley (2013), p. 42.
53. Jelley (2013), p. 29.
54. Groen et al. (1998), p. 172. It is possible that the red on the coat has faded. Traces of lake pigment were found here.
55. Wheelock (1995), p. 166; Groen (2007), p. 204. For further discussion of Vermeer's use of glazes over underpainting see Franits (2001), p. 21, and Wheelock (2001), p. 47.
56. Jelley (2013), p. 40.
57. Wadum et al. (1995), p. 23.
58. See Arasse (1994), p. 71.
59. Ducos in Cottet and Cottet (2016) 1'12"–13'22".... (this is) 'a retrospective idea expounded by 20th century art historians, with a fondness for technology'. However, Kemp (2007), pp. 243, 246, comments on the denial of some experts faced with strong evidence of Vermeer's use of optics.
60. Pénot (2010) does not think this argument will ever be resolved, p. 278.
61. Robert Wald (2010), does think, however, that Vermeer could have 'selectively combined techniques to achieve aesthetic goals', p. 312, and 'seems to have referenced both mechanical (perspective) theories and optical devices' in *The Art of Painting* (Fig. 1.4), p. 316.
62. See Vergara (2003), p. 208.
63. There is a suggestion that some things are at different scales, see Westermann (2008), p. 43. This could occur if a picture was composed of a composite view of elements, studied on different occasions, and then put together.
64. As discussed, Vermeer may have had to travel to be able to include expensive accoutrements such as musical instruments or a chandelier. See Broos (1995), p. 51; also Huerta (2003), p. 105.
 See Chapter 8 in this book.
65. Schneider (2004), p. 88.
66. See Westermann (2008), p. 38.
67. Kemp (2007), p. 246 who refers to David Hockney looking for visual evidence of the use of optical devices by painters, which included the 'obvious cases, like Vermeer'.
68. See Wadum (1995), pp. 67–79; also Wald (2010), pp. 314–316.
69. Gowing (1977), pp. 24, 138.
70. See Fink (1971), pp. 504–505; Kemp (1990), p. 196, who outlines a scenario with the artist using a camera obscura, and suggests that it would not be 'such as to produce a "mindless" or mechanical image, but necessitates a controlled series of aesthetic choices at every stage'.
71. See Wheelock (2016), p. 18, who comments on the difficulties of interpreting infrared reflectograms The images in Fig. 10.9 were all provided by The Metropolitan Museum of Art, New York. It is difficult to know what precisely

we are seeing here, but it appears that Vermeer started his picture using 'patches of light and dark' as described by Westermann (2008), p. 38. Wheelock (1995), pp. 106–111, made an analysis of this picture and of infrared reflectograms. In his patchwork of images, we can also see part of the jug; and the table, lit strongly at its edge. Wheelock says 'it seems apparent that Vermeer, from the early stages of the creative process, was thinking of patterns of light and shade as well as the arrangement of form'. Since Vermeer appears to have been brushing in shapes with a dark paint, it is reasonable to assume that very light spaces are made by leaving the 'greyish white' ground untouched, as he did when roughing out other pictures. See Costaras (1998), p. 165, who tells us that the ground is made from 'lead white, chalk and umber'.

CODA

1. See Blankert et al (2007), pp. 164–166, regarding Bleyswijck's book on Delft and the poem by Arnold Bon. Dirck van Bleyswijck's *Beschryving der Stadt Delft* (Description of the City of Delft), was published in 1667. See also <www.essentialvermeer.com>.
2. For a discussion of Vermeer's reputation, see Arasse (1994), pp. 12–13; 104, note 5; 107, note 31. See p. 243, note 66 in this volume.
3. For a review of Vermeer's clients and patrons, see Montias (1989), pp. 246–262.
4. See Runia and van de Ploeg (2005), p. 28; Noble et al. (2009), p. 159.
5. Arnold Houbraken's book titled *Groote Schouburgh der Nederlantsche Kindstschilders en Schileressen* hardly makes mention of Vermeer. See Blankert et al. (2007), p. 166.
6. See Broos (1996), pp. 47–51.
7. See Kaldenbach <https://kalden.home.xs4all.nl/>; Montias (1989), p. 364.
8. Thoré also rediscovered Fabritius' *The Goldfinch* (Fig. 2.4). See Bailey (2001), pp. 218–221. Buijsen (2010), pp. 54–57.
9. Montais in Gaskell and Jonker (1998), pp. 100–101, comments on information provided by Jan van der Waals, who found an entry with Vermeer's name in the records of the civic guard in Delft. Montias suggests that membership of the militia 'must have' given Vermeer good social connections, bringing him into contact 'with rich collectors who were potentially his clients'.
10. Another self-portrait in a glass sphere: *A Vanitas*, 1666–1700, by Pieter Gerritz. van Roestraten (*c*.1631–1700), was discovered quite recently under the dust of ages in Highgrove House, home of Prince Charles and Camilla, Duchess of Cornwall. See Reynolds et al. (2016), pp. 170, 186. They say 'reflected self-portraits have been identified in at least nine of Roestraten's still lifes'.
11. See Buijsen (2012), pp. 14–22. This is not the only time that Clara Peeters shows herself in her work. See Vergara (2015), pp. 68, 106, for other examples, including one with multiple self-portraits in the bosses of a drinking cup.

Other seventeenth-century Dutch painters showed their reflection in still lifes, e.g. Vincent Laurenze van der Vinne and Simon Luttichuys. See Brusati (1990–1991), pp. 168–182.

12. See Arasse (1994), pp. 74–75.

13. Personal communication with Philip Steadman.

14. In 1921, the critic Jean-Louis Vaudoyer wrote an appreciation of an exhibition at the Jeu de Paume, Paris, in which he suggested that Vermeer was intensely secretive, see Arasse (1994), p. 96: '[Vermeer] hides all that he knows, all that he does'.

SUPPLIERS OF MATERIALS

The materials for this experiment came from many places. Some were purchased from specialist suppliers, and a few were processed at home. Pigments in particular can vary according to their source and method of manufacture, and from batch to batch. It is no surprise to find that the colours are not necessarily consistent.

Casa Hernanz, cl Toledo, 18.28005 Madrid, Spain: Linen string for the trampoline canvas.

Zecchi, Via dello Studio, 19/R- 50122 Firenze, Italy. <http://www.zecchi.it/>: Cochineal beetles, arzica (weld), smalt, verdigris, bone white, malachite, azurite, ultramarine ashes, fresco brushes.

Ditta G.Poggi, Via del Gesu, 74/75-00186, Roma, Italy. <http://www.poggi1825. it/>: Carmine red (rosso laccato francia).

Arcobaleno, San Marco, 3457, 30124, Venezia, Italy. pigmenti3457@gmail.com: Red earth, yellow ochre, natural umber, fresco brushes.

L. Cornellison & Son, 105 Great Russell Street, London WC1B 3RY, UK. <https:// www.cornelissen.com/>: Lead white, bone black, lamp black, lapis lazuli, madder, massicot (lead yellow), natural indigo, cold pressed linseed oil, linen canvas, glass muller, brushes in quills.

Sennelier, 3 Quai Voltaire, 75007 Paris, France. <http://www.sennelier.fr/>: Earth colours. Leaflets from Terres et Couleurs. <http://www.terresetcouleurs.com>.

Wallace Seymour Fine Art Products Ltd., Unit 1 B Cragg Hill Industrial Estate, Cragg Hill Road, Horton in Ribblesdale Settle, North Yorkshire BD24 0HN, UK. info@wallaceseymour.co.uk: Smalt in oil, Brecon sinopia, sanguine.

de Kat, Kalverringdijk 29, 1509BT ZAANDAM, The Netherlands. <https://www.verfmolendekat.com/en/webshop/pigments/>: Fine chalk, azurite, black earth, ochres and siennas, Italian green earth.

Green & Stone, 259 Kings Road, Chelsea, London SW3 5EL, UK. <http://www. greenandstone.com/>: Rabbit-skin glue.

Great Art, Normandy House, 1 Nether Street, Alton, Hampshire, 1EA. <www.greatart. co.uk>: Stretchers.

Alec Tiranti, 27 Warren Street, London W1T 5NB, UK. <http://www.tiranti.co.uk/>: Chalk.

Shepherds Falkiners, 30 Gillingham St, Pimlico, London SW1V 1HU, UK.
<http://store.bookbinding.co.uk/store/>: Paper (RM 1790's laid 65gsm 680 ×
510 mm. natural).

Anthony Davenport Prints, Abingdon, Oxfordshire, UK: Antique paper.

M Feller, Son & Daughter, 54-55, The Oxford Covered Market, Oxford OX1 3DY,
UK. <http://www.mfeller.co.uk/>: Pigs' bladders.

BIBLIOGRAPHY AND FURTHER READING

Further information related to this book can be found at
<www.tracesofvermeer.com>.

Ainsworth, Maryan W., *Art and Autoradiography: Insights into the Genesis of Paintings by Rembrandt, Van Dyck, and Vermeer*. (London and New Haven: Yale University Press, 1997).

Alberti, Leon Battista *On Painting* (1435), trans. Cecil Grayson, Introduction and notes by Martin Kemp. (London: Penguin Books, 1991).

Albus, Anita, *The Art of Arts*, trans. Michael Robertson. (New York: Alfred A. Knopf, 2000).

Alpers, Sveltlana, *The Art of Describing: Dutch Art in the Seventeenth Century*. (Chicago: University of Chicago Press, 1983).

——, *Rembrandt's Enterprise: The Studio and the Market*. (London: Thames and Hudson, 1988).

Anderson, Douglas, *Lens on Leeuwenhoek* <http://lensonleeuwenhoek.net/>.

Anonymous, *The Excellency of the Pen and Pencil*. (London: Radcliffe and Daniel, 1668).

Anonymous (JF), *The Plain-dealing Linen Draper: Shewing how to buy all sorts of Linnen and Indian goods*. (London: John Sprint at the Bull and George Conyers at the Golden Ring in Little Britain, 1695).

Arasse, Daniel, *Faith in Painting*. (Princeton: Princeton University Press, 1994).

Armenini, Giovanni Battista (1533?–1609), *On the True Precepts of the Art of Painting* (1587), trans. Edward J Olszewski. (New York: B. Franklin, 1977).

Aynsley, Jeremy, and Charlotte Grant (eds), with Harriet McKay, *Imagined Interiors: Representing the Domestic Interior since the Renaissance*. (London: V&A publications, 2006).

Ayres, James, *The Artist's Craft, A History of Tools, Techniques and Materials*. (Oxford: Phaidon 1985).

Baer, Ronni, 'The Life and Art of Gerrit Dou', in Baer and Wheelock (eds), (2000).

——, and Arthur K. Wheelock, Jr. (eds), *Gerrit Dou 1613–1675: Master Painter in the Age of Rembrandt*, with contributions by Arthur K. Wheelock and Annetje Boersma. (London and New Haven: Yale University Press, 2000).

Baer, Ronni, et al., *Class Distinctions, Dutch Paintings in the Age of Rembrandt and Vermeer*. (Boston: MFA Publications, 2015).

Bailey, Anthony, *Rembrandt's House: The World of the Great Master*. (London: J. M. Dent and Sons, 1978).

——, *Vermeer: A View of Delft*. (London, Chatto and Windus, 2001).

Balfour-Paul, Jenny, *Indigo*. (London: British Museum Press, 1998).

Bakker, Piet, 'Gerrit Dou and his Collectors in the Golden Age', <http://www.theleidencollection.com/scholarly_essay/gerrit-dou-and-his-collectors-in-the-golden-age/>.

Ball, Philip, *Bright Earth: The Invention of Colour*. (London:Viking books, 2001).

Barbaro, Daniele, *La Pratica Della Perspettiva*. (Venice, 1568).

Barber, Tabitha, with Mary Bustin, *Mary Beale: Portrait of a Seventeenth-Century Painter, her Family and her Studio*. (London: Geffrye Museum Trust, 1999).

Barrett, Sylvana, and Dusan C. Stulik, 'An Integrated Approach for the Study of Painting Techniques', in Wallert et al. (eds), (1995).

Beale, Charles, *Diary and Notebook, 1671*. Bound and interleaved with a copy of *Merlini Anglici Ephemeris*, by William Lilly (1602–1681). (London: 1644). Bodleian Library, Oxford. 8° Rawl. 572.

——, *Diary and Notebook, 6 January 1680–31–December 1681*. MS 18. 1 vol. (146 leaves): 18 cm. Bound and interleaved with a copy of *Merlini Anglici Ephemeris*, by William Lilly. (London: Printed by J. Macock for the Company of Stationers, 1681). National Portrait Gallery Heinz Archive, typed transcript by Richard Jeffree (c.1975).

Berger, Ernst, *Notes on the De Mayerne MS*, trans. R. Bedell, in Fels (2010).

Binstock, Benjamin, *Vermeer's Family Secrets: Genius, Discovery, and the Unknown Apprentice*. (London and New York: Routledge, 2009).

Blaak, Jeroen, *Literacy in Everyday Life: Reading and Writing in Early Modern Dutch Diaries*, trans. Beverley Jackson, Egodocuments and History Series, vol. 2. (Boston and Leiden: Brill 2009).

Blankert, Albert, *Vermeer of Delft*. (Oxford: Phaidon, 1978).

——, John Michael Montias, and Gilles Aillaud, *Vermeer*. (London and New York: Overlook Duckworth 2007).

——, 'Vermeer's Work', in Blankert et al. (2007).

Bleyswijck, Dirck van, *Beschryving der Stadt Delft* (Description of the City of Delft), 2 vols. (Delft: Arnold Bon, 1667).

Boersma, Annetje, 'Dou's Painting Technique: An Examination of Two Paintings', in Baer and Wheelock (eds), (2000).

Bok Marten Jan, 'Not to be Confused with the Sphinx of Delft: The Utrecht Painter Johannes van der Meer (Schipluiden 1630–1695/97 Vreeswijk?)', in Gaskell and Jonker (1998).

——, 'Society, Culture and Collecting in Seventeenth-Century Delft', in Liedtke (2001).

Bolton, Sarah K., *Famous Artists*. (Edinburgh, London, and New York: T. Nelson and Sons, 1892).

Bomford, David, Jo Kirby, Ashok Roy, Axel Rüger, and Raymond White, *Art in the Making: Rembrandt*. (London: National Gallery Company Ltd., 2006).

——, with Jill Dunkerton and Martin Wyld, *A Closer Look: Conservation of Paintings*. (London: National Gallery Company Ltd., 2009).

——, and Ashok Roy, *A Closer Look: Colour*. (London: National Gallery Company Ltd., 2009).

Bonafoux, Pascal, *Rembrandt: Substance and Shadow*. (London: Thames and Hudson, 1992).

Boyle, Robert, *Of the Cosmicall Quality of Things*. (Oxford, 1671).

Brandenbarg, Ton and Rudi Ekkart (eds), (1996), *The Scholarly World of Vermeer*. (The Hague: Museum van het Boek, 1996).

Braque, Georges, *Illustrated Notebooks 1917–1955*, trans. Stanley Appelbaum. (New York: Dover, 1971).

Broecke, Lara, *Cennino Cennini's Il Libro dell' Arte: A new English translation and commentary with Italian transcription*. (London: Archetype Publications, 2015).

Broeke, Johan Ten, Arno van Sabben, and Richard Woudenberg, *Antique Tiles*. (The Hague: van Sabben, 2000).

Brook, Timothy, *Vermeer's Hat: The Seventeenth Century and the Dawn of the Global World*. (London: Profile Books, 2008).

Broos, Ben, 'Un celebre Peijntre nommé Verme(e)r', in Wheelock and Broos (eds), (1995).

Brown, Christopher, *Carel Fabritius*. (Oxford: Phaidon, 1981).

——, 'The strange case of Jan Torrentius: Art, Sex, and Heresy in Seventeenth-Century Haarlem', in Susan Scott (ed.), (1997).

——, David Bomford, Joyce Plesters, and John Mills, *Samuel van Hoogstraten: Perspective and Painting. National Gallery Technical Bulletin*, vol. 11. (London: National Gallery, 1987).

——, Jan Kelch, and Pieter van Thiel, *Rembrandt: The Master and his Workshop: Paintings*. (London and New Haven: Yale University Press, 1991).

Brusati, Celeste, 'Stilled Lives: Self-Portraiture and Self-Reflection in Seventeenth-Century Netherlandish Still-Life Painting', in *Simiolus: Netherlands Quarterly for the History of Art*, vol. 20, nos 2/3 (1990–1991).

——, *Artifice and Illusion: The Art and Writing of Samuel van Hoogstraten*. (University of Chicago Press: 1995).

Bucklow, Spike, 'Processes and Pigment recipes: Natural Ultramarine', *Zeitschrift für Kunsttechnoligie und Konservierung*, vol 20, no. 2 (2006).

——, *The Alchemy of Paint: Art, Science and Secrets from the Middle Ages*. (London: Marion Boyars, 2010).

——, *The Riddle of the Image: The Secret Science of Medieval Art*. (London: Reaktion Books, 2014).

——, *Red: The Art and Science of a Colour*. (London: Reaktion Books, 2016).

Buijsen, Edwin, with a contribution by Geerte Broersma, *The Young Vermeer*. (Zwolle: Waanders Publishers, 2010).

——, 'Clara's Cheeses', *Mauritshuis in Focus*, vol. 25, no. 2 (2012).

Buijsen, Edwin, "Music in the age of Vermeer" in Haks and van der Sman (eds) (1996).
——, and Louis Pieter Grip (eds), *Hoogsteder Exhibition of Music and Painting in the Golden Age*. (Zwolle: Waanders Publishers, 1994).
Buning, Robin, 'An Unknown Letter from Henricus Reneri to Constantijn Huygens on the Themometer and the Camera Obscura', *Lias: Journal of Early Modern Intellectual Culture and its Sources*, vol. 37, no. 1 (2010).
——, 'Henricus Reneri (1593–1639) Descartes' Quartermaster in Aristotelian Territory', unpublished PhD Thesis presented at the University of Utrecht (2013), <www.academia.edu/5093352>.
Butler Greenfield, Amy, *A Perfect Red: Empire, Espionage and the Quest for the Colour of Desire*. (London: Black Swan, 2006).
Buvelot, Quentin, 'Scenes of Everyday life: Some Reflections on Dutch Genre Painting in the Seventeenth Century', in Shawe-Taylor and Buvelot (2015).
——, 'The Food of Love', in Waiboer et al. (2017).
——, 'Under the Influence', in Waiboer et al. (2017).
Campbell, Lorne, Susan Foister, and Ashok Roy (eds), *Materials and Methods of Northern European Painting: National Gallery Technical Bulletin*, vol. 18. (London: National Gallery, 1997).
Carlyle, Leslie, 'Beyond a Collection of Data: What we can Learn from Documentary Sources on Artists' Materials and Techniques', in Wallert et al. (eds) (1995).
——, *The Artist's Assistant: Oil Painting Instruction Manuals and Handbooks in Britain 1800–1900*. (London: Archetype Publications, 2001).
Cennini, Cennino (c.1398), *Il libro dell' Arte o Trattato della Pittura*, trans. Christiana J. Herringham, *The Book of the Art of Cennino Cennini*. (London: George Allen & Unwin, 1930); trans. Daniel V. Thompson Jr., *The Craftsman's Handbook, 'Il Libro dell' Arte', Cennino d' Andrea Cennini*. (London and New Haven: Yale University Press, 1933); trans. Lara Broecke, *Cennino Cennini's Il Libro dell' Arte: A new English translation and commentary with Italian transcription*. (London: Archetype Publications, 2015).
Chalumeau, Jean-Luc, *Jan Vermeer*. (Barcelona: Ediciones Polígrafa, 2002).
Chapman, H. Perry, Wouter Th. Kloek, and Arthur Wheelock, *Jan Steen: Painter and Storyteller*. (Amsterdam and Washington: National Gallery of Art, Washington/Rijksmuseum, 1997).
Chenciner, Robert, *Madder Red, a History of Luxury and Trade: Plants Dyes and Pigments in World Commerce and Art*. (Richmond: Curzon Press, 2000).
Clark, Kenneth, *Landscape into Art*. (London: Penguin Books, 1961).
Cocquyt, Tiemen, 'The Camera Obscura and the Availability of Seventeenth-Century Optics—Some Notes and an Account of a Test', in Lefèvre (ed.), 2007.
Colie, Rosamund, *Some Thankfulnesse to Constantine*. (The Hague: Martin Nijhoff, 1956).
Cook, Paul, and Julia Dennin, 'Ships plans on oil and resin impregnated tracing paper', *The Paper Conservator: Journal of the Institute of Paper Conservation*, vol. 18, no. 2 (1994).

Cook, Peter, 'What, Why and How? The Technical examinations of paintings explained', in Sheldon, Cook, and Streeton (2007).

Coremans, Paul, *Van Meegeren's Faked Vermeers and de Hooghs: A Scientific Examination*, trans. A. Hardy and C. M. Hutt. (London: Cassell and Company, 1949).

Cornelis, Mireille, 'Hercules Segers: An Introduction to his Life and Work' in van Berge and de Koekkeok (2016).

——, and Leonore van Sloten, 'Under the Spell of Hercules Segers: Rembrandt and his Pupils', in van Berge and de Koekkeok (2016).

Costaras, Nicola, 'A Study of the Materials and Techniques of Johannes Vermeer', in Gaskell and Jonker (1998).

Cottet, Jean-Pierre, and Guillaume Cottet, *Vermeer, the Sphinx of Delft* (DVD). Arte Editions, Musée du Louvre (2016).

de Boogert, *Colour Treatise*. Aix-en-Provence, 1692. Bibliothèque Municipale/ Bibliothèque Méjanes, MS 1389 (1228), <http://www.e-corpus.org/notices/ 102464/gallery/>.

de Mayerne, Sir Theodore Turquet (1573–1655), *B.M. Sloane 2052*. (See Fels).

de Nave, Francine, and Leon Voet, *Plantin-Moretus Museum Antwerp*. (Amsterdam and Ghent: Ludion, 2004).

de Vries, Lyckle, *How to Create Beauty: De Lairesse on the Theory and Practice of Making Art*. (Leiden: Primavera Press, 2011).

de Winkel, Marieke, 'Costume in Rembrandt's Self-Portraits', in White and Buvelot (1999).

——, 'Ambition and Apparel', in Baer (2015).

Dekker, Rudolf, *Childhood, Memory and Autobiography in Holland from the Golden Age to Romanticism*. (London: Macmillan Press, 2000).

Delamare, François, *Blue Pigments: 5000 Years of Art and Industry*. (London: Archetype Publications, 2013).

——, and Bernard Guineau, *Colour: Making and Using Dyes and Pigments*. (London: Thames and Hudson, 2000).

Delfia Bavatorum, *Story of Delft*. (Delft: Delft Bavatorum Historical Society, 2014).

della Porta, Giovanni Battista (John Baptist), *Natural Magick*. First published in English by Thomas Young and Samuel Speed (1658); Facsimile edition: (London and New Haven: Yale University Press/Basic Books, 1957).

Dent Weil, Phoebe, and Sarah Belchetz-Swenson, 'Technical Art History and Archeometry III: An Exploration of Rembrandt's Painting and Drawing Techniques', *Revista Brasileira de Arqueometria Restauração e Conservação*, vol. 1, no. 6 (2007).

Dijksterhuis, Fokko, J., 'Labour on Lenses: Isaac Beeckman's notes on lens making', in Albert van Helden et al., *Origins of the Telescope*. (Amsterdam: Royal Netherlands Academy of Arts and Sciences, 2010).

Dobell, Clifford, *Antony van Leeuwenhoek and his 'Little Animals'*. (London: Staples Press, 1932).

Dreyfus, Rebecca, *Stolen* (DVD). USA, Persistence of Vision Films (2004).

Ducos, Blaise, and Dominique Surh, *Masterpieces of the Leiden Collection*. (Paris: Musée du Louvre, 2017).

Eckersley, Chris, <http://www.chriseckersley.co.uk/section745248.html>.

Ekirch, Roger, *At Day's Close: A History of Nighttime*. (London: Orion Books, 2005).

Elkins, James, *What Painting Is*. (Abingdon: Routledge, 1999).

Evelyn, John (1620–1706), *Diary* (ed.), *Guy de la Bédoyère*. (Woodbridge: The Boydell Press, 1999).

Eyb-Green, Joyce Townsend, Mark Clark, Jilleen Nadolny, and Stefanos Kroustallis, *The Artist's Process: Technology and Interpretation*. (London Archtype Publications, 2012).

Fahy, Conor, 'Paper Making in Seventeenth-Century Genoa: The Account of Giovanni Domenico Peri (1651)', in *Studies in Bibliography*, vol. 56. (Charlottesville: Bibliographical Society of the University of Virginia, 2003–2004).

Feller, Robert L. (ed.), *Artists' Pigments—A Handbook of Their History and Characteristics*, vol. 1. (New York, Oxford: NGA Washington, 1986).

Fels, Donald. C. Jr., *Lost Secrets of Flemish Painters: Including the First Complete English Translation of the De Mayerne Manuscript (B. M. Sloane 2052)*. (Eijsden, The Netherlands: Alchemist Publications, 2010).

Filipczak, Zirka Z., 'Vermeer, Elusiveness and Visual Theory', *Simiolus: Netherlands Quarterly for the History of Art*, vol. 32, no. 4 (2006).

Fink, Daniel, 'Vermeer's use of the camera obscura—a comparative study', *The Art Bulletin*, vol. 53, no 4 (1971).

Finlay, Michael, *Western Writing Implements in the Age of the Quill Pen*. (Carlisle: Pen and pencil facsimile edition of Plains books, 1990).

Finlay, Victoria, *Colour: Travels through the Paintbox*. (London: Hodder & Stoughton, 2002).

Flam, Jack, *Matisse on Art*. (Oxford: Phaidon, Third edition, 1990).

Fock, C. Willemijn, 'Semblance or Reality? The Domestic Interior in Seventeenth-Century Dutch Genre Painting', in Mariët Westermann (ed.), (2001).

Ford, Brian J., *Single Lens: The Story of the Simple Microscope*. (London: William Heinemann Ltd., 1985).

——, *The Leeuwenhoek Legacy*. (London: Farrand Press, 1991).

——, 'Surprise of the Century-Three more Leeuwenhoek Microscopes', *Microscopy Today* (November 2015).

Franits, Wayne E., 'Johannes Vermeer: An Overview of his Life and Stylistic Development', in Franits (ed.), (2001).

——, (ed.), *The Cambridge Companion to Vermeer*. (Cambridge: Cambridge University Press, 2001).

——, *Vermeer*. (London: Phaidon Press, 2015).

Freedberg, David, and Jan de Vries (eds), *Art in History/History in Art: Studies in Seventeenth-Century Dutch Culture*. (Los Angeles: Getty Press, 1991).

Friedenthal, Richard, *Letters of the Great Artists: From Blake to Pollock*. (London: Thames and Hudson, 1963).

Gaskell, Ivan, and Michiel Jonker (eds), *Vermeer Studies: Symposium Papers XXXIII*. Center for Advanced Study in the Visual Arts, History of Art Series, no. 55, National Gallery of Art, Washington. (London and New Haven: Yale University Press, 1998).

Gaskell, Philip, *A New Introduction to Bibliography*. (Oxford: Oxford University Press, 1972).

Gerard, John, *The Herball, or General Historie of Plants*. (London: E. Bollifant, for B. and I. Norton, 1597).

Gifford, E. M., 'Painting light: Recent Observations on Vermeer's Technique', in Gaskell and Jonker (1998).

Gill, Michael, Melvyn Bragg, and Andrea Stretton, *Jan Vermeer, Light, Love and Silence*. LWTP: Malone Gill Productions (1996).

Goedings, Truusje, and Karin Groen, 'Dutch Pigment Terminology I: A seventeenth-century explanation of the word "schulpwit"'; and 'Dutch Pigment Terminology II: "schiet" yellow or "schijt" yellow?', *Hamilton Kerr Institute Bulletin*, 2 (1994).

Golahny, A., M. M. Mochizuki, and L. Vegara, *In His Milieu: Essays on Netherlandish Art in Memory of John Michael Montias*. (Amsterdam University Press, 2007).

Goldfarb, Hilliard T., *The Isabella Stewart Gardner Museum: A Companion Guide and History*. (London and New Haven: Yale University Press, 1995).

Goodman, Elise, 'The Landscape on the Wall in Vermeer', in Franits (2001).

Gordenker, Emilie E. S., *Directors Choice, Mauritshuis* (English edition). (London: Scala Arts and Heritage, 2014).

Gowing, Lawrence, *Vermeer* (1952). (Third edition, London: Giles de la Mare, 1997).

Grabsky, Phil, *Girl with a Pearl Earring and other treasures from the Mauritshuis* (DVD). London, Seventh Art Productions (2015).

Graham-Dixon, Andrew, *The Secret Lives of the Artists: The Madness of Vermeer* (DVD). BBC films (2003).

Grijzenhout, Frans, *Vermeer's Little Street: A View of the Penspoort in Delft*. (Amsterdam: Rijksmuseum, 2015).

——, and Niek van Sas, *The Burgher of Delft*. (Amsterdam: Rijksmuseum, 2006).

Grip, Louis Pieter, 'Dutch Music of the Golden Age', in Buijsen and Grip (eds), (1994).

Groen, Karin M., 'Earth Matters: The Origin of the Material used for the Preparation of the *Night Watch* and many other canvases in Rembrandt's workshop after 1640', *Art Matters*, vol. 3 (2005).

——, and Ella Hendriks, 'Frans Hals: A Technical Examination', in Seymour Slive (1989).

——, 'Painting Technique in the Seventeenth Century in Holland and the Possible Use of the Camera Obscura by Vermeer', in Lefèvre (ed.), (2007).

——, *Paintings in the Laboratory*, ed. Esther van Duijn. (London: Archtype Publications, 2014).

Groen, Karin M., Inez D. van de Werf, Klaas Jan van den Berg, and Jaap J. Boon, 'Scientific examination of Vermeer's Girl with a Pearl Earring', in Gaskell and Jonker (1998).

Haag, Sabine, Elke Oberthaler, and Sabine Pénot (eds), *Vermeer: Die Malkunst*. (Vienna: Kunsthistorisches Museum, 2010).

Haks, Donald, and Marie Christine van der Sman (eds), *Dutch Society in the Age of Vermeer*. (Zwolle: Waanders Publishers/The Hague Historical Museum, 1996).

Hale, Philip, *Vermeer*. (Boston: Hale, Cushman and Flint, 1937).

Hammond, J., *The Camera Obscura: A Chronicle*. (Bristol: Adam Hilger, 1981).

Harley, R. D., *Artist's Pigments, c.1600–1835: A Study in English Documentary Sources*. (London: Archetype Publications, Second edition, 1982).

——, 'Artists Brushes: Historical evidence from the sixteenth to the nineteenth century', in *Conservation of paintings and the graphic arts: Contributions to the 1972 IIC Congress, Lisbon, 1972*. (London: International Institute for Conservation of Historic and Artistic works, 1972).

Harris, Lawrence Ernest, *The Two Netherlanders: Humphrey Bradley and Cornelis Drebbel*. (Cambridge: W. Heffer and Sons, 1961).

Hebborn, Eric, *The Art Forger's Handbook*. (London: Cassell, 1997).

Hell, Maarten, Emma Los, and Norbert Middelkoop, with contributions by Tom van der Molen and Paul Spies, *Portrait gallery of the Golden Age*. (Amsterdam: Heleen van Ketwich Verschuur, 2014).

Helm-Clark, C. M., *Medieval Glues up to 1600 CE*, <http://www.rocks4brains.com/glue.pdf>.

Hendriks, Ella , 'Johannes Cornelisz. Verspronck. The Technique of a Seventeenth Century Haarlem Portraitist', in Hermens et al. (1998).

Herbert, Zbigniew, *Still Life With a Bridle*. (Hopewell: Ecco Press, 1991).

Hermens, Erma, with Annemiek Ouwerkerk and Nicola Costaras, *Looking Through Paintings: The Study of Painting Techniques and Materials in Support of Art Historical Research*. (London: Archetype Publications, 1998).

——, and Airie Wallert, 'The Pekstok Papers: Lake Pigments, Prisons and Paint-mills', in Hermens et al. (1998).

Herringham, Christiana J., *The Book of the Art of Cennino Cennini*. (London: George Allen & Unwin, 1930).

Herrisone, Rebecca, and Alan Howard (eds), *Concepts of Creativity in Seventeenth-Century England*. (Woodbridge: The Boydell Press, 2013).

Heuer, Christopher, 'Perspective as Process in Vermeer', *Anthropology and Aesthetics*, no 38 (Autumn 2000).

Heyden, Anne C., and Rob H. van Gent, 'The Lens Production by Christiaan and Constantijn Huygens', *Annals of Science*, vol. 56 (1999).

Heydenreich, Gunnar, 'The Colour of Canvas: Historical Practices for Bleaching Artists' Linen', in Townsend et al. (2008).

Hicks, Carola, *Girl in a Green Gown: The History and Mystery of the Arnolfini Portrait*. (London: Chatto and Windus, 2011).

Hicks, Carola, *The King's Glass: A Story of Tudor Power and Secret*. (London: Chatto and Windus, 2007).

Hilliard, Nicholas (1598), *The Arte of Limning*, ed. R. K. R. Thornton and T. G. S Cain. (The Mid Northumberland Arts Group, UK: Carcanet Press, 1992).

Hills, Richard L., *Power from Wind: A History of Windmill Technology*. (Cambridge: Cambridge University Press, 1994).

Hockney, David, *Secret Knowledge: Discovering the Secrets of the Old Masters*. (London: Thames and Hudson, 2001).

——, 'The mass media has lost its perspective', *Financial Times*, 26th October (2012).

Huerta, Robert D., *Giants of Delft: Johannes Vermeer and the Natural Philosophers, the Parallel Search for Knowledge during the Age of Discovery*. (Lewisburg: Bucknell University Press, 2003).

Hyatt Mayor, A., 'The Photographic Eye', *The Metropolitan Museum of Art Bulletin*, vol. 5 (1946), <http://www.metmuseum.org/pubs/bulletins/1/pdf/3257398.pdf.bannered.pdf>.

James, N. P., *Vermeer and the Transfixed Moment: Critical Approaches to the Artist*. (Fishpond, Australia: Cv/Visual Arts Research, 1996).

Janson, Jonathan, <www.essentialvermeer.com>.

Jansen, Anita, 'De "Klaerlightende Spiegel der verfkonst"', in *Cultuurhistorisch Magazine Voor Delft*, vol. 17, no. 2 (2015).

Jansen, Guido, and Peter C. Sutton, *Michael Sweerts (1618–1664)*, ed. Duncan Bull. (Zwolle: Waanders Publishers, 2002).

Jardine, Lisa, *Ingenious Pursuits: Building the Scientific Revolution*. (London: Little, Brown and Company, 1999).

——, *Going Dutch: How England Plundered Holland's Glory*. (London: Harper Perennial, 2009).

——, 'An Irregular Life, Not a Biography of Constantijn Huygens', in Sharpe and Zwicker (2012).

——, *Temptation in the Archives, Essays in Golden Age Dutch Culture*. (London: University College London Press, 2015).

Jelley, Jane, 'From Perception to Paint: The Practical Use of the Camera Obscura in the Time of Vermeer', *Art and Perception*, vol. 1, nos 1–2 (2013).

——, <www.tracesofvermeer.com>.

Jenison, Tim, *Tim's Vermeer*, directed by Tim Teller and produced by Penn Jillette and Farley Ziegler (DVD). Sony Picture Classics (2013).

——, Jonathan Janson, and David Walsh, *The Hound in the Hunt: Optical Aids in Art*. (Tasmania: Museum of Old and New Art, 2016).

Jenkins, Simon, *The Selling of Mary Davies and other writings*. (London: John Murray, 1993).

Jensen, Merle H., and Alan J. Malter, *Protected Agriculture: A Global Review*. World Bank Publications: Technical Paper, no. 253 (1995).

Johnson, Jr., Richard C., and William A. Sethares, 'Canvas Weave Match Supports Designation of Vermeer's Geographer and Astronomer as a Pendant Pair', *Journal of Historians of Netherlandish Art*, vol. 9, no.1.

Kahr, Madlyn Millner, 'Vermeer's "Girl Asleep": A Moral Emblem', *Metropolitan Museum Journal*, vol. 6 (1972).

Kaldenbach, Kees, *Vermeer*, <https://kalden.home.xs4all.nl/>.

——, 'Optica Prints', *De Boekenwereld*, vol. 1, nos 2 and 3 (1985).

——, 'Vermeer Geography: Homes of Artists and Patrons in the Age of Vermeer (with fold-out map)', in Franits (2001).

Keith, Larry, 'Carel Fabritius' *A View in Delft*: Some Observations on its Treatment and Display'. *National Gallery Technical Bulletin*, vol. 15. (London: National Gallery, 1994).

Kemp, Martin, *The Science of Art*. (London and New Haven: Yale University Press, 1990).

——, 'Vermeer's Vision', *Nature*, vol. 392, no. 27 (1998).

——, 'Imitation, Optics and Photography: Some Gross Hypotheses', in Lefèvre (ed.), (2007).

——, *Christ to Coke: How Image Becomes Icon*. (Oxford: Oxford University Press, 2012).

——, *Art in History*. (London: Profile Books Ltd, 2014).

——, (ed) *Leonardo on Painting*, trans. with Margaret Walker. (Yale University Press, 1989).

Kirby, Jo, *The Painter's Trade in the Seventeenth Century: National Gallery Technical Bulletin*, vol. 20. (London: National Gallery, 1999).

——, *Studio Practice and the Training of Artists*, in Bomford et al. (2006).

——, *A Closer Look: Techniques of Painting*. (London: National Gallery Company Ltd., 2011).

——, Maarten van Bommel, and Andre Verhecken, *Natural Colorants for Dying and Lake Pigments: Practical recipes and their Historical Sources*. (London: Archetype Publications, 2014).

——, Susie Nash, and Joanna Cannon, *Trade in Artists' Materials: Markets and Commerce in Europe to 1700*. (London: Archetype Publications, 2010).

——, and Raymond White, *The Identification of Red Lake Pigment Dyestuffs and a Discussion of their Use: National Gallery Technical Bulletin*, vol. 17. (London: National Gallery, 1996).

Kirsh, Andrea, and Rustin S. Levenson, *Seeing Through Paintings*. (New Haven and London: Yale University Press, 2000).

Koester, Olaf, *Painted Illusions: The Art of Cornelius Gijsbrechts*. (London: National Gallery Company Ltd., 2000).

Konstam, Nigel, <http://www.verrocchio.co.uk/nkonstam/blog/2010/01/04/vermeers-method/>.

Kovats et al., 'Europe', in *Climate Change 2014: Impacts, Adaptation, and Vulnerability*. (IPCC: Fifth Assessment Report (AR5), 2014).

Krakora, Joseph J., and Ellen Bryant, *Vermeer, Master of Light* (DVD). National Gallery of Art, Washington/Microcinema (2001).

Kühn, Herman, 'A Study of the Pigments and Grounds used by Jan Vermeer', *Report and Studies in the History of Art*, vol. 2. (Washington: National Gallery of Art, 1968).

——, *Conservation and Restoration of Works of Art and Antiquities.* (London: Butterworths, 1986).

Lammertse, Friso, Nadia Garthoff, Michel van de Laar, and Arie Wallert, *Van Meegeren's Vermeers: the Connoisseur's Eye and the Forger's Art.* (Rotterdam: Museum Boijmans Van Beuningen, 2011).

——, and Jaap van der Veen, *Uylenburgh & Son: Art and Commerce from Rembrandt to De Lairesse 1625–1675.* (Zwolle: Waanders Publishers, 2001).

Laurenze-Landsberg, Claudia, 'Neutron-Autoradiography of two Paintings by Jan Vermeer in the Gemäldegalerie Berlin', in Lefèvre (ed.), (2007).

Leeflang, Huigen, and Pieter Roelofs (eds), *Hercules Segers: Painter-Etcher.* (Amsterdam: Rijksmuseum 2016).

Lefèvre, Wolfgang (ed.), *Inside the Camera Obscura – Optics and Art under the Spell of the Projected Image.* Preprint 333. (Berlin: Max Planck Institute for the History of Science, 2007).

——, 'The Optical Camera Obscura 1: A Short Exposition', in Lefèvre (2007).

Legère, Eva, 'A Foolish Passion for Sweet Harmony', in Buijsen and Grip (eds), (1994).

Leurechon, Jean, *Les recreations Mathematiques. Mathematicall Recreations: Or, a Collection of Many Problemes, Extracted Out,* trans. William Oughtred. (London: Printed for W. Leake, 1653).

Levy-van Halm, Koos, 'Where did Vermeer buy his painting materials? Theory and practice', in Gaskell and Jonker (1998).

Lhote, André, *Treatise on Landscape Painting,* trans. W.J. Strachan, (London: A. Zwemmer, 1950).

Liedtke, Walter, 'The *View in Delft* by Carel Fabritius', *The Burlington Magazine,* vol. 118 (February 1976).

——, *'A View of Delft': Vermeer and his Contemporaries.* (Zwolle: Waanders Publishers, 2000).

——, *Vermeer and the Delft School.* (New York: The Metropolitan Museum of Art, 2001).

——, *Vermeer: The Complete Paintings.* (New York: Abrams, 2008).

——, *'The Milkmaid' by Johannes Vermeer.* (New York: The Metropolitan Museum of Art, 2009).

——, C. Richard Johnson Jr., and Don H. Johnson, 'Canvas Matches in Vermeer: A Case Study in the Computer Analysis of Fabric Supports' *Metropolitan Museum Journal,* vol. 47 (2012).

Linton, William, *Ancient and Modern Colours.* (London: 1852).

Livingstone, Margaret, *Vision and Art: The Biology of Seeing.* (New York: Abrams, 2002).

Logan, Anne Marie, 'Rubens as a Teacher: "He may teach his art to his students and others to his liking"', in Golahny et al. (2006).

Lokin, Danielle H. A. C., 'Life and Work in Seventeenth-century Delft', in Wheelock (2000).

Loughman, John, and John Michael Montias, *Public and Private Spaces: Works of Art in Seventeenth-Century Dutch Houses.* (Zwolle: Waanders Publishers, 1999).

Lovell, Robert, *Enchiridion botanicum, Or A Compleat herball*. (Oxford: Printed by William Hall, for Ric Davis, 1659).

Lucas, E. V., *Vermeer of Delft*. (London, Methuen and company, 1922).

——, *Vermeer the Magical*. (London, Methuen and company, 1929).

Luijten, Ger, Peter Schatborn, and Arthur K. Wheelock, *Drawings for Paintings in the Age of Rembrandt*. (NGA Washington and Fondation Custodia Paris, 2016).

Lyons, Rebecca, *Vermeer and the Delft School* (DVD). National Gallery Films, London, National Gallery Company Ltd. (2001).

MacTaggart, Peter, and Ann MacTaggart, *Practical Gilding*. (Welwyn Herts: Mac and Me, 1985).

Malone Gill Productions, *Jan Vermeer, Light, Love and Silence* (DVD). LWTP (1996).

Mann, Sargy, and Belinda Thomson, *Bonnard at le Bosquet*. (London: the South Bank Centre, 1994).

Markham, Gervase, edited by Michael R. Best, *The English Housewife*, 1615. (Kingston and Montreal: McGill-Queen's University Press, 1986).

Marlow, Tim, *Exhibition on Screen: Vermeer from the National Gallery. Vermeer and Music: The Art of Love and Leisure* (DVD). London, Seventh Art Productions (2013).

——, with Phil Grabsky and Philip Rance, *Great Artists from Giotto to Turner.* (London: Faber and Faber, 2001).

Massey, Robert, *Formulas for Artists*. (London: B. T. Batsford 1968).

Massing, Ann, 'From Books of Secrets to Encyclopedias: Painting techniques in France between 1600 and 1800', in Wallert et al. (eds.), (1995).

Mayer, Ralph, *The Artist's Handbook of Materials and Techniques*, ed. E. Smith. (London: Faber & Faber, 1951).

McKerrow, Ronald B., *An Introduction to Bibliography for Literary Students*. (Oxford: Clarendon Press, 1927).

McNaughton, Phoebe, *Perspective and other Optical Illusions*. (Glastonbury: Wooden Books, 2007).

Merrifield, Mary P., *Medieval and Renaissance treatises on the Arts of Painting: Original Texts with English Translations* (1849). (New York: Dover Publications 1999).

Metzger, Catherine, National Gallery of Art, Washington, <http://www.sanders-studios.com/instruction/tutorials/historyanddefinitions/nationalgallery.html>.

Middelkoop, Norbert, and Anne van Grevenstein, *Frans Hals: Life Work Restoration*. (Haarlem: Frans Halsmuseum, 1989).

Molesini, G., 'The Optical Quality of Seventeenth-Century Lenses', in Lefèvre (ed.), (2007).

Mollon, John, 'Seeing Colour', in Trevor Lamb and Janine Bourriau (eds), *Colour, Art and Science*. (Cambridge: Darwin College Lectures, Cambridge University Press, 1995).

Monconys, Balthasar, *Journal des Voyages de Monsieur de Monconys*, 3 vols. (Lyon: Horace Boissat and George Remeus, 1666).

Montias, John Michael, *Artists and Artisans in Delft*. (Princeton: Princeton University Press, 1982).

——, *Vermeer and His Milieu: A Web of Social History*. (Princeton: Princeton University Press, 1989).

——, 'Recent Archival Research on Vermeer', in Gaskell and Jonker (1998).

——, 'Chronicle of a Delft Family', in Blankert et al. (2007).

Morris Pack, Jane, <http://www.janepack.net/camera-obscura-project/>.

Mountague, William, *The Delights of Holland: Or A three months travel about that and other provinces*. (London: John Sturton, 1696).

Muizelaar, Klaske, and Derek Phillips, *Picturing Men and Woman in the Dutch Golden Age*. (London and New Haven: Yale University Press, 2003).

Mundy, Peter, *Itinerarium Mundi* (1667). MS. Rawl.A315, Bodleian Library, Oxford.

Museum Boerhaave, Leiden, *Guidebook*. (Leiden: Museum Boerhaave, 1991).

Nash, John, *Vermeer*, 1991. (Amsterdam: Scala Publications, Second edition, 1995).

Netta, Irene, *Vermeer's World: An Artist and his Town*. (Berlin, London, Munich, New York: Prestel, 2004).

Natter, Bert, *The Rijksmuseum Cookbook*. (Amsterdam: Thomas Rap, 2004).

Nicéron, Jean-François, *La Perspective Curieuse du Reverend P. Niceron, Minime: 'Oeuvre tres-utile aux peintres ('very useful to painters'), Architectes, Sculpteurs, Gravueurs, et à tous autres qui se mettent du Dessein'*. (Paris: F. Langlois, 1652).

Noble, Petria, Sabrina Meloni, Carol Pottasch, and Peter van der Ploeg, edited by Epco Runia, *Preserving Our Heritage: Conservation, Restoration and Technical Research in the Mauritshuis*. (The Hague: Waanders Publishers/Royal Picture Gallery Mauritshuis, 2009).

——, and Annelies van Loon, 'New insights into Rembrandt's Susanna; changes of format – smalt discoloration – identification of vivianite – fading of yellow and red lakes – lead white paint', *Art Matters, Netherlands Technical Studies in Art*, 2 (2005).

Norgate, Edward, *Miniatura or the Art of Limning* (1627), ed. Jeffrey M. Muller and Jim Murrell. (London and New Haven: Yale University Press, 1997).

Nuttall, R. H., 'That Curious Curiosity: The Scotoscope', in *Notes and Records of the Royal Society of London*, vol. 42, no. 2 (1988).

Ossing, Franz, 'Realities in the Skies'. *Potsdam: GFZ Helmhotz Centre* (1991).

Parker, Geoffrey, *Global Crisis: War, Climate Change and Catastrophe in the Seventeenth Century*. (New Haven and London: Yale University Press, 2014).

Peacham, Henry, *The Art of Drawing with the Pen*. (London: Braddock and Jones, 1606); see Early English Books Facsimile edition of the original, in the Folger Shakespeare Library, <http://eebo.chadwyck.com/home>.

Pennell, Joseph, 'Photography as a Hindrance and a Help to Art', *British Journal of Photography*, vol. 37 (1891).
——, *The Adventures of an Illustrator*. (London: T Fisher Unwin Ltd, 1925).
Pénot, Sabine, 'Johannes Vermeer's *The Art of Painting*. A picture marked by light. Questions on pictorial invention', in Haag et al. (2010).
Pepys, Samuel, *The Diary of Samuel Pepys*, edited by Robert Latham and William Matthews. Vol X: Companion. (London: Bell and Hyman, 1983).
Phillips, Derek, *Well-being in Amsterdam's Golden Age*. (Amsterdam: Pallas Publications, 2008).
Pijzel-Dommisse, Jet, *The 17th Century dolls' houses of the Rijksmuseum*, trans. Patricia Wardle. (Amsterdam: Inmerc BV in Wormer/Rijksmuseum Foundation, 2007).
Plesters, Joyce, 'Ultramarine Blue, Natural and Artificial', *Studies in Conservation*, vol. 11, no. 2 (1966).
Plomp, Michiel C., 'The most Beautiful and Lovliest Town of Holland: A Visit to Delft in the Seventeenth Century', in Wheelock (2000).
Pool, Hans, and Koos de Wilt, *Views on Vermeer* (DVD). New York, Icaraus Films (2009).
Potter, Beatrix, *The Tailor of Gloucester*. (London: Frederick Warne and Co. Ltd).
Pritchard, R. E. (ed.), *Peter Mundy, Merchant Adventurer*. (Oxford: Bodleian Library, 2011).
Quevedo, Francisco de, *The Visions of Quevedo*, c.1627, trans. Sir Roger L'Estrange (1616–1704), introduced by J. M. Cohen. (Fontwell: Centaur Classics, 1963).
Rasmussen, Steen Eiler, *Experiencing Architecture*. (London: Chapman and Hall, 1959).
Ray, John, *A Compleat Collection of English Proverbs* (1670). (London: J Hughes, 3rd ed. 1737).
——, *Travels through the Low-countries, Germany, Italy and France with Curious observations*, vol. I. (London: J. Walthoe et al., 1738).
Renoir, Jean, *Renoir My Father*. (London: Little Brown and Company, 1962).
Reynolds, Anna, Lucy Peter, and Martin Clayton, *Portrait of the Artist*. (London: Royal Collection Trust, 2016).
Riley, Gillian, *Painters and Food: The Dutch Table*. (San Francisco: Pomegranate Artbooks, 1994).
Rilke, Ranier Maria, *Letters on Cezanne*, ed. Clara Rilke, trans. Joel Agee. (London and New York: Vintage, 1991).
Roodenburg, Herman, 'Visiting Vermeer, Performing Civility', in Golahny et al. (2007).
Roy, Ashok (ed.), with Rachel Billinge, Lorne Campbell, Jill Dunkerton, Susan Foister, Jo Kirby, Jennie Pilc, Marika Spring, and Raymond White, 'Methods and Materials of Northern European painting in the National Gallery, 1400–1550', *National Gallery Technical Bulletin*, vol. 18. (London: National Gallery, 1997).
——, and Jo Kirby, 'Rembrandt's Palette', in Bomford, et al. (2006).

Ruestow, Edward G., *The Microscope in the Dutch Republic: The Shaping of Discovery*. (Cambridge: Cambridge University Press, 2004).

Ruger, Axel, *Vermeer and Painting in Delft*. (London: National Gallery Company Ltd. / Yale University Press, 2001).

Runia, Epco, and Peter van der Ploeg, *In the Mauritshuis: Vermeer*. (Zwolle: Waanders Publishers, 2005).

Russell, John, *Vuillard*. (London: Thames and Hudson 1977).

Saitzyk, Steven, *The Definitive Guide to Artists' Hardware*. (New York: Watson-Buptill, 1987); <http://www.trueart.info/?s=The+Definitive+Guide+to+Artists'+Hardware>.

Saunders, David, Marika Soring, and Andrew Meek (eds), *The Renaissance Workshop*. (London: Archetype Publications and the British Museum, 2013).

Schama, Simon, *The Embarrassment of Riches: An Interpretation of Dutch Culture in the Golden Age*. (London: William Collins Sons and Co, 1998).

——, 'Through a glass brightly', in *Hang-ups: Essays on Painting (Mostly)*. (London: BBC Books, 2005).

Schellmann, Nanke C., 'Animal Glues: A Review of their Key Properties Relevant to Conservation', *Reviews in Conservation*, vol. 8 (2007).

Schneider, Norbert, *Vermeer 1632–1675: The Complete Paintings*. (Cologne: Taschen, 2004).

Schot, Wim, and Pieter Dreu, *Rembrandt's Painting Materials*. (Amsterdam: The Rembrandt House Museum, 2015).

Schwartz, Gary, The Schwartzlist (1995), <https://garyschwartzarthistorian.com/2016/09/30/348-today-in-delft-340-years-ago/>.

Schwarz, Heinrich, 'Vermeer and the Camera Obscura', in W. E. Parker (ed.), *Art and Photography*. (Chicago: University of Chicago Press, 1987).

Scott, Susan (ed.), *Rembrandt, Rubens and the Art of their Time: Recent Perspectives*. (Pennsylvania: Penn State University, 1997).

Searight, Sarah, *Lapis Lazuli: In Pursuit of a Celestial Stone*. (London: East and West Publishing Ltd, 2010).

Seymour, Charles, Jr., 'Dark chamber and Light-Filled room: Vermeer and the camera obscura', *Art Bulletin*, vol. 46 (1964).

Seymour, Pip, *The Artist's Handbook*. (London: Grange Books, 2003).

Sharpe, Kevin, and Steven N. Zwicker, *Writing Lives: Biography and Textuality, Identity and Representation in early Modern England*. (Oxford: Oxford University Press, 2012).

Shawe-Taylor, Desmond, 'The *Broad-Bottomed Dutch School*, Royal Taste and Netherlandish painting', in Shawe-Taylor and Buvelot (2015).

——, and Quentin Buvelot, *Masters of the Everyday: Dutch Artists in the Age of Vermeer*. (London: Royal Collection Trust, 2015).

——, *The Music Lesson* <https://www.google.com/culturalinstitute/beta/asset/lady-at-the-virginal-with-a-gentleman-the-music-lesson/CwFxCw3kUr-Lrw>.

Sheldon, Libby, 'Blue and yellow Pigments: The hidden colours of light in Cuyp and Vermeer', *Art Matters*, vol. 4 (2007).

Sheldon, Libby, 'The Newest Vermeer: How technical research convinced the doubting scholars', *The Picture Restorer*, no. 41 (Autumn 2012).

——, and Nicola Costaras, 'Johannes Vermeer's "Young Woman Seated at a Virginal"', *Burlington Magazine*, vol. 148, no. 1235 (2006).

——, Robert Cook, and Noelle Streeton (eds), *From Idea to Object: Painting Practices Revealed*. (London: UCL Art Collections, 2007).

Simon, Jacob, *Three-quarters, kit-kats and half-lengths: British portrait painters and their canvas sizes 1625–1850*. (National Portrait Gallery, London, 2013), <http://www.npg.org.uk/research/programmes/artists-their-materials-and-suppliers/three-quarters-kit-cats-and-half-lengths-british-portrait-painters-and-their-canvas-sizes-1625-1850/2.-four-historic-sizes.php>.

Sivel, Valerie, Joris Dik, Paul Alkemade, Libby Sheldon, and Henny Zandbergen, 'The Cloak of "Young Woman Seated at a Virginal": Vermeer, or a later hand?', *Art Matters*, vol. 4 (June 2007).

Six, Jan van Hillegom, *The House of Six*. (Amsterdam: Six Art Promotion, 2001).

Slatkes, Leonard J., *Vermeer and his Contemporaries*. (New York: Abbeville Press, 1981).

Slive, Seymour, *Frans Hals*. (London: Royal Academy of Arts, 1989).

——, *Jacob van Ruisdael: Master of Landscape*. (London: Royal Academy of Arts, 2005).

Sluijter, Eric Jan, 'Ownership of Paintings in the Dutch Golden Age', in Baer et al. (2015).

Smith E., *The Compleat Housewife*, 1729. (London: Literary Services and Production Limited, 1968).

Smith, John (1687), *The Art of Painting in Oil*. (London: J Bew, Sixth ed. 1753).

Smith, Marshall, *The Art of Painting According to the Theory and Practice of the Best Italian, French and German Masters*. (London, 1692).

Snow, Edward, *A Study of Vermeer*. (Berkley and Los Angeles: University of California Press, 1994).

Snyder, Laura J., *Eye of the Beholder*. (London: W.W. Norton and Company, 2015).

Sooke, Alistair, 'Art theft: the stolen pictures we may never see again', *The Telegraph* (17th December 2013), <http://www.telegraph.co.uk/culture/art/art-news/10524230/Art-theft-the-stolen-pictures-we-may-never-see-again.html>.

Sorbière, Samuel (1615–1670), *Relation d'un voyage en Angleterre*, 1664, trans. *A Voyage to England*. (London: J Woodward, 1709).

Spring, Marika, Rachel Grout, and Raymond White, 'Black Earths: A Study of Unusual Black and Dark Grey Pigments used by Artists in the Sixteenth Century'. *National Gallery Technical Bulletin*, vol. 24. (London: National Gallery, 2003).

Stallybrass, Peter, Roger Chartier, J. Franklin Mowery, and Heather Wolfe, 'Hamlet's Tables and the technologies of Writing in Renaissance England', *Shakespeare Quarterly*, vol. 55, no. 4 (2004).

Staubermann, K., 'Comments on 17th-Century Lenses and Projection', in Lefèvre (ed.), (2007).

Steadman, Philip, *Vermeer's Camera: Uncovering the Truth behind the Masterpieces.* (Oxford: Oxford University Press, 2001).

——, 'The orientation of the camera image', *Vermeer's Camera: Afterthoughts, and a Reply to Critics* (2002), <www.vermeerscamera.co.uk>.

Stone-Ferrier, Linda, 'The engagement of Carel Fabritius's Goldfinch of 1654 with the Dutch Window, a significant site of neighbourhood social exchange', *Journal of Historians of Netherlandish Art*, vol. 8, no. 1 (2016).

Stork, D. G., *Colour and Illumination in the Hockney Theory: A Critical Evaluation.* (Stanford: Stanford University, 2003), <www.diatrope.com/stork/CIC.pdf>.

Streeton, Noëlle L. W., *Perspectives on the Painting Technique of Jan van Eyck.* (London: Archetype Publications, 2013).

Sutton, Peter, *Pieter de Hooch 1629–1684.* (Hartford Connecticut: Wadsworth Atheneum, 1998).

Swillens, P. T. A., *Johannes Vermeer: Painter of Delft, 1632–1675.* (Utrecht/Brussels: Spectrum Press, 1950).

Talley, Mansfield Kirby, *Portrait Painting in England: Studies in the Technical Literature before 1700.* (London: Paul Mellon Centre for Studies in British Art, 1981).

Taylor, Paul, 'The concept of *Houding* in Dutch Art Theory', *Journal of the Warburg and Courtauld Institute*, vol. IV (1992).

——, 'The Glow in Late Sixteenth and Seventeenth Century Dutch Paintings', in Hermens et al. (1998).

——, *Condition: The Ageing of Art.* (London: Paul Holberton publishing, 2015).

Tazartes, Maurizia, *Vermeer.* (London, Munich, New York: Prestel, 2012).

Temple, William (1628–1699), *Observations upon the United Provinces of the Netherlands* (1690). (London: printed for Jacob Tonson, and Awnsham and John Churchill. The seventh edition 1705, corrected and augmented).

Terrasse, Antoine, and Jean Clair, trans. Richard Howard, *Bonnard–Matisse: Letters Between Friends, 1925–1946.* (New York: Harry N. Abrams Inc., 1992).

Theophilus, *On Divers Arts*, trans. John G. Hawthorne and Cyril Stanley Smith. (New York: Dover Books, 1979).

Thompson Jr., Daniel V., *The Craftsman's Handbook, 'Il Libro dell' Arte', Cennino d'Andrea Cennini.* (London and New Haven: Yale University Press, 1933).

——, *The Materials and Techniques of Medieval Painting.* (New York: Dover Publications, 1956).

Thornton, Peter, *Seventeenth-Century Interior Decoration in England, France and Holland* (1978). (London and New Haven: Yale University Press, Fourth edition, 1983).

Tierie, Gerrit, *Cornelis Drebbel (1572–1633).* (Amsterdam: H.J. Paris, 1932).

Tissink, Fieke, *The Rembrandt House Museum, Amsterdam.* (Amsterdam, Ludion, 2013).

Townsend, Joyce H., Tiarna Doherty, Gunnar Heydenreich, and Jacqueline Ridge, *Preparation for Painting: The Artist's Choice and its Consequences.* (London: Archetype Publications, 2008).

Tree, Isabella, *Wilding: The return of nature to a British farm* (London: Picador, 2019).

Trevor-Roper, Hugh, *Europe's Physician: The Various life of Sir Theodore de Mayerne*. (London and New Haven: Yale University Press, 2006. ©The Literary Estate of Lord Dacre of Glanton).

Turner, Jacques, *Brushes: A Handbook for Artists and Artisans*. (New York: Design Books, 1992).

van Berge, Nollie, and Lidewij de Koekkeok (eds.), with contributions by Mireille Cornelis, Leonore van Sloten, and Eddy de Jongh, *Under the Spell of Hercules Segers: Rembrandt and the Moderns*. (Amsterdam and Zwolle: WBooks / Hercules Segers Foundation/Rembrandt House Museum, 2016).

van Berkel, Klaas, 'Vermeer and the Representation of Science', in Brandenbarg and Ekkart (eds), (1996).

van de Wetering, Ernst, *Use of the Palette by the Seventeenth-Century Painter'*, in Wallert et al. (1995).

——, *Rembrandt: The Painter at Work*. (Berkeley: University of California Press, 2009).

——, *Rembrandt Thinking*. (Amsterdam: University of Amsterdam Press, 2016).

van der Gaag, Stef, *Historical Atlas of Delft: From Town of Crafts to City of Technology* (English edition). (Nijmegen: Vantilt Publishers, 2015).

van der Sman, Marie Christine, 'The Year of Disaster: 1672', in Haks and van der Sman (1996).

van der Woude, Ad, 'The Volume and Value of Paintings in Holland at the Time of the Dutch Republic', in Freedberg and de Vries (eds), (1991).

van der Wulp, Bas, 'A View of Delft in the Age of Vermeer', in Haks and van der Sman (eds), (1996).

van Eikema Hommes, Margriet, *Changing Pictures*. (London: Archetype Publications Ltd, 2004).

van Geenen, Léon-Paul, *De Tijdloze Schoonheid van Delfts Wit / The Timeless Beauty of White Delft*. (Hoorn: Uitgeverij PolderVondsten, 2013).

van Gogh, Vincent, *The Letters*. Van Gogh Museum, Amsterdam, <http://vangoghletters.org/vg/>.

van Helden, Anne C., and Rob H. van Gent, 'The Lens Production by Christiaan and Constantijn Huygens', *Annals of Science*, vol. 56 (1999).

van Hout, Nico, 'Meaning and development of the Ground Layer in Seventeenth-Century Painting', in Hermens et al. (1998).

——, and Arnout Balis, *Rubens Unveiled: Notes on the Master's Technique*. (Antwerp: Ludion Koninklijk Museum voor Schone Kunsten, 2012).

van Maarseveen, Michel P., *Vermeer of Delft: His Life and Times*, trans. M. E. Bennett and M. Holthuizen. (Amersfoort: Bekking, 2016).

van Strien, Cornelis Daniël, 'British Travellers in Holland during the Stuart Period', unpublished PhD Thesis presented at Vrije Universiteit, Amsterdam (1989).

van Strien, Kees, *Touring the Low Countries: Accounts of British Travellers, 1660–1720*. (Amsterdam University Press, 1998).

van Suchtelen, Ariane, *Dutch Self-Portraits of the Golden Age*. (The Hague: Waanders Publications, Zwolle, 2015).

——, and Frederik Duparc, Peter van der Ploeg, and Epco Runia, *Holland Frozen in Time*. (The Hague: Waanders Publications, Zwolle, 2001).

van Thiel, P. J. J., and Luitsen Kuiper, *Purloined, Damaged, Recovered, Restored: Vermeer's 'The Love Letter'*. (Amsterdam: Delta, 1973).

Vergara, Alejandro, 'Vermeer: Context and Uniqueness. Dutch Painting of Domestic Interiors, 1650–1675', in Vergara and Westermann (eds), (2003).

——, *The Art of Clara Peeters*. (Madrid: Museo del Prado, 2016).

——, and Mariët Westermann (eds), *Vermeer and the Dutch Interior*. (Madrid: Museo Nacional del Prado, 2003).

Vermeylen, Filip, 'The Colour of Money: Dealing in Pigments in Sixteenth-Century Antwerp', in Kirby et al. (2010).

Verslype, Ige, 'The Restoration of *Woman in Blue Reading a Letter* by Johannes Vermeer', *Rijksmuseum Bulletin*, vol. 60, no. 1 (2012).

Villa, Renzo, *Vermeer: The Complete Works*. (Milan: Silvana Editoriale, 2012).

von Sonnenburg, Hubert, 'Technical Comments', *The Metropolitan Museum of Art Bulletin*, vol. 31, no. 4 (1973).

Vossestein, Jacob, *The Dutch and their Delta: Living Below Sea Level* (Schiedam: XPat Scriptum Publishers, 2014).

Wadum, Jørgen, *Jan Vermeer, Light, Love and Silence*. (DVD). London, Malone Gill Productions, LWTP (1996).

——, 'Johannes Vermeer and his use of Perspective', in Wallert et al. (1995).

——, 'Vermeer in Perspective', in Wheelock and Broos, (1995).

——, 'Vermeer and the Spatial Illusion', in Brandenbarg and Ekkart eds, *The Scholarly World of Vermeer*. (1996).

——, 'Contours of Vermeer', in Gaskell and Jonker (1998).

——, René Hoppenbrouwers, and Luuk Struick van der Loeff, *Vermeer Illuminated: Conservation, Restoration and Research*. (Mauritshuis, The Hague: V+K Publishing, 1995).

Wahrman, Dror, *Mr Collier's Letter Racks: A Tale of Art and Illusion at the Threshold of the Modern Information Age*. (New York: Oxford University Press, 2012).

Waiboer, Adriaan, with contributions by Wayne E. Franits, E. Melanie Gifford, Bianca M du Mortier, Pieter Roelofs, Marijn Schapelhouman, and Linda Stone-Ferrier, *Gabriel Metsu*. (London and New Haven: Yale University Press, 2010).

——, Arthur K. Wheelock, Blaise Ducos, Eric Jan Sluijter, and Piet Bakker, *Vermeer and the Masters of Genre Painting: Inspiration and Rivalry*. (London and New Haven: Yale University Press, 2017).

Wald, Robert, '*The Art of Painting*: Observations on Approach and Technique', in S. Haag, Oberthaler and Pénot et al. (2010).

Wallace, Robert, *The World of Rembrandt*. (New York: Time-Life, 1975).

Wallert, Airie, *Still Lifes, Techniques and Style*. (Zwolle: Waanders, 1999).

——, 'A Peculiar emblematic still-life painting from Johannes Torrentius', *Art Matters: Netherlands Technical Studies in Art*, vol. 4 (2007).

——, Erma Hermens, and Marja Peek (eds), *Preprints: Historical Painting Techniques, Materials, and Studio Practice*. Preprints of a Symposium held at the University of Leiden, The Netherlands, 26–29 June 1995. (USA: The J. Paul Getty Trust, 1995).

——, and Willem de Ridder, 'The Materials and Methods of Sweerts's Paintings', in Jansen and Sutton (2002).

——, 'Forms that Lay Hidden in a Chaos of Paints: Style and Technique in Hercules Segers's Paintings', in Leeflang and Roelofs (2016).

Walsh, John, 'Skies and reality in Dutch Landscape', in David Freedberg and Jan de Vries, *Art in History/History in Art: Studies in Seventeenth-Century Dutch Culture*. (Lunenburg,: Stinehour Press, 1991).

Walterfield, Giles (ed.), *The Artist's Studio*. (Compton Verney: Hogarth Arts, 2009).

Ward, Gerald (ed.), *The Grove Encyclopaedia of Materials and Techniques in Art*. (Oxford: Oxford University Press, 2008).

Weber, Gregor, 'Vermeer's Use of the Picture-within-a-Picture: A New Approach', in Gaskell and Jonker (1998).

——, *Woman in Blue Reading a Letter*. (Amsterdam: Rijksmuseum Publications, 2013).

Welu, James A., 'Vermeer: His Cartographic Sources', *The Art Bulletin*, vol. 57, no. 4 (1975).

——, 'Vermeer's Astronomer: Observations on an Open Book', *The Art Bulletin* Volume 68, 1986, Issue 2.

Westermann, Mariët, *A Worldly Art: The Dutch Republic 1585–1718*. (London: Weidenfield and Nicolson, 1996).

—— (ed.), *Art and Home: Dutch Interiors in the Age of Rembrandt*. (Zwolle: Waanders Publishers/Denver Art Museum, 2001).

——, '*Vermeer and the Interior Imagination*', in Vergara and Westermann (2003).

——, *Johannes Vermeer (1632–1675)*. (Zwolle: Waanders Publishers/ Rijksmuseum, 2008).

Wheeler, Jo, with Katy Temple, *Renaissance Secrets Recipes and Formulas*. (London: V&A, 2009).

Wheelock, Jr., Arthur K., *Perspective, Optics, and Delft Artists around 1650*. (New York: Garland Science, 1977).

——, 'Vermeer's Painting technique', *Art Journal*, vol. 41, no. 2 (1981).

——, and C. J. Kaldenbach, 'Vermeer's *View of Delft* and his Vision of Reality', *Artibus et Historiae*, vol. 3, no. 6 (1982).

——, *Vermeer*. (London: Thames and Hudson, 1988).

——, *Vermeer and the Art of Painting*. (London and New Haven: Yale University Press, 1995).

Wheelock, Jr., Arthur K., and Ben Broos, *Johannes Vermeer*. (The Hague and Washington: Waanders Publications, 1995).

——, *The Public and Private in the Age of Vermeer*, with contributions by Michiel C. Plomp, Daniëlle H. A. C. Lokin, and Quint Gregory. (London: Philip Wilson Publishers, 2000).

——, 'Dou's Reputation', in Baer and Wheelock (eds), (2000).

——, 'Vermeer's Craft and Artistry', in Franits (ed.), (2001),

——, *Gerard ter Borch*, with contributions by Alison McNeil Kettering, Arie Wallert, and Marjorie E, Wieseman. (Washington: National Gallery of Art, 2005).

——, 'The Art of Painting', in Haag et al. (eds), (2010).

——, with Daniëlle H.A.C. Lokin, *Human Connections in the Age of Vermeer*. (London: Scala Publishers, 2011).

——, 'Drawings and Underdrawings: The Creative Process in Dutch Painting', in Luijten et al. (2016).

White, Christopher, and Quentin Buvelot, *Rembrandt by Himself*. (London and The Hague: Yale University Press, 1999).

White, Raymond, and Jo Kirby, *Rembrandt and his Circle: Seventeenth-Century Dutch Paint Media Re-examined*. National Gallery Technical Bulletin, vol. 15. (London: National Gallery, 1994).

Wieseman, Marjorie E., with contributions by H. Perry Chapman and Wayne E. Franits, *Vermeer's Women: Secrets and Silence*. (London and New Haven: Yale University Press, 2011).

——, *Vermeer and Music: The Art of Love and Leisure*. (London: National Gallery Company Ltd., 2013).

——, *Inviting Duets*, in Waiboer et al (2017).

Williams, Quentin, 'Projected Actuality', *British Journal of Aesthetics*, vol. 35, no. 1 (1995).

——, and Peter Kemp, 'The Music Dealer: An Explanation of Distorted Perspective'. (National Gallery Research Archive, London, 2016).

Wirth, Carsten, 'The Camera Obscura as a Model of a new Concept of Mimesis in Seventeenth-Century Painting', in Lefèvre (ed.), (2007).

Wood, John, *A Journey to the Source of the River Oxus*. (London: John Murray, 1872).

Woud, Ad van de, *The Volume and Value of Paintings in Holland at the Time of the Dutch Republic*, in Freedberg and de Vries (1991).

Wrapson, Lucy, Jenny Rose, Rose Miller, and Spike Bucklow, *In Artists' Footsteps: The Reconstruction of Pigments and Paintings, Studies in honour of Renate Woudhuysen-Keller*. (London: Archetype Publications, 2012).

Zuidervaart, Huib, J., 'The True inventor of the Telescope: A Survey of 400 Years of Debate', in Albert van Helden et al., *Origins of the telescope*. (Amsterdam: Royal Netherlands Academy of Arts and Sciences, 2010).

——, 'The "Invisible Technician" Made Visible: Telescope Making in the Seventeenth and Early Eighteenth-century Dutch Republic' in *From Earth-Bound to Satellite: Telscopes, Skills and Networks*. (Leiden: Brill, 2011).

Zuidervaart, Huib, J., *A New Theory on the Origin of Two Paintings by Johannes Vermeer of Delft*. (Paper in press).

——, and Douglas Anderson, 'Antony van Leeuwenhoek's microscopes and other scientific instruments: new information, partially from the Delft Archives', *Annals of Science*, vol. 73, no. 3 (2016).

——, and Marlise Rijks, '"Most Rare Workmen": Optical Practitioners in Early Seventeenth-Century Delft', *The British Journal for the History of Science* (March 2014).

Zumthor, Paul, *Daily Life in Rembrandt's Holland*. (Stanford: Stanford University Press, California, 1994).

PICTURE CREDITS

1879. Acc.n.: 1723 © 2016. Copyright The National Gallery, London/Scala, Florence, 8.3 Salting Bequest, 1910. Acc.n.: 1784 © 2016. Copyright The National Gallery, London/Scala, Florence, 10.6a ©2016. Image copyright The Metropolitan Museum of Art/Art Resource/Scala, Florence, 10.9 bottom left and top right: © 2017. Image copyright The Metropolitan Museum of Art/Art Resource/Scala, Florence; TopFoto: 4.4 The British Library; University of Amsterdam, Special Collections: 6.1 OG 63-3674 (2); University of Michigan Library: F.1; Van Gogh Museum, Amsterdam (Vincent van Gogh Foundation): 2.3; Wellcome Library, London: 3.3

Picture Research by Sandra Assersohn

INDEX

Page numbers for illustrations are indicated in **bold**